VAN GOGH'S EAR

On a dark night in Provence in December 1888 Vincent van Gogh cut off his ear. It is an act that has come to define him. Yet for more than a century biographers and historians seeking definitive facts about what happened that night have been left with more questions than answers.

In *Van Gogh's Ear* Bernadette Murphy sets out to discover exactly what happened that night in Arles. Why would an artist at the height of his powers commit such a brutal act? Who was the mysterious 'Rachel' to whom he presented his macabre gift? Was it just his lobe, or did Van Gogh really cut off his *entire* ear? Her investigation takes us from major museums to the dusty contents of forgotten archives, vividly reconstructing the world in which Van Gogh moved – the madams and prostitutes, café patrons and police inspectors, his beloved brother Theo and his fellow artist and house-guest Paul Gauguin. With exclusive revelations and new research about the ear and about 'Rachel', Bernadette Murphy proposes a bold new hypothesis about what was occurring in Van Gogh's heart and mind as he made a mysterious delivery to her doorstep that fateful night.

Van Gogh's Ear is a compelling detective story and a journey of discovery. It is also a portrait of a painter creating his most iconic and revolutionary work, pushing himself ever closer to greatness even as he edged towards madness – and one fateful sweep of the blade that would resonate through the ages.

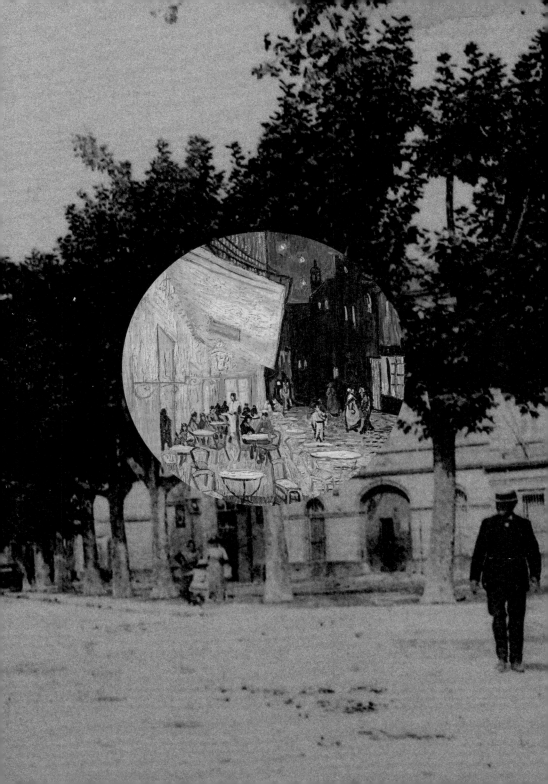

VAN GOGH'S EAR

The True Story

Bernadette Murphy

Chatto & Windus
LONDON

1 3 5 7 9 10 8 6 4 2

Chatto & Windus, an imprint of Vintage,
20 Vauxhall Bridge Road,
London SW1V 2SA

Chatto & Windus is part of the Penguin Random House group of companies whose
addresses can be found at global.penguinrandomhouse.com.

Penguin
Random House
UK

Copyright © Bernadette Murphy 2016

Bernadette Murphy has asserted her right to be identified as the author of this Work
in accordance with the Copyright, Designs and Patents Act 1988

First published by Chatto & Windus in 2016

www.vintage-books.co.uk

A CIP catalogue record for this book is available from the British Library

Hardback ISBN 9781784740610
Trade paperback ISBN 9781784740627

Typeset in Dan... ...Stirlingshire
Printed...

Penguin Random House i... ...ss, our readers and
our planet. This book is made from Forest Stewardship Council® certified paper.

MIX
Paper from
responsible sources
FSC
www.fsc.org FSC® C018179

In honour of my parents, who, despite having eight children, gave me the precious gift of their time – my mother by teaching me to read before I started school and my father by taking me to a public library and, more importantly, showing me how to use it.

As, painfully to pore upon a book
To seek the light of truth, while truth the while
Doth falsely blind the eyesight of his look.

William Shakespeare, Act 1, scene i, *Love's Labours Lost*

Contents

Illustrations

All drawings and paintings are by Vincent van Gogh unless otherwise stated.

Jacket and Endpapers

Jacket
Detail from *Self-Portrait*, Paris, March to June 1887 (© Van Gogh Museum, Amsterdam, Vincent van Gogh Foundation)

Endpapers
Photograph of place Lamartine, Arles (© Private Collection); detail from *The Yellow House (The Street)*, Arles, September 1888 (© Van Gogh Museum, Amsterdam, Vincent van Gogh Foundation); detail from *Café Terrace at Night (place du Forum)*, Arles, September 1888 (© Rijksmuseum Kroller-Müller, October)

Black and white illustrations

Colour illustrations

VAN GOGH'S EAR

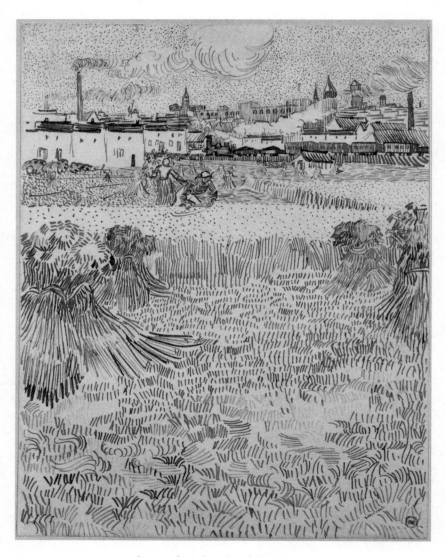

Arles seen from the Wheatfields, July 1888

Prologue

Le Petit Marseillais, Wednesday 26 December 1888:

Local news, Arles: Christmas Eve was favoured by very mild weather. The heavy rain which had been falling continuously for four days stopped completely and everyone was eager to run out to get treats or fulfil their religious duties. As a result, there were many people in the streets and even more in the churches. And everywhere it was remarkably calm and peaceful. The police, who finished doing their rounds at 5.00 in the morning, did not have a single case of drunkenness on the streets.[1]

It was still dark outside as Joseph d'Ornano, the chief of police, sat down to his first cup of coffee of the morning on Monday 24 December 1888. It was his favourite time of day. Already the station was alive with activity. From his window looking over the courtyard he watched the horseback patrol and the city police set off on their rounds.[2] The previous few days had been blighted by continuous rain and particularly quiet, but Monday dawned sunny and mild.[3] In just a few hours they would all sit down to enjoy their communal feast. It was the perfect start to the Christmas holidays.

On the chief of police's walnut desk the paperwork from the night before awaited his attention. Apart from the routine list of brawls and domestic disputes, one report stood out. Just before midnight on Sunday 23 December, something very strange had happened on the rue Bout d'Arles. This street was at the heart of the red-light district and almost every one of its twelve houses was either a working brothel or a lodging house for prostitutes.[4] As he began reading, Joseph d'Ornano examined the small package, messily bundled in newspaper, that accompanied the report. What took place in Arles that night was

so unusual, and so utterly bewildering, that everyone involved would
recall it until the day they died.

At around 11.45 p.m. a local policeman doing his rounds had been
called to one of the town's official brothels, the House of Tolerance
no. 1, situated just inside the walls of the city on the corner of rue
des Glacières and rue Bout d'Arles. There had been a commotion
involving a man, and a girl had fainted. The man lived just across the
road from the police station, so the chief inspector asked his assistant
to send someone over to the house. At around 7.15 a.m. a gendarme
was dispatched.[5]

The side of the house on the main road faced east and this part of
the building caught the very first rays of winter sunshine. There were
no shutters on the windows at street level and, as dawn was breaking,
the gendarme peered inside. No one appeared to be home. The
ground-floor room was modestly furnished with a table, several chairs
and a couple of easels. At first nothing seemed out of the ordinary.
Yet slowly, as the morning light became stronger, the gendarme noticed
a pile of soiled rags on the floor and dark spots and splashes splattered
across the walls. He returned to his superior to report his findings.

The chief of police had only recently taken up his post in Arles
and the short, portly forty-five-year-old Corsican had quickly earned
a reputation for being honest and fair.[6] Joseph d'Ornano listened
carefully to the young policeman, before dismissing him. Leaning back
in his chair he glanced at the package wrapped in newspaper lying on
his desk. This particular incident would warrant his own special atten-
tion. Donning his bowler hat and picking up his cane, the chief left
the office and accompanied by two gendarmes crossed the road to
2, place Lamartine.

By the time he arrived on the scene, a small group of locals had
gathered and the morning air was bristling with gossip and curiosity.
The policemen opened the door. Inside it was eerily quiet. There was
an acrid smell that struck them on entering – the unique combination
of oil paint and turpentine. The room doubled as kitchen and painter's
studio: on one side were brightly coloured canvases stacked against
the wall, brushes in jars, half-used tubes of oil paint, paint-smeared
rags and a large mirror propped on one of the easels; on the other

side was a burner with an enamel coffee pot, cheap earthenware crockery, a pipe and loose tobacco, and on the windowsill a spent oil lamp, as if someone had been expected back late.[7] Although there was gas lighting in the house, it was turned off citywide at midnight. The place still held the gloom of night-time and the easels threw shadows across the red-tiled floor.

The room was in complete disarray. Rags were strewn all over the floor, blotted with dark-brown stains. More dark stains were on the terracotta tiles, and a trail of drops led to the blue wooden door that opened onto a hallway. The vestibule had a brown front door that led to a narrow staircase. Early in the morning only the barest sliver of light from the large upstairs window pierced the shutter and lit the stairwell. Holding onto the metal banister, Chief d'Ornano began to climb the stairs. There were rust-coloured stains mottling the wall, as if someone had accidentally dropped a loaded paintbrush to the floor. At the top of the landing there was a single entry to the right. The chief of police pulled the door towards him and entered a cramped, attic-like room, shrouded in darkness.[8]

He ordered a gendarme to open the shutters, and light from the street flooded into the bedroom. Behind the door there was a double bed made of cheap pine.[9] In a corner a washbasin and jug stood on a table, with a small shaving mirror on the wall above. There were a few paintings on the walls: a couple of portraits and a landscape. Unlike the room downstairs, here there were no obvious signs of disorder. Half-hidden under the dishevelled bedding was the body of a man. His legs were drawn towards his chest and his head slumped to one side in a foetal position, his face shrouded by a pile of rags. The mattress was heavily stained and dark blooms of blood spread on the pillows next to the man's head.[10] The victim, as the local newspaper later put it, showed 'no signs of life'.

Joseph d'Ornano walked across the room and opened the door into the adjoining guest bedroom. There was a large Gladstone bag half-open on a chair, as if the guest was on the point of leaving. On the walls hung several paintings in a brilliant yellow hue, which even in the depths of winter brightened the room.[11] The blue blanket, plump pillows and folded white sheets indicated that the bed had not been

slept in overnight.[12] Signalling to his fellow policemen that he had seen enough, the chief pulled the door to and, walking past the body, made his way back downstairs. In the small, quiet town news of a crime started to spread.

Around 8 a.m. on that Christmas Eve morning, almost exactly the hour that Joseph d'Ornano was inspecting the guest bedroom in the Yellow House, an imposing middle-aged man was seen walking across the park. He wore a long woollen overcoat and had the bearing and elegance of a gentleman. As he strode past the porte de la Cavalerie and across the public gardens, he could hear the muted sounds of excited voices in the distance. The sounds got louder as he walked purposefully in their direction. When he reached place Lamartine and the little house he shared with his fellow painter, he saw a large crowd amassing in the street.

For the chief of police, it was an open-and-shut case. Faced with the scene – the bloody rags, blood-spattered walls, a body and a missing lodger – he could come to only one conclusion: the eccentric red-haired painter had been killed. Joseph d'Ornano didn't have to look too far for the culprit because, as luck would have it, he was walking directly towards him across the square.

Upon reaching the Yellow House that bright Christmas Eve morning of 1888, the artist Paul Gauguin was arrested for the murder of Vincent van Gogh.[13]

CHAPTER I

Reopening the Cold Case

The start of a new adventure is always the most enjoyable – not knowing where you are going, or what you might find; it can be very exciting. This particular adventure began seven years ago.

I live in the south of France about 50 miles from the town of Arles, famed for its Roman ruins and for being the home of Vincent van Gogh in the late 1880s. It was in Arles where Van Gogh famously cut off his ear. I'm a frequent visitor to the city with friends or family and around every other corner there is a tour guide peddling the legend of the crazy Dutch artist to hordes of spellbound tourists. The strange tale never fails to excite. From my experience, few of the locals seem to know Van Gogh's life story in depth, details have been embroidered and exaggerated, others have become pure invention. As his fame has grown so have the opportunities. A local bar had for more than sixty years a prominent sign that proudly proclaimed it was 'the café painted by Van Gogh'. The oldest woman in the world, a native of Arles, made the end of her life more interesting when she declared that she was the last person to have 'known Vincent van Gogh'. Even the ear part of the story has a particularly local twist: Van Gogh gave his ear to a girl because that's what the matador does at the end of a bullfight – one of many theories that have created the myth. It is arguably the most famous anecdote about any artist and has come to define his character and his art for generations. We cannot see a Van Gogh painting without interpreting his brushstrokes in the light of his much-documented breakdown. Yet it is a story swathed in myth.

The Van Gogh Museum in Amsterdam, the world's centre of expertise in all things Van Gogh, describes what happened: 'On the evening of 23 December 1888, Van Gogh suffered an acute mental breakdown.

As a result he cut off part of his left ear and took it to a prostitute. The police found him at home the following day and had him admitted to hospital.'[1]

Something happened to Vincent van Gogh in Arles, something had made his painting reach its greatest expression and yet had also pushed him to utter despair. One day, I thought, I would try to better understand what had taken place that December night in 1888.

I came to live in Provence more than thirty years ago, by chance. I was visiting an older brother and I ended up staying. With practically no knowledge of French I stumbled from job to job, gradually improving my language skills. For a long time, I struggled to make a living and it was more than ten years before I managed to get regular work. Slowly, I began to build my life; I moved to a little village and in time bought a house. One day I realised that I had spent more time in France than I had in the country of my birth. Despite this stability, I was restless. The challenge – and excitement – of working and living in a new environment had long gone. As the years passed, I felt underwhelmed by what life seemed to be offering me. Then fate intervened. My oldest sister died and around the same time I had health problems of my own. Off work recuperating, I had plenty of time on my hands. Ever since I was a child I have enjoyed unravelling puzzles. The thought of investigating Van Gogh's story and really understanding what happened on that fateful day in December 1888, suddenly seemed the perfect way to spend my time.

Stuck at home with no access to a library or archives, I used the art books I had on my shelves and did some research online to begin with. I went back to the Van Gogh Museum's summary and immediately had questions.[2] 'Cut off part of his left ear' – only part? Like most people, I had always believed that he had cut off his whole ear. Where had this assumption come from? And who was this prostitute? Why would Van Gogh take her such a gory gift? And how did Van Gogh arrive in Arles in February 1888 with such excitement and promise, only to kill himself less than two and a half years later?

Before long I had set out a timeline of Van Gogh's life in Arles. Yet the more I learned, the more I questioned. At first these were small issues; just points that I felt had been misunderstood or were illogical to

someone who lived locally. But the more I delved, the more these inconsistencies began to niggle me. For example, apparently Van Gogh caught a train from Paris to the south that dropped him in a town a full 10 miles from his destination – why would he do that, if he was weighed down with luggage and painting paraphernalia? Generations of experts and scholars had looked at every aspect of the artist's life and I found it hard to believe that I was the first person to notice some of these discrepancies. Perhaps they were small inconsequential details that hadn't bothered others or hadn't been followed up, but I began to wonder – if these points had been misunderstood, what else might be wrong. The greatest number of my questions concerned the infamous ear story.

Vincent van Gogh was a dedicated correspondent, and most of what we know about his life outside the paintings comes from his own pen, yet he never referred directly to the drama in his letters. The facts surrounding the night of 23 December 1888 are decidedly murky. The one person who could have answered these questions, and whose first-hand testimony should have been trustworthy, was the French artist Paul Gauguin, who was staying with Van Gogh at the time. But Gauguin in fact added to the confusion by leaving two differing accounts of the drama, one given shortly after the event, and one many years later. It soon became clear: there is very little actual proof of what happened that night. Our principal knowledge of the drama rests on two self-portraits and a single newspaper article:

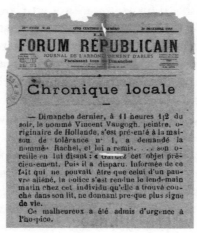

Le Forum Républicain, 30 December 1888

Le Forum Républicain, Sunday, 30 December 1888
Local news: Arles
Last Sunday, at half-past eleven in the evening, Vincent Vaugogh
[*sic*] a painter, a native of Holland, turned up at the 'House of
Tolerance no. 1', asked for a certain Rachel, and handed her . . .
his ear, telling her: 'Keep this object carefully.' Then he disap-
peared.[3]

It was astonishing there was not more coverage. Nineteenth-
century newspapers are full of the minutiae of life from ordinary
people: a lost purse, linens stolen from washing lines, an earring
found, locals arrested for drunkenness. Even if Vincent was still a
relatively unknown painter in 1888, I wondered why the other
newspapers in Arles had never bothered to report this strange
incident.

The timing of my project was fortuitous. It coincided with a new
publication of Van Gogh's letters, which were also made available
online.Some of the less palatable aspects of his life – his patronage
of brothels, for example – had been glossed over in earlier editions,
particularly in translated versions of the correspondence. To date,
almost 800 letters have been published, which provide invaluable
insights into the life and creativity of this extraordinary man. The
largest number, and the most intensely personal of the letters, were
those Van Gogh sent to his younger brother, Theo. Many of these
were written while the brothers were living apart, especially after
Van Gogh moved to Arles in February 1888. They provide a unique
snapshot of his arrival in the city and the friends he made there.
Reading his letters, I entered his world, shared his enthusiasm and
disappointment and watched over his shoulder as he painted his
greatest artworks. As the months went by, if I was ever in doubt,
I would return to read Vincent's own words.

For my investigation I decided I would start from scratch. It feels
odd to re-examine the work of those who have spent years on the
study of Van Gogh and his work; what could I possibly bring that
hadn't already been discovered or rejected? At this stage, I had no
idea. But I wanted to find out for myself. If I was to find anything

new, I would have to look in places that others perhaps hadn't. I decided to use primary sources as much as possible in my research. I hoped to build up a picture of Vincent and his life in Arles that was entirely my own. This would be my adventure and my discovery, and perhaps all the more fun for it.

I understand the region and its idiosyncrasies well. Like Van Gogh, I come from northern Europe and moved south. I, too, am the outsider, and I have had to confront confusion, prejudice and presumption – many of the issues he faced in the 1880s – and such intimate local knowledge has proved vital to my investigation and afforded me many invaluable insights. France is a regional country: each area has a particular way of life, cuisine, landscape, language and culture that has formed over centuries. Provence has its own distinct personality. That a person from Paris is completely different to a person from Arles is as true now as it was at the end of the nineteenth century. Parisians are famous in France for being self-contained and snooty; whereas Provençal people are considered exuberant and, superficially at least, are friendly. In my experience, once you are accepted, local people will help you in any way they can, though this acceptance might well take many years. Above all, the people of southern France are clannish, inherently wary of what they call *estrangers*. This Provençal term signifies much more than its literal meaning of 'foreigner'. It is used to refer to anyone who is not from your family, religion or immediate environment. In a wider sense, calling someone an *estranger* implies that the person is not completely trustworthy; true today, but even more so a hundred years ago.

From the outset my plan was to undertake a forensic investigation into what happened on 23 December 1888. It seemed logical to put myself in the shoes of Joseph d'Ornano, the chief of police in Arles at the time. He would be my guide. There was common ground: the chief had arrived in the city at the beginning of 1888 and would have had to learn about the people, the geography, the customs, in exactly the same way I would to understand Van Gogh's time there.[4] Arles was the most appropriate place to start, so I wrote to the town archives to make an appointment to visit. One sparkling winter day I set off

on the first of what would turn out to be more than a hundred trips
to the city.

The town archives are housed in the chapel of the former public hospital
– the only remaining building in Arles still standing where Vincent van
Gogh spent time. There is a garden in a central courtyard; these days it
is constantly planted and replanted to resemble the scene Van Gogh
described as being 'all full of flowers and springtime greenery'.[5] Walking
through the austere stone gateway into the abundance of flowers and
shrubs is truly enchanting. The early-morning walk along the first-floor
terrace, facing due south, towards the heavy walnut door of the Municipal
Archives is now very familiar. It is a peaceful moment, when there is hope
and anticipation of what I might find that day. As the beautiful wrought-
iron handle is turned, the old door makes a loud click, announcing the
arrival of a new visitor. Few people look up. Each person is hunched over
a table, absorbed in his or her work. Inside, the room is very quiet, with
just the gentle rustle of dusty sheets of paper being turned.

Although I was welcomed and helped by the kind staff at the archives,
my first visit was disappointing. I was shown everything the city had
on Van Gogh. I had imagined I would have stacks of boxes to rummage
through; yet all I was given were a few sheets of paper dating from
early 1889. It felt almost as if Van Gogh had never lived in Arles. There
are no police reports of the ear-drama, no witness statements and no
patient records from the hospital. There are no hotel registers that list
his name and no trace of any house rented by Van Gogh. And no one
who knew him in Arles ever wrote down their recollections of the
artist. This lack of background detail was even more surprising because
the story unfolded in a country that, certainly from my experience, is
steeped in bureaucracy and red tape. It was bewildering.

Founded by the Romans more than 2,000 years ago, Arles is one
of the oldest cities in France. Its archive is monumental for such a
relatively small place, with documents dating from the twelfth century;
Van Gogh is only a tiny part of its long history. The archive is so vast
that it hasn't yet been digitally catalogued, so I spent that first day
flicking through the old-fashioned card index and familiarising myself
with the system. Given the lack of ready information, I would have

to go deeper, I reasoned, and try to find information through a circu-itous route. Van Gogh lived in Arles between 20 February 1888 and 8 May 1889 so I requested the census records closest to that date, to see if I could find anything. Censuses were taken in 1886 and 1891, but only the 1886 census was available. I asked where I could consult the missing census and was told by Sylvie Rebuttini, the chief archivist, that she had never seen a copy in Arles. I found all sorts of informa-tion that day, though how relevant it was going to be later, I could only guess at. With so little to go on, anything could be important. Scrolling through the names, I found details concerning the prostitutes working in the city in the 1880s, listed as being 'FS', meaning *fille soumise*, literally a 'girl under the thumb'. Given that a prostitute called Rachel featured in Van Gogh's story, I thought this research might provide some useful information. I started a small list of these working girls and the brothel owners, described as *limonadiers* (lemonade-sellers) on the census returns. The quaint terms tickled me.

No matter how delighted I was by these details, a much bigger problem was becoming increasingly apparent. I had no idea what Arles looked like in 1888. Not only did the part of town that Van Gogh lived in bear little relation to the modern-day city, but new street names and an extensive post-war building programme had made it even more confusing and unrecognisable. I wasn't the only researcher who had encountered this problem. A two-dimensional map of Van Gogh's part of town had been drawn in 2001, but it lacked detail.[6] If I was to build up a picture of what Arles was like in the 1880s when Van Gogh first stepped off the train, I needed to know more. The first task was to understand exactly why and how the city had changed so dramatically.

On 25 June 1944 the 455th Bomb Group of the US Air Force took off at 5.20 a.m. from San Giovanni airfield near Foggia in the south of Italy. The mission of these thirty-eight B-24s was to disable the bridges along the Rhône to prepare the terrain for the Allied landings. This expedition would be part of the first phase of the Liberation. For the 455th Bomb Group it was a particularly long-haul flight – a 1,770-kilometre (1,100-mile) round trip. This was its sixty-seventh mission, and one of the targets was the railway bridge in Arles.[7]

By late June 1944 air-raid sirens had been going off for months, but Arles had never yet suffered a direct hit. The frequency of these air-raid warnings quickly followed by an 'all clear' led the people of Arles to become a little complacent.

It was a beautiful clear Sunday morning and most of the city was returning from Mass. The shelters were located close to one another in the centre of town, in the only places considered strong enough to withstand aerial bombing – under the Roman amphitheatre and forum. As the first air-raid siren sounded at 9.25 a.m., people in the city centre rushed to the designated shelters.[8]

The bombardment came at 9.55. Within ten minutes the aircraft had dropped 112 tonnes (110 tons) of bombs from a height of 14,500 feet, over the marshalling yards and warehouses on both sides of the river.[9] From such a height it was impossible to bomb accurately, and no direct hits were observed on the bridge itself. As the aircraft made its way back to base, the crew's report noted that fires could be seen near the target.

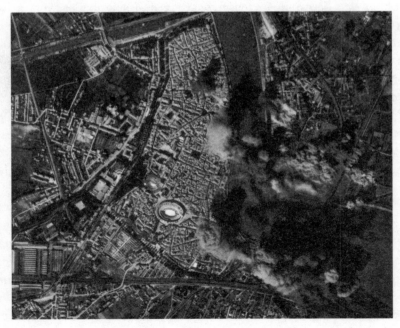

American bombing raid of Arles, 09.55 hours, 25 June 1944

On the ground there was pandemonium. The 'all clear' siren wasn't working, so no one dared leave the shelters. Only the emergency services ventured out to see what had happened, rushing nervously to the ruins to help dig out the wounded and excavate bodies from the rubble. On that midsummer morning forty-three people lost their lives. The devastation to the city was such that some of the victims were only discovered a month later.[10]

The area that had received the worst of the bombing was north of the city, close to the station. It was a section of town outside the walls, called La Cavalerie, named after the old city gate, which was still standing. In 1888 this area had been the home of Vincent van Gogh. Within minutes on 25 June 1944 the city Van Gogh knew – the cafés he frequented, the first hotel he stayed in, the brothels he visited and even his home, the Yellow House – was wiped completely off the map.

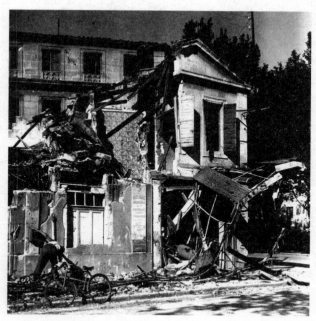

The Yellow House, 2, place Lamartine, Arles, in 1944

While looking into the bombing, I came across this previously unpublished photo of the Yellow House. Although plans of the house

had been drawn up in 1922, for the first time I got a glimpse inside.[11] Then, quite by chance, many months later, I came across two incredible aerial photographs of Arles taken in 1919. They made a huge difference to my understanding of the geography. I could finally see what Arles looked like thirty years after Van Gogh had lived there.

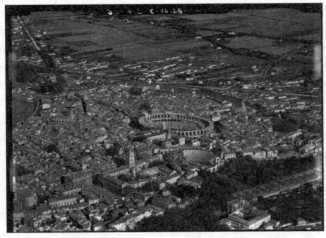

Arles, 1919

By working with an architect, using old maps, plans of the public gardens, land registries and these rare early photographs, I have been able to re-map the city, as well as the complete interior of Vincent's Yellow House.[12] This painstaking groundwork has been enormously useful, and has proved vitally important for me: this part of Arles is not only the place where most of the protagonists lived and worked, but it is also the scene of the crime.

Doing research is like doing a huge crossword puzzle. After the initial euphoria of discovery, the excitement wears off and the puzzle is all that remains. There is rarely one eureka moment; instead, it's a long, slow process, with some clues falling into place only much later. I work in a circular fashion on several things at once, the problem I'm trying to solve ticking over at the back of my brain. To an outsider, it might look as if I'm all over the place; but out of the chaos comes order!

My love for research has always been part of who I am. Like many people, I began to look into my family history after the death of my

parents. I had great difficulty tracing my Irish ancestors before 1864, when civil registration began. Eventually I mapped out my Irish family tree by pursuing other avenues: checking tax records and land transactions, legal documents and newspapers. From this arduous process I learned much about how rural communities work: they help each other out. This network was how they found jobs and spouses. Those who migrated were sponsored by relatives, and their social life in the New World centred around people they would have known from home. In order to understand these relationships, I put together a database of the entire parish in Ireland where my family came from.

The experience taught me that seemingly unimportant groundwork is invaluable. So early on in my Van Gogh research, and somewhat foolhardily, I decided to create a database of the people who lived in Arles in 1888. My reasoning was that even if it was mind-numbingly dull to compile a file on each individual – café owner, butcher, postman, doctor – I needed to amass a cache of verified information on Van Gogh's contemporaries and neighbours if I were ever to understand his life in Arles. I assumed at first I'd need files on perhaps 700–1,000 people; now, seven years later I hold records on more than 15,000 individuals. Each time a new detail on someone comes to light, I add it to the database. Over time these figures have become rich, real people to me, almost like characters in a long nineteenth-century novel. Through this I have got to know a man and a place. Like Van Gogh's letters, the details in my database take me into his day-to-day existence and, with his paintings, form a unique diary of his time in the city. I can identify and flesh out the lives of the people Vincent painted. I feel I know them, their habits, their children, and I can spot small details in paintings that give signs of their life or their identity. They are no longer simply faces on canvas as they once were to me, but Vincent's friends, the workers and locals he saw every day and the people who played a significant part in his life.

I began this project with a vague idea: how did a single event that took place in a Provençal backwater 125 years ago come to define the painter Vincent van Gogh? I had no idea of the thousands of hours I would spend trying to unravel the whole story, or of the false leads, the disappointments and the exhilarating highs I would encounter.

The ear was simply the beginning.

CHAPTER 2

Distressing Darkness

Theo's brother is here for good, he is staying for at least three years to take a course of painting at Cormon's studio. If I am not mistaken, I mentioned to you last summer what a strange life his brother was leading. He has no manners whatsoever. He is still at logger-heads with everyone. It really is a heavy burden for Theo to bear.

Andries Bonger to his parents, Paris, about 12 April 1886[1]

In late February 1886 Vincent van Gogh arrived in Paris, attracted by the vibrant modern art scene in the city, to live with his younger brother, Theo, an art dealer. Turning up with no prior warning, Vincent sent a note to Theo's office that began with the words, 'Don't be cross with me that I've come all of a sudden.'[2] Van Gogh's move to the centre of the contemporary art world was an inevitable step on a journey that had begun six years earlier, when he had decided to devote his life to art.[3]

Vincent Willem van Gogh was born on 30 March 1853, to Reverend Theodorus van Gogh and his wife Anna Cornelia van Gogh (née Carbentus) at their parsonage in Zundert in the Netherlands. This new baby arrived exactly a year to the day after a stillborn male child, also called Vincent Willem.[4] Both boys were named after the Reverend Van Gogh's father.[5] The pastor had followed his father's calling, but art was the family profession – three of Van Gogh's uncles were art dealers. There was a constant round of social visits between the relatives, but the six Van Gogh children lived considerably more modestly than their cousins. Obliged to make sacrifices to ensure that his children received

the best possible education, Reverend Van Gogh left the family home in 1871 to take up a better living in another village. Life in Zundert had been a calm, idyllic time for all the family. While recovering from his first breakdown many years later, Vincent's thoughts turned back to this childhood home: 'I again saw each room in the house at Zundert, each path, each plant in the garden, the views round about.'[6]

Through their close-knit family network, the children met suitors and found work. The family were close to their Uncle 'Cent (Vincent), who, with no children of his own, had always taken a particular interest in his nieces and nephews. He was a partner in the Goupil & Cie. gallery – one of the most prominent inter-national art dealers in Paris – which catered to the emerging upper middle class and specialised in modern works by painters such as Corot and others of the Barbizon School. He arranged that sixteen-year-old Vincent should start as an apprentice in The Hague branch of the firm, and within four years he was promoted to the London office. That same year, 1873, Van Gogh's younger brother, Theo, joined Goupil in Brussels. The brothers were extremely close and shared a passion for art. At the start of their working

Vincent van Gogh, aged eighteen

lives, it seemed as if both men were destined to be art dealers; but where Theo thrived, rising to become manager of one of the prestigious Paris branches, Vincent was not remotely suited to the convention and rigour of the business world.

Described by his contemporaries as intense, peevish and quick to anger, Vincent was often the subject of his friends' jokes: 'Van Gogh provoked laughter repeatedly by his attitude and behaviour – for everything he did and thought and felt . . . when he laughed, he did so heartily and with gusto, and his whole face brightened.'[7] Vincent was unfailingly generous, profoundly kind to others and inspired great loyalty; but he was also a man of extremes. While working at Goupil's

in London, he had become increasingly involved in an evangelical form of Protestantism. This interest soon became an all-consuming passion, and after transferring to Goupil's Parisian office in 1875, he was dismissed in April 1876. Vincent explained the situation to Theo:

> When an apple is ripe, all it takes is a gentle breeze to make it fall from the tree, it's also like that here. I've certainly done things that were in some way very wrong, and so have little to say . . . so far I'm really rather in the dark about what I should do.[8]

He returned to London to work as an assistant schoolmaster and began lay preaching at weekends. Over the Christmas holidays he told his parents he wished to become a pastor, insisting that the Church was his true calling. However, his family persuaded Vincent to return for good and found him a job in a bookshop in Holland. As Vincent hadn't finished his schooling, this new plan would mean at least seven long years of study. But even this could not dissuade him. In May 1877 he moved to Amsterdam where he began the preparation for his theological studies, but he didn't stay long. During the summer of the following year he started training as an evangelist in Belgium, but disappointingly was not offered a job at the end of the three-month trial period. Finally in January 1879, thanks to family connections, Vincent obtained a post as a trainee pastor. He would begin his first post as a lay minister amongst the working-class miners of the Borinage, in Belgium.

Van Gogh threw himself into this new world with total conviction. He took his pastoral duties very seriously, tending to the sick and destitute parishioners personally. Wishing to better experience the life of the poor and emulate a Christ-like existence, Vincent gave away all his unnecessary possessions and clothes, refused to sleep in a bed, and spent hours working hard on his sermons. Scared by this eccentric and extreme behaviour, the parish elders decided Van Gogh was not suited to the life of a pastor and by July he had been dismissed, barely managing to complete the six-month probationary period.

If his professional life was fraught, his love life was possibly worse still. He had a series of relationships, each more disastrous than the last. With no sense of restraint, Van Gogh would pursue the object of his

affections relentlessly, with an unequal passionate intensity, completely unaware that his feelings were not reciprocated, nor even welcome.

In 1881 Van Gogh decided he was in love with his recently widowed first cousin, Kee Vos, and proposed marriage. In addition to the manifest unsuitability of marrying such a close relative, Kee was not in love with him and had no wish to remarry. In an effort to win her over he turned up at his uncle and aunt's house in Amsterdam one night while they were having dinner, demanding to see her. When he was refused entry, he thrust his hand over a lamp, and refused to remove it from the open flame, begging her dumbfounded parents to let him see her even if it was only for as long as he could hold his hand over the flame. Melodramatics aside, this sort of behaviour underscored the impression the wider Van Gogh family held of him – Vincent was more than odd, he was mad.

During Vincent's early adulthood, his mental health was a constant source of anguish to his parents and was evoked frequently in their correspondence. As he moved into his twenties, his family did what they could to help him find his path in life, but his eccentricities only became more entrenched. His father wrote to his favourite son in 1880: 'Vincent is still here. But oh, it is a struggle and nothing else . . . Oh, Theo, if only some light would shine on that distressing darkness of Vincent.'[9]

In the late nineteenth century the study of the mind was still in its infancy. Private institutions to house the mentally ill did exist, but were more akin to holding pens.[10] For anyone with an emotionally disturbed child, the only option was a state lunatic asylum, and few people survived many years in one of those. In 1880, after a series of particularly distressing events, Reverend Van Gogh and his wife took steps to place twenty-seven-year-old Vincent in an institution in Belgium, but the family, with strong objections from Vincent, was unable, or unwilling, to force the issue and he was never committed.[11] Van Gogh recalled this period in a letter to Theo the following year: 'It causes me much sorrow and grief but *I refuse to accept* that a father is right who curses his son and (think of last year) wants to send him to a madhouse (which I naturally opposed with all my might).'[12] After the drama in Arles in December 1888, recalling the professional appraisal of her son given eight years earlier, Anna van Gogh wrote to Theo, 'there is something missing or wrong with that

little brain . . . Poor thing, I believe he's always been ill.'[13] There were many signs that Van Gogh had psychiatric problems. Alas, in the family these were not confined exclusively to Vincent. It is impossible to know whether he had a hereditary disorder, but there are indications that there was a family history of mental illness, which Vincent later mentioned to one of his doctors.[14] Of the six children born to the Reverend Van Gogh and his wife, two would commit suicide and two would die in asylums, though Theo was diagnosed with syphilis of the brain.[15]

Throughout his life, Van Gogh was attracted to the destitute, the suffering, those in desperate need, certain he was the only person who could save them. In January 1882 he met Sien Hoornik, an ex-prostitute, pregnant with another man's child and three years older than Van Gogh.[16] By July Sien, her new baby and her five-year-old daughter moved in with Van Gogh. This was the first time Vincent had lived with a woman and for a time it worked well. Van Gogh was happy to have some semblance of an idealised family life and Sien became his model. They separated in September 1883. Vincent explained his feelings to Theo: 'From the beginning with her, it was a question of all or nothing when it came to helping. I couldn't give her money to live on her own before, I *had* to take her in if I was to do *anything* of use to help her. And in my view the proper course would have been to marry her and take her to Drenthe. But, I admit, neither she herself nor circumstances allow it.'[17]

Throughout the first half of the 1880s, as his parents despaired over his constantly erratic behaviour, Vincent was intermittently estranged from his family. Like many young men, he was desperate to live independently but, unable to survive without his parents' or Theo's financial support, from time to time he was forced to return home.

Over the summer of 1884, he got to know Margot Begemann who lived next door to the Van Gogh family in Neunen. In July, Margot took over his mother's sewing class when she was laid low after breaking her leg, and began a relationship with Vincent. Both families strongly disapproved of the liaison and Vincent explained to Theo on 16 September, 'Miss Begemann has taken poison – in a moment of despair, when she'd spoken to her family and people spoke ill of her and me, and she became *so* upset that she did it, in my view, in a moment of definite *mania*.'[18] Vincent's reaction to her attempted suicide was to

feel he should marry her, yet he complained in the same letter that her family had requested that he should wait two years.

Quite unexpectedly, on 26 March 1885, four days before Vincent's thirty-second birthday, the Reverend Van Gogh died. Notwithstanding the often fractious nature of their relationship, Vincent and his family were united in mourning. The truce was only temporary, though, and after an argument with his sister Anna, Vincent left the family home in May 1885 – this time for good.

Van Gogh had dabbled in drawing and painting since he was a child, and since the mid-1880s he was working more seriously. Around this time he executed his first major work, *The Potato Eaters*. The canvas is unrelentingly harsh: a social commentary on the life and dire conditions of the Dutch peasant community. The rough living conditions of the workers, gathered together to eat the most lowly and basic meal, are accentuated by the subdued palette. With its dark interior and sombre tones, the painting is modern in subject matter, showing the working class in the brutal reality of their hand-to-mouth existence. Although he was not entirely satisfied with the work, Van Gogh knew he had achieved something. When he met Émile Bernard in Paris a year later, he proudly showed him *The Potato Eaters*, though Bernard remarked that he found it 'frightening'.[19]

Much though the idea of sharing an apartment with Theo had been in the offing for a while, his sudden arrival in Paris was a surprise. Yet this impetuous behaviour was – if disorientating for Theo – entirely in Vincent's nature. At the time, twenty-eight-year-old Theo was working as manager at Boussod, Valadon et Cie., the renamed Goupil & Cie., at 19, boulevard Montmartre.

In late February 1886, desperate to be elsewhere, Vincent left Belgium, not even paying his bills, as he later confessed in June 1888: 'Wasn't I forced to do the same thing in order to come to Paris? And although I suffered the loss of many things then, it can't be done otherwise in cases like that, and it's better to go forward anyway than to go on being depressed.'[20]

He began to study drawing and painting at the studio of the artist Fernand Cormon, finding new friends among its pupils: Émile Bernard,

the Australian artist John Peter Russell, and Henri de Toulouse-Lautrec.[21] Yet he didn't stay long at the art school:

> I was in Cormon's studio for three or four months but did not
> find that as useful as I had expected it to be. It may be my fault
> however, anyhow I left there . . . and [ever] since I have worked
> alone, and fancy that I feel more my own self . . . I am not an
> adventurer by choice but by fate and feeling nowhere so much
> myself a stranger as in my family and country.[22]

Since the early 1880s Theo had been providing Vincent with a
monthly stipend from his own salary, supplementing the allowance
he received from his parents. Theo loved his brother dearly and
wished to help him live the life he chose, but he also felt a moral
obligation to help Vincent be the person – and the artist – he had
the potential to be.[23] Theo's meticulous account books demonstrate
his extreme generosity: he gave an estimated 14½ per cent of his
salary to his brother to fund his life as a painter.[24] This expenditure
increased substantially after Vincent moved to Arles.

In addition to Vincent's own painter friends, Theo, as a well-known
dealer, was his brother's conduit into
the Parisian art scene. Vincent met
and swapped paintings with a few
of his contemporaries. The brothers
saw this arrangement as an invest-
ment they were making in the future
of modern art; Vincent, financed by
Theo, contributed his artwork to the
deal and through the exchange of
paintings. For a while it worked well;
the brothers built up a sizeable
collection of contemporary works
and Japanese prints, which, with
Vincent's paintings, are now part of
the collection of the Van Gogh
Museum in Amsterdam.

Theo van Gogh, c.1887

The relationship between the brothers was very close. Devoted to his older sibling, Theo not only financed Vincent's life, but also supported and regularly defended him. Without that financial and emotional investment, Vincent's achievements would not have been possible. We know Van Gogh's work today thanks to his remarkable brother (and later Theo's widow, Johanna Bonger), who preserved Vincent's letters, drawings and paintings for posterity. Their relationship has become an essential part of Vincent's life story: the genius of Van Gogh, aided and abetted by the selfless generosity of Theo. Yet this is a sugar-coated portrayal. Living together in Paris was not without its strains; the two men argued, and occasionally these rows were nasty. In early 1887 they reached crisis point:

> Vincent continues his studies and he works with talent. But it is a pity that he has so much difficulty with his character, for in the long run it is quite impossible to get on with him. When he came here last year he was difficult, it is true, but I thought I could see some progress. But now he is his old self again and he won't listen to reason. That does not make it too pleasant here and I hope for improvement. It will come, but it is a pity for him, for if we had worked together it would have been better for both of us.[25]

A few days after writing this letter, Theo began seriously to question his arrangement with Vincent, and wrote to his sister Willemien about it:

> I have often asked myself whether it was not wrong always to help him and I have often been on the verge of letting him muddle along by himself. After getting your letter I have seriously thought about it and I feel that in the circumstances I cannot do anything but continue . . . You should not think either that the money side worries me most. It is mostly the idea that we sympathise so little any more. There was a time when I loved Vincent a lot and he was my best friend but that is over now.[26]

Vincent had moved his life and work wholesale into Theo's space, transforming the apartment into an artist's studio. His irascibility and erratic

behaviour compounded the issue. The story of the brothers' perfect rela-
tionship has been cultivated over the years, ever since Theo's widow edited
the first edition of the letters, published in 1914. With Jo leaving certain
details out of her book, the business of editing Vincent's life story began.

Van Gogh had initially come to Paris to learn from modern masters,
particularly the Impressionists – the group at the forefront of contem-
porary art – but by the time he arrived the movement had run its
course and the Impressionist exhibition of 1886 was to be its eighth
and final show. Impressionism, with its bright palette capturing the
middle class at play, had been a radical departure from the academic
paintings that still dictated public taste in the 1880s. Yet younger artists
were beginning to move on, embracing new ideas like Symbolism.
Strongly influenced by Japanese prints, these painters would go further,
using pure colour in a vibrant, raw fashion to illustrate a new side of
nineteenth-century life: laundresses, prostitutes and peasants, subject
matter which suited Vincent van Gogh perfectly.

While in Paris, he tried to find new outlets for his work, showing
some of his paintings including his *Sunflowers* at a restaurant called
Le Tambourin.[27] Vincent had a brief affair with the owner, and in 1887
he painted *Portrait of Agostina Segatori,* showing her sitting at one of
her tambourine-inspired tables.

In November and December 1887, frustrated by the few galleries that
were willing to show modern art, Van Gogh organised a group show
at the restaurant known as Le Petit Chalet.[28] One of the artists who
saw the exhibition was Paul Gauguin, recently returned from a painting
trip to Martinique. The show was not the success Van Gogh had hoped
it might be: just two paintings were sold, and Vincent's aspiration to
create a new brotherhood of like-minded painters in the capital appeared
foolish. To Van Gogh, it seemed that everyone in the Paris art world
was thriving and, after two years, he had barely sold any paintings.
Disillusioned and depressed with his life in Paris, he was now desperate
to leave and start afresh somewhere new. He revived an idea he had
first mooted in 1886: to go to the south of France.

Living in the metropolis had made him physically unwell, as Van
Gogh told his brother within days of arriving in Arles. 'At times it seems
to me that my blood is more or less ready to start circulating again,

which wasn't the case lately in Paris, I really couldn't stand it anymore.'[29] The French capital, with its sophisticated social circles and endless noise, was the antithesis of what Vincent sought in life. Working in Paris had taught him the importance of contrasting colour and, from the Japanese prints he collected with Theo, he had learned to use unconventional perspectives and compositions. With these new ideas at his disposal, he turned back to the subject matter of his early canvases from Holland: landscapes and portraits of simple working people. To find what he was looking for, he needed to leave Paris.

No one knows exactly why Van Gogh decided on Arles. Marseille would have seemed a more obvious choice. Not only was it the last home of the painter Adolphe Monticelli, whom Van Gogh particularly admired, but it was also the departure point for ships to Japan, which he hoped to visit one day.[30] Yet despite mentioning in his letters his intention of going there, Vincent never actually visited Marseille. Perhaps the bustling port was simply too big and noisy, the very thing he was trying to avoid. Given that Vincent's reasons for choosing Arles in particular remain hazy, there has been plenty of speculation: was he in search of the famed light of the south? A new subject matter? Or was he simply looking to escape the capital? Women are usually mentioned as a possible reason, especially given that the 'Arlésiennes' – the women of Arles – were famed for their beauty throughout France.[31] Degas had been to the city on a painting trip as a young man, and Toulouse-Lautrec – a fellow pupil of the Atelier Cormon – might well have suggested it to Vincent as a relatively cheap place to stay.[32] Although Vincent had considered leaving for warmer climes as early as 1886, his journey south on 19 February 1888 seems to have been a spur of the moment decision.

On the day of his departure, Theo came to see him off from the station. On taking the No. 13 express train that left at 9.40 p.m., it would take Vincent a night and a day to get to Provence.[33] While his train rattled through the flat landscape around Paris, Theo returned alone to the apartment they had shared at 54, rue Lepic. Pushing open the door, he turned on the gas lamps and intense colour flooded the rooms from the dozens of vibrant paintings that had been hung by his brother a few hours before. Vincent's presence was everywhere.[34]

CHAPTER 3

Disappointment and Discovery

After working for several months on my own in France, preparing what I thought was a fairly complete chronology of the artist's time in Arles, I felt ready to set off for the archives at the Van Gogh Museum in Amsterdam. At the time I was under the impression that I knew quite a lot about Vincent van Gogh and hoped that I would find a straight-forward answer, somewhere in the museum's archives, to the most perplexing of my questions: what exactly had Vincent cut off? Apart from the famous self-portraits showing Van Gogh with a bandaged ear, I still hadn't been able to find any further contemporary information to go on other than the local newspaper that had published the story.

There were a number of points that I hoped I could clarify during my trip and in the back of my mind I had a wild hope that the search for the truth about 'Van Gogh's Ear' might make an interesting subject for a documentary film or a newspaper article. Since the museum was the world authority on Van Gogh, I assumed its scholars had already inves-tigated every aspect of Vincent's life and there was nothing new to be uncovered, and certainly not by me. Before I left I read a 1930s French article about his ear, written by two psychiatrists who had studied Vincent's pathology. With no access to a major archive nearby, I was lucky one of the doctor's sons, Robert Leroy, lived close to me and kindly sent me a copy of the article.[1] It included an eyewitness account that was new to me: the recollections of a local policeman who had been called to the red-light district on 23 December 1888.

It was late November and already deep winter in Amsterdam when I arrived. As I left the airport it began to snow. It is a myth that we only have hot and balmy days in the south of France. Provence can get

bitterly cold during the winter months, catching the visitor unawares. With a heavy frost and no cloud cover, it can regularly reach -10°C overnight. But even in the depths of winter, the sky is almost always a deep blue, and the light is particular – brighter than in the summer, as the dust in the air is blown away by the force of the local wind.

So under a horribly depressing grey northern European sky, I made my way to the building next to the Van Gogh Museum, where the research library is housed. I had corresponded with Fieke Pabst, a gentle, smiling woman who welcomed me warmly that wintry morning. As my time was limited, I had ordered all the files that I thought might be useful in understanding Van Gogh's first breakdown in 1888. Some of the boxed files I had requested were waiting for me on my table in the reading room. I was also given a list of all the documents that the library possessed, and eagerly ordered lots more. As Fieke continued adding to my pile, we chatted about my project and she asked me why I had begun my research. I muttered something about my sister's death and she whispered, 'Cancer?' I nodded. 'Me too, my sister died last year,' she said and then, 'Let's have lunch.' In that instant, Fieke became a very dear friend.

The damp, cold weather and the night drawing in so early meant that I barely saw daylight during the four days I spent in Amsterdam. I felt low and melancholy. My subdued mood was compounded by the piles of boxes awaiting me each morning at the library. I thought my original idea had been fairly simple and uncomplicated: to research the night Vincent cut off part of his ear. As I ploughed through the files, I realised I couldn't begin to understand one night in 1888 when I barely knew anything about Van Gogh or his contemporaries.

As I read, I began to understand the story in a different way. In 1970 the Museum's academic journal, *Vincent*, focused on the events that took place in Arles at the end of 1888 and in early 1889, and printed in full some of the letters to Theo from Vincent's friends and from the doctor who treated him in Arles. The letters from Vincent's friend Joseph Roulin, who worked at the Arles post office, his doctor, Dr Félix Rey, and the protestant pastor of Arles, Reverend Salles, were really interesting as they kept Theo informed of his brother's progress, bearing witness to events as they were actually happening. Until then, I had only come across extracts from these letters. Reading them through completely, in their

original French, gave me a whole new perspective on the aftermath of Vincent's breakdown.

Towards the end of that first day in Amsterdam I opened a file entitled 'Ear'. I skimmed through the first few pages. Suddenly I felt sick. In the file was an article by the journalist Martin Bailey, from a highly respected art magazine.[2] It included the famous portrait of Vincent with a bandaged ear, and even used the title 'Van Gogh's Ear' on its cover. My heart sank. Not only did the article go over every single aspect of the story that I understood up to that point: questioning what Vincent had cut off, the name of the girl to whom he gave his mutilated ear, and Gauguin's conflicting accounts, it had already been *published*. It made my quest utterly redundant. I sat for a while in the library, numb. My hunt had come to a very abrupt end. I was devastated. This was only my first day, and I had no idea what I was going to do next.

Just before the library shut at 5 p.m., Fieke came by my desk. We talked briefly about the article I had discovered and, at my request, she gave me Martin Bailey's email address. She also asked whether I had been into the museum yet and when I replied 'No', she kindly offered me a ticket so that I could pop in to see the paintings next door. Although I had seen some of Van Gogh's works elsewhere, I had never had the opportunity to see a large number of Vincent's paintings all together. As I walked into the large modern building someone muttered an unintelligible greeting in Dutch and I rushed inside. With only an hour left before the building closed, I moved quickly through the galleries, taking in early works from Holland and Belgium. Those paintings were dark and sombre and they mirrored my mood. As I rounded the corner into another room, I was stopped in my tracks. Above the paintings on the wall, I read the words:

'I feel a failure' – Vincent van Gogh.[3]

I stared at the words for several minutes. My morale was so low that I had begun to doubt I could bring anything new to his story. I had spent the past ten months working on a project that someone else had already done. Suddenly I was full of empathy for this troubled man I had never met. In that moment the artist was transformed by

the realisation that he, one of the most revered painters in the world, had felt like a failure. He was no longer simply the subject matter of my research. Vincent van Gogh had become *real*.

Then I turned another corner and suddenly I was home, back in the south of France, bathed in the sunlight and images I know so well. The canvases were bright and full of life. I wandered around slowly, savouring every painting. They were so much more *intense* than I had ever imagined. In a strange country, feeling overwhelmed and stunned by Vincent's paintings, I was deeply moved. Back in the warmth and the sun of Provence, quite unexpectedly, I started to cry.

In my rented flat that night, I emailed Martin Bailey, explaining my research project and offering to give him all my material to date. He wrote back saying that the offer was most gracious, but he had no intention of doing any more work on the ear in the foreseeable future. It gave me a little glimmer of hope. I spent the evening reading his article carefully and I was intrigued by something that I hadn't yet uncovered: mention of a second press article about the ear-story. This was a tiny newspaper cutting sent to one of Vincent's friends, the Belgian painter Eugène Boch. It had lain hidden in an envelope in the Royal Archives in Belgium until Bailey had found it.[4] At first it didn't appear that there was much new:

Arles – The crackpot: Last Wednesday, under this heading we related the story of a Polish painter who had cut his ear with a razor and had given it to a girl who worked in a café. Today we learned that this painter is in a hospital, where he suffers cruelly from the self-inflicted blow, but it is hoped that his life will be saved.[5]

The term 'Polish painter' wasn't overly worrisome – in French the word for Dutch is *hollandais* and Polish is *polonais*, and the words sound almost identical when spoken. There was no date, or any indication of which newspaper it was from, but the reference to a self-inflicted wound surely meant that the story could only be about Van Gogh. But the article said it was a follow-up to something that had been published earlier that same week: this was an exciting discovery. I had always thought it was unfathomable that such a juicy story could have been ignored by other newspapers, and these few lines in the newspaper

confirmed what I had long suspected: the drama in Arles had made the press elsewhere. In his article, Martin Bailey mentioned that he had tried in vain to find the newspaper source for this cutting. I vowed that when I got back to France I would try to find the original article.[6]

There were two points in Bailey's article that also struck me: according to Theo van Gogh, Vincent used a 'knife' to mutilate his ear, yet this new source clearly stated 'a razor'.[7] Who was right: Theo or the newspaperman? Secondly, the article described Van Gogh as giving his ear to 'a girl who worked in a café', which was contrary to every other account of that night that had been written. The mysterious 'Rachel' was always referred to as a prostitute. Was this quaint term of 'a girl who worked in a café' a euphemism or was it something else?

Towards the end of my stay in Holland, a tall, slender Dutchman walked into the library. Fieke introduced him as Dr Louis van Tilborgh, a senior museum researcher. Louis has worked at the Museum for many years and is one of the world authorities on Vincent's paintings and all things Van Gogh. I had already read so much contradictory material about the ear and here was an expert who might be able to shed some light on my confusion. I asked him his opinion of the discrepancies in the reports about Van Gogh's ear: some said he cut off the whole thing, others just the lobe. If it were only the lobe, would that really be dramatic enough to make someone faint – as 'Rachel' the prostitute apparently had? 'Well,' he replied, 'some people faint at the sight of blood.'

During our meeting, Louis asked me if I had come across Gustave Coquiot's biography of Van Gogh. Only the name, I responded. He was the first native French speaker to write a biography of the artist. Until my conversation with Louis, I was completely unaware that Coquiot had visited Arles in 1922 and had met people who had known Vincent in the late 1880s. Moreover, he was the first person to have published a contemporary account of Vincent's injury, which was of great interest to me.

Louis told me that Coquiot's biography might be helpful, to give me more background information on Arles at the end of the nineteenth century, quite apart from the very useful photographs he took on his visit, when the whole atmosphere and layout of the town wasn't much changed from 1888. Coquiot's photographs show the Yellow

House as Vincent would have known it. It was strange and wonderful to have his home in front of me now, a ghostly presence from the past. I noticed the slanting façade: Vincent's famous bedroom was not square, as I had always assumed.[8]

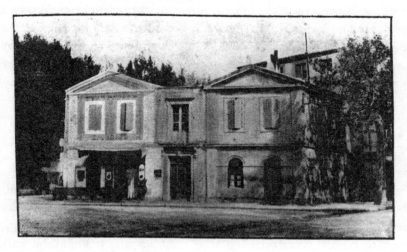

The Yellow House, 2, place Lamartine, 1922

As the days in Amsterdam rushed by, a seemingly endless stream of boxes was brought to my table. In the beginning I looked carefully at each document, weighing up the need to copy it or not. Everything was interesting. At one point a file was placed on the table called 'Curiosa', containing ephemera inspired by the drama in Arles: Van Gogh ears made of rubber, a plethora of cartoons, album covers and even a disappearing-ear coffee mug. I love anything kitsch and spent far too long enjoying these curiosities. Then a new panic set in. I couldn't see how I would ever be able to get through all the material in this short visit. I began frantically recording anything and everything that seemed vaguely interesting. I started taking hundreds of digital pictures and making endless photocopies from the huge pile of boxes to haul home.

Louis told me that the museum had purchased Coquiot's notebook in the 1960s. The original was in storage offsite. If I wanted to see the whole book, I would have to return.

★ ★ ★

In the spring of 1889 Vincent was at the hospital in Arles on one of the many occasions he stayed there after a breakdown. Far away in Paris, Theo asked the artist Paul Signac, en route south to the Mediterranean coast, if he could stop off in Arles to visit his brother. Coquiot had written to Signac and asked him for his recollections of the trip. Signac's reply, dated 6 December 1921, is the officially accepted version of Van Gogh's injury. The original letter is now lost, but was transcribed by Coquiot in his notebook. One particular sentence has been quoted by almost every author of any Van Gogh biography ever since:

> I saw him for the last time in the spring of 1889. He was still in the city hospital. A few days earlier he had cut off the lobe (and not the whole ear) in the circumstances you know.[9]

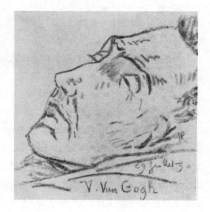

A drawing done on Vincent's deathbed in July 1890 by Dr Gachet, who met the artist in the last few weeks of his life, confirmed Signac's recollections. Naturally, the injury Vincent sustained in Arles two years before had healed by the time the drawing was made. It is only a sketch, and roughly drawn at that, but it appears to show the left side of Van Gogh's face, including most of the ear. I supposed that the two newspaper accounts had got it

Van Gogh on his deathbed, 29 July 1890, Dr Paul Gachet

wrong, or had exaggerated to make more of a story, and Vincent in fact had cut off a small amount of his ear, or just his lobe.

Although I continued researching many different avenues related to Van Gogh's stay in Arles, the question of the ear continued to plague me. Some while later once I was home Louis got in touch. He had kindly checked exactly what Theo's widow had said on the subject. She had met Vincent in 1889 after he'd left Arles. He had stayed at her home in Paris and later, in the weeks before his death, she had gone with her husband to Auvers-sur-Oise where Vincent was staying. I assumed she

would have seen Vincent's ear uncovered and known exactly what he had done. She had stated that Vincent had cut off *'een stuk van het oor'* ('a piece of the ear'). Her remark really did not help me at all. What did she mean by 'a piece of the ear'? 'Piece' was such an inexact term.

We have Jo to thank for Van Gogh's legacy of correspondence and artwork: she bequeathed all this to her son – Vincent Willem van Gogh. In 1962 he gave everything on permanent loan to the Dutch state, and this gift forms the core of the Van Gogh Museum's collection. Yet her remark about the ear seemed vague. With still with no way of ascertaining exactly what Van Gogh had cut off, the entire ear-story was getting more confusing.

I returned home to Provence with my huge pile of photocopies and images – everything that my magpie eye had spied. That December I started to organise and catalogue the files from my trip. Christmas is a quiet time of year for me in Provence, and it is very different from Christmases I knew as a child. Presents are given only to family members, and there are almost no parties; instead it is a private time, and most people spend the holiday at home with their families. Many homes set up a typical Provençal nativity, with brightly coloured clay figurines called *santons*, and at midnight on 24 December the family places the figurine of the baby Jesus in the manger: the signal that Christmas has begun. Some villages still have a live nativity during midnight Mass, when a local couple dressed as Mary and Joseph bring in a newborn baby. The real fun begins when the shepherds arrive with sheep and donkeys at the church, making a lively, if unpredictable, tableau.

The French are obsessed by food, and never more so than at Christmas. The main meal is eaten late on Christmas Eve and often lasts several hours. Fish is the principal Christmas dish, followed by thirteen desserts, which sounds more exciting than it really is. The *treize desserts* include dried fruits, nuts and nougat and bear witness to the humble origins of the tradition, when the fruits preserved during the summer months were saved until Christmas to be eaten as an exceptional treat. Although it's rather unusual to include a non-family member at the table, I have on many occasions been invited for Christmas dinner with good friends. That Christmas, however, I stayed

quietly at home, working through the papers I had copied in Amsterdam. By early January 2010 I had looked through most of the nineteenth-century documents. Then I stumbled upon something exciting.

In some correspondence from the 1950s I found a reference to the writer Irving Stone.[10] In 1934, at the height of the Great Depression, Stone had written a fictionalised biography of Vincent called *Lust for Life*. The story of the painter who had never been recognised in his own lifetime, and who had suffered great hardship for his art, reminded Americans of the difficult times they were living through and brought the artist to the attention of a wider public. It was Stone's first book and became a huge best-seller, making him a wealthy man. Stone never pretended that *Lust for Life* was anything other than fiction based on Vincent's life story. He had borrowed the idea from a German writer who had written a similar fictionalised biography of the artist. Yet Stone's Van Gogh is the version most people know. After the Second World War the book was made into the film *Lust for Life*. All the drama, violence and passion of Hollywood was preserved in Technicolor celluloid by Vincente Minnelli and Kirk Douglas.[11]

I had already written to two libraries in the USA, which I hoped had papers connected to the book and the film. These were unlikely leads, but I felt it was worth looking in unusual places to see if anything turned up. Watching the film as a child was the first time I had ever heard of Van Gogh or seen images of Provence. The brilliant colours and sheer beauty of the landscape inspired me, and I knew that one day I would go there. Many years later I watched a documentary on the 'making of' the film on French TV in which Kirk Douglas spoke to one of the extras in perfect French – an elderly lady who had actually known Van Gogh, which made me wonder if she had known Rachel. It was a lead that I needed to follow up. So I hunted down the Vincente Minnelli archive, held at the Oscar Library in Los Angeles.[12] The archivist kindly sent me copies of the few documents they held on the film – some production notes and photos taken with extras during the filming. At the same time I had written to the library at the University of California, Berkeley, in San Francisco, which houses Irving Stone's papers. The archivist, David Kessler, told me that the archive was vast and warned me to expect disappointment:

Much of the correspondence is in French or a language that must be Flemish or Dutch. There is no mention of Arles as a place of research, just a single folder that notes Marseille. The note cards are in no apparent order . . . There is nothing that I can see that amounts to a transcription or description of original documents. Short of reading all the correspondence, there is no way to definitively know if there is anything about the 'ear' episode or the prostitute in this material. My belief is that this material, which is described as very limited, will not shed light on your questions.

That's the best I can do.

In peace,

David

Until I read the letter I'd copied from the archives in Amsterdam,[13] I was unaware that Mr Stone had actually made a trip to Arles. Moreover, he had visited Dr Félix Rey, a very important figure in the story of Vincent in Arles. Rey had just started working as an intern at the local hospital when Van Gogh was admitted with a wound to his ear. Rey was one of the people who kept Theo van Gogh informed of his brother's progress while Vincent was hospitalised; and, as time passed, Rey became Vincent's friend. The artist honoured this friendship by painting a beautiful portrait of the young doctor.

As Rey continued to work at the public hospital in Arles until his death in 1932, any visitor keen to investigate the life of Vincent van Gogh in Arles would have found the doctor the easiest of Vincent's acquaintances to locate. Despite the librarian's assurance that there was nothing more to find in the Stone archive, the mention of a trip Stone had made to Arles gave me a small glimmer of hope. One cold January afternoon I opened my computer and excitedly started writing an email. I did not realise then how significant that moment would come to be.

CHAPTER 4

Almighty Beautiful

Vincent van Gogh had slept through the night as his train travelled through the French countryside from Paris. It was a twenty-hour journey from the capital to the south. After a stop in Lyons at 9.30 a.m.,[1] Vincent sat in his compartment fascinated by the changes in scenery: the countryside became rugged and mountainous, and the slate roofs gradually transformed into the red tiles of the south. In the early afternoon, just before he reached Avignon, Van Gogh caught his first sight of Mont Ventoux looming over the Provençal landscape. It was February, and in wintertime the mountain's snow-capped peak looks uncannily like Mount Fuji; Vincent might have been in Japan. He wrote to Theo, 'Before reaching Tarascon I noticed some magnificent scenery – huge yellow rocks, oddly jumbled together, with the most imposing shapes . . . magnificent plots of red earth planted with vines, with mountains in the background of the most delicate lilac. And the landscape under the snow with the white peaks against a sky as bright as the snow was just like the winter landscapes the Japanese did.'[2]

The train pulled into Arles station at 4.49 p.m. on Monday 20 February 1888.[3] In literature, the south of France is associated with sunshine and light, and Vincent had gone to Arles expecting to find both, so he was surprised to arrive as the city was experiencing a rare cold snap. The temperature had remained stubbornly below 0°C all day.[4]

Daylight was fading as he made his way through the remains of the old city gate, the porte de la Cavalerie. Passing the cafés that lined both sides of the street, he took the road to the right of the colourful Pichot fountain, completed only a few months before and named after a local writer.

Having travelled overnight and most of the day to get to Provence, an exhausted Vincent walked through the doors of the family-run Hotel-Restaurant Carrel at 30, rue Amédée Pichot around 5.30 p.m.[5] He probably heard about Carrel's from someone in Paris, as he went directly to the hotel.[6] He took a room, dropped off his bags and went for a short walk around town to get his bearings. He popped into an antique shop on the same street and talked to its owner about locating Adolphe Monticelli paintings to buy, as he later related to Theo.[7] Monticelli had died nineteen months previously in Marseille and the brothers had plans to invest in his work. At the time there were four antique dealers in the city, but the shop Van Gogh visited was probably M. Berthet's establishment. This was a sprawling emporium, which ran over two streets and was set back from the newly cobbled rue Amédée Pichot.[8]

Destroyed during the bombing raids in 1944, Carrel's was a two-storey building on a main thoroughfare, within the old Cavalerie walls. At street level there was a dining room for hotel guests and a restaurant that was open to the public.

The next floor housed the bedrooms, and on the top floor there was a half-covered roof terrace. It was from this terrace in late April that Vincent drew the rooftops looking towards the nearby church of Saint-Julien.

Tiled roof with chimney and church tower, Arles, 1888

Albert Carrel was forty-one when he first crossed paths with Vincent. He had inherited the hotel-restaurant from his father, who had died when he was five. Within months of the death of his mother, when he was twenty, Carrel married seventeen-year-old Catherine Garcin. With his sizeable inheritance, he had built up a large portfolio of properties and had business links with many of the people whom Vincent would get to know in the city. Like most hotels of the period, Carrel's catered to the largely bachelor population of shepherds and the occasional passing tourist.[9]

Arles came as a surprise to Van Gogh. Enclosed by medieval city walls that were largely intact, it had an impressive number of ancient buildings, but it was smaller than he had imagined. In 1888 it had a population of around 13,300 people – considerably fewer than has previously been estimated.[10] This revised figure is significant and helps put into perspective the reactions of the townsfolk to Van Gogh as his mental state degenerated.

Vincent's first day in Arles was to have a surprising finale. While he was eating his supper in the hotel dining room at around 8 p.m., it began to snow. According to the official weather records, more than 20 centimetres (8 inches) fell overnight and snow continued falling into the next day.[11] Inside the city walls the snowfall was a major event. A local newspaper reported drifts of 40–45 centimetres (16–18 inches), with the town seemingly 'dead, as the snow eerily muffled all noise', with only the sound of children at play; as the report informed the paper's readers, 'passers-by were being hit by snowballs and snowmen appeared on the streets'.[12] He wrote excitedly to his brother, 'there's been a snowfall of at least 60 centimetres all over, and it's still snowing'.[13]

Heavy snow is rare in Provence, and everything grinds to a halt. I am usually the only person who goes out for a walk, occasionally bumping into another crazy northerner. With the blanket of heavy snowfall lending it an ethereal quality, Arles must have been a magical sight. Unable to venture far, Van Gogh chose his first subjects close at hand: the scene directly across from the hotel dining room featuring the local butcher's shop.

His paintings are full of clues to understanding Van Gogh's experience

in Arles. They document his mood, his friends and his way of life. I tried to ascertain when, why, where and how each picture was painted, in the hope that I might uncover some small gem to illuminate further the events of that incredible year – a year that had started with such promise and ended on such a dark note.

Situated at 61, rue Amédée Pichot, the butcher's shop was owned by Antoine Reboul and his son Paul.[14] Reboul's was already an institution in Arles before Van Gogh arrived in 1888. For at least twenty years it had been not simply a butcher's, but also a *charcuterie*, a place where they cured meats.[15] In the painting you can see sausages hanging at the right of the window and can just about make out part of the lettering indicating 'charcutier'. In nineteenth-century southern France fresh meat was eaten rarely, as it couldn't be kept without being preserved; cured meat, prepared at the butcher's, was inexpensive, long-lasting and part of most daily diets. For this reason, practically all the town's butchers were located near the porte de la Cavalerie, where the huge ice-blocks for the cold-rooms were stored. The street name rue des Glacières (ice-maker's street) reflects this use.

In the immediate foreground, dominating the painting, are the wrought-iron frames of the dining-room windows. The decorative curl on the left pane indicates a window opening rather than a door, and to the right the metalwork forms an X-shape. This device is still used in Provence to protect the glass from breaking, should the window accidentally slam shut – essential in a region famed for its strong gusts of wind. The only human presence is a woman scurrying along the street, about to enter the butcher's. Wearing a cap over her hair, with a green shawl over her shoulders, she hitches up the hem of her skirt as if to avoid getting it wet in the wintry sludge. On the pavement there are the melting remains of recent snowfall. From the weather records, I discovered that the snowy weather continued without pause for four full days, until it rained on 25 February – a strange beginning for Van Gogh in the south. As I ascertained from maps that the windows of Reboul's faced due west, the winter sun would hit the shop-front only in the late afternoon, so with its sludge-covered street and partly lowered blind, this picture can be dated fairly precisely. One afternoon around 24 February 1888, after the lunch service was over,

Van Gogh sat in the dining room of his hotel in Arles and painted Reboul's shop.

At about the same time Vincent also made a portrait of an old lady, his first Arlésienne. Dressed in traditional costume and wearing a widow's black scarf over her hair, the woman sits next to a bed. She is most likely someone Van Gogh met through staying at the hotel, and is almost certainly Elisabeth Garcin (née Paux), Albert Carrel's widowed mother-in-law, who was sixty-eight at the time.[16]

It is easy to forget that by flicking through a magazine, watching films and television or browsing the internet today we see more images than anyone might see in their entire lifetime in the nineteenth century. Although paintings and drawings were on show in a couple of shops in Arles, they tended to be classical in nature, with subject matter that conformed to certain traditional tropes – history paintings, landscapes, portraits, religious art. Vincent's first two choices of a butcher's store and an elderly woman must have seemed fairly astonishing and modern to the people of Arles. News that an artist was in town travelled fast, and within days Vincent had a courtesy call. 'On Saturday evening I had a visit from two amateur painters, one of whom is a grocer and also sells painting materials – and the other a justice of the peace who seems kind and intelligent.'[17] The grocer, Jules Armand, had a shop a few doors up from the hotel, which sold basic art supplies, and he must have seen Vincent working as he walked past Carrel's dining-room window. Later that spring Vincent would seek out the kindly justice of the peace, Eugène Giraud, asking him to settle a dispute.

Though the poor weather remained an issue, Vincent began painting in nearby fields as the snow began to melt. As February turned into March, the snowfall was followed by the harsh local wind known as the mistral, which also made painting outside challenging:

Now at long last, this morning the weather has changed and has turned milder – and I've already had an opportunity to find out what this mistral's like, too. I've been out on several hikes round about here, but that wind always made it impossible to do anything. The sky was a hard blue with a great bright sun that

melted just about all the snow – but the wind was so cold and dry it gave you goose-pimples. But even so I've seen lots of beautiful things – a ruined abbey on a hill planted with hollies, pines and grey olive trees . . . I haven't yet been able to work in comfort and in the warm.[18]

Settling in was not easy for the painter, especially as making friends among the locals took time. Van Gogh stood out simply by the colour of his hair and his height – he was fairly tall compared to the men of Provence. He was a foreign gentleman living in a poor part of town largely populated by farmers and railway workers. Within days of his arrival everyone in his immediate neighbourhood knew him by sight. This didn't mean that the locals spoke to Vincent with anything more than casual courtesies, but that his presence in Arles was noted. His surname, 'Van Gogh', was almost impossible to pronounce in French, coming out as 'Van Gog'. Soon after arriving he wrote to his brother Theo in Paris, 'in future my name must be put in the catalogue the way I sign it on the canvases, i.e. Vincent and not Van Gogh, for the excellent reason that people here wouldn't be able to pronounce that name'.[19] Indeed, in Arles he was only ever known as 'Monsieur Vincent'.

Happily his loneliness was short-lived. In the first few days of March he made the acquaintance of a Danish artist who was also in town, Christian Mourier-Petersen.[20] The two men found that they knew some of the same people in Paris and soon began working together.

Mourier-Petersen was living only a few minutes' walk from the Hotel Carrel, at the Café du Forum on one of the city's main squares.[21] He had come to Provence after abandoning his medical studies to focus on his painting. Vincent implied in a letter that his escape from medicine had been caused by a breakdown, writing to Theo that 'When he came here he was suffering from a nervous condition that came from the strain of the examinations.'[22] Van Gogh liked his friends to have 'nervous disorders', later even claiming that Gauguin should see a medical specialist, as he was suffering from 'insanity'.[23] In Mourier-Petersen's case, however, it was nothing of the sort; he was a man of independent means who simply had decided he wanted to be a painter.

In a letter to a friend back in Denmark, he described his first encounter with Van Gogh: 'I am working on a few paintings and have been in the company of a very interesting Dutchman, an Impressionist who has settled here. In the beginning, I considered him quite mad, but now I think there is some method in it . . . I can't remember his name – Von Prut or something like that.'[24] The same day Vincent wrote to Theo, 'I have company in the evening because the young Danish painter who's here is very nice; his work is dry, correct and timid, but I'm not averse to that when the person is young and intelligent.'[25]

Quite why Mourier-Petersen thought that Vincent was 'mad' was never explained, but he was not the only person to make this judgement. There could have been several factors that gave an odd first impression: Van Gogh's eccentric demeanour, his manner of speaking or dress. Mourier-Petersen was by all accounts a rather staid young man, despite rebelling against medicine. Van Gogh, on the other hand, was a bohemian by nature and, recently arrived from Paris, dressed and behaved in the modern ways of the capital. During Van Gogh's life, one of the signs that he was moving towards a crisis was the apparent neglect of his appearance. Sometimes he just didn't care what he was wearing. This isn't at all unusual for people suffering from mental illness, but has mistakenly led to a belief that Vincent was often shabbily dressed. Fuelled by fictional accounts of the 1910s and '20s, the 'mad' Vincent van Gogh is a dishevelled wreck with no gentlemanly bearing, dress or manners.[26] There is quite a lot of evidence that the contrary was true. His self-portraits from Paris show him dressed smartly. In the south, he was sometimes quite the dandy. He was known to wear a white suit and straw hat and later, to emulate his hero Adolphe Monticelli, he purchased a black velvet jacket.[27] Yet the longer he stayed in Arles, the more he began to adopt local dress, no matter how strange that may have seemed at the time to the people around him. He took to wearing the clothes of local workers, such as the shepherd's jacket seen in his self-portraits with a bandaged ear.

As most recollections of Van Gogh were written posthumously, by people aware of his mental breakdown, it is difficult to know exactly how he came across to his contemporaries. He was regularly described

as being overly enthusiastic and a bit eccentric. Gauguin mentioned that Van Gogh had a strange gait, with distinctive, rapid footsteps. Also, due to the loss of ten teeth in 1886, he had a slight speech impediment and spoke quickly, which, combined with his Dutch accent, apparently made him hard to follow.[28] He had an extraordinary way of pouring out sentences in Dutch, English and French, then glancing back over his shoulder and hissing through his teeth. In fact when thus excited, he looked 'more than a little mad,' remarked one contemporary.[29]

Despite Mourier-Petersen's initial hesitation, they soon became firm friends. He knew his way around the region, thanks to an earlier painting trip, and he and Vincent started exploring and taking long walks in the surrounding countryside.[30] By mid-March the weather in Arles was getting warmer and the first signs of spring appeared. Spring in Provence is spectacular – an ever-changing kaleidoscope of colour. Almond trees grow wild, producing the first spring blossoms in late February. It seems as if overnight the trees are laden with flowers. Each day brings a new set of the most beautifully coloured blossom: white almond flowers, the delicate blush of peach, as well as the pure white of apricot and pear trees, always the last to bloom.[31] The sudden arrival of spring was enchanting and Vincent was inspired. 'This morning I worked on an orchard of plum trees in blossom – suddenly a tremendous wind began to blow, an effect I'd only ever seen here – and came back again at intervals. In the intervals, sunshine that made all the little white flowers sparkle. It was so beautiful!'[32]

In the urban environment of Paris, Vincent had few opportunities to work directly from nature, but the Impressionist technique of capturing a fleeting moment, which he had learned in the capital, was perfectly suited to painting the orchards that dotted the countryside around Arles. He completed seventeen canvases of trees in blossom that spring. There is also a painting of the orchards by Mourier-Petersen from this time. They 'formed a habit of working together', he recalled, meeting at their favourite café to go out, 'braving the mistral to paint orchards'.[33] They would paint side-by-side: Vincent sitting down, whilst the Dane worked at an easel standing up.[34] This wasn't the only difference in their approach: Vincent is known to have

used a perspective frame to help him pin down compositions and could well have done so in the south, while Mourier-Petersen used a more modern contraption – a camera. This was very unusual, since at the time photography was mostly studio-based and only the fairly wealthy might actually own a camera.

With so few photographs of Van Gogh in existence, I cherished a hope that I might find some more images of Vincent, taken by Mourier-Petersen from their time together. I sent letters to the four people listed in the Danish phone directory with the surname Mourier-Petersen. Three people replied, all of whom were descendants of the artist. They told me that Mourier-Petersen's photos had been sold at auction after the death of his daughter-in-law. Perhaps one day these pictures, which almost certainly still exist, will turn up.[35]

March 1888 was blustery almost all month long, with ten strong days of mistral wind.[36] But Vincent had come south to paint, and nothing would put him off. He had to find a way to work outside: 'I fix my easel to pegs stuck in the ground and work anyway, it's too beautiful.'[37] Now with friendly company and positive good humour, Vincent began to paint in earnest. He wrote to Theo, 'almond trees are starting to blossom everywhere . . . my dear brother – you know, I feel I'm in Japan. I say no more than that, and again, I've seen nothing yet in its usual splendour'; and to his sister Wil, 'I have no regrets about having come here, since I find nature here almighty beautiful.'[38] In a frenzy of activity he completed more than thirty paintings in his first nine weeks in Provence.

Easter Sunday 1 April 1888 was a beautifully sunny day and there were many visitors in town. Two years previously, it had been declared a national holiday, so there was a festive atmosphere in the air as people came into Arles for the long weekend. All over the city there were amusements for the visitors, with concerts at the bandstand and people strolling in the parks and boulevards in their finery. One of the holiday events was the first bullfight of the season in the Roman arena. Curious to experience all that Provence offered, Vincent decided to go and see the bullfight the following weekend. 'Five men were working the ox with banderillas and rosettes . . . The bullring looks so beautiful when there's sunshine and a crowd.'[39] It was the first time

Vincent had ever seen such a spectacle, though he was rather disappointed at the anticlimactic finale: the matador was forced to withdraw after injuring himself leaping over a barrier.[40]

In Spanish bullfights, the toreador cuts off the bull's ears to give as a prize to the most beautiful lady in the crowd. In 1938 the writer Jean de Beucken suggested that Van Gogh's ear was 'a Christmas present' for a girl – 'she'd asked for one and in arenas ears are given to ladies as homage during bullfights'.[41] In Provence, this has spawned one of the most popular 'why did Vincent do it?' theories, seemingly providing a perfect explanation. However, in a letter to Émile Bernard, the artist stated that he had seen 'lots of bulls, but no one was fighting them'.[42] I was intrigued by this comment, as it implied he had seen a Provençal or Camarguaise bullfight, in which the bull is not killed, nor mutilated. A thorough check of the archives and local newspapers confirmed that only Provençal bullfights had taken place on the dates Vincent attended. Given that he never saw a Spanish bullfight, it makes it hard to stake the explanation for his self-harm on this tradition.[43]

The following weekend an American artist called William Dodge Macknight travelled to Arles from nearby Fontvieille, where he was staying.[44] Walking through town, he bumped into Vincent, who was out with Mourier-Petersen. Vincent and the American had a mutual friend – the Australian artist, John Russell, who had introduced them in Paris. Mourier-Petersen had spent time in Fontvieille in 1887 where he had also met Macknight.[45] In his rather stilted English, Vincent wrote to John Russell to tell him of their encounter: 'Last Sunday I have met Macknight and a Danish painter and I intend to go and see him at Fontvieille next Monday. I feel sure I'll prefer him as an artist to what he is as an art critic, his views as such being so narrow that they make me smile.'[46] This letter, when viewed alongside his remarks on the work of Mourier-Petersen, suggests that Vincent felt he was on a different level artistically from his new friends. This could be attributed to his age – he was a few years older than both men – but it is more likely an indication of the intensity of his personality. These remarks hint at a deeply rooted trait in his character that would get steadily worse – his refusal to accept anyone else's views. Over the coming months, as his mental health declined, he became more

entrenched in his opinions and could neither accept, nor tolerate, being contradicted.

On 23 April, as planned, Vincent and Mourier-Petersen set off to spend the day in Fontvieille. The following weekend the American paid them a return visit. Before long, Macknight had written to the Belgian artist Eugène Boch inviting him to join them in the south – a small artistic community was forming.[47]

Far from the popular image of a lonely man in the south, cut off from friends and family, Van Gogh was surrounded by good company and creative stimulation. Within months of his arrival he found himself in a coterie of other artists. Boch, heir to the ceramics manufacturer Villeroy & Boch, was typical of these new friends, all of whom were educated upper-middle-class gentlemen of independent means. Later that year, after both Mourier-Petersen and Macknight had left Provence, Boch stayed on, spending time in Arles with Vincent, who found him by far the most sensitive and talented of his new painter friends.

In June, Mourier-Petersen was on the point of leaving and Vincent kindly arranged for him to stay with Theo in Paris on his way back to Denmark. 'I'm still going about with the Danish painter, but he's going home soon. He's an intelligent boy and fine as far as loyalty and manners go, but his painting is still very poor.'[48] He was only five years younger than Van Gogh, who was approaching his thirty-fifth birthday when they met; and, despite the condescending tone in the letter, both artists had been painting for about the same length of time. Even though Vincent had never enjoyed the slightest recognition of his own talents, he was disparaging of the other painters he met in Arles. Van Gogh was more talented than the people around him, and he knew it.

CHAPTER 5

Living in Vincent's World

Today Arles is very different from the city Van Gogh knew. The part of town where he lived was never rebuilt after the bombing in 1944, and the open fields and countryside of which he was so enamoured are no more and are largely residential. Luckily, not everything has disappeared. The public hospital is still standing, and both the Langlois bridge and the café exterior that Vincent painted at night have been re-created for the tourist trade (though in the case of the bridge, in a quite different location).

In spite of the physical transformation of the city, the way of life and the character of the people have not changed all that much. Life is fairly simple and uncomplicated in Provence, dominated by the climate and the rhythm of the seasons. There is a particular scent in the air of the herbs that grow wild in hedgerows and fields – thyme, rosemary and fennel. Provence is bathed in sunshine almost daily, which means people live, work and eat outside. Fresh, good food is bountiful and full of flavour. The light is particular here, a warm golden glow in the morning and evening, creating the most beautiful, intense colours and effects, quite unlike anywhere else I've been. And the end of the day brings rich deep-red sunsets.

Vincent was enchanted. The pace of life, even now, is slower. Arles was the polar opposite of the sophisticated French capital; with its narrow streets and houses cheek by jowl, people knew their neighbours and had time for one another. In Arles, Van Gogh found the quiet and calm he had craved so badly. In contrast to the hustle and bustle of Paris, there was very little traffic, other than on market days. Transport to the outlying villages was via a 'diligence' – a stagecoach –

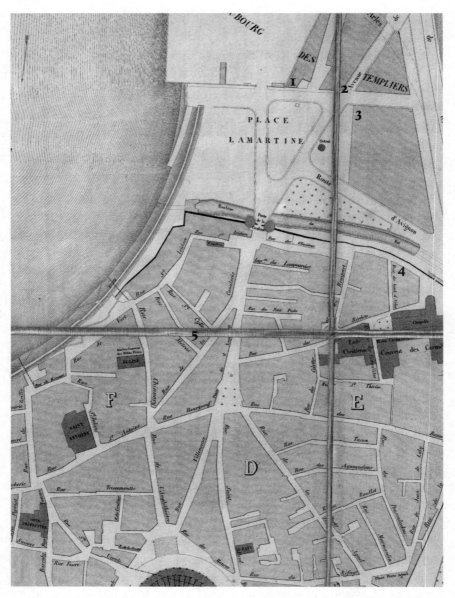

Detail from a Map of Arles, drawn up in 1867 by Auguste Véran, the town architect. This was Van Gogh's local neighbourhood in Arles in 1888 and 1889. **1** is the Café de la Gare; **2** is the Yellow House; **3** is the Gendarmerie; **4** the House of Tolerance no. 1; and **5** the Hotel-Restaurant Carrel.

but this service operated infrequently, so most people travelled by horse and cart or, more commonly, on foot.[1] The quiet was punctuated only by intermittent sounds that travelled for miles across the flat plains: a train whistle and church bells tolling to mark the time or call people to prayer. The working day began at dawn and ended with the Angelus, to celebrate the day. At sunset, peasants at prayer were a common sight around Arles. All over Provence it is still possible to see the remains of the *oratoires* (crosses or small altars) that were used for these simple daily devotions. Whilst most men were away during the day, working in the fields or in factories, women were at home taking charge of domestic duties or out at work as washerwomen. Decent women rarely ventured far from home. However, Provence was slowly moving on from its traditional agricultural past.

In the late 1880s Arles was also an army town, as several garrisons were stationed there, including the Zouaves–African colonial troops. The city was still undergoing major changes brought about by the coming of the Paris–Lyon–Méditerranée (PLM) railway, which had opened in 1844. Many people – *estrangers* – had moved to the city, attracted by the employment that the railway could provide. Houses were springing up around the station and near the railway yards; other people built homes outside the city walls beyond the porte de la Cavalerie. It was in this part of town that Vincent would find his only home in the south – the Yellow House.

Despite the generally harsh conditions of working life in nineteenth-century France, a decent living could be made in Arles. The railway brought economic prosperity and trade. *Cheminots*, as railway workers were known, were a family business; generation after generation, whole families worked for the PLM. Many of the new people who moved to Arles were members of the same family or people from the same village. The city not only had the railway line, but also the workshops where the trains were built and repaired.

The largest number of railway workers came from Protestant families based in the nearby Cévennes region.[2] This new population had grown to such a volume in Arles that it had recently taken on its own pastor, the Reverend Frédéric Salles, who would become Vincent's friend, and a vital support for him after his breakdown. The new

Protestant inhabitants were easily distinguished from the Catholic locals: their womenfolk did not dress in the traditional clothing of the city and, like Vincent, these newcomers neither spoke nor understood Provençal. The locals mostly conversed in their own tongue, even though schooling was exclusively in French, underscoring the differences between the old and new inhabitants of the city.

In 1854 a group of poets, the Félibrige, was founded in Provence. Mindful of the dramatic change brought to rural life by the Industrial Revolution, this association was devoted to celebrating the regional language and preserving the past. Nationalism was in the ascendancy in many countries throughout Europe, as the continent rapidly industrialised, lurching uncomfortably into the modern era. The Félibrige movement was an attempt to retain, and treasure, a culture that was essentially Provençal. Novels and poetry were written and published in the Provençal language for the first time, and its president, Frédéric Mistral, was one of the two writers who shared the Nobel Prize in Literature in 1904.[3] Despite Van Gogh's delight at the pace of life in Provence, the nationalist movement likely contributed to him feeling an outsider.

There were other divisions, too: Catholics and Protestants tended to live in different parts of town. Unsurprisingly, Van Gogh, the son of a Dutch pastor, found himself living amongst the Protestant population of Arles. For the people of his *quartier*, Vincent – who so loved the city, and made friends indiscriminately across all religious and social divides – was still resolutely 'not one of us'.

Indeed, Arles was a small insular community in many ways, and the local people were still very attached to a traditional way of life. There were bullfights, which took place most weekends from Easter to late October in the Roman amphitheatre.[4] The arrival of the bulls – the *abrivado* – driven into town by the local cowboys, was an exciting spectacle and a way for young men to impress the girls. Other entertainment was provided by public concerts, a theatre and a music hall, Les Folies Arlésiennes, an annual ball on 14 July and a couple of public parks for promenading at weekends in the summer.[5] It was all far removed in atmosphere from Paris, much to Van Gogh's delight.

Van Gogh spent any time he wasn't painting exploring his new

surroundings, writing in the evening to Theo and Wil with his impressions of his new home and descriptions of his experiences. An avid reader of newspapers, he regularly mentions the left-leaning national daily *L'Intransigeant* in his letters, and on Sundays it is likely that he would have sat in his favourite café and read one of the three newspapers published in Arles. He also loved books and soon after arriving in Provence, he began to re-read local writers, especially Alphonse Daudet, whose highly comic characters are particular to Provence and embody the type of people that Vincent would have met on a daily basis. In 1869 Daudet wrote the novel *L'Arlésienne*, later made into an opera by Bizet, which granted the Arlésiennes a reputation throughout France as women of incomparable beauty and mystery. Traditional costume was still worn daily in Arles, and many of Vincent's portraits show women in the recognisable Arlésienne attire. Nowadays, on special occasions women in Arles still wear this highly stylised costume. Its most distinctive component is the hairstyle: piled high on the head, with a decorative velvet ribbon around the topknot. The large collar or bodice of the dress is made of pleated white lace or cotton, with a full, long skirt, falling into a small train at the back. This costume was much more than a simple country tradition; it set the Catholic Arlésiennes apart from any *estrangers*.

Arlésiennes, *c.*1909

Van Gogh thrived in the country air, telling Theo that the move to the countryside was good for his health:

> The air here is definitely doing me good, I could wish you deep lungfuls of it. One of its effects is quite funny, one small glass of cognac goes to my head down here, so without having recourse to stimulants to get my blood circulating, my constitution won't be taxed so much all the same.[6]

Yet despite his delight at the countryside and the way of life, he struggled with the food. The diet in Provence in the late nineteenth century consisted largely of cereals and home-grown fruit and vegetables – a world away from the stodgy stewed meat and potato-based Dutch cuisine of his youth and different to what he'd eaten in Paris. In Provence, bread, beans and lentils are staples of the working man's diet, along with a liberal amount of olive oil from the plentiful local olive groves. Vincent, who had often experienced problems with his digestion, suffered from the moment he arrived:

> If I had some very strong broth, that would get me going right away, it's dreadful, I've *never* been able to get even any of the very simple things I've asked these people for. And it's the same everywhere in these little restaurants. Yet it's not hard to boil potatoes. Impossible. And no rice or macaroni either, or else it's ruined with fat or they don't do it, and make the excuse: it's for tomorrow, there's no room on the stove, etc.[7]

Being of Irish descent, potatoes feature in many of my meals, so when I read this I thought Vincent was exaggerating. So I checked the order books for Arles' hospital which still exist, to see what Van Gogh would have been eating in early 1888. There is a list of produce supplied and prices paid. Though chickpeas, dried beans and rice are listed regularly, I can find no mention of potatoes at all.[8] Locals here set me straight; although widely available in the nineteenth century, potatoes were rarely eaten by people in Provence and prior to the Second World War were cultivated almost uniquely as animal fodder.

It wasn't only the food that proved problematic. In his autobiography, Gauguin would famously call Arles 'the filthiest town in the south'. The city was surrounded by an open canal, La Roubine du Roi, into which all household waste was tipped before it flowed into the Rhône. Another unhealthy practice common in Vincent's day called *tout à la rue* – literally throwing 'everything into the street' – wasn't outlawed until 1905. In the city archives there are complaints by the director of hygiene about farmers using the water from the Roubine, 'including fecal matter', to irrigate the fields, growing the produce that was destined for market.[9] Most of the city had access to running water – if not in their home, then at least from a nearby fountain – but in 1888 this water was unfiltered and came directly from the Rhône. For daily ablutions there were two bathhouses, and public urinals could be found all over the city, though very few dwellings had their own indoor facilities.[10] Vincent remarked to Theo that:

It will seem funny to you that the water closet is at the neighbour's, in quite a large house that belongs to the same owner. In a southern town I think you'd be wrong to complain about it, because these facilities are few and far between, and dirty, and you can't help thinking of them as nests of germs.[11]

Not all the streets were paved in 1888, particularly in the area where Vincent rented. In the summer months there was a local statute to douse these routes with water. This would have a double effect: cooling the air and, especially if the wind was blowing, limiting dust.[12] From early June, the town-hall bell was rung at 6 a.m. and again at 5 p.m. to remind everyone of their daily duty. This local ordinance on dampening the streets for two hours morning and evening was followed religiously, but by 5 July 1888 the local newspaper was complaining that overzealous cleansing had turned the streets into quagmires and was warning of the danger of cholera – transmitted through fetid water – which had wreaked devastation in Arles four years previously.[13] Disease and infection would always pose a threat, but the standards of hygiene in Arles were pretty much the norm in the late 1880s for a country town of its size.

Still, people were surprisingly healthy, living much longer in Arles than in many major cities. They lived and worked mainly outdoors, and were blessed by the sun and food associated with the south of France, which kept disease at bay. Unusually for the time, the people of Arles had small families, with the average being four to five children. If children made it through the first few years of life, statistics show that they were likely to live well into their sixties and, at a time with no antibiotics or universal healthcare, in 1888 seven per cent of the population of Arles lived beyond the age of eighty.[14]

Painting outside for Van Gogh was hindered by the obstacle of the infamous Provençal mistral wind. Arles is situated close to the delta of the Rhône on a large flat plain that has fed livestock for centuries. To the north-east of the city, the terrain changes dramatically, with the Alpilles mountain range looming in the distance. It is from this northerly direction that the famous wind blows. The mistral is particularly strong on the banks of the Rhône, and Arles has little protection from its force. For generations, farmers have planted rows of cypress trees in the surrounding countryside to act as windbreaks for their fruit crops, and the landscape around the city is criss-crossed with these deep-green rows of trees – a familiar image from Vincent's paintings. In a letter to fellow painter Émile Bernard, Vincent explained how he coped with the wind while working:

> I painted it out in the mistral. My easel was fixed in the ground with iron pegs, a method that I recommend to you. You shove the feet of the easel in and then you push a fifty-centimetre-long iron peg in beside them. You tie everything together with ropes; that way you can work in the wind.[15]

The first time I experienced the mistral was unforgettable; it seemed as if every part of my being was buffeted by the wind. No matter how long I live here, I will never get used to this sheer force of nature. Blowing through the region for around a hundred days a year, and invariably for one, three, six or nine days at a time, the mistral fluctuates in strength and intensity.[16] In winter it is particularly harsh, and

when the air is cooled by a hard overnight frost, the wind pierces you
to the bone. The temperature can drop dramatically – by up to 10°C
in a matter of hours. When the wind is blowing really hard – up to
60 miles per hour – it is nearly impossible to walk outside. Dust swirls
into eddies, irritating the eyes and sinuses. Yet in summer, the mistral
is welcome. Hot, humid days magically disappear as the wind blows
in, leaving the air crystal-clear, the sky that deep blue Van Gogh
captured so perfectly.

The mistral wasn't the only obstacle for a man from the north,
though, for there were other difficulties to overcome: flies, mosquitoes
and the heat of the sun. The mistral can mask the ferocity of the rays,
and Vincent had little way of protecting himself while working outside
other than a straw hat which, if the wind was blowing, it was a chal-
lenge to keep on:

I look different nowadays, in so far as I no longer have either
hair or beard, both being always shaved off close; further, my
complexion has changed from green-grey pink to grey-orange,
and I have a white suit instead of a blue one, and am always
dusty, always more laden like a porcupine with sticks, easel,
canvas, and other merchandise. Only the green eyes have
remained the same, but another colour in the portrait, naturally,
is a yellow straw hat like a grass-mower – and a very black pipe.[17]

Tanned and buffeted by the mistral, Van Gogh seemed happy in
the south. In his first few months in Arles, he settled into a regular
routine. Leaving the Hotel-Restaurant Carrel after breakfast, he would
spend his day walking, drawing and painting in the surrounding coun-
tryside.[18] This route generally took him north of the city to the banks
of the Rhône and the local farms and abundant cornfields.[19] In the
evenings he would dine at the hotel, before retiring to his room to
write letters, read and smoke his pipe. Never particularly good with
money, if he had enough left at the end of the week, Vincent would
occasionally head off through the narrow, dimly lit back streets near
the hotel to a part of town where a man might find a girl.

CHAPTER 6

Night Owls

There wasn't a lot to do in the evening if you were a single man in Arles. After dinner Vincent could go for a walk along the river, where courting couples strolled, or to a café on one of the nearby squares to watch passers-by. The place du Forum, a few streets up from the Hotel Carrel, where Mourier-Petersen was staying, was the place to be seen in the evening. The comings and goings from the upmarket hotels and carriage stands on the square made it a lively place, both day and night.

After the cafés closed, though, most single men ended the evening in the red-light district, and it was to a brothel that Van Gogh went on the fateful night of 23 December 1888 and asked for 'Rachel'.

Postcard of place du Forum, Arles, *c.*1910

In late nineteenth-century France, visiting a prostitute was a normal part of the life of any unmarried man. Brothels, controlled by the town council 'for hygienic purposes', remained legal in France until 1946. Coming from a place where prostitution had always been against the law, I found the official organisation of prostitution fascinating. Strangely, there is little left in the archives concerning prostitution in Arles. On my first day in the archives I had found prostitutes and brothel owners on the census returns and added them to my database. The census returns were short on information, though, and all I found were references to the district where the brothels were located, with no actual addresses. Yet the obvious route is not always the only route. I carefully stitched together seemingly unrelated snippets of information found in different parts of the archives, to develop a portrait of the life of a prostitute in Arles in 1888.

In Vincent's day there were eight official *Maisons de Tolérance* near the porte de la Cavalerie, not far from where Van Gogh lived.[1] The largest concentration of prostitutes was in and around a tiny back street called rue Bout d'Arles. According to Vincent's letters, there were three brothels there, but at first with access only to the 1886 Census, I could only locate two.[2] In 1886 numbers 1 and 16 of rue Bout d'Arles were official brothels, and ten *filles soumises* were listed as working there. The other addresses were occupied by ordinary families.

As rue Bout d'Arles became the heart of the vice-trade, local people began to move away. Just five years later in 1891, thirty-two working girls were recorded as living on this one street; and nine houses were occupied by prostitutes: four were brothels, the other five were their lodgings.[3] In the Mayor's papers in the archive I found endless complaints about late-night drinking, street fighting and girls immodestly flashing their bodies at any passing man. There was a Carmelite convent in the centre of the district, and many of the complaints came from nuns bemoaning the girls' lack of decorum and requesting the removal of the brothels to another part of town. In the late 1880s France was undergoing a period of huge social change. Religion was gradually becoming less important as the country became more secular. Less than twenty years later, in 1905, there was a complete

separation of Church and State. The nuns were promptly divested of their property in Arles and a boys' school took over the convent building. Yet the red-light district remained dangerously close. Eventually the decision was taken to 'protect the town's youth' and relocate the red-light district. It was this decision to move the brothels, combined with the changes in street names, that caused such confusion about the layout of the town for many years to come.

Decades later, as the wider public outside the art world became interested in Van Gogh, journalists were dispatched to Arles to document 'Vincent's Arles'. They photographed the streets and the working girls to illustrate magazine articles, most notably for *Life* in 1937.[4] Any early writer on Van Gogh might reasonably assume the artist had frequented the whorehouses on the quays, which flourished until after the Second World War. At first I couldn't make any sense of it, especially as the archives provided scant information. Although Martin Bailey had already located the brothel Vincent went to on 23 December 1888, it took an inordinately long time and lots of patience to map the red-light district of Arles in 1888. For starters there were numerous challenges to trouble my research: the houses had an ad hoc numbering system. There could be a House of Tolerance no. 1 and a no. 9, but no brothels numbered 2 to 8. I eventually realised that the numbering referred to the street number, and had little to do with the other brothels in the town. This wasn't the only issue I had to confront. I wanted to understand exactly how they were viewed by the general population and how they functioned in Vincent's day. From the little I could glean from the archives, they seemed to be a business activity like any other, quite unlike our modern-day perception. Eventually, I stumbled upon a file in the archives in Marseille that demonstrated clearly the local reaction towards prostitution. 'Scandal in Arles' was a confidential report written in 1884 for the *Préfet*, the most important regional official.[5] The 'scandal' constituted sex crimes against children and resulted in two court cases, and custodial prison sentences for the guilty parties. As several prominent citizens were involved, more than 400 people from Arles travelled to Tarascon to watch the first trial. Prostitution may have been authorised in Arles, but the corruption of minors was a serious offence.

The local statutes concerning the *Maisons de Tolérance* explained

how these businesses functioned. Prostitutes had to be at least twen-
ty-one years old – a minimum that was rigorously enforced. I was
surprised to find that the women who worked as prostitutes were on
average at least thirty years old. They had to register with the police,
providing proof of identity, age, place of birth and the names of both
parents. A similar register was kept by the brothel madam.[6] There
were regular police inspections of the houses, checking up on health
and working conditions. The girls had to have their own private room,
access to fresh running water for drinking and washing, and regular
meals. They were not allowed to leave the immediate confines of their
'house' to promenade in public places or to frequent bars, though
they could go to the theatre, where they were given specially allocated
seats.[7] This was all surprising to me, given the reputation of prosti-
tution in the nineteenth century – the tales of squalor and debauchery,
destitution and manipulation.

Access to the brothel was via a double door that had to be kept
locked at all times, and every window on the ground floor had to be
painted over and the shutters closed, to shield passing members of
the public from the activities inside. Any other doors were to be
blocked, though in practice, this rule was not strongly enforced.[8] Yet
these new rules still didn't go far enough, for locals who lived nearby.
It was common practice in late nineteenth-century France to mount
a petition to the mayor to draw his attention to a problem of local
import: in 1878 the town council of Arles received a petition
complaining about the red-light district:

> every single day, our children, daughters and wives witness the
> most scandalous scenes, the most vulgar swearing and the most
> obscene shouting . . . and every evening the noise is intolerable,
> arguments and fights break out, disturbing the rest of law-abiding
> workers, exhausted from the long, hard working day.[9]

But the residents were fighting a losing battle. There was good
money to be made from prostitution. With tenants and income
guaranteed, even a member of the town council rented out his prop-
erty to a madam.[10]

It is probable that Vincent would have asked the hotel proprietor, soon after arriving in Arles, where he could find some female company, and Carrel, ever the good businessman, likely directed him to his friends' establishments. Two well-known brothel-keepers, Isidore Benson and Virginie Chabaud, lived just a few doors away and had business dealings with Carrel.[11] It was to the House of Tolerance no. 1, one of Chabaud's brothels, that Vincent went on 23 December 1888.[12] Proof that he made her acquaintance fairly early on in his stay can be found in a letter to Theo, around 16 March: 'I attended the inquiry into a crime committed at the door of a brothel here; two Italians killed two Zouaves. I took advantage of the opportunity to go into one of the brothels in the little street called "des Récollets". Which is the limit of my amorous exploits vis-à-vis the Arlésiennes.'[13]

According to one of the local newspapers, the police inquiry that Vincent attended took place on the morning of 12 March.[14] The night before, three Zouaves and a friend had turned up at a brothel at 1, rue Bout d'Arles at the same time as some Italian labourers.[15] At the door there had been a violent scuffle. The altercation ended with the Zouaves and their friend pushing the Italians aside and entering the brothel. The Italians loitered nearby until three of the men left, ambushed them in rue des Récollets and stabbed two of them to death in the doorway of a nearby building. Despite a growing population and burgeoning immigration, Arles was still relatively quiet, and murders were a rare occurrence. The murder of the French soldiers had the locals baying for Italian blood.

The Italian population was small, but they formed the largest group of foreigners living in Arles, and despite a healthy economy, there was underlying resentment that these newcomers were taking jobs from locals. The newspapers in Arles were happy to whip people into a frenzy of anti-Italian sentiment: they fuelled the fury by referring to the immigrant workers who 'sit at our table, take the bread from our workers and who repay these acts of great hospitality with insults and by committing crimes'.[16] While the defendants were being interviewed at the town hall, a crowd descended on the building, making it impossible to transport the prisoners. In the dead of night the two men were escorted to Tarascon prison. A few days later Arles ground

to a halt, as the funeral cortège for the soldiers slowly wound its way through the streets to the cemetery, and cries of 'Vive la France!' and 'Down with Italians' were heard from the crowd.[17] During the funeral a speech was given at the graveside: 'Chase these miserable assassins from our town . . . Long live the army! Long live the Republic!'[18] Newspapers wrote about the 'bloodsucking' Italians, and vigilante groups forced them out of town. Vincent must have felt the waves of hate and tension and, as a foreigner, kept his head down.

According to *The Letters*, the documents made available online by the Van Gogh Museum, the brothel Vincent went to on that early visit was situated at 30, rue des Récollets, a few hundred metres from his hotel. I had no reason not to trust this information, yet I could find no brothel at that address. I spent ages poring over maps and land registries looking for it; I reread Vincent's letters and looked at local accounts of the murder. In the end it was the contemporary local newspapers that gave me the clue I needed. The men were stabbed in the doorway of number 30, where the inquiry was held, but Vincent actually went to a brothel a few doors along the street. The only possible *Maison de Tolérance* he could have visited was situated on the corner of rue des Récollets with rue Bout d'Arles – the House of Tolerance no. 14.[19]

Madame Chabaud ran most of the girls in rue Bout d'Arles, and occasionally her older sister Marie would look after one of her brothels while she oversaw the other, including the whorehouse where the two Zouaves had their final tryst. Officially, men were not allowed to run brothels – it was felt they would take advantage of the working girls – so women of at least twenty-five years of age either owned them outright or were used as figureheads. The brothel mentioned by Vincent, now a private residence, is one of the few original buildings standing in this part of Arles, and still has a small door that gives onto rue des Récollets, exactly as Van Gogh described in his letter. These provincial brothels were not the luxurious Parisian places seen in the works of Toulouse-Lautrec or Degas. They were small and rather basic, with three to five women per house, catering to young soldiers from the barracks, shepherds or single male visitors in town, like Vincent.[20]

When she first encountered Van Gogh in 1888, Virginie Chabaud was forty-five and had been running brothels in the city for many years. Born in the nearby town of Cabannes in 1843, I found her first mentioned in the records in 1881, working for a Monsieur Louis Farce.[21] A decade later she sold the management rights of 1, rue Bout d'Arles for the princely sum of 5,000 francs, while still maintaining ownership of the property.[22] She was a canny businesswoman, dying in one of her properties in 1915 at the ripe old age of seventy-one.[23] By the time of her death, Madame Chabaud had a virtual monopoly on the red-light district in Arles.[24] If a man wanted to spend time with a prostitute in late nineteenth-century Arles, it would have been very difficult to avoid Virginie Chabaud.

For Vincent, using the services of a prostitute was simply part of life. 'I ate at midday, but by this evening I'll have to sup on a crust of bread. And it all goes into nothing else but either the house or the paintings. Because for at least 3 weeks I haven't had enough to go and have a screw for three francs.'[25] Going to see a prostitute wasn't cheap – it was the equivalent of a night's room and board – yet the price wasn't always consistent: in other letters he mentioned paying just two francs. The different prices of Vincent's visits to the prostitutes I put down to services rendered, but I could never find any confirmation of this.

My question about the cost of 'hygienic visits', as Vincent called them, was answered in the most unlikely way. A friend in Milan had taken me on a day-trip to see the incredible Charterhouse Abbey in Pavia. After the visit we went into town for lunch and stumbled on a restaurant in the medieval part of the city. The dining room was rustic, with a haphazard selection of ephemera covering every inch of wall space: farming tools, 1930s transistor radios, old photographs and posters. With bottles of wine stacked around the room and a daily menu displayed on a chalkboard, it was exactly the sort of place I love. After a delicious plate of pasta, I spied a dog-eared sign on the wall decorated with a reclining nude crudely drawn. It stated, 'Girls mustn't be molested before the Madam is paid.' Hanging above it was a poster listing the rates for services at a *casa di tolleranza*. Although it was dated 1927 and Italian, it provided vital information on how

brothels operated – with tariffs for a single or double bed and the length of time spent with the girl, and amusingly an optional extra charge for soap and a hand towel. I imagine that a similar price structure existed in the brothels of Arles.

All of this background information on brothels was interesting, but it wasn't getting me any closer to identifying the girl Van Gogh had visited that night in December 1888. Early on in my research I had started a speculative file about this mystery girl, with snippets of found information. Even now the name given in the local press report, 'Rachel', is highly unusual in Provence; in the late nineteenth century it would have been even rarer. It was used almost exclusively by Jewish families and, although there are many ancient communities in Provence, the Jewish population in Arles was small indeed – the only record I could find indicated fewer than a hundred people in the 1880s, with not a single woman named Rachel among them.[26] I checked the census returns and again came up with nothing.[27] My initial hunt for Rachel had ended before it had barely begun.

I looked at my database to see if it could provide any clues. Could Rachel have left Arles and moved elsewhere? As a registered prostitute, moving to another town was complicated and strictly controlled, with the girls obliged to have a special 'passport'. Again, I came to a dead end. I looked through local newspapers for mention of prostitutes over the decade leading up to Van Gogh's arrival in Arles, and although there were a few whose real names were mentioned, there were no Rachels there, either. I began to compile a list of women whom Vincent might have known in Arles consisting of anyone between the ages of fifteen and forty-five. It was soon obvious from the sheer number of women that I would never find her this way, either.

I thought I'd broaden the hunt by looking at all prostitutes operating in Arles. Even if I had no match for the name, perhaps there might be other information that would lead me in the right direction. On the 1886 census in Arles there were twenty-eight girls described as *filles soumises*. Added to this number were independent women and a few unregistered prostitutes. There were an estimated fifty women according to the Sous-Préfet working as prostitutes in Arles in Vincent's day.[28] Most were local girls from Arles or the surrounding villages;

while a few came from further afield in France or from neighbouring countries such as Italy or Spain, the foreign women didn't seem to stay long before moving on.

Then I had a small sliver of good fortune. On a record of prostitutes' medical checks from the 1860s and 1870s I found a girl whose working name was Rachel. Over two decades of mentions, this Rachel referred to several women whose real names were different. It was customary for prostitutes in Arles to have business cards printed with their working name. The brothel madam provided these, for a fee, and the girls gave them to their clients and I found that there was always a 'Rachel' in the brothels in Arles. A great discovery, but a highly confusing one at that. If 'Rachel' was not the real name of the girl Vincent went to see that night, how would I find out which, of all these women, was Van Gogh's girl?

One day in the archives in Arles I came across a book with a lovely old-fashioned serif script on the cover that proudly stated 'Crimes et Délits'.[29] It was a police register that listed the names and ages of criminals, along with details of their crimes and misdemeanours from 12 July 1886 to 10 November 1890 – the entire period that Vincent was in Arles. Among the many individuals listed there were a small number of prostitutes, usually arrested for their part in a brawl. These entries recorded their real names and occasionally – helpfully – also their working names. I added these new girls to my list of prostitutes and spent laborious hours cross-checking one list against another, one name against another. Still no 'Rachel', but I felt I was getting closer.

Many of the women on my list had troubling life stories, of which there were brief snatches in the records. Drink seems to have played its part, but of course the overriding reason that women turned to prostitution was poverty: many had lost their parents at a young age or were widows trying to bring up children. With no welfare system in place, there were few alternatives for a destitute woman. Once they fell into prostitution it was almost impossible to change their fate, and many of the girls stayed on, becoming madams of brothels themselves.[30]

While looking for something else in the archive, I came across a list of people treated for venereal disease at the hospital in Arles. The

dates covered a whole year, from 1 January to 31 December 1889, which overlapped with Vincent's stay at the hospital.[31] These four sheets of paper are the only extant patient records from the nineteenth century in Arles. Both men and women were on the list, but from the surnames of the men it was obvious they were not locals, but soldiers posted to the town. I compared the names of the women on the list with the list of prostitutes I had taken from other sources. Many of the names matched. I could now identify sixteen women who were treated for venereal disease while Vincent was in Arles. These women were almost certainly prostitutes. Even if there was no one with the name 'Rachel', I knew most of these women would have known her.

I now felt certain she had to be listed somewhere on my database. I had scoured the census returns for 1886, with no luck. Maybe she had moved to Arles after 1886? The 1891 census was only available in Marseille, and when I enquired, I was told by the archive that everything they had was online. When I checked their listing for 1891, I realised someone had uploaded the 1886 census twice. Try as I might to explain this, the web-master of the regional archives told me I was wrong: 'Everything we have is online.' In the nicest possible way, I began a systematic campaign of bothering the staff in Marseille. This doggedness finally paid off. After eighteen months of persistence, someone took the time to go back to the shelves and check. The 1886 census had indeed been uploaded twice.

I was given the exceptional privilege of consulting the 1891 Arles census in person. I was certainly the first Van Gogh researcher to do so, which gave me a little thrill. This census wasn't in the lovely bound ledgers that I was used to seeing; it was a pile of dirty, dusty sheets of paper all out of order. I took a photo of every page, rapidly scanning each one to see if I could find the name Rachel. All the people I had come to know, who lived near Vincent, were listed on these fragile sheets of dog-eared paper. But there was no mention of a Rachel. The thought that she could be there – that I was overlooking her in a different guise – was beyond frustrating, but there was little I could do until I had more information.

I resorted to asking friends and people who had lived locally for generations whether they knew anything more about this Rachel. The

first lead didn't seem particularly promising. In the early 1980s a local historian had undertaken a series of interviews with elderly residents of Arles.[32] None of the people he talked to named Rachel directly, but he was told that her family had a garage near the station. I started looking through commercial directories and newspapers, but as the local automobile industry flourished in the 1920s and '30s, there were a plethora of petrol stations, with many different owners. It was too unwieldy a search. Yet again I was left with nothing. I went back to my sources, hoping I might have overlooked something significant. A letter from Alphonse Robert, the first policeman on the scene on rue Bout d'Arles, gave an eyewitness account of the night Van Gogh mutilated his ear that was rich in important details. How could I have missed it?

On 23 December 1888 Alphonse Robert set off from his house in rue des Récollets to do his rounds on the nightshift. It was an evening he would remember for the rest of his life. He had moved with his wife and young son the year before to take up a post in Arles.[33] A couple of years later, in 1891, no longer able to walk the beat after badly injuring his knee chasing a suspect, he was given the comfortable job of warden at the local jail. On his retirement in 1929 there was a small article about him in the local newspaper, which mentioned that he had been the policeman called to rue Bout d'Arles on the night Van Gogh cut off his ear. This brought him to the attention of Dr Edgar Leroy, who was now the director of the hospital in Saint-Rémy where Van Gogh had been a patient after leaving Arles in May 1889.[34] With unlimited access to Van Gogh's patient records in the asylum, Dr Leroy was collaborating with fellow psychiatrist Victor Doiteau on an article about Vincent's madness.[35] Dr Leroy soon contacted Monsieur Robert about what he remembered of that night in 1888. Robert replied:

Arles 11 September '29
 Sir,
 In reply to your esteemed letter of 6th last asking me for some information, here is what I recall.
 At that time in 1888 I was a policeman. On the day of the

case, I was assigned to the reserved area [where the brothels were situated]. I was passing by the *Maison de Tolérance* no. 1, at that time in rue Bout d'Arles, managed by a woman called Virginie, the prostitute's name escapes me, [though] her working-name was Gaby . . . The Chief of Police d'Ornano was sent for and with other policemen left to go to the man's home.[36]

This was research gold: not only did Robert confirm the brothel-owner as Virginie Chabaud, but he gave me a vital new piece of information: the prostitute's name was Gaby. This was an exciting development. Unlike the highly unusual name of Rachel, Gaby (Gabrielle) was a fairly popular name in the late nineteenth century. She was probably still alive in 1929 and, given how small towns work, it is likely Alphonse Robert knew her. This was a real development, as Gaby could potentially be her *real* name.

As my 'Rachel'/'Gaby' research rumbled on, I was also still trying to follow the garage lead. There was only one relevant file in the archives, a document entitled 'Garages, Arles 1957–1959', so I drove over to Arles to order it.

'Oh no, you can't have that file,' I was told.

'Why not?'

'The lift is broken and I can't go and get the box – I have a bad back and it's in the other building.'

This went on and on. For weeks the lift was broken and I couldn't get hold of the document. I even wrote to the mayor. Eventually the lift was repaired. On my next trip to Arles, I requested the document again.

'Oh no, you can't have that.'

'Why not?'

'The lift is broken again and with my bad back . . .'

I wrote another letter to the mayor, this time a little less polite. The archives are a branch of the town hall, and any new building project takes a lot of time to come to fruition. It is discussed, voted on, sent for public tender; finally the work is awarded to a company and a date is set. After several months the decision was made to rebuild the lift completely. Documents were now completely inaccessible for

the duration of the building works. The whole saga took more than a year. Rachel and the garage link were becoming an impossible quest.

Then I had a small breakthrough. At the end of a French biography about Van Gogh written by Pierre Leprohon in the early 1970s, there was a small appendix that detailed the lives of some of Vincent's protagonists after he had left Arles.[37] Amongst the people mentioned, was the girl to whom Vincent gave his ear: 'Rachel who was known as Gaby while working' (certainly taken from Policeman Robert's statement) had 'died aged eighty'. In 1952 Leprohon recorded that after the events of 23 December 1888, she had entered the service of a 'Monsieur Louis who ran a brothel'.[38] This was the first time I had heard that Rachel/Gaby was employed elsewhere and I checked the database that I had compiled. There was only one 'Monsieur Louis' who ran a brothel in Arles, Louis Farce. His address in the electoral registers from 1888 to 1891 was 5, rue Bout d'Arles, merely two doors down from the House of Tolerance no. 1.

There were thirty Gabrielles in my database and I knew that one of these was my Rachel. I started by eliminating those who were too young or who had died as children. I then looked in the Arles death registers, to see if I could find a woman who died around the age of eighty and was alive throughout the right period. There were two contenders. I researched their family trees online, but could find nothing that linked them to local garages. I ruled out one of the two women fairly quickly: Gaby was her second name, and she had never left her village in the countryside. The other woman, though, seemed more promising: her first name was Gabrielle and she had lived in Arles. She had married a local butcher and, thanks to her married name, I managed to trace her descendants who were still living locally. Yet I felt nervous about getting in touch with them without total conviction that she was the one.

Many months later, I got a message that the lift was finally up and running. The next day I drove over to Arles. I ordered the file on the local garages and the relevant box was brought to my table. I rifled through the dusty papers, located the file 'Garages, Arles 1957–1959' and opened it. The file was empty. I searched through all the others

in the box to see if it had been misplaced, slipped out, buried at the bottom, but to no avail.

Crestfallen, I decided to take a break and go for lunch with my friend Michèle. She runs a designer boutique and comes from a family that has been in Arles for generations; there's not much about the people of Arles she doesn't know. During lunch I asked her if the surname of the woman I thought could be Gaby meant anything to her. 'Oh yes,' she replied, 'the family had a garage near the station when my parents were young.' Bingo!

I found the name of the family in the phone directory. Taking a very deep breath, I dialled the number. I said simply that I was doing some research into the history of Arles and was looking for a family that had owned a garage here. The woman who answered told me that another branch of the family had run the garage and that it might be better to speak to her father who was Gabrielle's grandson – an elderly man in his nineties living in a retirement home outside Arles. It was difficult to know how to broach such a delicate subject; I finally decided to send him a letter explaining that his grandmother's name had cropped up several times in my research on Van Gogh and suggesting that we meet to talk. I got no reply and, disappointed and frustrated, I assumed I'd hit another dead end.

CHAPTER 7

Monsieur Vincent

The simple life of Arles embodied an ideal for Vincent. His paintings and choice of subject matter clearly illustrate his fascination with this rural idyll. At first he painted largely landscapes, enchanted by the spring blossom, wide plains and uninterrupted sky. He also turned his focus on the city itself, and made studies of women washing clothes in the river and views of the Langlois bridge. Between his arrival in February and the end of April 1888, he didn't stop painting and drawing, amassing a vast hoard of canvases, which he propped awkwardly in his bedroom at the Hotel-Restaurant Carrel to dry. But there was never enough space, and his work spilled over into other parts of the hotel, much to the proprietor's chagrin: canvases were left to dry on the terrace, blocking the corridors and perfuming his bedroom with the acrid stench of oils and turpentine.[1]

Although officially there were set room rates at the Hotel Carrel, like many things in Provence these were '*à la tête du client*' – what the owner felt each client should pay. At first Van Gogh was charged five francs a night for room and board. He managed to renegotiate this to four francs, and later still to three francs a night. Although his life was simple, with relatively few expenses – tobacco, coffee, and visits to the red-light district, in addition to room and board – he was not good with money and found himself constantly battling his budget.[2] He had no income save for Theo's regular stipend, and soon that was in jeopardy.

In April, Theo had been upbraided by his superiors at the Boussod, Valadon et Cie gallery for neglecting to advance the more profitable traditional painters. He favoured the Impressionists' work, which did

not bring in a reliable income. For all our delight in these paintings now, at the time they were still considered shocking, modern and disturbingly new, and collectors were wary of investing. From their correspondence, it is obvious that Theo was considering resigning. This would be a devastating blow to Van Gogh; without Theo's financial help, he would be forced to give up his grand projects in the south.

With his canvases taking up space outside his bedroom, the proprietor of the Hotel Carrel had started threatening to charge him extra. Vincent began to look at ways of making savings, initially abandoning oil paints in favour of pen and ink. He wrote to Theo:

> I have some annoyances. I don't now think that I'll benefit from staying where I am, I'd rather take a room or two rooms, if need be, one to sleep in, one to work in. Because the people here, *in order to make me pay pretty high rates for* EVERYTHING, *make too much* of the fact that I take up a little more room with my paintings than their other customers who aren't painters. For my part, I'll make the point that I'm staying longer and spend more in the guest house than labourers who just stay a short time. And they won't get a sou out of me so easily any more. But – it's always a really miserable thing dragging your equipment and paintings along behind you, and that makes coming in and going out more difficult.[3]

The financial pressure began to affect his health. Throughout April his letters are peppered with references to his 'terribly weak stomach'. He claims to be 'troubled by fits of faintness', plagued with 'toothache'. 'I suffer a lot some days,' he wrote. He simply could not stay at the Hotel Carrel any longer, 'I don't feel comfortable here.'[4] Worse still, 'I want my nervous system to calm down.'[5]

By late April the owners of the hotel had decided to sequester Vincent's possessions to force him to pay his bill. Yet they hadn't reckoned on Van Gogh. Within days he had taken the proprietors to court and retrieved his belongings. Thirty years later, Madame Carrel was still complaining about his behaviour: 'He was', she said,

'unbalanced, temperamental, he ate when it pleased him. One day he even demanded our presence at the Justice of the Peace, about the payment.'[6]

Finding somewhere to rent was no easy task for a newcomer with very few connections. In small provincial cities, and especially in Provence, everything is dependent on who you know. It isn't much different today, nearly 150 years later. He needed lodgings where he would have enough space to sleep, paint and store his work. It would take a stroke of luck, if Vincent were to find anything at the last minute.

On 1 May he wrote to Theo with good news: 'I've just sent you a roll of small pen drawings, a dozen I think. That way you'll see that even though I'd stopped painting I haven't stopped working. Among them you'll find a hasty croquis on yellow paper, a lawn in the public garden at the entrance to the town. And in the background a house more or less like this one.' He went on enthusiastically:

Today I rented the right-hand wing of this building, which contains four rooms, or more precisely, two, with two little rooms. It's painted yellow outside, whitewashed inside – in the full sunshine. I've rented it for fifteen francs a month. Now what I'd like to do would be to furnish a room, the one on the first floor, to be able to sleep there. The studio, the store, will remain here for the whole of the campaign in the south, and that way I have my independence from petty squabbles over guest houses, which are ruinous and depress me.[7]

Vincent would not have been able to rent without a recommendation from a trusted local source. Who could possibly have enabled him to lease the Yellow House? It seems like such a minor question, when there are the huge unknowables of what actually happened on the night of 23 December. But research is like this: a few small steps, uncovering something that feels negligible and unimportant, often illuminates a much bigger picture.

A sketch of the Yellow House in a letter from Vincent to Theo, 1 May 1888

The route Van Gogh took to the orchards around Arles to paint his first landscapes took him via a small café. 'It's what they call a "night café" here (they're quite common), that stay open all night,' he wrote to Theo. 'This way the "night prowlers" can find a refuge when they don't have the price of a lodging, or if they're too drunk to be admitted.'[8] Before long, the Café de la Gare became 'his' café in Arles. This is an important designation. A café is not merely a place to drink; it is an integral part of French social life, particularly in rural areas. In rural France a café is where friendships are forged, games are played and deals are made. The style of café you choose influences how you are perceived, and the time of day will dictate the sort of people you meet.

During the spring of 1888, Vincent would probably have complained to his fellow café regulars about the problems he was having with the

proprietors of the Hotel Carrel. By late April he was clearly desperate. According to the 1888 trade directory of Arles, a certain M. Nicolas ran the Café de la Gare at 30, place Lamartine.[9] Yet confusingly, in Vincent's letters he states that its proprietors were M. and Mme Joseph Ginoux. The confusion over the café ownership cleared when I came across a photocopy of a newspaper article on one of my trips to Amsterdam. It was an official announcement explaining the Ginoux acquisition of the tenure of the business of the Café de la Gare from Pierre Nicolas.[10] Despite the fact that Van Gogh later lived with the Ginoux for five months, there was very little information on this couple in the archives, other than their names and dates. As the newspaper gave the name of the lawyer handling the purchase, I could look up the relevant legal paperwork; I decided to make a special trip to Marseille, where these archives are held. Happily, it was not a wasted trip. Legal documents are incredibly detailed in France and the purchase agreement had lots of background information on the couple.[11]

Monsieur and Madame Ginoux had bought the building that housed the café some years before, but until 1888 they had never owned the business; instead they had leased it to a series of tenant-proprietors, including M. Nicolas.[12] Born not far from Arles in Tarascon, Joseph Michel Ginoux – the future café-owner – lost his father when he was just three years old. As a young adult he learned a trade, barrel-making, from his Uncle Joseph and moved with him to Arles when he relocated his business there. Van Gogh was a regular visitor at the Café de la Gare and would have stood out, with his strange accent, fiery red hair and bundles of canvases and sketches under his arm. The Ginoux soon became close friends and Van Gogh kept in touch with them even after he left Arles. Vincent formed a strong bond with Joseph's wife, Marie Ginoux, immortalising her in one of his most famous paintings, *L'Arlésienne*. Marie was a local girl and a well-known figure in the area. Her maternal uncle, Joseph Allet, had lived on the place Lamartine in a newly built house – it was light, airy, south-facing and overlooked the square. When Joseph died in 1854, Marie's mother moved her whole family there.[13] For thirty years Marie's parents had lived in this house and both died there.[14] It was located at 2, place Lamartine and would become Vincent's future home: the Yellow House.

Another acquaintance from the Café de la Gare was sixty-two-year-old Bernard Soulè, a retired train driver.[15] He held several jobs in Arles after his retirement, including serving as a member of the town council and being a house agent for absentee landlords.[16] One of the places he looked after was 2, place Lamartine, just across the road from his own home.[17] I was finally able to understand how Vincent had found the Yellow House. Marie Ginoux, who knew Van Gogh from the Café de la Gare and from Soulè of old, must have recommended Vincent as a tenant for her former home.

Mindful of Theo's problems at work and the extra expense of furnishing an entire house, Van Gogh initially agreed only to take the ground floor of 2, place Lamartine. By the time he moved in, the property had been empty for almost two years since the death of Marie's parents and needed serious refurbishing. 'I've got them to agree to repaint the house, the front, the doors and the windows outside and inside,' Van Gogh wrote to Theo. 'Only I have to pay ten francs for that myself. But I think it will be well worth the bother.'[18] From May until mid-September 1888 Van Gogh used the house as a studio – 'I enjoy working there' – still sleeping at the Café de la Gare and taking his meals next door at the Auberge Venissac, for a total outlay of around ninety francs a month.[19] This was a considerably less expensive option than the Hotel Carrel. The Ginoux were never officially listed as having rooms to rent in Arles, so it would appear that the couple made an exception for Vincent.

To the right of the Yellow House, and part of the same building, was a grocery shop owned by François Damase Crévoulin, whose wife, Marguerite, was Marie Ginoux's niece.[20] The couple lived just behind their shop, at 68, avenue Montmajour.[21] All these local figures – the Ginoux, the Crévoulins, the Widow Venissac who owned the restaurant where Van Gogh took his meals, Bernard Soulè, the letting agent for the Yellow House, simply names on a page – would have an important role to play in what happened to Vincent the following spring.

Just before moving into the Yellow House in mid-September – which he hoped would mark the beginning of a new phase in his life in the south – Van Gogh decided to paint the interior of a café at night; *his* café at night. It's a rich scene, full of colour: the deep russet-red of

the café walls and the unlikely bright turquoise of the ceiling, with a few late-night folk drinking and socialising, and evidence of a long evening's enjoyment in the empty glasses and bottles littering the tables in the foreground. It's easy to imagine Van Gogh as part of this scene, and this night being like any other night that he spent there with friends and neighbours.

Scholars had long realised that it seemed improbable that this wasn't a scene from the Café de la Gare. Yet until its demolition in the 1960s, another establishment – the Café de l'Alcazar – was the one featured in press articles and books as Vincent's famous night café.[22] Unlike the Café de la Gare, the Alcazar had rooms to rent. It also had a billiard table and a clock that looked more or less identical to the one in Vincent's painting. By the 1920s, with no one left alive to contradict him, the proprietor of the Café de l'Alcazar had a large sign painted on his awning, which proudly proclaimed that his establishment was 'The Café painted by Van Gogh'.[23] It served him well over the years, bringing in a steady stream of custom, Van Gogh enthusiasts and scholars. The idea was so widely accepted that, at the end of the 1950s, a couple of art historians from the United States travelled to Arles to see if there was anything more to learn about Van Gogh from the café. The owner let them remove a chunk of plaster from one of the bedroom walls, to see if Van Gogh had left behind any trace of his genius.[24] Unsurprisingly, they found nothing.

After moving to his new house, Van Gogh wrote to Theo in late September about his local area in a letter with a sketch of his new home:

> the house to the left is pink, with green shutters; the one that's shaded by a tree, that's the restaurant where I go to eat supper every day. My friend the postman lives at the bottom of the street on the left, between the two railway bridges. The night café that I painted isn't in the painting; it's to the left of the restaurant.[25]

I spent a lot of time visualising Vincent at his table in the Yellow House writing this letter to Theo, trying to see where he could be sitting, which way he could be facing, to get all the buildings in the right order, but it just didn't make sense. The Café de l'Alcazar was

not to the left of the Yellow House, but to the right, at 17, place Lamartine, next to the gendarmerie and immediately across the square from the Yellow House. During the post-war regeneration of the area, both cafés were pulled down and, in the decades since, most scholars have accepted that the painting of the café interior showed the Café de la Gare as Vincent clearly mentions in his letter – it could be no other. Yet there are no interior photographs of either café in existence, to definitively resolve the issue.

The legal documents for the purchase were a remarkable resource: every object in the Café de la Gare, from the number of spoons to the interior decoration, was described in the inventory of 1888. Finally, I could look at Vincent's painting of the café interior and compare it to the extant legal papers, object by object. Every item was listed, from the lamps to the number of bottles on the counter. By juxtaposing these documents with Vincent's artwork, it is not only possible to build up a picture of the place in which he painted and lived during the summer of 1888, but it also provided confirmation that Van Gogh's *The Night Café* is a painting of Vincent's local – the Café de la Gare.

Although a simple working-man's café, the Café de la Gare had a richly decorated façade with sculpted stone finials. Under the awning, two large pots framed the entryway. Turning right through the door, clients entered the café through two long curtains used to keep out the draught in the winter months. On the wall to the left of the entrance hung a large mirror, and opposite was a clock in a wooden case that separated the main room from the stairs that led to the upper floors. The café was fairly small, accommodating only thirty-eight people at marble-top tables with Provençal straw chairs. Lighting came from lamps hanging from the ceiling and from the windows at the end of the room, overlooking the place Lamartine and its gardens; and in the main room was a wood-burning stove, which heated the café during the cold winter months. On the bar counter were numerous bottles; these were listed on the inventory as '100 empty bottles', though interestingly the inventory, despite including an extensive list of unopened, full bottles of alcohol, made no mention of absinthe, the liquor so often blamed for Van Gogh's unstable temperament. There was also a baize-topped card table in

the corner for playing a whist-based game called Boston and, in the middle of the room, a billiard table with ivory balls.

Beyond his café acquaintances, Vincent also made a couple of other significant friendships in Arles. In May 1888, once he had settled into the studio space at the Yellow House, he felt he belonged at last. The Reverend Louis Frédéric Salles, the Protestant pastor in Arles, sought the newcomer out.[26] There is no mention of him in Van Gogh's letters prior to the drama of late December, and it has always been assumed that Vincent met him during his hospitalisation. However, both of Salles' daughters maintained in separate interviews that their father knew Monsieur Vincent before his breakdown and that the two men first met thanks to a note left in the pastor's personal letter box at the hospital where he was chaplain.[27] The Reverend Salles and his family lived opposite the Protestant church at 9, rue de la Rotonde. Although the 'temple' – as Protestant churches are called in France – was across town, Salles was a familiar figure around the place Lamartine, attending to many of his local parishioners. Like Vincent, the pastor was well read and intelligent, he spoke languages and was a warm, kindly, compassionate man whose company Vincent enjoyed.[28] According to his children, he and the Dutchman would often go walking together, or Van Gogh would join the family for dinner. Reverend Salles is the only one of Vincent's close friends in Arles whom he didn't paint, although it wasn't for lack of trying: Van Gogh asked the pastor to pose for him, but the Reverend Salles, a modest man, refused.[29] Before leaving Provence, Van Gogh gave the Salles family a painting of flowers in a vase, which hung in the living room of the presbytery for many years. 'I've given M. Salles a little canvas with pink and red geraniums on a completely black background.'[30] Although it was kept until the 1920s, the painting was sold by the Reverend Salles' daughter for a paltry sum to a bric-a-brac dealer in Nîmes and has never been seen again.[31]

Van Gogh's closest friend in Arles, however, was the postal employee Joseph Roulin, whose job involved loading the mailbags on and off the trains at Arles station.[32] The artist must have noticed him soon after he arrived, as the Roulins lived further up the same street as the Hotel Carrel. In September 1888 the Roulin family moved much closer

to the Yellow House, just under the railway bridge off the avenue Montmajour.[33] In late July 1888, when Vincent first began to paint Roulin, his wife Augustine was back in her home village of Lambesc awaiting the birth of her fourth child, and had taken her children home with her for the summer holidays.[34] The postman was free to sit for Vincent, and they soon become firm friends. Vincent liked to keep up with current affairs, and in Roulin he found someone with whom he could have lively debates.[35] 'Now I'm working with another model, a postman in a blue uniform with gold trimmings, a big, bearded face, very Socratic. A raging republican, like *père* Tanguy. A more interesting man than many people.'[36] And he added, 'Last week I did not only one but even two portraits of my postman, one half-length, with hands, and a life-size head. The chap, not accepting money, *was more expensive*, eating, drinking with me. . .'[37] Once Joseph's wife and children returned from the country in early September, Vincent soon found himself a welcome addition to the Roulin family. This warm, uncomplicated household represented an ideal that he longed to emulate. As he became closer to the family, each member became the subject of a canvas:

I've done the portraits of *an entire family*, the family of the postman whose head I did before – the man, his wife, the baby, the young boy and the sixteen-year-old son, all characters and very French, although they have a Russian look.

What is much more revealing of the strength of Van Gogh's connection to the family was that he added: 'And if I manage to do *this entire family* even better, I'll have done at least one thing to my taste and (which is) personal.'[38] Van Gogh painted Joseph Roulin, his wife and children over twenty times – more than any other subject.

Throughout his adult life Vincent formed close friendships with older, unobtainable women. These relationships do not appear to have been driven by desire but by a deep kinship that Vincent felt he had with certain women. They are ever-present, like shadows during the most turbulent periods of Van Gogh's life. Both Augustine Roulin and Marie Ginoux were painted multiple times, as if Vincent were trying

to capture something that was beyond his reach. From May 1888 onwards, with new friends, a new studio and greater stability in his life, Vincent would paint some of his greatest works: *The Yellow House*, *La Mousmé*, *Starry Night over the Rhône*, *Sunflowers* and a view of *The Langlois Bridge*. As the artist was working, the idea of sharing the Yellow House with someone began to coalesce in Vincent's brain; after all, 'two could live as cheaply as one'. He began to think that a fellow painter might join him in Arles.

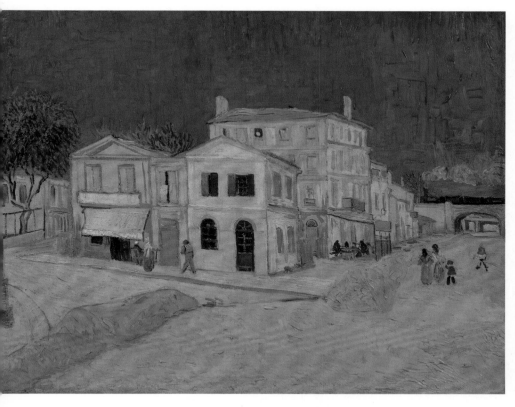

Van Gogh's first and only home in Arles, *The Yellow House (The Street)*. The studio and kitchen were at street level, above which were two bedrooms. Crévoulin's grocery store was part of the same building and to the extreme left of the painting was the restaurant run by the widow Venissac where Van Gogh took his meals.

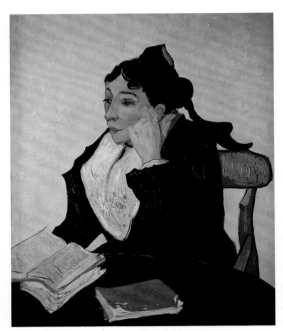

Van Gogh's friend and neighbour in Arles, *Marie Ginoux (The Arlésienne)*. He stayed with Mme Ginoux and her husband Joseph at the Café de la Gare from May until September 1888, while using the Yellow House as a studio.

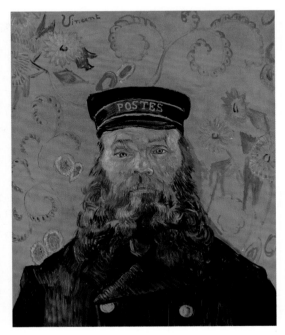

Vincent's close friend, postal worker, Joseph Roulin was forty-seven years old when Van Gogh painted this portrait. Roulin moved to Marseille in late January 1889, and would have been painted either from memory or on one of his return trips to Arles in the spring of that year. It has a highly decorated wallpaper-like background that Vincent reserved for special friends.

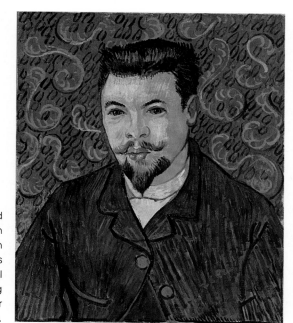

Dr Félix Rey was a twenty-three-year-old intern at the town hospital in Arles when he met Vincent for the first time on 24 December 1888. This portrait was painted in his office at the hospital when Vincent went to have his dressing changed in January 1889, and was later given as a gift to the young doctor.

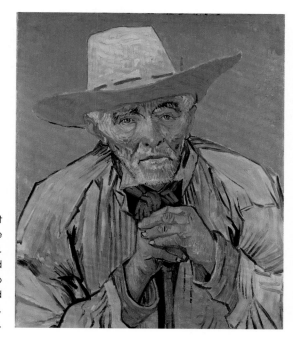

With its burnt-orange tones, redolent of the hot summer of 1888, this is one of Vincent's most remarkable portraits. Patience Escalier was a local shepherd and journeyman, aged seventy-two when he sat for Van Gogh. He died on 17 April 1889 in Arles hospital, overlapping with Vincent's time there.

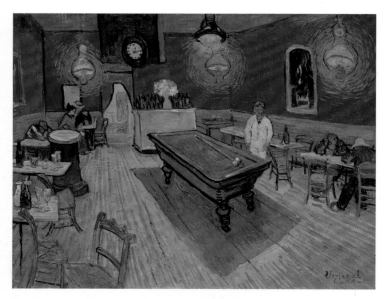

The Café de la Gare, where Vincent lived during the summer of 1888. Showing the prowlers that hung around in this all-night café, Vincent's canvas *The Night Café* of September 1888 shows exactly the same café interior that is described in the inventory earlier that year, even down to the '100 empty bottles' shown on the counter.

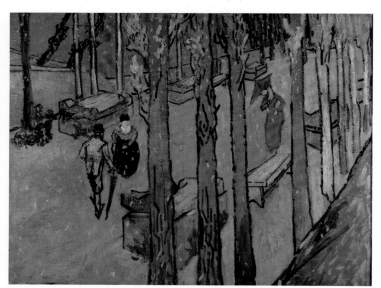

Les Alyscamps (Leaf fall) was painted in late October 1888, a few days after Paul Gauguin had joined Vincent in Arles. The two men worked side-by-side in the ruins of the old Roman necropolis as the autumnal wind brought down the leaves. The poplar trees were felled and replaced with cypress trees in the 1920s.

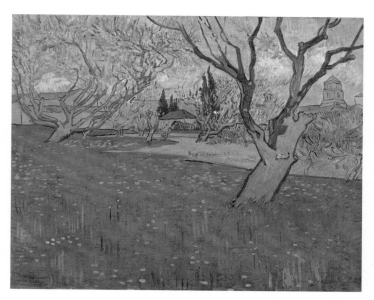

Orchard in Blossom with a View of Arles was painted in April 1889, just before Vincent left for the asylum in Saint-Rémy. A short walk from Arles hospital and opposite one of the public parks, Vincent worked in the far corner of the fields on the south side of Boulevard des Lices.

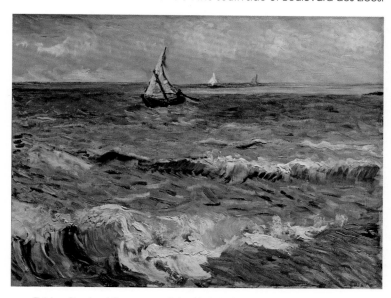

Fishing Boats at Sea was painted in late May to early June 1888, when Vincent went on a week-long excursion to Les Saintes-Maries-de-la-Mer. Impressed with the effect of wind on the water, he compared the sea to the scales of a mackerel.

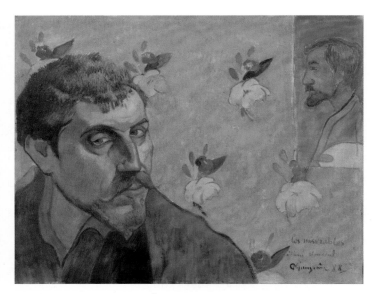

Self-Portrait with Portrait of Émile Bernard (Les Misérables), forty-year-old Paul Gauguin is still showing signs of the ill-health that had dogged him since his trip to Panama and Martinique the previous year. Thanks to this portrait Gauguin was recognised at the Café de la Gare when he arrived in the early hours of the morning on 23 October 1888.

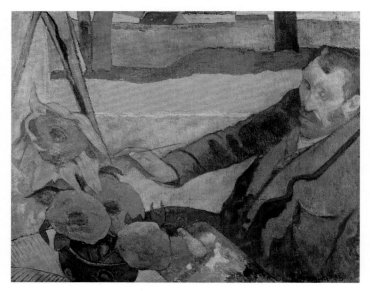

Gauguin's portrait of *Van Gogh Painting Sunflowers* seems to be a composition rather than an actual scene: sunflowers were not in season and Vincent is shown wearing a suit – unlikely everyday clothing. In his autobiography Gauguin gave Vincent's reaction when he first saw the finished work: 'It's me alright, but me gone mad'.

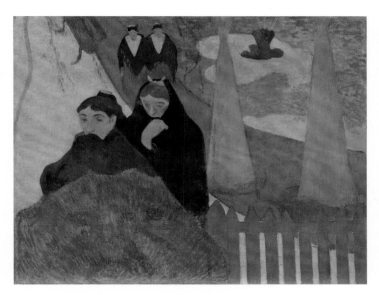

Arlésiennes (Mistral) shows a group of women from Arles wrapped in shawls and walking against the harsh mistral wind. Like much of Gauguin's work at this time the scene is composed from his imagination. Though the pathway, fences and trees are reminiscent of the park in front of Vincent's home, the fountain clearly places this work in the courtyard of Arles hospital.

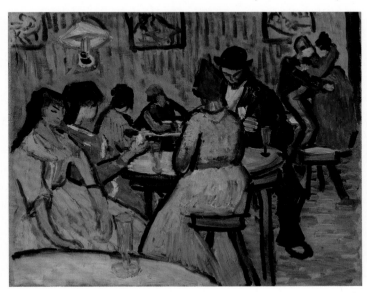

This is the only interior scene that Vincent ever painted of the brothels in Arles, dated November 1888. It is perhaps Virginie Chabaud's brothel, as it was one of two establishments in Arles with five working girls. On the walls are images similar to the work of Vincent's contemporaries Degas and Toulouse-Lautrec, whom Van Gogh admired.

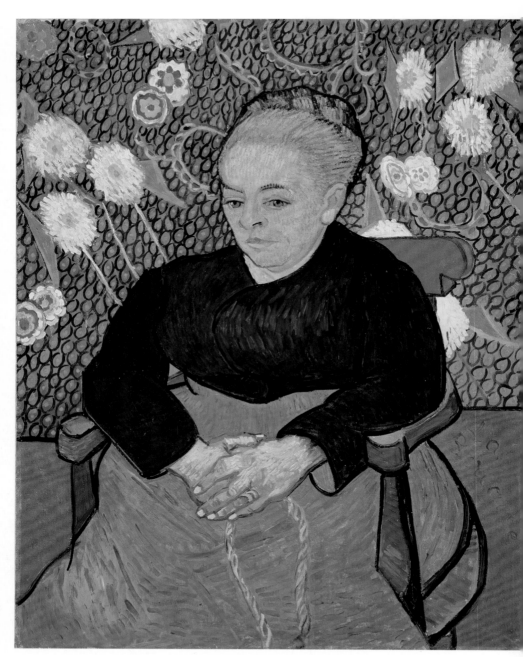

Vincent painted five portraits of Augustine Roulin (*La Berceuse*), wife of his good friend Joseph Roulin. This canvas was painted in January 1889 soon after Vincent returned from hospital for the first time. Probably still breastfeeding, Augustine holds a rope in her hand that was used to rock the crad of her five-month-old daughter Marcelle, though the spectator sees neither the baby nor the cradle.

CHAPTER 8

A Friend in Need

I'd like to do the portrait of an artist friend who dreams great dreams, who works as the nightingale sings, because that's his nature.

Vincent van Gogh to Theo van Gogh, 18 August 1888

Despite his closeness to Reverend Salles and the postman and his family, Van Gogh longed for contact with the artists he had met in Paris. He kept in touch with a few people he knew from the capital, but other than his brother Theo, his main correspondent was the young artist Émile Bernard.[1]

Van Gogh had become friends with the eighteen-year-old Bernard during the winter of 1886, through the Cormon studio in Paris where Van Gogh had studied earlier that year. According to Bernard, Vincent was 'the most noble character of man you could ever meet, frank, open, lively to be with, a certain touch of malice, funny – a good friend, inexorable judge, devoid of all selfishness and ambition'.[2] After leaving Cormon's studio, Bernard went on a walking trip to Brittany and Normandy, where he ran into the amateur painter Émile Schuffenecker, who gave him a letter of introduction to his close friend, Paul Gauguin.[3] In 1887 Bernard returned to Brittany, where a number of painters had taken residence at the Pension Gloanec in Pont-Aven. Gauguin joined them in early 1888.

Eugène Henri Paul Gauguin was born in Paris in 1848. His father died when he was an infant, and Paul spent his childhood in Peru under the shadow of two strong women: his mother and his grandmother,

who had Peruvian connections through her Spanish ancestors. After finishing school, he enlisted in the merchant navy and spent the next five years at sea. By the time he returned to Paris in 1871 at the age of twenty-three, he had travelled the world as a sailor and had a sizeable portion of his mother's inheritance at his disposal. She had been the lover of Gustave Arosa – a wealthy businessman of Spanish origin, based in Paris – who, through his connections, got Gauguin a job as a stock-exchange agent, and later introduced him to his future Danish wife, Mette-Sophie Gad.[4]

Gauguin took up painting just before his wedding in 1873, but a growing family and work commitments slowed his progress. His interest continued unabated though, and he began to collect instead. Thanks to Arosa, he became close friends with the Impressionist painter Camille Pissarro, visiting him regularly on Sundays to paint in his garden. Through Pissarro, Gauguin managed to secure an unlikely last-minute invitation to exhibit at the Fourth Impressionist Exhibition in 1879, and before long his growing passion to paint had overtaken all other concerns and his marriage began to suffer.

In 1882, thanks to a disastrous endeavour in Panama, the French Bourse crashed leaving a devastated economy in its wake. Gauguin's investments took a serious hit. He launched a series of desperate – and ultimately unsuccessful – schemes to raise cash. Distracted by painting and serious financial straits, Gauguin was making little effort to support his wife and five children in Paris.

In 1883 Mette decided to return to Copenhagen with their children, where she began to earn her own living as a teacher and translator. In 1885 with the promise of a fresh start Gauguin persuaded Mette to return to Paris. The family moved into a new house, but Gauguin's priorities were clearly weighted towards finding a

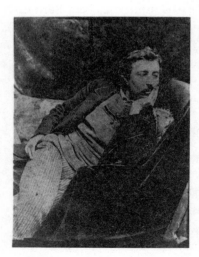

Paul Gauguin in his studio on rue Vandamme, 1891

home that had sizeable studio space for his art. Exasperated that Gauguin had no intention of finding a proper job, Mette returned to the refuge of her family in Denmark. It was to be for the last time: reconciliation was impossible.

Now on his own in Paris, Gauguin began painting full-time. Although almost unknown outside artistic circles until after his death, he was admired by a younger generation of artists for his bold use of colour and for exploring different media: he made ceramics and woodcuts as well as painting in oils. He was a fervent advocate for the art of Asia and Africa, primitive art that was now being seen for the first time in Europe. Although Japanese art had been in vogue for a while during the latter half of the nineteenth century, Gauguin was one of the earliest artists to champion the African art being brought into the capital from the French colonies. Gradually other painters began to invest in his work, including Pissarro and Edgar Degas, who bought Gauguin's paintings from Alphonse Portier, a dealer who lived in the same building as Theo van Gogh.[5]

Exactly when Gauguin met Van Gogh is not completely clear, though it was sometime in late November or early December 1887 at the exhibition Van Gogh arranged at the restaurant Le Chalet, soon after Gauguin returned to Paris from a six-month trip to Panama and Martinique.[6] The meeting led to an exchange of paintings.[7] Vincent received a note to arrange this swap in December 1887, and it is obvious from its formal tone that they did not know each other well at that point:

Dear Sir,

If you come on my behalf you will find at Cluzel's, the framer in rue Fontaine, a painting that I have delivered for you (for our exchange). If you do not consider it suitable, let me know, and come and choose yourself. Forgive me if I do not come to collect your paintings myself, I am so rarely in your part of town. I shall collect them from 19, Boulevard Montmartre if you will be so kind as to leave them there.

Yours,

Paul Gauguin[8]

At the beginning of the new year the two Van Gogh brothers visited Gauguin, who was staying with Émile Schuffenecker at the time. At almost forty years old, Gauguin was embarking on an entirely new phase in his life, and at the end of January 1888 he left Paris to work alongside the group of painters that had formed in Pont-Aven in Brittany.

Yet within weeks of his arrival Gauguin found himself in trying circumstances. He had recurring bouts of the malaria, dysentery and hepatitis that he had caught on his voyage to Panama and the West Indies. He sold very little in Paris before his departure, and the small amount of money Gauguin had saved was fast disappearing. As early as late February 1888 he began seeking favours from friends and patrons, including Theo van Gogh, who had purchased a canvas during his visit to Gauguin's studio in January.[9] Yet rather than go for a direct approach to someone he had only just met, he appealed to Theo's brother and fellow painter, not realising that Vincent had already left for Arles. His letter was duly forwarded south.[10]

Vincent immediately began thinking of ways he could help. He wrote to Theo on 2 March explaining Gauguin's predicament. Might someone purchase a painting to tide him over and pay off his mounting debts? He also wrote to John Russell, the wealthy Australian painter who had been a fellow student at the Cormon studio, but by the time the letter reached him, Russell had moved and was overseeing the building work on his new house off the coast of Brittany. As a last resort Van Gogh asked his good friend Émile Bernard, who was also in Brittany, to look in on Gauguin.

Van Gogh's reaction to Gauguin's crisis was typical of his relationships with both men and women. Although altruism was expected in his devout family, as instilled by his pastor father, Vincent felt compelled to go far beyond what a normal person might do for his friends. He didn't just want to help people out of their difficulty; he needed to be their saviour.

At the end of May 1888 Vincent decided to take a short trip out of the city. Leaving Arles early in the morning on the last day of the month, he took a horse-drawn carriage to the small coastal town of Les Saintes-Maries-de-la-Mer.[11] The journey took him across the

Camargue, large flat grassy plains peopled only with bulls and 'half-wild and quite beautiful' white horses.[12] Van Gogh was entirely seduced. Les Saintes-Maries-de-la-Mer is renowned for a special ceremony it has practised since the late Middle Ages, when gypsies from all over Europe make a pilgrimage to the town to venerate their patron saint, Sara. The festival is quite magical – a feast of colour and ritual. *Gardians* (Provençal cowboys), women dressed in brightly coloured costumes and exotically robed gypsies give thanks to the sea for conveying Sara safely to Provence. Later that summer Vincent painted some gypsy caravans that were camped on the allée de Fourques outside Arles.[13]

Initially worried that it might be too windy for oil painting *en plein air*, Van Gogh had only brought three canvases to Les Saintes-Maries, but he produced nine drawings and three paintings in the week he was there. He painted fishermen setting off in the early morning, and the effect of the wind on the waves, but what really captivated him was the colour of the sea. He wrote to Theo, 'the Mediterranean – has a colour like mackerel, in other words, changing – you don't always know if it's green or purple – you don't always know if it's blue – because a second later, its changing reflection has taken on a pink or grey hue'.[14]

The trip to Les Saintes-Maries confirmed his desire to settle more permanently in the south. He was enthralled by what he saw and felt sure that other artists would be similarly inspired. The experience made him determined to create a brotherhood of painters in Arles, encouraged by the example of the group in Brittany and the established clan of Impressionists who had gathered in the Parisian cafés.[15] In his opinion, Arles had something new to offer the artistic community: it was relatively cheap to live there and within walking distance of the countryside. Above all, there was the light; rainy Brittany could not rival the southern sun.

Thanks to Vincent, Émile Bernard had gone to see Paul Gauguin in Pont-Aven and they had become friends. As Gauguin's health improved, the two men began working side-by-side, discussing painting and sharing letters from Van Gogh. A sort of working 'triumvirate' evolved between the two men in Brittany and Van Gogh in the south.

Though fruitful, it did little to alleviate the loneliness Vincent had felt
since Mourier-Petersen had left in early June: he wanted another
painter by his side, with whom to work and discuss ideas.

The choice of Gauguin as a member of his atelier was never obvious.
Even though both Van Gogh brothers admired his work, Vincent was
much closer to Émile Bernard. Unfortunately his younger friend was
unable to join him, due to family opposition. Though still unwell and
constantly strapped for cash, Gauguin soon emerged as the main
candidate to join Vincent in Arles. He had already established quite a
reputation amongst artists and collectors. Not only had he shown his
work with the Impressionists, but he was also a friend of Edgar Degas
and had worked closely with Camille Pissarro. He was a *bon vivant*, a
legendary bohemian who had sailed around the world, then abandoned
his wife and family to paint.

In the late spring of 1888 Theo van Gogh was having problems at
work. Vincent suggested that Theo become an independent dealer of
Impressionist paintings, with his projected atelier in the south being
the perfect crucible for creating new work for him to sell. It would
be a relatively inexpensive enterprise, as Van Gogh saw it:

> as Gauguin's a sailor there's a likelihood we'll manage to make
> our grub at home. And the two of us will live on the same
> money as I spend on myself alone. You know I've always thought
> it ridiculous for painters to live alone &c. You always lose when
> you're isolated.[16]

In June 1888 Theo set the wheels in motion and wrote to Gauguin
with a formal proposition. For Theo, the business arrangement was
clear: he would provide Gauguin with a stipend, in return for one
painting each month. From Gauguin's perspective, it was a good deal:
a source of income, a fresh start in the south, and a connection to a
dealer whom he respected and who admired his work. When he
received Theo's letter, Gauguin was already three months in debt,
with no ready source of income in the foreseeable future. Yet, despite
this possible escape from penury, he was hesitant. Summer was coming
and bringing with it the promise of potential buyers on holiday in

Brittany who might rescue him from his dire situation. He would be fine in Pont-Aven for a little longer.

Returning to Paris was no longer a viable prospect for Gauguin – not only was it prohibitively expensive to live and work there, but as someone who had taken up painting later in life he was seen as a dilettante by many of the Parisian avant-garde. Pissarro wrote a letter to his son in 1887 – 'to be destroyed upon reading' – repeating the remarks of a fellow artist who disparagingly described Gauguin's work as 'a sailor's art picked up here and there'.[17] With his health on the mend, in late July Gauguin wrote confirming that he wanted to come south.[18] Yet he stayed on in Brittany.

Vincent was frightened about living alone for prolonged periods of time: 'Each of us living alone, we live like madmen or criminals, in appearance at least, and to some extent in reality, too.' For him, Gauguin couldn't come soon enough: 'I believe that it would make an enormous difference to me if Gauguin was here, because the days pass now without saying a word to anyone.' There was admiration, if not hero-worship, in the way Van Gogh perceived Gauguin: 'a very spirited painter', he wrote to his sister Wil. 'He's someone who works like one possessed.'[19] However, in his letters he was also mindful about the difficulties of living with someone else, given how difficult it had been sharing the apartment with Theo in Paris. He acknowledged the importance of working harmoniously with Gauguin and trying not to quarrel, especially given Gauguin's reputation for arguing with artists and dealers.

In mid-August, Van Gogh received a letter from Émile Bernard who was seeing Gauguin regularly. Not only was there no mention in Bernard's letter about Gauguin moving to Arles, but Van Gogh hadn't heard a word from Gauguin in more than a month. Vincent, who had put his friends in touch in the first place, was beginning to feel left out and started to consider whether he should go up to Brittany and join his fellow painters there.

Meanwhile in Arles there were practical issues that had to be addressed. The lease on the Yellow House was up for renewal on 29 September, and on the first of the month the house agent needed to know whether Van Gogh would be staying:

I told my chap that I'd take it on again for three months only, or preferably by the month. That way, supposing that our friend Gauguin arrived, we wouldn't have a very long lease ahead of us should he not like it.[20]

Supposing that Gauguin would be coming sometime soon, Van Gogh threw himself into getting the house ready. But as summer drew to a close, Vincent began to fear that Gauguin might not come after all:

I believe that Gauguin doesn't give a damn . . . I'm ceasing to believe in the urgent need to come to his assistance. Now let's be careful about it. If it doesn't suit him, he could reproach me: 'why have you made me come to this filthy part of the country?' And I don't want any of that. Of course, we can remain friends with Gauguin all the same, but I see all too clearly that his attention is elsewhere.[21]

Then, after ignoring Vincent for some weeks, Gauguin sent him a letter with new demands: he wanted Theo not only to provide a monthly stipend, but also to cover his debts and pay his fare to Arles. Distressed, Vincent wrote to Theo immediately, full of indignation that the brothers were being 'had'.

I instinctively feel that Gauguin is a calculating person, who, seeing himself at the bottom of the social ladder, wishes to regain a position by means that will be honest, to be sure, but which will be very shrewd.[22]

Frustrated by Gauguin's constant prevarication, Vincent found succour in work. For a while he had been planning some paintings with starry-night backgrounds. The centrepiece of the planned triptych was to be a portrait of Gauguin, the artist 'who works as the nightingale sings'.[23] But without Gauguin to sit for him, he replaced him with the Belgian painter Eugène Boch, who was finishing his summer sojourn in Arles. The portrait of *Eugène Boch* accompanied Vincent's

other work, *Starry Night over the Rhône*, and used the same daisy-like star motifs he deployed in his night paintings.

For his third night painting he took his easel and paints across town to a square in the centre of Arles, working outside in a noticeably public place for the first time. The painting depicted the café where Mourier-Petersen had been staying earlier that spring, and which he had also frequented with Boch later in the year.[24] Painting at night was so unusual that he even made it into the local newspaper: 'M. Vincent, an Impressionist painter, works at night by gaslight in one of our squares.'[25] With its starry sky and dominant sulphur-yellow hue, this painting *Café Terrace at Night* has become one of Van Gogh's most famous works.

By the end of September, Gauguin was at breaking point in Pont-Aven. His landlady was now sequestering his work until he paid his bills. He needed the Van Gogh brothers' help, and quickly. 'My dear Vincent,' he wrote:

> I'm very late in replying to you; but what can I say, my sickly state and my worries often leave me in a state of prostration, in which I sink into inaction . . . You turn the dagger in the wound when you do all you can to prove to me that I must come to the south, given that I'm suffering on account of not being there at this moment.[26]

With his plans back on track, Vincent suggested that Bernard and Gauguin should paint portraits of each other for an exchange, inspired by a tradition called *surimonos*, whereby Japanese artists swapped prints with one another.[26] The two artists in Brittany chose to send double portraits and painted them alongside each other; but their work is radically different. Bernard's painting seems simplistic, with almost a caricature-like 'Wanted' poster of Gauguin in the background. Gauguin's painting shows Bernard in profile at the back of the painting, with his own face centre-stage, looking wan and tired, his recent illness evident. He appears drawn, with deep shadows under his eyes, staring at the viewer with a brooding, almost menacing air. The decorative wallpaper-like background contrasts

and accentuates his sinister countenance. Gauguin himself described it as 'The mask of a thief, badly dressed and powerful . . . who has his nobility and inner gentleness.'[28] He called the painting *Les Misérables*, 'The Unhappy Ones'. Vincent's reaction to the double portraits provides a fascinating insight into his own personal taste:

> The Gauguin is immediately remarkable, but I myself like Bernard's very much, it's nothing but an idea of a painter, some cursory tones, some blackish lines, but it's as stylish as real, real Manet. The Gauguin is more studied, taken further . . . for me it certainly has above all the effect of representing *a prisoner*. Not a hint of cheerfulness. It's not flesh in the very least, but we can boldly put that down to his intention to make something melancholy; the flesh in the shadows is lugubriously tinged with blue.[29]

Gauguin's sickly countenance made Vincent even more determined that he should really come south. A flurry of letters between Vincent and Theo illustrates the ever-evolving plans. The final decision was to allocate Gauguin 150 francs a month, in exchange for a painting a month for Theo to sell in Paris. It was a business deal that would potentially benefit the Van Gogh brothers, yet at the same time help a friend. It was the perfect arrangement, or so it seemed in those heady autumnal days.

The question of when Gauguin would arrive in Arles was the subject of numerous letters between the brothers. It was mysterious why Gauguin was stalling. Then, while Vincent was hard at work getting the house and studio ready for the two of them, another setback occurred:

> Letter from Gauguin to say that . . . he won't come until the end of the month. That he's been ill . . . That he dreads the journey . . . What can I do about it . . . is this journey so exhausting, then, when the worst consumptives do it??? . . . But isn't it clear, or shouldn't it be, that he's coming here precisely in order to get better? And he claims to need to stay over there in order to recover! What stupidities! Honestly.[30]

Five months since the first suggestion of an atelier in the south –
after months of planning and correspondence between Theo, Vincent
and Gauguin, months of Vincent painting on his own, feeling loneli-
ness and the black clouds of melancholy creep up on him – Gauguin
finally sent word. On 17 October, Vincent's reply to Gauguin was
buoyant:

> Thanks for your letter, and thanks most of all for your promise
> to come as early as the twentieth . . . I almost envy you this trip,
> which will show you, *en passant*, miles and miles of countryside
> of different kinds with autumn splendours. I still have in my
> memory the feelings that the journey from Paris to Arles gave
> me this past winter. How I watched out to see 'if it was like
> Japan yet'! Childish, isn't it?[31]

On 21 October, after receiving 500 francs from Theo to settle his
debts and pay his train fare, Paul Gauguin set off on the long journey
south. It would take him two days.

As the two artists made plans to share the Yellow House, to paint,
eat, talk and live together, neither of them seemed to have taken into
account one basic fact: Vincent van Gogh and Paul Gauguin barely
knew one another.

CHAPTER 9

A Home at Last

From the bedrooms of the Yellow House, Van Gogh had a wide view of the neighbourhood, the gardens of the place Lamartine, planted in 1875, and the light, airy public square – the centre of the local community. By the 1920s, when the first historians[1] arrived in Arles looking for information on Van Gogh, place Lamartine was no longer the pretty public garden, with flowering borders and wooded walk-ways, that he had known and used as the backdrop to many of his paintings and drawings; it was a rough space of dusty scrubland where local children played.[2]

Despite the bombing of 1944 and the destruction of the area around

Public garden and pond in front of the Yellow House, April 1888

the place Lamartine, it is possible to build up a picture of the Yellow House. Vincent's letters and paintings, early photographs, a floorplan from the 1920s and a description of it before its conversion into a café all provide details of its former life. To Vincent, the Yellow House was the sanctuary he had longed for. He moved in full-time in September 1888; until then he had only used the house to work in, describing it to his sister as 'a little yellow house with green door and shutters, whitewashed inside – on the white walls – very brightly coloured Japanese drawings – red tiles on the floor – the house in the full sun – and a bright blue sky above it and – the shadow in the middle of the day much shorter than at home'.[3]

From the outside, the house was surprisingly colourful: the window frames, shutters and kitchen door were painted a bright green, and the façade a rich butter-yellow. There were two entrances: on the right a small door led into the kitchen; and the main door gave onto the hallway. Inside, the walls were whitewashed and the floor was laid with unglazed red tiles.[4] A small set of stairs with a wrought-iron handrail led to the bedrooms. From May until mid-September 1888, Vincent used the ground floor as his studio. Painters generally prefer to work in rooms with pure, colourless north light, yet the ground floor of the Yellow House faced due south and was flooded with warm sunlight. The windows gave onto busy roads and the constant traffic of neighbours. It was an exposed spot for a painter's studio. In his first letter to Theo after taking full possession of the house, Vincent moaned about the lack of privacy: 'the studio is too open to view for me to think it could tempt any woman, and it would be hard for a petticoat episode to lead to a cohabitation'.[5] Girlfriends were a regular topic of conversation between the two brothers, who both hoped to marry one day.[6] In Vincent's case this 'divine unity' remained an unfulfilled dream, due in no small part to his choices of partner: 'I still continually have the most impossible and highly unsuitable love affairs from which, as a rule, I emerge only with shame and disgrace.'[7]

In the Yellow House there was a fireplace and running water in the kitchen, but no bathroom. Vincent could use a *pot de chambre*, whose contents were collected by a horse-drawn cart every day in July and August, or there was a lavatory in the courtyard to the rear. These

toilettes turcs, which were still in use when I first moved to France more than thirty years ago, were very basic – little more than holes in the ground. For anything more than superficial ablutions, Vincent would go to one of the two public bathhouses – the nearest was a few minutes' walk away, just inside the city walls.[8] A fastidiously clean person, Van Gogh was often noticed by the local policeman with his towel over his arm going to the *bains publics*.[9]

Outside the house, the unpaved streets were particularly dusty, which led to Vincent taking on his first employee at twenty francs per month. 'Most fortunately I have a charwoman who's very loyal; without that I wouldn't dare begin the business of living in my own place. She's quite old and has a mixed bunch of kids, and she keeps my tiles nice and red and clean.'[10]

Van Gogh never named her in his letters, and no one has ever identified her. This seemed surprising to me because of the role she would play later in Vincent's story in Arles and I felt compelled to find her, certain she had to be someone in his immediate environment – but who? Vincent remarked only that she was fairly old and had a number of children. One other clue I found came in a letter to Theo from Reverend Salles, who mentioned that the cleaning woman's husband worked at the train station. Such tiny flashes of a life: how could I identify someone from so little?

I turned to my database. From my research I knew that women in nineteenth-century Arles had fairly small families, unlike their counterparts in larger cities. Vincent's cleaner had, by his account, many children, so I made a table of all women with four or more children, checked their age and their husband's occupation.[11] There were only two people who fit every part of the description. One of them seemed too young (just forty years old in 1888) and she gave birth in October of that year. As Vincent mentioned that his charwoman worked for him in September, it would be fairly unlikely she would be cleaning his house so late in her pregnancy.

In 1888 the other candidate, Thérèse Balmossière, was forty-nine years old, had eight children, numerous grandchildren, and her husband worked at Arles railway station.[12] At the age of forty-nine, she might appear older still to a single man of thirty-five, like Vincent.

Once I investigated her family network a little more closely on my database, I felt further convinced that I had found the right person. Thérèse's husband, Joseph Balmossière, had worked as a train driver alongside Vincent's house agent, Bernard Soulè. Van Gogh's next-door neighbour and Thérèse's cousin, Marguerite Crévoulin (Marie Ginoux's niece), ran the grocer's shop located in the same building as the Yellow House.[13] It seems likely that one of these two – his neighbour or his house agent – might have suggested Madame Balmossière as a cleaner.

There also seems to be a connection between Thérèse and one of Vincent's most famous models. Throughout July 1888 Van Gogh worked on a portrait of a young girl he called *La Mousmé*. Vincent described this painting in a letter to Émile Bernard: 'Have just finished portrait of young girl of 12.'[14] And in a letter of the same day to his brother he explained, 'A mousmé is a Japanese girl – Provençale in this case – aged between 12 and 14.' The *mousmé* has never been identified. Who could she be? Van Gogh's local friends were still few, and I thought it unlikely a mother would let a young girl pose for Van Gogh, unless she knew him well and trusted him completely.

Sketch for *La Mousmé*, 1888

The painting and preliminary drawings of the *mousmé* gave me two clues straight away: first, she wasn't wearing traditional Arlésienne costume. Local teenage girls wore traditional costume daily, so either she was not originally from Arles or she wasn't a Catholic. She also appeared to be wearing a corset under her dress, as the enforced curve at her waist is very pronounced; yet she seemed very young for such constrictive dress. An expert in costume told me that in the late 1880s corsets were actually common apparel for young girls and even for children. Remarking on the *mousmé*'s burgeoning breasts, she put her at about twelve or thirteen years old, as most young women began to wear corsets just before reaching puberty.[15] Armed with this information, I went back to Thérèse's family to see if anyone fitted this new profile. There were two possible candidates: one of her daughters and her niece.[16] In late July 1888 when Vincent was working on the painting, Thérèse's daughter, Thérèse Antoinette, was just about to turn fourteen; her niece, however, who was twelve and a half in late July, seemed a better match to the age estimate. This young girl, Thérèse Catherine Mistral, lived on avenue Montmajour, just five minutes' walk from the Yellow House, and her family were good friends of Bernard Soulè. It was still only a hypothesis, but I felt pleased that I might have found the young girl who sat for Vincent in her lovely striped dress nervously holding an oleander.[17]

Vincent worked tirelessly in late July 1888 and it exhausted his spirit: 'I wasn't able to do anything else, having been not too well again . . . in order to finish off my *mousmé* I had to save my mental powers.'[18] His investment in his art involved so much more than putting paint on canvas. His was a frenzy of execution, draining his emotional energy and leaving him physically broken and fragile. He would be utterly absorbed as he worked. Some observers recorded that Vincent seemed to blink constantly, smoked his pipe without pause and barely communicated with his model.[19] The more he pushed himself, the greater the result. Over the summer of 1888 he had been obsessively striving to achieve a 'high yellow note' in his painting. Everything was at maximum intensity: the energy he hurled into his work, the effort he put into setting up the Yellow

House and his anxiousness about Gauguin's arrival. Something had to give.

The weather in Provence is always extreme and the heat never arrives gradually. Suddenly, it is summer. The saving grace is the mistral, which as we have seen clears away any dust and humidity, cooling the air and rendering the colours sparkling and clear. Van Gogh mentions the pure light and the beauty of the landscape in almost every letter.

By 4 June 1888 the temperature had already reached 28°C. As Arles got hotter, the cicadas in the trees of the place Lamartine began to hum, getting louder and louder. This sound is the background to summer and, although almost imperceptible at first, can reach a deafening pitch during the ferocious heat of the day. Facing due south, the studio in the Yellow House would have felt the brunt of the heat, the trees of the public park being too far away to give any shade. Yet Vincent welcomed the weather into his world. Light was vital to him; though his neighbours sensibly kept their shutters closed during the long hot hours of the Provençal summer, in all of Vincent's illustrations of the Yellow House the shutters are thrown wide open.[20]

For a northern European, the climate in Provence is magical. It has always surprised me that the locals moan about the weather: it's too hot, too cold, too windy. They have never experienced the wet, grey days of February in northern Europe and they have no idea how lucky they are. Vincent was also struck by this negativity. In early July he wrote to his sister Wil:

I find the summer here very beautiful, more beautiful than any I ever experienced in the north, but the people here are complaining a great deal that it's not the same as usual. Rain now and then in a morning or afternoon, but infinitely less than at home.[21]

Working on his own and with no distractions, he painted feverishly and in all weathers, though the heat during the day made it increasingly difficult for him to work outdoors. In late July he started working on a series of portraits at his studio in the Yellow House. Some of these portraits were of new friends, like Boch or Paul Eugène Milliet,

a Zouave officer stationed in Arles, but he found it extremely hard to persuade other people to sit for him.[22] The locals didn't have the time, or see any interest in having their portrait painted by the strange fellow with red hair. A few indications of what inspired Vincent to choose his models appear in his letters: one woman appealed to him because her 'expression was like that of Delacroix' with a 'strange, primitive bearing', but she never turned up. Complaining later to Theo, Vincent wrote, 'she earned a few sous with some riotous living and has better things to do'.[23]

On another occasion he described to Theo how he had chased an old shepherd across the countryside to ask if he could paint him. There are two remarkable portraits of this man, Patience Escalier, with his weather-beaten face and gentle eyes, leaning on his shepherd's crook. Like the *mousmé*, I tried to trace him. There was no one called Patience Escalier on the contemporary census returns or featured in newspapers, and no other person I've yet come across living in Arles bore this first name. It seems likely that 'Patience' was his nickname (he would certainly require patience to look after his flock). There are only a few Escalier families in the region, most prevalent in the nearby village of Eyragues. The best candidate for these portraits was a man called François Casimir Escalier from Eyragues, who died at the hospital in Arles. At his death in 1889 he was of 'no fixed abode' and was described as working as a *journalier*, a term employed for journeymen and agricultural workers.[24] To give his portrait the intensity of the 'furnace of harvest-time', Vincent deliberately exaggerated the colour in one of his paintings and placed Escalier on a vivid orange background, like 'red-hot iron'.[25] He wrote to Theo, 'instead of trying to render exactly what I have before my eyes, I use colour more arbitrarily in order to express myself forcefully'.[26] The paint in Vincent's work was applied purely, expressionistically and with disregard for naturalistic colours: from the red rheumy eyes and the yellow stripe running down the peasant's nose, to the bright red of his skin and the flecks of turquoise in his beard. So radically different from the genteel landscapes and portraits seen in the shop windows of Bompard & Fils in Arles, where most artists exhibited, these portraits of Patience Escalier must have appeared to the locals as if from an alien world.[27]

Being unable to persuade anyone to sit for him without payment made a serious dent in Van Gogh's budget. But even paying for models did not always bring the expected result. One Arlésienne who was paid in advance scarpered with the cash. 'It's annoying, this constant aggravation with models,' he wrote to Theo.[28]

This aggravation continued until he met postman Joseph Roulin, who made a huge difference to Vincent's life in the town. The portraits of Roulin that he made that summer also bear witness to their burgeoning friendship; at first Roulin appears nervous, sitting bolt upright in his chair. Gradually his demeanour changes as he becomes more comfortable sitting for the artist, and the spectator begins to discover the man Vincent describes in his letters: a lively, amusing companion, someone to debate with, and a man who liked to go for a drink.

Vincent's costs increased dramatically once he took on the whole house, but his letters to Theo speak incessantly about his plans to decorate the rooms, and brim with detail about his purchases and his ideas.[29] Vincent wanted his brother to be able to visualise the house and justify his expenditure because, once it was settled that he should continue renting the house for the foreseeable future, Theo sent Vincent extra money to pay for furnishings. On 8 September, Vincent wrote to thank Theo for his generous gift of 300 francs.[30] Unable to contain his excitement about making the Yellow House a home, by the following day he had already been on a spending spree: 'I wanted to arrange the house not just for myself but in such a way as to be able to put somebody up . . . Naturally, that ate up most of my money. With what was left, I bought twelve chairs, a mirror, and some small indispensable things. Which in short means that next week I'll be able to go and live there.'[31]

Vincent chose the larger of the two upstairs bedrooms for himself – from where 'you can see the sunrise in the morning', he romantically wrote to his sister – in which he had a narrow double bed and a dressing table, newly bought.[32] His painting of his bedroom is one of the most famous and most beloved of his works. It is also a valuable piece of evidence, as it was where Vincent was found by the police on the morning of 24 December 1888.

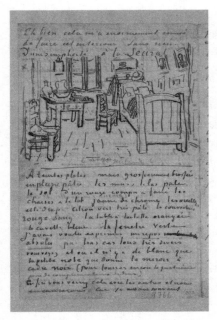

A sketch of Vincent's bedroom in a letter to Paul Gauguin, 17 October 1888

The strange angles created by the bedroom's almost rhomboid shape can be seen on the floor, under the washstand and in the corner above his bed, which doesn't sit true against the wall. On hooks on the wall behind the bed hang the jackets, coats and straw hat he wore, and which appear in many of his self-portraits. Vincent probably painted this work sitting beside or on a small fireplace, which came halfway into the room on the left. The distortion accentuates the intimacy of the scene, because the spectator is there with him in the tiny, cramped space.

The bedroom next door, closer to the busy avenue Montmajour and noisier, was designated as the guest room; with no direct access from the landing, any visitor had to pass through Van Gogh's bedroom to get there. 'For putting somebody up, there'll be the prettiest room upstairs, which I'll try to make as nice as possible, like a woman's boudoir, really artistic. Then there'll be my own bedroom, which I'd like to be exceedingly simple, but the furniture square and broad.'[33] Each of the bedrooms had an adjacent room of roughly 97 feet square presumably used as a walk-in cupboard or storage space.[34] Vincent went to great lengths to ensure that Gauguin – five years older, and more established than him – had the very best. He wrote describing what he was planning to do: Gauguin's room would have a walnut bed with a blue blanket, as well as a dressing table and chest of drawers, also in walnut. He planned to decorate the room with his own canvases: 'I want to stuff at least six very large canvases into this tiny little room, the way the Japanese do, especially the huge bouquets of sunflowers.'[35]

The Yellow House was not fit for big parties; it seemed odd to me that Vincent would buy as many as twelve chairs.[36] Already in the Yellow House was the bentwood chair he had used for sittings, and the portraits of Joseph Roulin and the *mousmé*. It has been suggested that the number twelve was significant to Van Gogh and indicated his desire to create an apostolic brotherhood of painters in Arles.[37] Although at first this idea may seem a little far-fetched, it actually has some foundation. As someone who, at one time in his life, had planned on taking holy orders, it is perhaps not so strange. Van Gogh liked religious metaphors and often used them in his letters. It is possible that, even subconsciously, he equated this studio of the south with the ideal of a monastic community. More than anything, seeing the Yellow House as a home clearly put to rest some of his emotional turbulence. For the first time in many months he was happy. He wrote to Theo, 'I can already see the goal, to have the means of having a roof over my head for a good long time. You wouldn't believe how much that calms me.' He was fervent about the future direction of the house and studio:

I have such a passion to make – an artist's house – but a *practical* one and not the usual studio full of curios . . . The great peace of mind that the house brings me is above all this, that from now on I feel that I'm working by providing for the future; after me another painter will find an enterprise under way.[38]

On 17 September 1888, Van Gogh slept in the Yellow House for the first time:

Last night I slept in the house, and although there are still things to be done, I feel very happy there . . . with the red tiles, the white walls, the furniture in deal or walnut, the patches of intense blue sky and greenery visible through the windows. Now the surroundings, with the public garden, the night cafés, the grocer's shop, aren't Millet, of course, but failing that, it's pure Daumier, pure Zola.[39]

He was finally settled: at ease in the neighbourhood, with a few fledgling friendships and the beginnings of a really exciting artistic project on the horizon. Only a few short months later, everything would be in tatters.

Since the early summer of 1888 a deep sulphur-yellow had permeated many of Vincent's paintings. By September it was completely dominant and defines much of his work of this period. Later that month he set up his easel on the pavement in front of the gendarmerie and painted his own home. The yellow of the house, his sunflower paintings, his famous painting *Café Terrace at Night* with its extraordinary luminosity – all bear witness to the dominance of this sole colour.

This painting *The Yellow House (The Street)* wasn't on display on my first visit to Amsterdam. When I saw it some years later, I already knew quite a lot about place Lamartine. That yellow is so hard to get right in reproductions, and I was startled by seeing the real painting. The yellow is intense and glowing, almost radiating out of the canvas, accentuating a feeling of heightened reality. It felt very special to be looking at Van Gogh's home in Arles through his eyes, full of the hope and optimism of that summer of 1888: at the bright-green shutters, the passers-by in the street, the men sitting having a chat at the café, the street lamp in front of his house; and the nod to Roulin, whose home was beyond the bridge. I could almost smell the smoke in the air and hear the whistle of the train. I could see where he went to eat every day and imagine him sitting in the courtyard after lunch with his pipe. The Crévoulins' pink awning was drawn down low, and I thought about how hot the sun would be at that time of day in late summer. I imagined the dust and inconvenience of the roadworks that are just visible. Despite the grey, modern museum surroundings, I was standing in front of the gendarmerie, looking across the road at the Yellow House, with the scorching sun on my back. I was in Arles in 1888.

In the archives in Amsterdam there was a document relating to the Yellow House that intrigued me. It was difficult to pin down exactly what it was for, or why it had been kept all these years, passed down

through the Van Gogh family presumably, to be left to the Museum. It is seemingly a proof of residency, and lists Vincent's full name, birthplace, parents' names and his address as 2, place Lamartine. I had often wondered how the journalist who had written about the incidents of 23 December had found out Van Gogh's full name, as he never used his surname and was known only as 'Monsieur Vincent' in Arles. This document must have been the source of *Le Forum Républicain*'s article on the drama, though how accessible it was in 1888 was anyone's guess.

Vincent had been in the city since late February and the form was dated 16 October 1888. If it was an obligatory piece of paperwork, the date should have been much earlier: May, for example, when Van Gogh took over the Yellow House. Why would Vincent have needed to prove residency so late in the year? This was not a normal piece of French red tape. In spite of extensive research in the archives, I couldn't find any record of this document, or its equivalent, in Provence. Then I read a comment that Vincent made in a letter to Theo in October: 'I've had gas put in, in the studio and the kitchen, which is costing me twenty-five francs for installation.'[40] In the painting of the Yellow House, roadworks are clearly visible along avenue Montmajour. The street was in the process of being dug up for the gas pipes that were being installed in his part of town. Van Gogh's atelier in the south wouldn't be very professional if he and his fellow painters – Gauguin – could only work in the summer months and during the daytime. In the long winter months daylight hours were short, as Van Gogh remembered from the early weeks of his stay. So he had a gas-jet installed in the house.[41] (On the wall of his painting *Gauguin's Chair*, this can clearly be seen.) To proceed with the installation, Vincent would need to establish 2, place Lamartine as his official residence. This seemed a perfect explanation for the need for the paperwork. But I was wrong.

This mysterious little document had nothing to do with the gas, which I found in a completely roundabout way. I needed to check something in the 1888 Arles newspaper *L'Homme de Bronze*, which has only recently been published online, and found a headline I hadn't noticed before, addressed to all foreigners living in Arles.

Since the murder of the two Zouave soldiers earlier in the year, there had been heightened tensions between the native population and the new migrant workers. On Sunday 14 October 1888 an article informed the good people of Arles that, by presidential decree, all foreigners needed to establish proof of residency within the month.[42] It's likely this announcement fuelled tensions and must have unsettled the already anxious Van Gogh.

Since 1917 all non-nationals in France have had to register officially within three months of arrival in the country. Until a few years ago this also applied to members of the European Union. It took twenty-six trips over six years to the *Bureau des Etrangers* before I finally received my first one-year Identity Card for Foreigners. Quite apart from the absurd amount of paperwork, I remember the ignominy of queuing up for hours, feeling decidedly unwanted. And then the loud thump of the stamp and the relief that I could stay in France for a further three months. In 1888 there were 296 foreigners living in Arles.[43] Along with all the others, Van Gogh would have walked to the main square and entered the town hall, as instructed, with his birth certificate, proof of his previous address in Holland and his passport. And then he would have been given the document that I found in the archives.[44]

As the summer progressed, with space and the tranquillity of not having to move his canvases around constantly, Van Gogh entered a period of intense creativity. If he couldn't work outside, he returned to his studio, fired by the comfort of having settled: 'You know, it really does you good to come back to your own home, and it gives you ideas for work.'[45] His painting had progressed enormously, becoming more assured and more particular, moving away from the trends of Paris to a style that was more uniquely his own. After the Impressionist style of his early orchard paintings, he now began to use paint in a different way, employing pure colour and smoother, more confident brushstrokes. Vincent was well aware that these works might not please everyone, as he said to his sister Wil:

I have a study of a garden, almost a metre wide . . . I know very well that not a single flower was drawn, that they're just little licks of colour, red, yellow, orange, green, blue, violet, but the impression of all those colours against one another is nonetheless there in the painting as it is in nature. However, I imagine it would disappoint you and appear ugly were you to see it.[46]

Notions of beauty change. Today we are surrounded by vibrant, overwhelming colour in every area of our lives: on giant advertising billboards, screens, in films and on every page of magazines and weekend supplements. Looking at this painting, *Flowering Garden*, with modern eyes, it is difficult to imagine just how radical Van Gogh's paintings really were at the time. The strong emotive reaction they provoked when I first saw them in Amsterdam surprised me. I can only imagine how these canvases seemed to locals in nineteenth-century Arles, used as they were to seeing art under layers of tawny-coloured varnish. They must have seemed the work of a madman.

In a letter written many years after Van Gogh's death, the artist Paul Signac recalled seeing Vincent's paintings of Arles for the first time in the Yellow House, describing them as 'wonderful . . . master-pieces'.[47] In those first six months in southern France, inspired by the beauty and colours of Provence, battling the wind, sun, flies and his own mental health, Vincent had become a great painter.

CHAPTER 10

The Artists' House

Shortly after 4 a.m. on 23 October 1888, Paul Gauguin descended from the train in Arles.[1] It wasn't yet light, though the early morning was balmy and promised a sparkling autumnal day. It was a welcome change for Gauguin, who had spent the previous eight months in rainy Brittany. Despite being tired from almost two days of travel, he decided to wait until it was a reasonable hour to wake Vincent. There was only one place open that early in the morning – the all-night café a short walk from the station. Loaded with bags, Gauguin walked into the Café de la Gare. He wrote that from the moment he arrived, the man behind the bar seemed to be observing him curiously. Eventually he addressed the traveller. 'So . . . you're the friend. I recognise you.'[2]

Arles is a small town. Any new arrival would stand out, especially at four in the morning, but Gauguin – a Parisian gentleman clearly carrying the paraphernalia of a painter – was a special case. The regulars had heard for some time that a guest of the red-haired painter was due to join him any day now. The barman's choice of words, 'I recognise you', suggested that he had seen the artist's self-portrait with Émile Bernard, which was now hanging in the Yellow House.

Once dawn broke and the long-awaited Provençal light cast a warm glow over the rooftops of Arles, Gauguin made his way to the Yellow House. With his new friend in tow, Van Gogh set about showing Gauguin his town and introducing him to his friends. Two days after his arrival, Vincent wrote to Theo with his first impressions of his new housemate: 'He's very, very interesting as a man, and I have every confidence that with him we'll do a great many things.'[3]

Yet all was not well. The preparations to ready the house for Gauguin's arrival had left Van Gogh physically and mentally exhausted. It is hard to gauge how self-aware Van Gogh was at this stage of his own delicate health: did he realise his problems were more to do with anxiety than diet? Theo, however, clearly saw the fragility of his brother's mental health, responding with characteristic kindness and foresight, sending more money and suggesting that Vincent obtain credit at the Auberge Venissac, to avoid having to worry about mealtimes:

I'm very, very pleased that Gauguin is with you, because I was afraid he'd found some obstacle to his coming. Now, from your letter I can see that you're ill and that you're giving yourself masses of worries. I must tell you something once and for all. To me it's as if the matter of money and sales of paintings and the whole financial side doesn't exist.[4]

In his first letter from the south to Theo, Gauguin confirmed that Vincent was out-of-sorts: 'I've been in Arles since Tuesday morning . . . however, your brother is a little agitated and I hope to gradually calm him down.'[5] Exactly how 'agitated' was not explained, but the fact that Gauguin found it necessary to mention it at all to Theo implies that it was relatively serious. Worried that perhaps Gauguin had said something to his brother, Vincent wrote to Theo immediately to reassure him. 'My brain feels tired and dry again, but I'm better this week than the previous fortnight.'[6] It was tempting to convince himself that he was simply tired. Luckily, he noted that his new housemate took the situation in his stride: 'Gauguin is astonishing as a man; he doesn't get worked up, and he'll wait here, very calmly, while at the same time working hard, for the right moment to take a huge step forward. He needed rest as much as I did.'[7]

This last line underlines Van Gogh's belief that a fragile mental health was a normal part of the creative process, rather than an affliction particular to him. Nevertheless he clearly wanted to reassure Theo:

As for *ill*, I already told you I didn't think I was, but I would
have become so if my expenses had had to continue. Since I was
in a state of terrible anxiety about making you make an effort
beyond your strength . . . I had, in fact, a terrible feeling of
anxiety for you.[8]

Gauguin's first project in Arles saw him reinterpreting one of
Vincent's own paintings: 'At the moment Gauguin has a canvas in
progress of the same night café that I also painted, but with figures
seen in the brothels. It promises to become a beautiful thing.'[9] Vincent's
letters in late October 1888 are full of admiration for his new friend
and optimism about the future. Gauguin's painting takes the café from
a very different angle, with Madame Ginoux right in the foreground.
In the background are various nocturnal characters, the 'night-prowlers':
a Zouave, a man slumped on the table in a stupor, and four characters
in conversation at the next table, including a bearded man in uniform
– probably Roulin – and a girl seemingly ready for bed with her hair
already in rags.[10] On the table in front of Madame Ginoux are a blue
siphon of water, sugar lumps and a glass of brownish liquid and a
spoon. This bottle is usually referred to as absinthe, given that the
materials for preparing it in the traditional manner – pouring water
over a sugar lump on a slotted spoon to heighten the effect of the
alcohol – seem to be laid out on the table. Absinthe was especially
associated with the hedonism of bohemian culture in the late nine-
teenth century, blamed for sending people mad, inducing hallucinations
and being dangerously addictive. Though it was widely available and
very fashionable in Paris at the time, I have not yet been able to find
any evidence of it being widely sold in Arles in 1888, so the question
of the availability of absinthe is still open to debate. It is possible that
absinthe was manufactured and sold on the black market in Arles.[11]
Marie Ginoux was a respectable figure running a local business; it seems
very unlikely that she would have posed for Gauguin sitting in front
of a glass of such a notorious drink, with its connotations of louche
living. It is possible, though, that Gauguin invented the scene or added
the blue bottle in later, as Madame Ginoux's hand is hidden behind
the soda siphon. Gauguin regularly liked to work from his imagination

or from memory, and encouraged Vincent to do so, too. It was this sort of inspiration that Van Gogh had so longed for, during his first eight months alone in Provence.

Gauguin also brought a degree of order and routine to Van Gogh's living habits. Vincent barely cooked and, by his own accounts, his eating habits were at best erratic. One story records him putting a pan of chickpeas on to boil before going out to paint, and returning hours later to eat the dry, overcooked meal. He usually ate at the Auberge Venissac next door to the Café de la Gare. The arrival of Gauguin introduced a new level of rigour to his life: 'I must tell you that he knows how to cook *perfectly*, I think that I'll learn that from him, it's really convenient.'[12] Gauguin was a fairly good cook, and he began to get things organised. He advanced the money to buy a chest of drawers and some kitchen utensils, enabling them to eat at home, thereby reducing their living costs. He also purchased 20 metres of strong canvas for painting.[13] Gauguin later explained in his autobiography:

> From the first month I saw our shared finances take on the same appearance of disorder. What was to be done? The situation was delicate . . . I had to speak out and clash with a very sensitive nature. Therefore it was only with great care and several gentle approaches somewhat at odds with my nature, that I broached the question. I must confess, I succeeded much more easily than I had imagined. In a box, so much for nocturnal excursions of a hygienic sort, so much for tobacco, and also so much for unexpected expenses including the rent. On top of all that a piece of paper and a pencil to write honestly what each of us took out of this box. In another box, what was left of the total, divided into four parts for the cost of food each week.[14]

This new arrangement worked well for both men: Vincent was responsible for buying the provisions, and Gauguin would make a delicious meal. Life at the Yellow House began to improve significantly. 'The house is going very, very well and is becoming not only comfortable but also an artists' house,' wrote Vincent.[15] Van Gogh introduced Gauguin to his

favourite haunts, and this odd couple – the Parisian gentleman and the flame-haired painter – soon became a familiar sight around Arles.

By late autumn the weather was still fairly mild and Vincent was painting almost non-stop. Still in the first flush of his love for the city, he found his subject matter out and about in Arles, though this time he was painting alongside Gauguin. He wrote to Theo that he had 'made two studies of falling leaves in an avenue of poplars, and a third study of the whole of this avenue, entirely yellow'.[16] Gauguin also painted the scene. These works show the alley of trees and tombs that line the Alyscamps. Vincent's perspective is aslant, looking down on the scene from above, through the lilac tree trunks, and still shows a strong Japanese influence. In Paris, he had used a box of wools, in order to test out which colours worked well together, twisting coloured wool to experiment with combinations, like the blue-lilac trees on the burnt-orange background seen in this canvas.

Gauguin, though, was not as enamoured by Arles as his housemate. It didn't inhibit his painting, but Van Gogh worried that Gauguin's mind was elsewhere:

What he tells me about Brittany is very interesting, and Pont-Aven is a quite amazing part of the world. Of course, everything there is better, bigger, more beautiful than here. Of a more solemn character, and above all more of a whole and more defined than the small, stunted, scorched countryside of Provence. Be that as it may, he, like me, nevertheless likes what he sees, and is particularly intrigued by the Arlésiennes.[17]

In early November, Vincent wrote to Theo that the two artists had already been to see the girls of the red-light district. Gauguin had been raised in an all-female household and had a reputation as a ladies' man. His behaviour surprised and sometimes shocked Vincent. He wrote to Émile Bernard, who knew Gauguin well from their days together in Brittany, 'Gauguin interests me greatly as a man – greatly . . . without the slightest doubt, we're in the presence of an unspoiled creature with the instincts of a wild beast. With Gauguin, blood and sex have the

edge over ambition.'[18] Given how intense emotions overwhelmed the vulnerable Van Gogh, his assessment of the more naturally gregarious Gauguin as a 'wild beast' is not surprising. The phrase implies both admiration and awe, as well as a tinge of apprehension.

Competition wasn't something he'd experienced since he'd arrived in the south. Mourier-Petersen never felt much of a rival, and Van Gogh was pretty certain of his own superiority. Gauguin was a different matter, though. He overshadowed Van Gogh, both physically and by the force of his personality. He was gregarious and told fantastic stories of his adventures with gusto and spirit, which impressed Vincent. There was also the question of the age difference: Van Gogh, five years younger, single and childless, was still naive and idealistic, whereas Gauguin, a forty-year-old man-of-the-world, had married, fathered five children and abandoned his family to travel the world and paint. Vincent saw the family unit as an ideal, and was perturbed by Gauguin's extravagantly egotistical choices:

> He's married and doesn't much appear to be, in short I fear there may be an absolute incompatibility of character between his wife and himself, but naturally he's more attached to his children, who judging from the portraits are very beautiful. We, on the other hand, aren't too gifted in that respect.[19]

The nature of the relationship between Van Gogh and Gauguin is best illustrated in the tone of their correspondence. There was mutual respect, but they were never really friends. Van Gogh always addressed Gauguin with the more formal '*vous*' rather than '*tu*', which he used with people such as Émile Bernard. Even after Gauguin left Arles, having lived with Vincent in close quarters for more than two months, Van Gogh continued to address him in the more formal manner.[20]

Working alongside another artist was certainly fruitful for both men, but the influence of Gauguin on Vincent's painting style should not be overestimated. There was some cross-pollination, but in the summer of 1888, when Van Gogh's art reached its greatest expression, he was working alone. In his autobiography, written ten years after Van Gogh's death, Gauguin implied that he had taught Vincent more

or less everything he knew and that the Dutchman regarded him as
his master. Jo van Gogh, Vincent's sister-in-law, was incensed:

> [Do not] . . . misrepresent Vincent for posterity . . . Never, but
> [truly] never did I hear Vincent call Gauguin 'master'. He never
> apologised to him; [to say] this is to not fully know the character
> of Vincent. It was a story invented by Gauguin many years later,
> and anyone who knew Gauguin, would tell you he was not
> scrupulous, excessively vain and prone to giving [himself] the
> best role. I repeat, this [notion is] to give a false picture of Vincent
> and assign a humble attitude toward the friend he never had;
> moreover Vincent was not a man to apologise, he was never
> wrong. On re-reading the letters that Vincent wrote at the time
> no one could get the impression that he considered himself
> inferior to Gauguin. I have forty letters from Gauguin, including
> several from that time, and his letters as well as those of Vincent
> clearly show that they held each other in high esteem, but that
> there was no [feeling of] superiority on one side or the other.[21]

Nonetheless, it is thanks to Gauguin that Van Gogh began to work
in a different fashion. For some time before arriving in Arles, Gauguin
had been encouraging Vincent to paint using his imagination. As he
had previously painted directly from life, Gauguin's suggestion repre-
sented a significant shift in Van Gogh's working methods, enabling
him to paint indoors without a model. It was a totally new direction
for his art and led to fulsome praise for his new friend: 'Gauguin gives
me courage to imagine, and the things of the imagination do indeed
take on a more mysterious character.'[22]

In late November, with their work going well, Vincent started
working on a series of portraits. Gauguin was also turning his mind
to portraiture. He wanted to paint Van Gogh. The portrait would
show Vincent as he worked on a painting of a vase of sunflowers,
though the season for the blooms was long over. Vincent had decorated
the walls of Gauguin's bedroom with canvases of sunflowers, and this
flower more than any other has come to symbolise his life and work.
As November came to an end the strains in their relationship began

to show, and Vincent remarked in his letter to Theo of 1 December that Gauguin's portrait was still unfinished. Gauguin described Vincent's reaction when he saw the canvas: "'That's me all right, but me gone mad.'"[23] Although Van Gogh recognised he had been 'agitated' when Gauguin arrived, he had soon calmed and, to his mind, was on an even keel, so his conclusion that the painting showed him 'gone mad' was more likely a retrospective interpretation by Gauguin than necessarily what Van Gogh actually said. As December progressed Van Gogh's behaviour changed. Gone was the optimistic and inspired artist that Gauguin had worked alongside in November; Vincent had started to become argumentative and erratic and was gradually becoming impossible to live with.

Paul Gauguin had arrived in Arles with a certain optimism for a new and fruitful working relationship, an improvement to his finances, a good relationship with a respected dealer and a new landscape to inspire his work. He had heard good things about Van Gogh from Émile Bernard, and he had come south in search of a collaborative relationship with a fellow painter, not to be the nursemaid to a very disturbed individual on the verge of a nervous breakdown.

CHAPTER II

Prelude to the Storm

Winter in Provence is a quiet time of year. Colour is bleached from the landscape and the nights draw in early. Once the sun has gone down there is little to do. My first winter here was rather a shock. With no television, I read and wrote letters, much as Vincent did in those short winter days of 1888. As the years have passed I have learned to love the crisp, sunny winter days when the light is so pure, all the tourists have left and the village becomes our own place again.

The last month of 1888 was a particularly difficult time for the artists in the Yellow House. The weather suddenly turned cold and there were heavy overnight frosts. The painters were stuck indoors, which did nothing to lift their mood; the initial joy and excitement of working together was replaced by almost constant bickering. Gauguin complained to their mutual friend Émile Bernard: 'I'm in Arles, like a fish out of water, I find everything – the landscape and the people, so small, so petty. Vincent and I rarely agree on anything, especially about painting.'[1]

One minute Van Gogh would be perfectly lucid, then suddenly his mood would change drastically. He felt pushed to his limits. In the evenings the two men would dine at home, write letters to friends and family, read books and newspapers, before going out for a drink to one of the bars that opened late around the place Lamartine – the Café de la Gare, Café de l'Alcazar or Bar du Prado – or occasionally to see a girl at the nearby red-light district, just a few minutes' walk away.

Van Gogh spent much of December painting the Roulin family. Augustine Roulin, who was still nursing baby Marcelle, became the

subject of a series of paintings of an ideal, the relationship between mother and child. Vincent had been reading the novel *Pêcheur d'Islande* by Pierre Loti, in which the sea becomes a metaphor for a mother gently rocking her child; his portrait of Augustine *La Berceuse* shows her holding a length of rope used to rock the baby's cradle. It was rare for Van Gogh to go for more than a few days without writing to Theo, but in the early days of December he went ten days before writing to his brother. Finally Theo received a short note from a despondent Vincent:

> I myself think that Gauguin has become a little disheartened by the good town of Arles, by the little yellow house where we work, and above all by me. Indeed, there are bound to be grave difficulties still to overcome here, for him as well as for me.

More worrying was Vincent's conclusion that 'these difficulties are rather within ourselves than elsewhere'. 'All in all,' he reasoned, 'he'll either definitely go or he'll definitely stay. I told him to think and do his sums again before acting.

> Gauguin is very strong, very creative, but precisely because of that he must have peace. Will he find it elsewhere if he doesn't find it here? I'm waiting with absolute serenity for him to make a decision.[2]

I doubt very much that Vincent was waiting with 'absolute serenity'. If Gauguin left, Van Gogh's dream of an atelier of the south would crumble. Perhaps Vincent thought there was something he might still do to persuade him to stay. Yet for Gauguin, the decision had already been made. He was determined to leave, writing tersely to Theo that same day, 11 December:

> I should be obliged if you would send me part of the money for the paintings that have been sold. Taking everything into account I am obliged to return to Paris; Vincent and I can absolutely not live side by side without trouble, as a result of incompatibility

of temperament, and both he and I need tranquillity for our
work. He is a man of remarkable intelligence, whom I greatly
respect and whom I leave with regret, but I repeat, it is necessary.[3]

Gauguin's discomfort and tact in this letter are evident. It was clear
by December 1888 that there was little he could do as Vincent was
manifestly mentally ill.

In the late 1880s in provincial France very little was known about
psychiatric disorders, generally referred to using the blanket terms
'mental alienation' or 'epilepsy', and less still about how to treat
patients with signs of recurring mental-health problems like Van
Gogh. With only a handful of acquaintances in the south and little
knowledge of what exactly Van Gogh was suffering from, Gauguin
was left with few options. To leave Vincent in this fragile state might
be considered the act of a callous man and so, after 'doing his sums',
the ex-stockbroker backtracked, writing to Theo on 14 December
that he had changed his mind and that his desire to leave was merely
a 'bad dream'.[4] In fact Gauguin had few alternatives: he still had a
wife and five children to support. If he left Provence any earlier than
planned, he would be obliged to repay the money Theo had advanced
to cover his debts, train fare and living expenses. It would also be
unwise to endanger his relationship with yet another dealer, especially
one who admired and sold his work. In Arles, Gauguin had free room
and board and he took the only available course of action: he did
nothing.

On 15 December 1888 it began to rain and continued raining the
following day. For two men who had little in common aside from
their art, the intense proximity was uncomfortable at best. As a respite
from the stifling atmosphere in the house, Gauguin suggested they
take a day-trip out of Arles to visit the Bruyas Collection at the Fabre
Museum in Montpellier, which he had seen as a young man.[5] Rather
than improve the situation, the trip created further discord. They
disagreed vehemently about the quality of the works in the collection:
Gauguin found the work third-rate and conventional, but Vincent
enjoyed it immensely. To Gauguin, these disagreements of taste were

stimulating banter, but Vincent was unable to separate conflicts in taste and opinion from a more personal discord. He was rattled, unsettled and the discussions aggravated his innate hypersensitivity.

Monday 17 December dawned on what would be the last week the artists spent together. Gauguin wrote to Émile Bernard of the difficulty of living with Van Gogh: 'He really likes my paintings, but when they are done he always finds this or that is wrong. He's a romantic and I'm more primitive.'⁶ As ever, this conflict between Gauguin's more visceral temperament and Van Gogh's sensitivity threatened to break their fragile companionship. Desperate not to acknowledge the escalating tension between them, Vincent wrote to Theo claiming that Gauguin was merely over-tired:

'It won't be long,' Gauguin said to me this morning, when I asked him how he felt, 'that he could feel his old self coming back', which gave me great pleasure. As for me, coming here last winter, tired and almost fainting mentally, I too suffered a little inside before I was able to begin to remake myself.

He ended the letter with an enigmatic sentence:

As regards setting up a life with painters as pals, you see such odd things and I'll end with what you always say, time will tell ... I would already have written ... if I'd felt the necessary electric force.⁷

This phrase, 'the necessary electric force', was significant for him. He was in a febrile state and, as the week continued, his behaviour became increasingly unsettled.

As the relationship between the two men disintegrated, Gauguin started to keep notes in his sketchbook. He later wrote in his autobiography:

During the latter part of my stay, Vincent became excessively brusque and noisy, then silent. Several nights I surprised Vincent who, having risen, was standing over my bed. To what can I

attribute my awakening just at that moment? Invariably it sufficed for me to say to him very gravely, 'What's the matter, Vincent?' for him to go back to bed without a word and to fall into a deep sleep.[8]

The following morning Van Gogh would have no recollection of his night-time behaviour, but for Gauguin it was deeply unsettling.[9] Incidents such as these are referred to medically as 'amnesia ictus' and tend to follow nervous crises: Gauguin even jotted down the word 'Ictus' in his personal sketchbook. There were other clues that things were seriously wrong. Shortly before he left Arles, Gauguin recalled in his autobiography that Vincent scrawled in chalk on the wall of the Yellow House, *'Je suis sain d'esprit, je suis le Saint-Esprit'* ('I'm sound of mind, I am the Holy Spirit'). Long thought to be an invention of Gauguin's, the same play on words was confirmed by one of the pages in Gauguin's Arles sketchbook. As Émile Bernard later recorded, Van Gogh was 'in the deepest mystic state . . .Vincent saw himself as Christ'.[10]

It's hard to know quite how extreme Van Gogh's behaviour really was during this last week before Christmas; his letters give little away, and he was always keen to play down the severity of his situation to his long-suffering brother. Similarly, Gauguin's account cannot necessarily be trusted. He wrote his autobiography more than a decade after the events of 1888, and after Van Gogh's subsequent actions distorted the memories of these late-December days. Nonetheless, a major clash seemed inevitable. In the last letter Vincent wrote to Theo prior to 23 December, the difficult atmosphere was palpable: 'Gauguin and I talk a lot about Delacroix, Rembrandt, etc. The discussion is <u>excessively electric</u>. We sometimes emerge from it with tired minds, like an electric battery after it's run down.'[11] Whilst literal, this translation does not convey the true meaning here: in French the word 'electric' can have negative connotations – 'extremely tense' or 'at breaking point' might better describe his situation. His underlining of the words emphasises the fraught atmosphere at home.

As the tension between Vincent and Gauguin escalated, the weather worsened. Days of torrential rain imprisoned the artists in the

cramped quarters of the Yellow House; in the three days from 21 to 23 December, Arles saw almost 30 inches of rainfall – more than 150 per cent of the monthly average.[12] Southern France is not made for rain: drains overflow and the narrow cobbled streets run with rivers of rainwater. Even one day of driving rain in Provence is hard to take. By the weekend, the intense rainfall was creating havoc in the town and at home.

After mentioning that Vincent drank a 'light absinthe' on the 'day of the drama', Gauguin continued in his autobiography:

> Suddenly, he threw the glass and its contents at my head. I avoided the blow and, taking him bodily in my arms, left the café and crossed the place Victor Hugo; some minutes later, Vincent found himself in bed, where he fell asleep in a few seconds, not to awaken again until morning.[13]

Written so long afterwards, some of Gauguin's recollections are a little confused: not only was there no 'place Victor Hugo' in Arles (he meant place Lamartine – both were the names of poets), but this incident didn't occur on the 'day of the drama', as he remembered, but sometime during the evening before, on Saturday 22 December, likely in the Café de l'Alcazar at 17, place Lamartine, as this was the only establishment from which you would need to cross the square to get to the Yellow House. 'When he awoke,' Gauguin continues, 'he said to me very calmly: "My dear Gauguin, I have a vague memory of having offended you last evening."'[14]

Gauguin no longer trusted himself to remain calm. He told Van Gogh, 'I gladly forgive you with all my heart, but yesterday's scene could happen again, and if I were struck I might lose control of myself and strangle you. So permit me to write to your brother and announce my return.'[15]

Despite his fear of losing control, Gauguin waited until the morning of the 23rd before writing to Theo. That Saturday, the evening of the 22nd, however, he did write to his old friend Émile Schuffenecker, who had put him up in Paris in the past.

My Dear Schuff,

You have been waiting for me with open arms, for which I'm grateful but unfortunately I'm not coming yet. My situation here is very difficult; I owe much to Van Gog [*sic*] and Vincent in spite of a few disagreements, I can't begrudge an excellent heart which is unwell, which suffers and needs me. Do you remember the life of Edgar Poe whose nervous state was such that he became an alcoholic after a series of heartbreaks. One day I will explain everything completely. Anyway, I'm staying on here, but my departure will just be a matter of time . . . Don't say anything to anyone, I would appreciate if you don't say a word to [Theo] Van Gog [*sic*], even if he talks to you about it.[16]

In the letter he also mentioned plans to return to Martinique, once he'd made enough money in Paris. Gauguin's thoughts had moved far beyond Arles and Van Gogh's fledgling atelier of the south. Taking his letter to Schuffenecker, he walked through the gas-lit streets to the station, but he had just missed the last post for Paris, which left at 10 p.m. that night.[17] With his plans now in place, Gauguin headed for bed. His letter was franked 'Gare d'Arles, 1–23 déc 1888'; it would have left by the first morning post and arrived in Paris later that day.

CHAPTER 12

A Very Dark Day

In my mental or nervous fever or madness, I don't know quite
what to say or how to name it, my thoughts sailed over many
seas.

Vincent van Gogh to Paul Gauguin, 21 January 1889

On the morning of 23 December 1888 the two men awoke to another
day of bad weather and another day of imprisonment in the Yellow
House. There was a temporary truce. Gauguin felt incapable of aban-
doning or antagonising a man who was patently ill; he would stay in
Arles for the time being, hold his tongue and maintain the equilibrium.
But by the time the day was over, Gauguin had decided to leave Arles
and Vincent van Gogh was in hospital. Exactly what transpired between
the two men that day is the subject of much debate and speculation.
What is in no doubt is that it brought Vincent to the very edge of his
sanity.

As Sunday was a day of rest in a fervently devout city like Arles,
most people spent the day with their family. Much of the city was
closed, including the restaurants that catered to working men. The
Christmas market on the place de la République, selling livestock for
Christmas feasting, was poorly attended due to the atrocious weather.
As the incessant rain droned down, there wasn't much to do other
than write letters or read.

Since Gauguin had arrived in Arles, discussions between the artists
had centred on the books they were reading. Vincent had read
Alphonse Daudet's novels *Tartarin de Tarascon* and *Tartarin sur les Alpes*,

classics of Provençal literature earlier in the year. A few months after Gauguin had left Arles, Van Gogh wrote to his brother equating the Parisian's behaviour with the character Bompard, a braggart and liar.

Tartarin is an endearing buffoon, who thinks he is capable of anything. In *Tartarin sur les Alpes* the buffoon and his good friend, Bompard, who have never hiked anything more than the local foothills, hatch a plan to climb the Alps. Before setting off the two friends make a solemn promise always to look after one another, <u>come what may</u>. During their ascent they come to a narrow impasse that looks like a death-trap. Separated by a long distance of rope neither man can see his friend and fears the worst. Convinced their compatriot is dead, in order to save their own skin they both sever the rope that attaches them to each other. Once home Bompard, like Gauguin a notorious teller of tall tales, boasts that in cutting the rope he acted selflessly to save Tartarin. The chapter ends with a sobering image: a sketch of the severed piece of rope. Tartarin, the rope and Bompard's cowardly betrayal would haunt Vincent van Gogh for days to come.

Soon after returning from hospital in 1889, Van Gogh wrote to Theo:

> Has Gauguin ever read *Tartarin sur les Alpes*? Does he remember the knot in a rope rediscovered high up in the Alps after the fall? And you, who wish to know how things happened, have you ever read the whole of *Tartarin*? That would teach you to recognise Gauguin pretty well.[1]

Vincent (like Tartarin) felt betrayed by his friend, and in his first letter to Gauguin after the drama he reiterated the point: 'Have you read *Tartarin* in full by now?'[2]

In his sketchbook, Gauguin jotted down the words *'crime, châtiment'* opposite a drawing that he called *Portrait of Vincent Painting Sunflowers*.[3] This was the title of Fyodor Dostoevsky's book *Crime and Punishment* of 1866. Vincent knew the book and mentioned it in his letter to Theo of 11 September. Throughout this novel the colour yellow is used to signify suffering and mental illness. In Russia the colour is so synonymous with madness that the term for a lunatic asylum or psychiatric ward is *zholti dom*, which translates as 'yellow house'.

At some point on 23 December one of the men popped out to buy a newspaper at the kiosk just inside the porte de la Cavalerie. Vincent tended to read either *Le Figaro*, an independent newspaper, or the socialist daily paper, *L'Intransigeant*, every day. That Sunday, Vincent must have sat in the kitchen silently reading the newspaper on his simple straw-seated chair, while Gauguin took the more comfortable armchair, both the subject of paintings soon after Gauguin's arrival in the house.[4]

Even though it was a Sunday, there were still normal postal deliveries. The inhabitants of the Yellow House were such dedicated correspondents that Arles' postmen were regular visitors to their door. The most eagerly awaited delivery came after eleven o'clock, when the post from Paris arrived. That morning Vincent received a letter that seemed to worsen his mood dramatically. He became very distressed and later that day, as Gauguin related to Émile Bernard, a row broke out between the two men:

Ever since the question arose of my leaving Arles he had been so queer that I hardly had a life any more. He even said to me: 'are you going to leave?' and since I had said 'Yes' he tore a sentence from a newspaper and put it into my hand: 'The murderer fled'.[5]

For many years this newspaper anecdote seemed just another of Gauguin's apocryphal tales. Yet on this occasion Gauguin was telling the truth. 'The murderer fled' is the last line of an article that appeared in *L'Intransigeant* that day.[6] The extract that Vincent chose to thrust into Gauguin's hand was from an article about a young man who had been recently stabbed in the capital, ominously titled 'Parisian Cut-throat'.[7]

In Gauguin's Arles sketchbook there is a seemingly random list of words on the same page as the phrase *'Je suis sain d'esprit, je suis le Saint-Esprit'*, the words Gauguin recorded Van Gogh scrawling on the wall.[8] At first this list, compounded by Gauguin's poor spelling, doesn't make much sense: 'Incar (or Incas), snake, fly on the dog, black lion, the fleeing murderer, Saul Paul Ictus, Save honour (money on table), Orla

(Maupassant)'. However, when read in the context of the situation, these jottings make it possible to build up a very dramatic picture of what took place on 23 December.[9] I believe that by noting these particular words or phrases Gauguin was recording Vincent's breakdown minute-by-minute as things were coming to a head in the Yellow House.

As I see it, as Vincent lost his tenuous grip on reality, he started to have strong hallucinations: Gauguin was the Peruvian 'Inca'. He was a 'snake'. Vincent was gesticulating wildly, as if he were trying to swat away something irritating like a 'fly on a dog'. Ripping out the top corner of the newspaper and thrusting it wildly at Gauguin, Vincent accused him of being a murderer who was running away. Just like Bompard, he had been betrayed by the friend he trusted. Vincent felt a presence following him, he said, like 'Horla' in Maupassant's novel of the same name, whose main character gradually descends into madness.[10] He was 'Saul', seeing Christ (Ictus) on the road to Damascus. He was 'St Paul' being persecuted.[11]

Gauguin's Arles sketchbook, 1888

Gauguin was desperate; he had to get out. In turmoil, Van Gogh must have watched him moving through the rooms in silence, going up and down the stairs gathering his belongings. Eventually Gauguin turned to his companion. He needed cash for the train fare back to Paris and probably would have asked Vincent whether he could take it out of their communal box. Vincent was probably furious, yelling at Gauguin to 'save his honour' as he threw the money down on the table.

The day wore on interminably. By evening there was calm before the final storm. The Auberge Venissac wasn't open for dinner, as the Protestant owners never worked on a Sunday. In late December in the depths of winter the evening meal would have been quite early, probably around 7.30, after which Gauguin went out for a walk; by now it was nearing nine o'clock in the evening. Gauguin gave this account of 23 December 1888:

> My God, what a day! Evening arrived and I quickly ate my dinner, I felt the need to go out on my own and take some air, scented with flowering laurels. I had already almost crossed the place Victor Hugo [sic], when I heard behind me the familiar short, rapid, irregular footsteps. I turned just at the moment when Vincent rushed towards me, an open razor in his hand. My look at that moment must have been powerful indeed, for he stopped, and lowering his head, took off, running in the direction of the house.[12]

Traumatised, Gauguin went to a local hotel for the night. Writing this account in his autobiography fifteen years later he cautioned his readers, 'Between Truth and Fable, I have never been able to distinguish, and I offer you this for what it is worth'.[13] But Gauguin, far away on the other side of the world, had forgotten a crucial detail: four days after the drama, on his return to Paris, he gave a friend a detailed account of everything that had taken place in Arles. And this person wrote down everything Gauguin told him.

CHAPTER 13

The Murky Myth

To get to the truth, it is essential once in your life, to question as much as possible.

René Descartes[1]

There is no doubt that Vincent had a nervous breakdown at the end of the year in 1888. The fact that he went mad in the middle of winter is glossed over, as it doesn't fit the story: one of passion, sun-baked earth and a misunderstood painter. Alcohol is almost always cited, and one drink in particular is believed to be responsible: absinthe. Journalists after good copy have tended to crassly presume that the heat and alcohol pushed Van Gogh over the edge: 'He probably wrecked his health and nerves painting for hours under the meridional sun,' wrote a journalist in 1971, 'afterwards spending his evenings drinking brandy and absinthe in some café on an almost empty stomach.'[2] Absinthe has become easy shorthand for explaining Vincent's woes: he drank excessive amounts, ergo he went mad.

I trawled through Van Gogh's letters and could find no evidence of heavy alcohol abuse. On the contrary, Vincent said in early April 1888 that he could barely drink a small glass of cognac, as it went straight to his head.[3] He did drink wine, but this was common at a time when the quality of the drinking water was unreliable. I was still bemused as to why absinthe, a drink with such a toxic reputation, had become so indelibly linked to Van Gogh. I didn't have to look far. The character of 'Vincent the absinthe drinker' came from the pen of the very man who had first-hand experience of Vincent's drinking habits: Paul Gauguin.

One day in the archives in Arles I came across a complaint lodged against a local policeman.[4] Included was a long list of the drinks he had consumed; and in this catalogue of obscure and long-forgotten beverages there was no mention of absinthe. Of course this corrupt official may simply not have liked the taste of aniseed, but amongst a list of varied alcoholic drinks, the absence seemed noteworthy. I remembered that in the Café de la Gare inventory, when Monsieur and Madame Ginoux had purchased the café earlier the same year, absinthe hadn't featured, either. Even if it was for sale in Arles, the inventory implied that at least in early 1888 it was not sold in Vincent's café. I began to question how widely available it was in Arles in 1888 and whether the artist ever drank it at all.

There is a famous portrait by Toulouse-Lautrec showing Van Gogh in a café sitting in front of a full glass of absinthe. Drinking absinthe with friends in Paris didn't necessarily prove that Van Gogh drank it in the south. I went back to Vincent's correspondence: in the 800-plus letters he mentioned absinthe seven times, twice referring to the colour that he had used to paint the river, twice commenting on characters he had painted in café scenes, and three times concerning the painter Adolphe Monticelli, whom he greatly admired.[5] But, interestingly, Van Gogh never once mentioned drinking absinthe himself.

In the 1850s absinthe was popular as a cure for dysentery and malaria amongst French colonial troops, and as the century wore on it gathered a louche reputation, becoming the drink of choice for artists. By 1900 it was the most popular aperitif in France. Absinthe is around 70 per cent ABV (alcohol by volume), which makes it very potent; to put this into context, gin, vodka and whisky all have an ABV of between 40 and 50 per cent. Made from wormwood, anise, mint, coriander and fennel, with no added sugar, absinthe was classed as a spirit rather than a liqueur. Drinking absinthe followed a certain ritual, akin to drinking mint tea in North Africa: absinthe was poured into a tall glass over a sugar cube placed on a specially perforated spoon, then water was added, which changed the hue from a lurid green to a paler opalescent colour. This process wasn't just a theatrical performance; the sugar heightened absinthe's effect and changed the taste. The reason for the drink's notoriety was the active ingredient, thujone,

which, though extremely toxic, is barely present in absinthe, repre-
senting less than 1 per cent. Vilified by the Temperance Movement as
leading to moral turpitude, in 1915 the manufacture and sale of absinthe
were banned in France. The scientific tests that led to the ban have
since been shown to be seriously flawed: a rat was injected with a
huge dose of thujone, significantly more than the quantity present in
several hundred glasses of absinthe, which unsurprisingly led to the
animal foaming at the mouth, having seizures and dying.[6] Absinthe
does not lead to hallucinations, but almost pure thujone does.

I contacted the Museum of Absinthe in Auvers-sur-Oise, the town
where Vincent later died. This private museum explains the history of
the drink and how it was consumed, naturally exploiting the connection
with the town's most famous inhabitant. When I asked a few questions
that expressed my doubts, the curator became quite indignant, telling
me, 'Of course it was available in Arles when Vincent lived there,' and
that absinthe could clearly be seen in Van Gogh's paintings. The curator
later got in touch saying she had found a manufacturer in Nîmes, as I
meanwhile continued to look for proof that it was on general sale in
Arles in 1888. I found a company nearby in Beaucaire, that made absinthe
during the same period, but this still didn't prove anything for certain.

I went on another mission to the regional archives in Marseille. I
read endless files concerning bar purchases and bankruptcies and, once
again, found records of lots of alcohol bought, served and stocked,
but only one bottle of absinthe was listed for the *whole town* over that
time period. As a result, I find it unlikely that Van Gogh ever drank
'large quantities of absinthe', as has been purported.[7] I can only
conclude that addiction to absinthe, as a contributory factor to Van
Gogh's psychiatric problems and part of the myth, is an exaggeration.

As I approached the details of the day of the drama, my overriding
sensation was one of circumspection. Many researchers had come
before me, but the details of the day remained hazy. Gauguin's role
has always been unclear. He left almost immediately afterwards and
never saw Van Gogh again. Traumatised by his time in Arles and its
dramatic conclusion, Gauguin freely gossiped on his return to Paris
about his escapade in the south and the painter 'who had gone crazy'.

When I first looked into Gauguin's time in Arles, like many others I noticed only the glaring inconsistencies in his account. By the time Gauguin's autobiography was published in 1903, fifteen years after the events, the story of the painter and his severed ear had already entered the realm of myth. Aware that he was writing for posterity, Gauguin was inevitably economical with the truth. Writing his version of events of what took place in Arles would help justify his actions – he had abandoned Vincent in his hour of need – and rewrite history.

When he was writing his memoir in the Marquesas Islands, his memory of the events was so hazy that he asked for a notebook from his time in Arles and Brittany to be sent on to him, in the South Pacific. But he did not remember another near-faultless source: his good friend Émile Bernard. Four days after returning to Paris from Arles in December 1888, Gauguin recounted the whole sorry affair to his friend. Distraught, Bernard promptly wrote a long letter to another friend of his, the art critic Albert Aurier, relaying the details of Vincent's breakdown. Since Bernard's letter was written only days after the drama, and although he wasn't actually in Arles, the timing gives it an authenticity that Gauguin's autobiography perhaps lacks.

To Bernard, Gauguin said that after Vincent accosted him in the park, the Dutchman ran off in the direction of the Yellow House. In his autobiography Gauguin adds that Van Gogh was holding an open razor. Yet Bernard never mentions this; if he thought Van Gogh had threatened Gauguin with a razor, surely he would have reported that to Aurier? In a letter to an unknown recipient dated January 1889, immediately after the drama, Gauguin summarised his time in Arles: 'I was meant to spend a year in the south working with a painter friend: unfortunately he went completely mad and for a month I feared a tragic, fatal accident.'[8]

Again there was no mention of a razor, a detail that only seems to have entered the story fifteen years later. If Gauguin's life was in imminent danger – the man was mad, he was being attacked – then running off to a hotel was completely justified; if not, it was the act of a coward. Perhaps, like Bompard in the Daudet novels, Gauguin needed posterity to believe that he was a better man than he really was: in his version of events he had almost been killed by Vincent van Gogh and was lucky to get away.

The local newspaper extract from *Le Forum Républicain* on 30 December 1888 confirmed the next part of the story: at some point between the end of dinner and approximately 11.20 p.m. Vincent cut his ear, managed to staunch the flow of blood, bandaged his head and left the Yellow House for the red-light district. The local press noted that Van Gogh turned up in the rue Bout d'Arles around 11.30 p.m. – presumably this was information supplied by the police. From place Lamartine to the brothel was a five-minute walk. Across the park and through the porte de la Cavalerie, Vincent would have gone immediately right, along rue des Glacières, to the House of Tolerance no. 1. At the doorway Vincent apparently asked for 'Rachel'. He was carrying a package, which he handed over, telling her 'to take care of it', before disappearing into the night. Here is Gauguin's account of the events after this as related to Bernard, and by Bernard to Aurier:

'I went and slept in the hotel and when I returned the whole of Arles was in front of our house. Then the police arrested me because there was blood everywhere. Here's what happened: Vincent had gone home after I'd left [the park], taken the razor and had sliced through his ear. He covered his head with a large beret and then went to a whorehouse . . . Immediately the girl fainted.' The police were called and went to the house. Vincent was taken to hospital. As for Gauguin, naturally he was let go without any charge.[9]

Gauguin's account in his autobiography takes quite a different tone:

Very agitated, I could not fall asleep [at the hotel] until about three in the morning, and I awoke rather late, about seven-thirty. Upon arriving at the square, I saw a large crowd assembled. Near our house, some gendarmes and a little gentleman in a bowler hat . . . the police inspector . . . It must have taken some time to stop the haemorrhage, for the next day there were many wet towels scattered about on the floor tiles of the two rooms downstairs. The blood had stained the two rooms and the little staircase that led up to our bedroom.

When he was in good enough condition to go out, his head covered up by a Basque beret pulled all the way down, he went straight to a house . . . and gave the 'sentry' his ear, carefully washed and enclosed in an envelope. 'Here,' he said, 'a reminder of me.' Then he fled and returned home, where he went to bed and slept. He took the trouble, however, to close the shutters and to set a lighted lamp on a table near the window.

The 'sentry' was the person at the door of the brothel. It is interesting that Vincent had the presence of mind not only to carefully wash and wrap his gift, but also to light an oil lamp so that Gauguin would be able to find his way through Vincent's bedroom to his own room. Obviously he had no idea how much he had scared Gauguin and expected him to come back to the Yellow House later that night. Gauguin's account continues:

Ten minutes later, the whole street given over to the *filles au joie* was in commotion and chattering about the event. I had not the slightest inkling of all this when I appeared on the threshold of our house and the gentleman with the bowler hat said to me point-blank, in a more severe tone:

'What have you done, sir, to your comrade?'

'I don't know.'

'Oh, yes . . . you know very well . . . he is dead.'

I would not wish anyone such a moment, and it took me a few long minutes to be able to think clearly . . . I stuttered when I said, 'Alright, sir, let us go upstairs, and we can explain ourselves up there.' In the bed, Vincent lay completely enveloped in the sheets, curled up in a foetal position: he appeared lifeless. Gently, very gently I touched the body, whose warmth surely announced life. For me it was as if I had regained all my powers of thought and energy.

Almost in a whisper, I said to the commissioner of police: 'Be so kind, sir, as to awaken this man with great care and, if he asks for me, tell him that I have left for Paris. The sight of me could be fatal to him.'[10]

It's astonishing how kindly Gauguin comes off in this account. He is clearly on the point of leaving, yet to some extent his appraisal of the events was accurate: there is no doubt that seeing Gauguin again might well have pushed Van Gogh further still into his nightmare. However, there is a letter to Theo from Vincent, written from the hospital later that month, which indicates that Gauguin was in the Yellow House when Vincent regained consciousness:

> How can Gauguin claim to have feared disturbing me by his presence when he would have difficulty denying that he knew I asked for him continually, and people told him time and again that I was insisting on seeing him that very moment?[11]

In his autobiography it was essential for Gauguin to paint himself as the innocent party, swept up in a drama of someone else's making. Rather conveniently, he maintained in both accounts that he wasn't anywhere near the Yellow House when Vincent cut off his ear. Yet there are two elements in his account that seemingly contradict this assertion. First, there is a gap in Gauguin's timeline for that night. He said he went for a walk after an early supper and then straight on to a hotel, which would suggest that he arrived there no later than 10 p.m. In his autobiography Gauguin said that he 'asked the time' when he arrived, but this detail is not in the story he told Bernard. It seems an odd, unnecessary remark, and it bothered me. Why go to the trouble of asking the time unless, of course, you need to establish an alibi? Gauguin then stated that he was unable to get to sleep until 3 a.m., some five hours later. He may well simply have lain awake worrying about his friend, concerned as to how and when he was going to get back to Paris. But it might also have been the sleepless night of someone who was more directly implicated.

This idea raises two possibilities: either Gauguin was present when Vincent cut off his ear, or more likely he was called to the rue Bout d'Arles, after Van Gogh turned up there. Gauguin wouldn't have been hard to locate, for there were only a few hotels near the place Lamartine and few people were about. It would have been an easy task to pop into the nearby lodging houses and ask if a Parisian was staying there.

Gauguin maintained that Vincent staunched the bleeding of his

ear, made a rough bandage and left the Yellow House, covering his
wound with a beret. The only independent accounts of the drama
are the press articles. In the newspapers there is no mention of any
head-covering whatsoever. Vincent bought a hat in August and a
second one a few months later in early January 1889; he records these
purchases in his letters to Theo.[12] There is no mention of a beret,
though Gauguin owned a large red Basque beret and Vincent painted
him wearing it. Featuring in both of Gauguin's accounts, it is a detail
that could only have been known by someone who saw a blood-
stained beret in the house the following day or who was actually
present that night.

In which case, Gauguin was more involved in the drama than he
ever suggested in either of his
accounts. A page in his sketchbook
appears to confirm this. To the left
of a drawing of a man, the word
'mystère' (mystery) figures promi-
nently. 'Mystère' is used in French to
describe something beyond reason or
comprehension and, when associated
with a person, means more than
simply that he or she is mysterious,
but that the person is utterly unfath-
omable.[13] The man in the drawing has
short, cropped hair with a prominent,
rounded nose. He appears to be
smoking a long pipe and is wearing
a beret, which is clearly covering the

Gauguin's Arles sketchbook, 1888

left side of his face. The hairstyle, pipe and covering of the left ear
seem to place this drawing in Arles on 23 December 1888. It would
appear to be a portrait of Vincent van Gogh.[14]

Gauguin did work from the imagination in many of his paintings,
but his sketchbook is also full of drawings done directly from life. I
wondered if he drew Vincent wearing the beret because he had actually
seen him later that night, immediately after he mutilated his ear. In
which case, this detail would place him at the scene of the crime. The

only other possible reasons that he might have known Vincent used this beret to cover his wound would have been thanks to the police or the women of the rue Bout d'Arles. I started to wonder whether Gauguin was really ensconced in his hotel for those missing five hours.

Whatever his role in the events of the evening of the 23rd, on the morning of 24 December 1888, Paul Gauguin found himself in a very strange position. Before coming to Provence he barely knew Vincent van Gogh. Living with Vincent had been fraught and intense. Vincent was obviously unwell and Gauguin felt no obligation to babysit him in the hothouse atmosphere of the Yellow House. From what he told the policemen, we are led to believe that he left for Paris immediately; yet one of his paintings tells a different story. One of the last works Gauguin painted in Arles shows a group of Arlésiennes huddled together as they walk against the wind. According to the Art Institute of Chicago, the background is the place Lamartine park opposite the Yellow House.[15] A fountain can be seen in this painting, which Gauguin had also drawn in his sketchbook. However, as the archives and Vincent's own drawing clearly show, there was a pond, but no fountain, in the place Lamartine park.[16] The fountain that Gauguin painted still exists today in the same location in Arles, but it was never in one of the public gardens. It is the fountain in the courtyard of the city hospital.[17] Seemingly insignificant, this small detail provides a clue as to Gauguin's whereabouts. He may not have actually spoken to Vincent again, but he certainly visited the hospital.

Even if Gauguin's autobiography has always been perceived as notoriously untrustworthy, he left further evidence about what took place in the Yellow House on that Christmas Eve morning in 1888. In the immediate aftermath of his arrest on Monday 24 December he made two drawings in his sketchbook that seem to do more than simply depict the events; they comment on the drama as it was unfolding.[18] Gauguin's caricatures of the chief of police in the kitchen of the Yellow House bring Joseph d'Ornano suddenly to life: he is shown with his hands thrust into his pockets, wearing small round glasses and sporting a bowler hat. Despite his rotund stomach and diminutive stature – barely 5 feet tall – he has swagger and a certain presence, as befits his rank.[19] Gauguin also adds commentary on the

pictures and the scene: in the first image he makes fun of d'Ornano's accent, especially the long-drawn-out Corsican way of speaking, by writing *'Je souis'* (instead of *'Je suis'*) underneath the figure. In the second drawing the chief inspector is seen examining a painting. Clutching his cane, hands clenched tightly behind his back, d'Ornano is drawn by Gauguin looking up at a canvas, which is propped on an easel. Standing in the artist's studio surrounded by paintings, tubes of colour and brushes, the chief inspector remarks with polite incomprehension and staggering understatement, *'Vous faites de la peinture!'* ('You paint!')

Joseph d'Ornano in the Yellow House on 24 December 1888
from Gauguin's Arles sketchbook

Yet Joseph d'Ornano was far from the country bumpkin mocked by Gauguin in these sketches. He had a reputation for being good, honest and unfailingly fair – qualities that would be manifest in the ensuing months. This Corsican chief of police would prove to be an invaluable ally to Van Gogh, long after Gauguin had abandoned him.

These drawings reveal more than just a commentary on the scene at the Yellow House on that Christmas Eve morning. There is one

rather eccentric detail that makes them infinitely more intriguing. In
the first picture the chief inspector is peering at the figure of a turkey
by his feet. Seemingly an afterthought, the turkey creeps into the left
of the drawing, only half of it fitting onto the page. In France, turkey
is not traditionally eaten at Christmas, so this was no seasonal reference.
The French word for a small turkey, '*dindon*', is slang for someone stupid
or clueless. There is also the expression '*dindon de la farce*', which means
'the joke is on me' or 'I'm the butt of the joke'. Exactly what Gauguin
meant by including the turkey is open to conjecture: is the inclusion of
the bird simply another attempt to ridicule the inspector or, more
pointedly, a comment on what Gauguin felt about the crazy situation
in which he found himself in December 1888? Many years later Gauguin
was sufficiently haunted by the drama in Arles to reuse the policeman
and the turkey from these sketches in his work – they pop up on some
menu cards that he painted in Tahiti in the late 1890s. Under the turkey,
the text reads, '*Je souis le commissaire de Police. Amusez-vous. Mais pas de
bêtises*' ('I am the chief of police. Have fun. But don't misbehave').[20] At
more or less the same time Gauguin created a magazine called *Le Sourire*.
For the cover of the December 1899 issue, he again used the turkey and
this time directly associated it with the expression '*dindon de la farce*'.
At the bottom of the woodcut of a beatific turkey Gauguin wrote
intriguingly, 'He who laughs last, laughs longest.'

But was Gauguin really making light of something that had obvi-
ously shaken him to the core? One of the first things he did on his
return to Paris was to go and watch a man being guillotined. Paul
Gauguin left a haunting clue as to the impact of what he had witnessed
during the last few days of 1888. Early in 1889 he made an earthenware
jug – as remarkable for its depth of colour as for its bizarre subject
matter. It shows the head of a man with blood randomly over his
face. With its closed eyes, it could be a death-mask, yet this is a
self-portrait of Gauguin, and amongst the bloody rivulets running
down the face it is barely noticeable that the head has no ears.

CHAPTER 14

Unlocking the Events

The drama of the ear is the best known story about Van Gogh, but it is rife with contradiction. All the keepers of the Van Gogh flame had some sort of investment in his legacy, and their accounts are never entirely dispassionate. I started this project with what seemed a simple question: what exactly did Van Gogh do on the night of 23 December 1888? Van Gogh never mentions the incident directly, but the local newspaper, Paul Gauguin, Theo and later the Impressionist painter Paul Signac all confirm that Vincent injured his ear, though none of these accounts tally concerning exactly what he did. Did he cut off the lobe, part of the ear or the full ear? It seems to me that there is a world of difference between cutting off your earlobe and cutting off your whole ear. Cutting off the lobe could be interpreted as an accidental slip of the hand – crucially, it could be seen as unintentional. If he cut off the whole ear, it was clearly not an accident and speaks volumes about Van Gogh's state of mind. The 'whole ear' theory is certainly the account most favoured by the general public, as it is the more dramatic and better fits the popular image of Van Gogh as 'the artist who went mad'. It also suggests that Vincent was creating his greatest art while he was losing his mind.

In the aftermath of his breakdown, Vincent did provide some details concerning the extent of the injury. By early January 1889 he had returned from hospital to pick up the threads of his life, writing to Theo from the Yellow House for the first time in two weeks: 'I hope that I've just had a simple artist's bout of craziness and then a lot of fever following a very considerable loss of blood, as an artery was severed.' Many years ago I accidentally punctured an artery in my

hand while cooking. The violent force of blood spraying everywhere, even reaching the ceiling, was shocking. As I was driven to hospital, I remember being fascinated by the rather agreeable warmth as the blood spurted into my hand each time my heart took a beat. I had cut only a small auxiliary artery and needed a couple of stitches. So I can only imagine what it must have taken for Vincent to staunch the flow of blood on 23 December.

The ear is full of tiny blood vessels that make it one of the most sensitive organs in the body. The main artery that feeds these vessels lies just above the ear. If Vincent had hit an artery, he must have cut the top part of his ear. In which case he suffered serious blood-loss. When the police arrived the next morning, the Yellow House would have had puddles of congealed blood still on the floor. This may explain the high cost of putting the house back in order; Vincent told Theo in mid-January 1889 that the expenses 'for having all the bedding, bloodstained linen etc. laundered' was 12 francs 50 centimes, which was more than half a month's rent.[1] This lends credence to the 'whole ear' story, but the issues in question do not stop here.

One source of unimpeachable and trustworthy evidence is hospital records. Yet none remain – none that document the various times Van Gogh spent in Arles hospital in 1888 and 1889; none that record the extent of his injuries, or how they were treated. The hospital in Arles moved to a new building in the 1970s and many old records were lost. To my great frustration; the only archival material that remains from Arles hospital in 1888–9 is the four sheets of paper listing the patients who had venereal disease. Because the ear-incident came to the attention of the police, there should also have been a record of it in the police files, but again I found nothing.

Still, there are some things we do know for certain. The first and the easiest question to answer is which ear Van Gogh mutilated. It may seem a small point, but such is the confusion surrounding his story that even on this point there has been dissent. His two self-portraits with bandaged ear, executed early in 1889, are the best known evidence of the incident. At first glance it appears that there is a bandage over the right side of his head, which early on led many to conclude that he had cut his right ear. However, self-portraits are done

while looking in the mirror, so clearly it was his left ear that he had wounded.[2]

In 2009 a new theory about Van Gogh's ear flashed round the world's media from two German academics, Hans Kauffmann and Rita Wildegans. They suggested that Paul Gauguin had sliced off Vincent's ear with a sword and that both men had made a pact of silence about the incident.[3] Gauguin was a keen amateur fencer and had brought his equipment with him to Arles (writing to Vincent after he'd left for Paris, 'at the next opportunity if you can send me by parcel post my 2 fencing masks and gloves, which I left on the shelf in the little upstairs room').[4] There are a number of problems with this theory. There is no clear indication of what type of sword (if any) Gauguin had with him – a foil, sabre or épée, only two of which would be able to slice through flesh. Since there was no other injury on Van Gogh's body, Gauguin would have had to attack Vincent with Zorro-like precision. And if Gauguin had been responsible for cutting off Vincent's ear, why on earth would Vincent agree to make a pact of silence about it?

It is generally accepted by most writers that Vincent used a razor, as claimed by Gauguin, yet one key correspondent seems to contradict this. In all things Theo van Gogh is the voice of reason, and his correspondence before and after the incident is almost always reliable. Yet in a letter to his fiancée he says that Vincent used a knife. The original letter was written in Dutch and, since I cannot speak a word of Dutch, I consulted the researchers I had got to know at the Van Gogh Museum in Amsterdam. Happily, Teio Meedendorp answered my query about the inconsistency Theo's letter raised about the implement:

In Dutch a cut-throat razor is called a 'scheermes' (lit.: razor knife, 'scheer mes'). In the days of old when the safety razor did not yet exist, cutting your beard was generally referred to as cutting it with the 'mes', by which the cut-throat type was meant. So when Theo refers to 'een mes' (a knife) with which his brother wounded himself, he could have referred to both the cut-throat razor and a 'regular' knife, the first one being more likely of course.[5]

A doctor friend of mine told me that cutting through an ear with a cut-throat razor would have been like slicing through butter. The ease with which Van Gogh could commit such a brutal act makes me wince.

The confusion as to how much of his ear Vincent actually cut off began during his lifetime. At first it didn't occur to me that the difference of opinion might also have a geographical subtext. As I began to reflect on who said what, I realised that the 'lobe' idea more often came from the north of Europe and the 'whole ear' idea from the south.

The people of the south of France are famous for exaggerating. In the pretty sing-song accent of Provence, many tall tales are told: 'The fish I caught last week was bigger than a car' or 'The mistral blew over my mother.' The most ridiculous but oft-repeated joke is that 'A sardine blocked the port of Marseille'. This story is actually true, but what's not explained is that the *Sardine* in question was a ship that got stuck in the harbour. Compensating for this Provençal propensity to exaggerate, writers on Van Gogh have tended to play down the incident. Van Gogh historian Marc Edo Tralbaut wrote dismissively in 1969 that 'The tendency to exaggerate associated with the people of the South should always be taken into account. In fact, it was only a lobe and Gauguin also made the same error when he wrote that he cut off his ear.'[6]

Yet the accounts from Arles tell a different story. During the 1920s and '30s anecdotes about Vincent were legion: he chased after women, was always drunk on absinthe, was known as the mad redhead.[7] Myth and gossip, together with false anecdotes, have grossly deformed Van Gogh's time in the city.[8] No historian would be blamed for treating the Provençal account of events with caution.

Still, it's hard to argue with evidence that comes from first-hand accounts and witnesses to the events. Gauguin, who was present before and after the incident, maintained that Van Gogh cut off his whole ear. The only independent account – the local newspaper in Arles – recorded that Vincent 'handed' his ear to the prostitute Rachel. Later, this was confirmed by Alphonse Robert, the policeman who was summoned to the brothel that night, who recalled that the girl, 'in

the presence of her boss . . . handed me a newspaper containing an ear, telling me this is what the painter gave her as a present. I questioned them a little, remembered the package and I found that it contained a whole ear.'[9] In theory this account should be foolproof: it came from the policeman who attended the scene and who actually saw the ear itself, but again it was written three decades after the event, and memory is unreliable.

Alphonse Robert's account was published in an article on the drama of the ear, written by two psychiatrists, Dr Edgar Leroy and Dr Victor Doiteau in 1936. At the time Dr Leroy was running the rest home in Saint-Rémy where Van Gogh had spent the last full year of his life. Despite Robert's testimony, the two doctors concluded that Vincent had cut off only part of the ear, including the lobe. To illustrate their argument they included an anatomical drawing with an arrow drawn through the ear.[10]

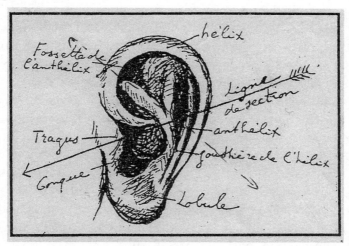

Illustration of Vincent's ear from the article by Edgar Leroy and Victor Doiteau, 1936

To slice across and down, alongside the face, is almost impossible. I tried to re-create the movement and couldn't, without twisting myself in knots; I wasn't in a frenzy of mania, it is true, but such a slice seemed to require precision, not passion. I contacted Dr Leroy's son and over lunch asked him about his father's article. 'My father got

one of his students to do the drawing,' he told me. 'I never thought it was meant to be an exact illustration of what Van Gogh did.'[11] But why include such a precise drawing? The story gets stranger still. Although the article concluded that Vincent cut off only part of the ear, Dr Leroy claimed something different in a personal letter to Irving Stone, whom he had met on Stone's trip to Provence in 1930 to research the book that would become *Lust for Life*.[12] After Stone returned to New York, the two men corresponded. Explaining that he was preparing an article on Van Gogh with Victor Doiteau, Leroy wrote, 'we state that Vincent cut off the whole ear'.[13] So why did he change his mind when he published his article some six years later? I wondered whether pressure had been put on the two doctors to modify their version of the facts, or whether there was another reason to reject the account told to them in Provence. Had they been encouraged to change their copy and, if so, by whom? This is when the Van Gogh family enters the story.

We have Jo, Theo's young wife, to thank for Van Gogh's legacy, for preserving his work and his correspondence. We may also have her to thank for unwittingly creating confusion as to how badly Van Gogh mutilated his ear that night. A confusion that has lasted more than a century. Through Theo, Jo was privy to all the details of Vincent's illness after his breakdown and must have known exactly what Vincent had done. Moreover, she had met Vincent in Paris when he stayed in her apartment on his way to Auvers for three days in May 1890, and again a few weeks later when the family went to visit him there.[14] In 1914 Jo wrote in her introduction to Vincent's letters what Dr van Tilborgh had told me: that only 'a piece of the ear' was cut off.[15]

Another person who knew in detail about Van Gogh's injury was a man who met the artist just seven weeks before his death. Dr Paul Gachet of Auvers-sur-Oise considered himself an artist. He specialised in engraving and taught Van Gogh what little he knew of the technique. He even drew a sketch of Vincent on his deathbed, which he dedicated to Theo van Gogh. There are three versions of this drawing, of which the first (seen in Chapter 3) was given to Theo as a souvenir for his mother.[16] This sketch was done in haste in a very hot room within hours of Vincent's death, and although simply an outline, it

does seem to support the idea that most of the ear remained. Yet on closer inspection the rough lines that show the ear could just as well be part of a pillow. Gachet further confused the issue when he produced an etching, after his own deathbed drawing, showing most of the upper ear intact.

Branding themselves experts on all things Van Gogh, the Gachet family certainly had a lot more to do with Vincent after his death than they ever did in his lifetime. Paul Gachet *fils* was regularly interviewed by Van Gogh scholars after his father died in 1909. Just seventeen when Vincent had lived in Auvers, he was a controversial figure who flagrantly exploited his contact with Van Gogh, no matter how tenuous it was.[17] When questioned in 1922 about the painter's injury, he maintained, 'It wasn't the whole ear and if I recall correctly, it was a <u>good part</u> of the outer ear (more than the lobe) (An ambiguous reply, you'll say.)'[18] Later he augmented this: 'The mutilation could be seen on the left side only – and could not be seen face-on. It wasn't even noticed by people older than me who saw Vincent in Auvers!'[19] Perhaps this is the only quote from Gachet *fils* that is truly significant: that Vincent's injury was not particularly noticeable.

Through all this fog of opinion it is hard to know what to believe. Each account comes laden with reasons to trust and reasons to doubt. The most widely accepted version of how Vincent wounded himself comes from the artist Paul Signac, who was unimpeachable as a witness. He had spent time with Van Gogh shortly after the incident and was, crucially, not personally invested in the incident. Everyone else – Gauguin, Jo van Gogh, even the Gachets – had something to gain or lose from Van Gogh's legacy. Signac stated unequivocally that Vincent 'cut off the lobe (and not the whole ear)',[20] despite contradictory evidence from policeman Robert, Paul Gauguin and the local newspaper. Yet, Signac became recognised as the acceptable source of what Vincent did that night; and thanks to Signac, and Jo's ambiguous remark, the official line from the Van Gogh Museum is that Vincent cut off the lower part of the ear. As I weighed each account, I began to think that the question of what Vincent had done that night might never be successfully resolved.

★ ★ ★

After my first trip to Amsterdam, while filing the photocopies I had taken there, I noticed something that sparked my interest. It was a single line in a letter from 1955 and it set me on a trail to a library in the United States.[21] In early 2010 I again emailed archivist David Kessler at the Bancroft Library at the University of California – that housed Irving Stone's papers:

[21 January 2010: 9.37 a.m., France; 00.37 a.m., USA]
Dear David,

I corresponded with you late last year concerning my research project on Van Gogh. After working in Amsterdam, I came across a reference in a letter written by *Time Life* concerning Mr Stone's papers that interests me greatly. I am looking for copies of any correspondence (in French) between Mr Stone and Dr Félix Rey of Arles.

There is mention of a drawing done for Stone by Dr Rey of Van Gogh's ear on a prescription form. I imagine it would be on headed paper, with his address (he lived at rue de Rampe but I imagine his office was elsewhere) and a signature. Do you have ANYTHING that looks like this? I am desperate to get hold of it.

I would be most grateful for any help you can give me,
Bernadette

Dr Félix Rey was a young doctor in Arles and the first person to treat Van Gogh when he arrived at the hospital on 24 December 1888. The likelihood of Stone having kept the drawing, given how rigorous he had been in discarding his other material, was slim. But the possibility was too exciting to disregard. I couldn't quite believe that there might perhaps be – tucked away in an archive in California – a drawing of exactly what lay under that bandage.

David's reply came promptly:

[8.14 a.m., USA; 5.14 p.m., France]
You will remember that the last time you inquired I made a thorough search of the relevant boxes (91–92) for research

material concerning Van Gogh. I found almost nothing . . . very little remains of Mr Stone's research material . . . except for his card file notes and research correspondence. I will retrieve the two boxes from offsite storage again and have another look.

Not being in California, and able to look through the documents myself, was maddening. I knew that Stone had the document as late as 1955, the year of the *Time Life* piece and twenty-five years after he'd met Dr Rey. He died in 1989; I only hoped he'd kept it that long. We corresponded several times that day and David asked me if I had any ideas about where in the collection it might be so I checked the library index online and wrote to him with my thoughts. That evening after asking him if he would mind going through the material one last time, I had an email from David:

[11.01 a.m., USA; 8.01 p.m., France]
Having looked at a lot of the family stuff over the years, I find it pretty inconceivable that the material would be there. It is very specifically personal stuff, involving family. I see no folder in these seven boxes that would seem to be an obvious place to look. I particularly notice the painful detail that has been lavished upon this collection, down to minutiae about individual items. It's hard for me to believe that something as startling and pointed as the drawing you want would be buried unnoticed and passed over in a miscellany . . . I think it probable that the clippings in box 531 are just that, but it won't hurt to have a look!
David

That night I barely slept.

[22 January 2010: 9.12 a.m., USA; 6.12 p.m., France]
Vous n'allez pas le croire, mais j'ai trouvé le dessin que vous cherchez!!![22] Isn't that something. It was the 3rd document in the 1st folder in the box, which certainly saved me time as I had

resolved to go through it document by document. The address (you describe the document well without seeing it) printed at the top is Docteur Rey Félix, 6, Rampe du Pont, Arles-sur-Rhône, and it's dated 18 août 1930. :-)

David

I wired the library payment for a scan of the document and then had to wait for a few days until it could be processed and sent to me. When I received it early one morning via email, I started to shake.

It was extraordinary, incredible and wonderful . . . I began to walk circles around the room. From the beginning I had given my project the working title 'Van Gogh's Ear' and resolved to find out what lay under his bandage, but I hadn't imagined finding anything that actually answered my question and embodied my project so perfectly. It was uncanny. The prescription form was signed and dated by the very doctor who had dressed the wound. This document was not conjecture, but tangible proof; it explained not only *what* Vincent had done, but *how*. As I paced around my living room on that cold winter morning, I could not believe that I had found new information about Vincent van Gogh.

Tangible proof or not, I needed to confirm its authenticity before I got too carried away. I found the signature of Dr Rey on one of the photos I had taken in the archives and compared it to the one on the prescription form. They were identical.

Signature of Dr Rey, 1930 Signature of Dr Rey, 1912

I wanted to check one more instance, but there was no marriage certificate online or any record of Dr Rey's children's births. I found him on the electoral register and in a trade directory, so at least I could verify his address. The prescription form gave his office as '6, Rampe du Pont'.[23] The archive sources confirmed this. But there was

still the issue of timing. It was dated 18 August 1930; Irving Stone had met Dr Rey some forty years after he had treated Vincent van Gogh. In my family we often disagree about an event just a few years in the past and have different memories of how something played out; I was worried that the doctor's recollection of the wound might have been distorted. Unless I could prove beyond any doubt that Rey had recalled Vincent's injury correctly, my document was worthless. I needed to do further research to prove the document was an accurate record of what had taken place on 23 December 1888.

After pacing around the house for most of the morning, I telephoned a few trustworthy friends for advice. I finally decided I needed to talk to an expert, so I called Louis van Tilborgh from the Van Gogh Museum. I pleaded with him not to tell to anyone about what I was going to tell him. Louis was polite, but wary. I learned later that the Museum is contacted several times a day about new 'paintings' and 'major discoveries', so his reaction was perfectly understandable. In retrospect, Louis was amazing; he listened to me patiently and with great respect as I described my find. After a lot of questions, a long discussion and the promise to keep it under wraps, I emailed him a scan of my precious document. He called back within minutes and we discussed the implications of the prescription form which lays to rest a discussion that has been going on for more than a century.

In August 1930 the American novelist Irving Stone went to see Dr Félix Rey at his surgery, at 6, rue Rampe du Pont in Arles. Born Irving Tannenbaum in 1903 (he later adopted his stepfather's surname), Stone was a great believer that education was the only way to succeed in life. After getting a degree he married a fellow student from Berkeley and, thanks to a generous gift from his wealthy father-in-law, travelled to Europe. In the summer of 1930 he was in Provence with his wife, who suggested the title for a book he was researching at the time: *Lust for Life*. Initially rejected by seventeen publishers, the novel made Stone's reputation when it came out in 1934.

In 1930 Dr Rey still worked at the hospital in Arles, which was in the same rundown building that Vincent had known in 1888. He was no longer the fresh-faced intern who had met Van Gogh, but was now

a sixty-five-year-old doctor on the verge of retiring. He worked for a few hours each month at the hospital, and ran his private practice from the sprawling family home at 6, rue Rampe du Pont. This was where Irving Stone went to meet him on 18 August 1930.

After Vincent had died, other writers went to Arles on the trail of Van Gogh, a number of whom had spoken to Dr Rey. Many of these early writers, such as Julius Meier-Graefe and Gustave Coquiot, had kept notes of their meeting with the doctor.[24] Stone went one better: he asked Dr Rey if he would kindly draw an illustration of Vincent's injury. Dr Rey tore off a page from his prescription pad and, using a black ink pen and in the manner of a doctor, hastily drew two diagrams of Vincent van Gogh's ear, both before and after the injury. He added a note at the bottom of the page:

> I'm happy to be able to give you the information you have requested concerning my unfortunate friend Van Gogh. I sincerely hope that you won't fail to glorify the genius of this remarkable painter, as he deserves,
> Cordially yours,
> Dr Rey.[25]

It seems strange that a small piece of paper found in the bowels of a Californian archive could change the direction of my life. It is hard to look back and think about the time before I found the drawing, and how different my world is now. My adventure had started with a simple question: what exactly lay under the bandage? I never imagined I'd actually be able to answer it so conclusively. Yet my investigation was by no means at an end. I needed to find further contemporary proof of Vincent's injury. If I were to understand fully the circumstances that had brought Vincent to this crisis and why Signac, Gachet and the Van Gogh family had all emphatically maintained that he cut off only part of the ear, I needed to continue my research: how had the story gone so awry?

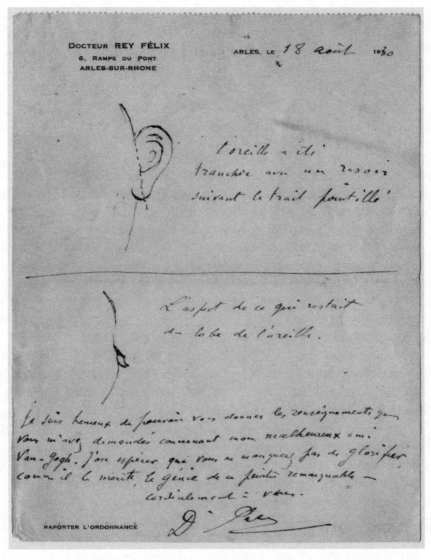

Vincent van Gogh's ear, drawn by Dr Félix Rey for Irving Stone, 18 August 1930.
The annotation on the first drawing reads: 'The ear was sliced with a razor
following the dotted line.' On the second drawing it reads: 'The ear showing what
remained of the lobe.'

CHAPTER 15

Aftermath

On 24 December 1888 a horse-drawn carriage had driven up to the austere wall of the Hôtel-Dieu in Arles. The large metal gate was opened and the patient was taken directly to the first door on the right to see the intern on duty that day, twenty-three-year-old local doctor, Dr Félix Rey. This was to be his first Christmas as a junior doctor, having taken up his appointment at the Hôtel-Dieu on 1 February 1888.[1] The intern lived at the hospital and was the only doctor on duty that Christmas Eve. His job was to look after the patients on a day-to-day basis, reporting to the Head of Medicine, who was expected to put in an appearance only for an hour each day. Medical care in the nineteenth century was rudimentary, and rural hospitals in particular did not have the best reputation. Yet luckily for Vincent, Félix Rey was a skilled physician who was interested in employing the most up-to-date treatments available.

The young doctor's office was on the ground floor of the hospital and opened onto the garden, with large, sunny windows that faced due south. The office led into a small treatment room, which by modern standards was fairly basic. Although the walls were tiled and easy to wipe down, a large open gulley ran across the floor, carrying sewage into the drains. It was also by no means private: members of staff would constantly drop in to consult patients' charts, which hung on numbered hooks on the wall.[2] On Christmas Eve morning, Vincent was taken directly to the treatment room and Dr Rey was confronted by a patient who was barely conscious and had to be helped onto the examining table. His clothes were heavily stained with blood and a torn strip of cloth was wound tightly round his head.

That morning ten-year-old Louis Rey, the doctor's younger brother, woke up excited. It was Christmas Eve, and not only did he have a day off school, but it was also his birthday.[3] His school was round the corner from the hospital, and since Félix had started working there in February, Louis regularly visited him, once classes were finished for the day.[4] Everyone at the hospital knew him; already fascinated by medicine – he would later become a doctor himself – Louis liked to observe his brother while he worked. On Christmas Eve, he popped into the hospital as usual and found Félix in the treatment room with the wounded Van Gogh. Louis Rey's strange encounter with the artist that morning would leave a strong impression, and more than fifty years later he reported his memories to a German journalist. It is hard not to trust his account, since it contained details that could only come from a witness to the scene.

> He wore a dirty cloth around his head like peasants do when they have toothache. My brother was on the point of carefully untying the rag. When I also noticed that the cloth on one side of the head was drenched with blood . . . I watched with interest, and saw to my horror that the patient was missing an ear. The organ had been separated from the head with a single, clean incision. Using hydrogen peroxide, my brother Félix carefully loosened the primitive bandage that because of dried blood had stuck to the injured man's cheek.[5]

The 'gift' that Vincent had taken to 'Rachel' had been sent with him to the hospital. Dr Rey's first challenge was to decide whether to sew Van Gogh's ear back on. It soon became clear that due to sclerosis – the flesh had withered and hardened since the night before – that would be impossible.[6] The best he could do at this stage was stem the bleeding and dress the patient's wound. Louis Rey remembered, 'My brother brought the bleeding to a halt and disinfected the wound. Then he put on a clean bandage around his head.'[7]

A few years earlier Van Gogh's injury would have been life-threatening. The only way to clean a wound was by rinsing it with water, but in Arles the hospital water supply came directly from the

rather polluted Rhône. The other possible solution was cauterisation of the wound, through the application of a hot poker – a practice that was still used for rabies bites in 1888. It was a brutal and imprecise method, though, as a large patch of surrounding skin would also be burned, and was considered unwise for facial injuries.

Generally wounds were sewn up using unsterilised catgut and, despite the risk of infection, smaller injuries were left to dry in the open air, because any covering placed over a wound would stick to the scab as it began to heal, making it impossible to remove it without pain. Luckily Vincent van Gogh found himself in the right place at the right time.

The recently graduated Dr Rey not only had the benefit of recent advances in medical training and technique, but was also keen to make his mark in his new post. The treatment he applied to Van Gogh's ear was a relatively new discovery for large wounds: an antiseptic cloth called a 'Lister' or oil-silk dressing, which would prevent a wound from getting an infection as it healed.[8] It had to be freshly prepared to be effective, and Félix Rey would have made it up himself or supervised the dispensary. After cleaning the wound, Dr Rey applied the dressing to what little remained of Vincent's ear. The dressing consisted of a very fine piece of silk taffeta soaked in oil and a weak carbolic-acid solution. Several layers of lint were applied on top of this first layer to pad the wound. The carbolic acid (nowadays called phenol) served as the antiseptic. The oil helped to keep the wound moist and enabled the dressing to be removed with ease and with the least distress to the patient. The dressing was changed every five to six days, though the oil had to be topped up regularly to prevent it drying out – every few hours for the first few days, and twice a day after that. After the initial treatment, Van Gogh was sent to a large open ward for men on the floor immediately above Dr Rey's office.

Whilst Vincent was lying in a hospital bed, recovering from the loss of so much blood, Arles was in crisis mode. After Christmas it began to rain again and did not stop. In just two days the city saw 203 centimetres (80 inches) of rainfall; four times the December average.[9] Arles had experienced the equivalent of five months' rain during the last

ten days of the month. The low-lying farmland was unable to absorb the deluge and the streets were awash, forcing many people out of their homes.

On the front page of a local paper, *L'Etoile du Midi*, on 6 January 1888 there was a short article explaining why it hadn't brought out an edition the week before: 'The recent rains led to severe damage at our printworks and we had to suspend all typographical work.' I had always wondered why the article in *Le Forum Républicain*, published the week after events, was the only press report of 23 December to have come down through history. The answer to this mystery was simple: flooding. In the face of such devastation, Vincent's dramatic story was insignificant.

Luckily, the passing mention of the existence of another article in Martin Bailey's work set me on the right course in my search. Meanwhile I resolved to track down the missing longer piece on the story that had been published in the paper in late December 1888, a few days after Vincent was whisked off to hospital. If I could find the original, longer article, then I hoped I would be able to locate another independent account of the drama.

It wasn't an easy task. I made a list of every newspaper published in 1888. Although nowadays archives keep copies of daily newspapers, scanned and carefully preserved, this was a bit of a hit-and-miss affair, even until the 1980s. Newspapers came to libraries and archives often as donations – not necessarily comprehensive. Sometimes the fragile paper they were printed on meant that I was unable to consult them. Or I'd find a copy of a newspaper for every day in 1888, but none for the last week of December. I made lots of phone calls and sent hundreds of emails. After months of fruitless searching, I learned a valuable lesson: always go back to the source.

I contacted the Royal Library in Belgium that held the original cutting, which had been found in a letter to Vincent's painter friend, Eugène Boch. The library kindly sent me a copy. On the cutting – slightly longer than the image Martin Bailey had published, there was a fragment of another story, a report about a farmer who had shot himself that week in Arles.[10] A quick check of the registers and I had the date of his death. I could now look for newspapers dated after his

suicide, which thankfully narrowed the search a little. The second piece of luck was the heading of the follow-up article. Arles is in a *département* of France called the Bouches-du-Rhône. This article obviously came from a newspaper that had regional news, as the typographer, limited by space in the column, had contracted the name to 'Bouch-du-Rhône'. If I could find a newspaper that used this contraction, I might perhaps find the source of the article.

There was a surprising consequence to this laborious hunt. While I was looking for this one particular article, I came across a number of new press sources that had published the story. To date, I've found five press articles.[11] The story of Vincent and his ear was covered far beyond Arles, reaching the regional and national press. Most of the jounalists tell the same story – a Dutch (or Polish) painter took his ear to a girl at a brothel, telling her to 'take care of this for me'. Each new article provided me with valuable independent information and helped me build a clearer picture of what happened that night.

There was also something surprisingly touching about reading the story that I had studied in such depth, as it was being told to newspaper readers in 1888. I imagined friends of Van Gogh and Gauguin hearing about the drama in Paris and beyond, and the gossip that would have ensued. Nevertheless, after trying more than fifty newspaper archives, the name of the newspaper that published Martin Bailey's cutting still eluded me.

Finally, I located Bailey's extract in *Le Petit Méridional* of 29 December 1888. It was a victory, no matter how small. The journalist who covered the story, Josuë Milhaud, also worked for another regional newspaper, *Le Petit Marseillais*, which also published the story – and I imagine the text varied little between the two articles.[12] Interestingly, this is the only other newspaper to mention the girl by name:

25 December 1888
Severed ear – Yesterday, V., a painter, went to a house of ill repute, asking to see someone called Rachel and gave her one of his ears that he was holding in place with his hand, but he had previously detached using a razor . . . [which] can only be seen as an act of madness.[13]

Despite the flooding in Arles, within hours of Vincent being found in the Yellow House by Joseph d'Ornano, the press was already onto the story.[14] One of the first newspaper accounts, *Le Petit Provençal* on Christmas Day, provided some new information:

Arles 24 December: Yesterday, a painter called Vincent, born in Poland, went to an establishment of ill repute and asked to speak to one of the girls. She came to the door and Vincent gave her a packet and asking her to look after it, ran off. The woman unwrapped the packet and with great surprise saw an ear, which belonged to none other than Vincent who had cut it off with a razor. The police went to the home of this individual today: they found him, lying on his bed, soaked in blood and apparently dying. The razor that he had used was found on the kitchen table.[15]

The details of exactly where the razor was found were significant. When Vincent was discovered by the police, showing 'no sign of life' in his own bed, it was easy to assume that he had taken the razor to his ear in his bedroom. Yet this article implied that Van Gogh had cut off his ear downstairs in the studio of the Yellow House. He must have sat in front of the very same mirror he used for his self-portraits, taken a razor in his hand, pulled his ear down and sliced it off. As I thought about Vincent's very deliberate act of mutilation, staring at himself as he began to cut, I found myself unconsciously putting my hand over my left ear as if to protect it. What state of mind must a person be in, to do something so drastic?

If Vincent had cut himself in the kitchen, it explained why Gauguin maintained that the ground floor was in such disarray when he got back the following morning, and why there were deep red splash-marks on the stairs. Despite the small error of Vincent's nationality, the article's details (painter, cut-throat razor) tallied with Gauguin's account. Better still, the articles seemed to prove that, even forty years after the event, Dr Rey had remembered everything correctly.

But there was still the issue of Paul Signac's version, a story that had been considered reliable evidence for the last hundred years. A

clue came from reading what Vincent himself had said about his ear. In a letter of late January 1889, he wrote that if he were to travel (to the tropics to paint), then he would need to make a fake ear – 'personally I'm too old and (especially if I get myself a papier-mâché ear) too jerry-built to go there'.[16] With a lesser injury, he would have no need for a papier-mâché ear. He went to great lengths to hide his wound, purchasing a hat immediately after he left hospital, probably the one seen in his *Self-Portrait with Bandaged Ear* and *Self-Portrait with Bandaged Ear and Pipe*.[17] At Auvers in 1889 the innkeeper's daughter recalled, 'For headgear, he wore a felt hat with large flaps . . . one shoulder slightly leaning on the side of his wounded ear.'[18] It was not far-fetched to assume that perhaps only medical staff ever actually saw Vincent's ear uncovered, and everyone else's account of his wound was based on what he said to them, rather than first-hand observation.

Little by little the story was becoming clearer. I returned to Paul Signac's account again and noticed a line in the latter part of the letter that I had overlooked: 'the day of my visit he was fine and the hospital intern let me take him out. He was wearing the famous band (round his head) and the fur hat.'[19] This short sentence gave me a sudden jolt of absolute clarity. It was one thing to have proof that Vincent had cut off most of his ear, but quite another to understand completely how the story had gone wrong. In his early book on Van Gogh, Coquiot had not published this part of Signac's letter, though the whole text was recorded in his notebook. Signac had never actually seen Vincent's mutilated ear uncovered. So what did he see? As ever, Vincent himself left a little clue in his own work, in a painting from April 1889. In his canvas *Ward in the Hospital in Arles* it looks as if Vincent had included himself in the painting. He is in the background reading a newspaper, wearing a straw hat under which there is a band wrapped around his head covering his ears. If it is Van Gogh, it is likely that this was how he appeared when Paul Signac visited him in Arles.

So why had Signac so explicitly stated that Vincent cut off only the lobe, and not the whole ear? Surely there could only be one source for this part of the story: Vincent van Gogh himself.

CHAPTER 16

'Come Quickly'

Theo van Gogh's Paris apartment was on the fourth floor of 54, rue Lepic, within walking distance of his office on boulevard Montmartre. It was a spacious apartment with rooms that opened onto each other over a single floor. Light flooded in from large windows and the walls were hung with his modern art collection, including many of the paintings that his brother had sent from Arles. On Sunday 23 December 1888, Theo spent the day at home with a young woman he knew from Holland, Johanna Bonger, the sister of his good friend Andries. Jo had recently joined her newly married brother in Paris.

In Amsterdam the previous year she had written in her diary: 'Friday was a very emotional day. At two o'clock in the afternoon the doorbell went: [Theo] Van Gogh from Paris.' Yet the meeting did not continue quite the way she had imagined:

> I was pleased he was coming. I pictured myself talking to him about literature and art, I gave him a warm welcome – and then suddenly he started to declare his love for me. If it happened in a novel it would sound implausible – but it actually happened; after only three encounters, he wants to spend his whole life with me . . . It is quite inconceivable . . . but, I could not say 'Yes' to something like that, could I?[1]

Although Jo had given him a definite 'no' the year before in Amsterdam, Theo was unable to forget her. Then in December 1888, whether by design on her part or by chance, she bumped into Theo in Paris. They had not seen each other since he'd proposed and much had

happened in the intervening months: thanks to his support of artists such as Monet and Gauguin, Theo was forging a reputation as a dealer of modern art in Paris. And now, far away from family constraints and conventions, their relationship rapidly blossomed.

On 21 December 1888, Theo van Gogh finished his day's work at Boussod, Valadon et Cie. and walked home through the winter gloom. Emboldened by their renewed friendship, he proposed to Jo again and this time she accepted. He wrote to her parents and his mother asking for their blessing and posted the letters that very evening. The lovers spent the weekend in each other's company as much as they could, blissfully unaware of the drama that was unfolding in Arles. If both families agreed, Jo would return to Amsterdam to prepare for the formal announcement of their engagement. They planned to marry as soon as they could, in April 1889. Being separated for even just a few hours was torment for the young couple, and in Paris they corresponded with one another, often several times a day. The letters between Theo and Jo detail a joyous love story, but also the day-by-day record of Van Gogh's breakdown as the news arrived in Paris from Arles.[2]

Sunday 23 December was the first full day the young couple had had any time alone to discuss their future life together since Jo had accepted. She was overwhelmed by her happiness, and she wrote to Theo later from Amsterdam:

I've told our good news to a few close acquaintances. It's strange talking about it – it sounds so banal, two people getting engaged – but when other people discuss it, I think: you really have absolutely no idea of what it means to us. We had wonderful times together in those few days, did we not? What I liked most was looking at the paintings – though better still in your room. That's where I usually picture you – it was so peaceful, I felt closer to you than anywhere else.[3]

Theo's mother and his sister Wil replied, offering their congratulations; and of course, given how close he was to his brother, it is likely that Theo had already written to Vincent, though no record of

their correspondence about his marriage exists.⁴ This news was the culmination of months of longing, and it would have been hard for Theo to suppress his joy.

Monday was Christmas Eve – a particularly busy time at the gallery for Theo. Apart from advising clients on purchasing gifts of artwork, the annual accounts and stocktaking needed to be organised for the end of the year. Sometime during the morning an urgent message came for Theo at work, and later that day he wrote a desperate letter to his fiancée sharing his awful news:

> My dearest,
>
> I received sad news today, Vincent is gravely ill, I don't know what's wrong, but I shall have to go there as my presence is required . . . of course I cannot say when I'll be back; it depends on the circumstances. Go home & I shall keep you informed . . . Oh may the suffering I dread be staved off.⁵

In her introduction to the compilation of their letters, *Brief Happiness*, Jo stated that Theo heard about the crisis in Arles in a telegram from Gauguin. The telegraph service between Paris and Arles was highly efficient: telegrams could be sent from the post office on place de la République, one of Arles' main squares, and would be delivered within the hour. On 24 December 1888 the branch was operating its winter schedule and opened at 8 a.m.⁶ Yet at that hour of the morning even Gauguin was unaware of the dreadful events of the night before. In his autobiography he provided a rough timeline of Christmas Eve morning. He got up late, according to him – around 7.30 a.m. – walked across to the Yellow House, was arrested by the police, went up to see 'the body' and was duly released. Then a doctor and carriage were called, to take Vincent to hospital. Gauguin wouldn't have had time to get to the post office to send Theo a telegram until mid-morning at the earliest. Later that afternoon he sent Theo a second telegram, reassuring him that all was not lost. Theo dashed off a short note to Jo at the post office: 'I hope it is not as bad as I thought at first. He is very sick but he might still recover.'⁷

Finally, after a long day at work, Theo went to the Gare de Lyon

to catch a train south. He had a welcome surprise: Jo, who was ill
with a cold, had delayed her trip back to Amsterdam and, despite
feeling unwell, had travelled across Paris to see off her fiancé at the
station. Leaving at 9.20 p.m., Theo began the arduous journey to
the city that he had only heard about through his brother's letters – the
very same journey Vincent had taken just ten months earlier. Given
the urgency, it's likely he caught the express train number 11, which
took only first-class passengers and arrived in Arles at the earliest
possible time.[8] In the whirlwind of activity – taking emergency leave
from work, packing his bags, seeking news from Arles and relaying
news to Jo – Theo was probably protected from the full force of his
emotions. As he sat on the train that Christmas Eve, rattling through
the night, the fear and apprehension of what might greet him in Arles
must have filled his thoughts.

Theo van Gogh arrived in Arles at 1:20 p.m. on Christmas Day 1880.
Paul Gauguin most likely met him at the station. It was a sunny, crisp
winter's day – in any other circumstances, the perfect weather to see
Arles.[9]

The town was exceptionally quiet. As they walked through the city
along the banks of the Rhône, I imagine Gauguin carefully answering
Theo's questions about what had taken place little more than thirty-six
hours before. Yet despite the desperate circumstances, Paul Gauguin
and Theo van Gogh were only acquaintances, not friends. There was
the financial arrangement between them that had enabled Gauguin
to come to Arles in the first place. There was also the issue of Gauguin's
work: Theo was a dealer and Gauguin his client. It was a delicate
situation for both men.

I wonder if Gauguin ever confronted Theo about the wisdom of
supporting his own stay in Arles. It's most likely that their discussion
would have been formal and polite; despite the raw emotion on both
sides, neither man could afford to alienate the other. Did Gauguin tell
Theo exactly what had taken place between him and his brother – the
desperate conversations, the threatening scenes, the anguished mind
in turmoil?

In Paris, Theo had stature and clout, and Gauguin needed his
patronage and his approval. Here in Arles, though, Theo badly needed

Gauguin's support. He had never been to Arles, didn't know his way
around or who to consult about Vincent's situation. While Gauguin
seems the most likely person to have accompanied Theo to the hospital,
Gauguin refused to go inside with him to see the ailing Van Gogh. As
he had said to the police the day before, 'If he asks for me, tell him
that I have left for Paris. The sight of me could be fatal to him.'[10]

On 26 December at 1.04 a.m. Theo took the overnight train back
to Paris with Gauguin. For Theo, it had been an exhausting and
stressful eleven hours in Arles.[11] For Gauguin, it was the end of a
peculiarly tumultuous few months. Once he was home Theo wrote
to Jo about his trip to Paris.

He seemed to be all right for a few minutes when I was with
him, but lapsed shortly afterwards into his brooding about philos-
ophy & theology. It's sad being there, because from time to time
all his grief would well up inside & he would try to weep, but
couldn't. Poor fighter & poor, poor sufferer. Nothing can be done
to relieve his anguish now, but it is deep & hard for him to bear.
Had he just once found someone to whom he could pour his
heart out, it might never have come to this. The prospect of
losing my brother, who has meant *so* much to me & has become
so much a part of me, made me realise what a terrible emptiness
I would feel if he were no longer there . . . for the past few days
he had been showing symptoms of that most dreadful illness,
of madness . . . Will he remain insane? The doctors think it
possible, but daren't yet say for certain. It should be apparent in
a few days' time when he is rested; then we will see whether he
is lucid again.[12]

In Arles, Theo had attended to his brother who had been placed
with the other patients in the men's ward. He then had a meeting
with Dr Rey before going to see a couple of Vincent's friends: the
postman Joseph Roulin and the Protestant pastor, Reverend Salles,
who was also one of the hospital's chaplains.[13] These two men, along
with Dr Rey, would be Theo's conduit to Vincent in the long months
that he spent far away from his brother in Paris.

Reverend Frédéric Salles, Protestant Pastor of Arles, c.1890

Theo and Gauguin arrived back in Paris in the late afternoon of Wednesday 26 December.[14] That same day at the hospital in Arles, Vincent had a visit from Joseph Roulin, who had promised Theo he would keep an eye on Vincent and report back. Later that evening he wrote with distressing news: 'I am sorry to say that I think he is lost. Not only is his mind affected, but he is very weak and down-hearted. He recognised me but did not show any pleasure at seeing me and did not inquire about any member of my family or anyone he knows.' Given the way Vincent had adopted the whole Roulin clan as a proxy family, this was especially alarming. He went on:

> When I left him I told him that I would come back to see him; he replied that we would meet again in heaven, and from his manner I realised that he was praying. From what the concierge told me, I think that they are taking the necessary steps to have him placed in a mental hospital.[15]

Theo immediately wrote to Dr Rey, but there appears to be no foundation to the concierge's comment that the paperwork to send Vincent to the asylum was already being prepared, although this was the standard procedure to commit a patient. Dr Rey's main concern was medical: as Vincent himself had put it, he had lost a 'very considerable amount of blood'[16] and it was vital to build up his strength before any decision about his future could be made. His mental health, which seemed deeply unclear at this stage – was he suffering from temporary trauma and exhaustion, or from a more innate delusion for which there was no respite? – was a secondary consideration.

Just before his breakdown Vincent had been painting a series of portraits of Joseph Roulin's wife Augustine, the most poignant of which he called *La Berceuse*. He chose to paint her at home.[17] Still breastfeeding, she is shown holding a rope, which she uses to gently rock the cradle of her baby daughter, Marcelle. These paintings depict an embodiment of the ideal mother that features so prominently in the Christian Christmas tradition. An obsession with religion and religious imagery, for example the Virgin Mary and the betrayal of Christ at Gethsemane, preceded – and was linked to – Vincent's mental crises. It was clearly hard for him to disassociate Augustine from this vision, and after she visited him in hospital on Thursday 27 December he had his second breakdown.

He'd begun to act erratically during her visit and, after she left, he became very agitated. Dr Rey was called immediately. Van Gogh later described what he remembered of this delirium:

and it seems that I sang then, I who can't sing on other occasions, to be precise an old wet-nurse's song while thinking of what the cradle-rocker sang as she rocked the sailors and whom I had sought in an arrangement of colours before falling ill.[18]

Later Dr Rey told Theo that Vincent had begun to deteriorate the day before her visit, on Wednesday 26 December, his behaviour becoming increasingly bizarre. Roulin updated Theo on 28 December,

the day before the hospital committee was due to meet to discuss the options for current patients:

> Today, Friday, I went to see him and wasn't able to. The intern and the nurse told me that after my wife left he had a terrible breakdown. He had a very bad night and they were forced to put him in isolation. The intern told me that the doctor was waiting a few days before deciding whether to commit him to the asylum in Aix.[19]

Vincent's strange behaviour had resulted in him being placed for the first time in an isolation cell, known as the *cabanon* or hut. This small room, of just 10 square metres (110 square feet), was outside the main hospital building and was an emergency solution for patients who were a danger to themselves or others. There was no heating and in late December 1888 the weather was bitterly cold, with torrential rain once again flooding parts of the city. Placing a patient in the *cabanon* was only ever a temporary solution until they could be sent to the asylum. Alone in the *cabanon*, Vincent was constrained with leather straps that passed through rings on the side of the metal bed, which were then firmly attached to the wall and floor.

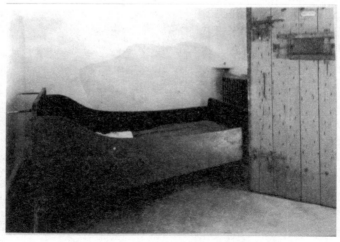

The *cabanon* at Hôtel-Dieu Saint-Esprit, Arles

Light came in through a small barred window high up on the wall
above the bed and the patients were checked from time to time, via
a small sliding hatch on the wooden door. Cold, damp, alone and
deeply fragile, Vincent was traumatised. He later spoke about the
experience: 'Where can I go that's worse than where I've already been
twice – the isolation cell.'[20] The conditions at the hospital were fairly
basic, but they were nothing compared to the truly dire conditions in
a nineteenth-century lunatic asylum.

Despite periods of lucidity after first being admitted to hospital,
Vincent's second breakdown within a few days led the doctors to
conclude that he needed specialised care and they began the official
process of interning him. If the paperwork was deemed to be in order,
the town hall would authorise transport to the regional asylum in
Aix-en-Provence, some 43 miles away. It would take a few days before
all the formalities were complete.

To the Mayor of Arles, 29 December 1888
I have the honour of addressing you the enclosed certificate from
Doctor Urpar, Chief Physician at the Hospital, stating that M.
Vincent, who on the 23rd of the month cut off his ear with a razor,
is suffering from a nervous breakdown. The care that the unfortu-
nate individual has received in our establishment has not been able
to bring him back to reason. I humbly request that you take the
necessary measures to have him admitted to a special asylum.[21]

Once his superiors had made their decision, Dr Rey wrote to Theo:

His mental state appears to have worsened since Wednesday.
The day before yesterday he went to lie down in another patient's
bed and would not leave it, despite my comments. In his night-
shirt he chased the Sister on duty and absolutely forbids anyone
at all to go near his bed. Yesterday he got up and went to wash
in the coal-box. Yesterday I was forced to have him locked up in
an isolation room. Today, my superior issued a certificate of
mental disturbance, reporting general delirium and requesting
specialised care in an asylum.[22]

Even though Dr Rey said nothing in his letter to suggest that Van Gogh's life was in danger, strangely Theo feared that Vincent was dying. He wrote to Jo about his fears:

Dearest Jo, I cannot speak my mind like this to anyone else and I thank you for it. My dear mother knows no more than that he is ill and that his mind is confused. She is not aware that his life is in danger, but if it lasts for any length of time she will find out herself.[23]

I imagine Van Gogh angry and frustrated in the tiny little cell, imprisoned like a caged animal, and Dr Rey described to Theo Vincent's reaction when he and the Reverend Salles visited him:

he told me that he wished to have as little as possible to do with me. He remembered, no doubt, that it was I who had had him locked up. I then assured him that I was his friend and that I wished to see him recovered soon. I did not hide his situation from him, and explained to him why he was in a room by himself.[24]

I wondered if Vincent was still attached to his bed by the leather straps when the two men entered the room. The paranoia and fear that Dr Rey described in his letter would be one of the recurring symptoms of Vincent's breakdown. Dr Rey continued, 'When I tried to get him to talk about the motive that drove him to cut off his ear, he replied that it was a purely personal matter.'[25]

The doctor then broached the delicate matter of what Theo wanted for Vincent: 'At present, we are treating only his ear, and no aspect of his mental state. His wound is greatly improved and is not giving us any cause for concern. A few days ago, we issued a certificate of mental disturbance.'[26] By this, Rey meant the certificate issued by Dr Delon, his superior. This was the obligatory first stage of the committal procedure. Placing someone in a psychiatric institution in France was a deliberately complex affair, to avoid any possible error. The second stage was the mayor's formal acceptance that the patient was 'suffering from mental alienation'. The paperwork to request a transfer to the

regional asylum was then started. Meanwhile the mayor would ask the police to conduct an inquiry.[27] This thorough and lengthy procedure could be stalled or delayed by any of the parties, if they felt fit. Dr Rey did make an alternative suggestion to Theo:

> Would you like to have your brother in an asylum close to Paris? Do you have resources? If so, you may very well send him to look for one; his condition easily allows him to make the journey. The matter has not progressed so far that it could not be halted, and for the chief of police to suspend his report.

Without criticising the regional asylum, Dr Rey implies that it might be better to place Van Gogh in a private institution. The last sentence, that the process could be stopped at this stage, reaffirms the notion that once Vincent was placed in an asylum he wouldn't be allowed out.[28]

Meanwhile, in Arles, anyone who hadn't already heard the story of Vincent and his ear now knew all about it, as an account of the incident appeared in the newspaper *Le Forum Républicain* on Sunday 30 December. Vincent, who was known by sight in the city, was suddenly the subject of gossip all over town, and gradually mistruths about the artist began to circulate.

On Monday 31 December the hospital committee met again. It was presided over by the Mayor of Arles, Jacques Tardieu, along with two hospital administrators, Alfred Mistral and Honoré Minaud, and Dr Albert Delon.[29] On New Year's Eve the Reverend Salles wrote to update Theo:

> I found him talking calmly and coherently. He is amazed and even indignant (which could be sufficient to start another attack) that he is kept shut up here, completely deprived of his liberty. He would like to leave the hospital and return home. 'At the moment I feel capable of taking up my work again,' he said, 'why do they keep me here like a prisoner?' . . . He would even have liked me to send you a telegram to make you come. When I left him he was very sad, and I was sorry I could do nothing to make his situation more bearable.[30]

Far away in Paris, with a wedding to plan and the gallery enjoying its busiest time of year, Theo must have felt powerless and distraught. The stress he was under is palpable in the tone of his letters to Jo. A round trip to Arles took almost three days. There was no way he could spare the time. Theo had to trust people he had met only once with the welfare of his beloved brother. Returning to live on his own in the Yellow House was no longer a feasible prospect for Vincent. There was only one place left: the asylum.

As always in a crisis, friends rallied round. In his letters to his fiancée, Theo mentions that three people had been particularly good to him: his future brother-in-law Andries Bonger was very attentive; the painter Edgar Degas came by regularly, having heard of what happened in Arles from his close friend, the dealer Alphonse Portier, who lived in the same building as Theo; and Gauguin also visited Theo, though how often is not clear, as he was staying with Schuffenecker on the other side of Paris.[31] At the very least he must have been there on the day Theo heard from Dr Rey and Joseph Roulin, as he mentioned the incident concerning the coal-box to Émile Bernard, who later relayed it to others.

On New Year's Eve, Theo heard back from his mother: 'Oh Theo, what sorrow,' she wrote:

Oh, the poor boy! I had hoped things were going well and thought he could quietly devote himself to his work! . . . Oh Theo, what will happen now, how will things turn out? From what I now hear something is missing or wrong in the little brain. Poor thing, I believe he was always ill, and what he and we have suffered are the consequences of it. Poor brother of Vincent, sweet, dearest Theo, you too have been very worried and troubled because of him, your great love, wasn't it too heavy a burden, and now you've again done what you could . . . Oh Theo, must the year end with such a disaster?[32]

CHAPTER 17

'Alone on the Sad Sea'

The Mayor of Arles and the Head of Medicine at the Hôtel-Dieu, who needed to sign Vincent's committal papers, returned to work on 2 January after the New Year's Day holiday. Although the official Certificate of Mental Disturbance was written, it was never actually signed. Nor is there any evidence of the mayor having signed the customary Order of Transfer to the asylum in Aix-en-Provence, though this, too, was drawn up.[1] These documents were put aside because the patient had made a miraculous recovery. Joseph Roulin sent a telegram and letter to Theo on 3 January 1889, declaring of Vincent, 'he's better than he was before this unfortunate incident happened' and that 'he is in a very healthy state of mind'.[2] This joyous news was confirmed by Van Gogh himself, who wrote to his brother about how much better he was feeling: 'I'll stay here at the hospital for another few days then plan to return home very calmly. Now I ask just one thing of you, not to worry, for that would cause me one worry TOO MANY.'[3]

Although he had not yet been released from hospital, on 4 January Vincent was allowed to return to the Yellow House for a short visit, for the first time since 24 December. Roulin wrote to Theo, 'he was pleased to see his pictures again, we spent four hours together, he's completely cured, it's really surprising'.[4] Roulin's letter is light and positive, but it must have been a strange experience for Van Gogh to go back to the scene of his crisis. Without Roulin there to support and comfort him, his visit to his home might have been quite different. Since the police had entered the Yellow House on Christmas Eve it had remained untouched. There was still blood-spattering on the walls,

soiled rags littering the ground floor, and upstairs Vincent's bedding was heavily stained with blood.[5]

Theo, Vincent and Dr Rey all played down the violent incident, regarding it only as a temporary moment of insanity, 'a personal matter',[6] Vincent told Dr Rey. There was never any investigation or discussion – or at least none was documented – of *why* Van Gogh cut off his ear. Today any sensible doctor would have mental-health specialists at Vincent's bedside immediately probing for reasons, but in 1888 the doctors were happy to see him recovered and delved no further. Once the initial crisis had passed, Vincent sent off a series of letters to Theo, his mother and sister, acknowledging that he had had a breakdown, yet minimising its importance. He was more concerned about the inconvenience that his illness had caused, especially to Theo: 'I am, my dear brother, so *heartbroken* by your journey, I would have wished that you'd been spared that, for all in all no harm has come to me, and it wasn't worth troubling you.'[7]

In the very first letter Vincent sent Theo after his recovery, he expressed concern about Gauguin. 'Now let's talk about our friend Gauguin, did I terrify him? In short, why doesn't he send me any news? He must have left with you . . . perhaps he'll feel more at home in Paris than here. Tell Gauguin to write to me, and that I'm still thinking of him.'[8] Van Gogh clearly still saw him as a close friend, as is evident from a letter to Gauguin in early January:

> I'm taking advantage of my first trip out of the hospital to write you a few most sincere and profound words of friendship. I have thought of you a great deal in the hospital, and even in the midst of fever and relative weakness . . . Trust that in fact no evil exists in this best of worlds, where everything is always for the best. So I want you . . . to refrain from saying bad things about our poor little yellow house until more mature reflection on either side. Please reply.[9]

It's clear from the tone of Van Gogh's letter how fragile he still feels. He wants reassurance, he wants a show of friendship, that all is not irrevocably lost after suffering such intense difficulties together.

Other than admonishing him for calling Theo to Arles, Vincent didn't have a negative word to say and quoted Voltaire – 'Trust that in fact no evil exists in this best of worlds' – as a note of hope.[10]

To his mother and sister, Vincent played down his illness still further, even implying that his hospitalisation might be a good opportunity to find new clients. 'I . . . will probably get several portraits to do.' Whether it was in desperate hope or denial, Van Gogh was trying to paint his breakdown as something so trifling that 'it wasn't worth telling you about'.[11]

On 7 January, Vincent was finally allowed to leave the Hôtel-Dieu, after spending more than two weeks there. He celebrated by going out to dinner with Joseph Roulin, who wrote to both Theo and his sister that Vincent was back home and feeling fine.[12] Vincent continued to play down the importance of the episode: 'How I regret that you were troubled for such a little thing, forgive me,' he wrote to Theo.[13] But it was impossible to move on as easily as Vincent would have liked.

Once back in the Yellow House, he was plagued by sleeplessness, and when he finally did manage to rest he was haunted by hideous nightmares. 'The most FEARSOME thing is the insomnia, and the doctor didn't talk to me about it, nor have I spoken to him about it yet. But I'm fighting it myself . . . I was very fearful of sleeping alone in the house, and I felt anxious that I wouldn't be able to sleep.' Van Gogh went on: 'My suffering . . . in the hospital was appalling, and yet in the midst of it all, though I was really low, I can tell you that strangely I kept thinking about Degas.'[14] He then asked Theo to tell Degas, who had long been a role model for Vincent, that 'he mustn't believe Gauguin if Gauguin says good things too soon about my work, which has only been done under the influence of illness'.[15]

Vincent's main concern was to get back to a normal routine – to eat, paint and sleep – but within days he had a visit that put him ill at ease; he felt it of sufficient importance to tell Theo: 'I've just been told that in my absence the owner of my house here apparently made a contract with a fellow who has a tobacco shop, to turn me out and give him, the tobacconist, the house.'[16]

Despite continually playing down his breakdown and minimising

the extent of his injury to others, Van Gogh couldn't ignore what had happened. Upon his return to his studio he completed two canvases: *Self-Portrait with Bandaged Ear and Pipe* and *Self-Portrait with Bandaged Ear* – possibly the most haunting images in his oeuvre. There is no shred of self-pity or melodrama: he looks straight out from the canvas at the viewer, unnervingly steady. Vincent was not only acknowledging in paint what he had done – his own particular way of expressing emotional experience – but he was also recording his self-harm.

I have my own reasons to interpret these self-portraits in this way. Many years ago as a young woman I had a major, life-saving operation that changed my life utterly. There was the 'before' – a carefree time in my life – and the 'after', as my existence is still dictated by the constraints of a chronic health condition. While in intensive care I secretly took a photograph of my wound, as a memento of what had taken place. I have never shown this photo to anyone; it is my own personal souvenir. I believe Vincent painted these works for the same reason: he found it necessary to bear witness to this momentous episode in his life.

These two iconic self-portraits are held in galleries in London and Switzerland, yet I was lucky enough to see both works within a few days of one another. Standing in front of these paintings and studying them carefully, in the light of finding Dr Rey's drawing, helped me understand many things about Van Gogh's injury.

Both self-portraits show Vincent wearing the same outfit: a woollen or felt hat lined with fur, which he bought soon after leaving the hospital, a white shirt and a heavy winter jacket or coat – almost certainly a shepherd's cape. This traditional Provençal shepherd's dress is fastened by one large button and would have kept Vincent warm, while giving him the necessary freedom of movement to paint.

In both self-portraits a large swab covers the whole of the left ear. It is held in place by a bandage that runs under the jaw, over the head and around the neck. By 1888 this style of bandaging was part of any young doctor's training and could be found in Sir William Watson Cheyne's book on antiseptic surgical techniques. Cheyne was a colleague and close collaborator of Joseph Lister, who had invented the oil-silk dressing that Dr Rey used on Vincent's wound.

Bandaging for a head wound, 1882

The paintings demonstrate that three to four weeks after the incident Vincent was still sporting a significant bandage, yet the bandaging differs in the two pictures. After seeing the paintings I consulted Dr Philippe Jeay, who worked for many years in the Accident and Emergency department at Marseille hospital. I thought that Vincent had perhaps been sleeping on the dressing for a few days when he painted *Self-Portrait with Bandaged Ear and Pipe* – the wadding is messy and the bandaging seems to be coming undone. Dr Jeay had a different point of view. He pointed out that the dressing is considerably bulkier in this portrait and felt it was probably executed earlier in his treatment, when Van Gogh would have needed thicker padding to soak up the blood or any suppuration from infection. In the *Self-Portrait with Bandaged Ear* in the Courtauld Institute in London, Van Gogh's bandaging is much more streamlined and fits closer to his head.

Dr Jeay told me that nowadays it would take about fifteen to twenty days for such a severe injury to heal, longer depending on the overall health and age of the patient. Vincent was young, just thirty-five years old, but had already experienced several health issues – the loss of ten teeth and venereal disease – which would have an impact on his immune system and therefore on the healing process. He had also lost a lot of blood. 'The risk of infection would be the principal danger with this type of injury,' Dr Jeay told me. Bearing in mind the insalubrious conditions at Arles' hospital in the nineteenth century, it is highly probable that Vincent did have some form of infection. In his letter to Gauguin of 4 January he mentioned that he had had a fever while at the hospital.[17] With no antibiotics available, a high temperature from infection would help to explain Vincent's insomnia and

hallucinatory nightmares. In Dr Jeay's opinion, his injury would almost certainly have taken longer to heal if it was infected, between three weeks and a month, which is the recorded length of Vincent's active treatment.

Over the last century these portraits have been the subject of much debate amongst art ctitics. It has been argued that one of them might be a fake. I was unaware of this at first, especially as the Van Gogh Museum does not doubt the authenticity of either self-portrait. However, a number of questions have been raised which have created lively discussion amongst the cognoscenti of the art world. Why would he paint himself twice with a bandaged ear? It has also been difficult to marry the extent of the injury – if Signac's lobe theory is to be believed – with the time needed to finish both portraits. In his letter to Theo on 17 January, Vincent mentioned that he had bought a hat – most likely the one seen in both paintings. But the colour of the fur trim in the two canvases seems quite different. In the *Self-Portrait with Bandaged Ear* the fur is completely black, while in the *Self-Portrait with Bandaged Ear and Pipe* it appears to be dark blue. In the portrait with the pipe he is sitting against a background of red and orange, which doesn't bear any relation to the known interior decoration of the Yellow House. In the *Self-Portrait with Bandaged Ear* he is sitting in front of a Japanese print. This detail has added weight to its authenticity, because Vincent was known to have had this print in his collection.[18] The main issue with the *Self-Portrait with Bandaged Ear and Pipe* is that it was owned at one point by Gauguin's friend Émile Schuffenecker, who reputedly created fake Van Goghs after the artist's death.

In February 1998 the fine-art journalist Geraldine Norman summarised the discussion among Van Gogh scholars concerning these two paintings in an essay about fakes for the *New York Review of Books*:

> Annet Tellegen says that the *Self-Portrait with Bandaged Ear* in the Courtauld Gallery, London, is an 'absolute fraud'. The portrait, complete with bandage is, she says, copied from a similar picture owned by the Niarchos family [*Self-Portrait with Bandaged Ear and Pipe*]. The copyist has omitted the pipe in Vincent's mouth, but

not unpursed his lips, while the studio background does not tally with the Yellow House where Vincent lived. Benoit Landais says the picture is perfectly genuine. Ronald Pickvance says he thinks it is genuine on Mondays and a fake on Tuesdays.[19]

The article provides no clear conclusion about the authenticity of one or other painting. Scientific study helps to weed out fakes and forgeries, yet only detailed analysis of the quality, age and type of paint, canvas and brushstrokes can prove this beyond doubt. Paint ages differently, depending on the life of the canvas since the artist laid down his or her brushes: heat conditions, light, humidity and dust, for example, can all discolour an artwork. Varnishing helps to protect the pigments but Van Gogh – like many late nineteenth-century painters, and especially the Impressionists – rarely used varnish as it tended to muddy the colours. Recent analysis of paint used by Van Gogh has shown that the colours on many of his canvases would have looked very different to him in 1889 from how they look to us in the twenty-first century. This is particularly significant in the case of these two self-portraits. Ageing differently, in two different locations and climatic conditions, has radically changed their appearance, but only one of these self-portraits has been subject to the full barrage of modern testing procedures. A scientific study of the *Self-Portrait with Bandaged Ear* was undertaken by the Courtauld Gallery and the Van Gogh Museum in 2009. Interestingly, it revealed that the black fur seen on the hat in the Courtauld portrait has discloured with age and in fact it was originally a deep blue, akin to that seen in the *Self-Portrait with Bandaged Ear and Pipe* in Switzerland.[20]

I have come to the conclusion that these portraits were painted at least a week apart: the first as soon as Van Gogh returned to the Yellow House, and the second just prior to his final dressing being removed. I believe the first of these works to be completed was *Self-Portrait with Bandaged Ear and Pipe*. Van Gogh looks haggard and drawn and his bandaging is bulky and thick. On 9 January, Vincent wrote to Theo, 'This morning I went to the hospital again to have my wound dressed', so he probably painted this between 7 and 8 January 1889, immediately upon his return from hospital.[21]

In the second bandaged-ear portrait Vincent is sitting close to the door that opened onto the stairwell of the Yellow House. Behind him on the wall is a copy of the Japanese print *Geishas in a Landscape* by Sato Torakiyo, which was part of Vincent's collection of Japanese art.[22] His face appears more rested and the bandage lies flat against the ear. On 17 January, Vincent mentioned to Theo that he had finished a self-portrait – likely to be this painting. According to my calculations, based on Lister's recommendation of changing the dressing every five to six days, Vincent's last visit to the hospital to have his wound checked and his dressing changed was on 13 January and the bandage was finally removed on 17 January.[23] The flatter dressing dates this painting to a week after the *Self-Portrait with Bandaged Ear and Pipe* – so on, or around, 15 January 1889. The discovery of Dr Rey's drawing conclusively shows that Van Gogh's injury was very severe, more severe than had previously been thought. This information, along with the new information concerning the treatment he received, reinforces the argument that both paintings are genuine. With those extra days needed for healing from such a serious wound, Van Gogh easily had enough time to paint the two self-portraits after he returned from hospital.[24] These self-portraits have a special resonance amongst Van Gogh's works: he is at his most intimate at the lowest moment in his life and struggling to come to terms with precisely what he had done.

Van Gogh's breakdown had more than just a heavy emotional cost; his medical treatment had not come cheap: ten francs – half a month's rent – was paid to the nurses for his treatment around the middle of January.[25] Based on this expense and Lister's recommendations, it would appear that the oil-silk dressings probably cost around two francs apiece and there were extra expenses related to his breakdown. This list, noted in a letter to Theo, makes for very sad reading. There were charges for cleaning the house, laundering blood-stained bedding and linens, buying new brushes, clothes and shoe repair. Did Vincent rip up his clothes and trash his home during his breakdown? The list would certainly imply something of this sort, and further accentuates the mayhem at the Yellow House on 23 December that Gauguin described in his notebook.

Alongside the self-portraits, there is another painting that acts as a valuable and telling piece of evidence in the aftermath of Van Gogh's breakdown. *Still Life with Drawing Board, Pipe, Onions and Sealing-Wax*, also painted in early January 1889, seemingly depicts a few random everyday objects from the Yellow House. Apart from the pipe, onions and sealing wax of its title, there is also a letter and a book on the table. The book is a medical dictionary and shows that Vincent was likely trying to come to terms with his illness. However, the most interesting detail in this painting is the envelope placed on the table. The Van Gogh Museum's *Letters* project showed that this letter bore the franking in use over the Christmas period in 1888 and was sent from a postbox close to Theo's apartment in Montmartre.[26] The fact that Vincent chose to include this letter in one of his first paintings on returning to his studio would suggest the message contained within was of some importance. In an article in 2010, Martin Bailey concluded that the envelope is almost certainly the announcement of Theo's engagement to Jo Bonger.[27] The postal service in Arles made four deliveries every single day, but only one brought mail from Paris, which was distributed after 11 a.m.[28] Theo proposed to Jo on the evening of 21 December and, even if he informed his brother straight away, it would have been too late to catch the last post for Arles. Vincent couldn't have received Theo's letter as early as the 11 a.m. post on 22 December, so he heard about his brother's forthcoming marriage on Sunday 23 December, the day of his breakdown.

Since moving to Arles and installing himself – and Gauguin – in the Yellow House, Vincent's future was bound up in his dream of an artistic brotherhood in Arles, a future entirely reliant on his brother's goodwill and financial backing. As Bailey surmised, Vincent knew that marriage for Theo meant that children would likely follow; supporting a family was much more costly than supporting a single man in Paris, and Theo would suddenly have far less disposable income to finance Vincent or other painters in Arles. Receiving this news on the very day Gauguin announced he was leaving had to have been devastating for Van Gogh. His vision of the studio of the south now seemed completely impossible. What was his future, if not this? I think these three paintings from January 1889, less than a

month after Vincent's breakdown, show a mind fervently trying to come to terms with loss.

On 17 January he wrote to Theo that he had completed three studies and a portrait of Dr Rey.[29] Vincent would probably have painted this last canvas on his final visit to have his wound dressed, probably on 13 January. Van Gogh admired the young doctor and the two men had become close. There are faint traces of decorative motifs in Dr Rey's office even today. This highly patterned background in Dr Rey's portrait is significant; it was a device he used repeatedly in portraits of people he was fond of – those of Joseph and Augustine Roulin, and Eugène Boch.[30]

Due to the severe loss of blood, Van Gogh had suffered from anaemia since his injury and Dr Rey recommended that he build up his strength by eating more regularly and avoiding stimulants. But since leaving the doctor's care, the artist had been struggling both physically and mentally. In the middle of January there was a cold snap that lasted for ten days, with snow falling on 22 January.[31] 'I'm still very weak,' he wrote to Theo, 'and I'll have difficulty in regaining my strength if the cold continues. Rey will give me some quinine wine, which I dare believe will have some effect.'[32] This letter was written two days after another letter from Vincent. 'As to answering all your questions, can you do it yourself, at the moment I don't feel up to it . . . my paintings are worthless, they cost me an extraordinary amount, it's true, perhaps sometimes even in blood and brain.' Theo must have been worried yet Vincent still tried to play down his distress: 'So this time again there's no more serious harm than a little more suffering and relative anguish. And I retain all good hope. But I feel weak and a little anxious and fearful. Which will pass, I hope, as I regain my strength . . . for the moment I myself am not yet mad.'[33]

This last comment is very revealing. Although aware that he suffered from fragile mental health, Vincent didn't *feel* mad. He had also made clear, in his remarks concerning other painters such as Mourier-Petersen and even Gauguin, that he couldn't conceive of creative expression without being close to mania. So intense was painting for him that he pushed himself to his physical and mental limits.

The end of January brought bad tidings for Van Gogh. His great

friend Joseph Roulin left Arles on Sunday 20 January to take up a new post in Marseille. This was a promotion for Roulin, but left Vincent with no close friend in Arles. Augustine and the children would remain for a short time until Joseph could sort out accommodation for his family, and in her husband's stead she kept an eye on Van Gogh. 'His transfer necessitates his separation from his family,' he wrote to Gauguin, 'and you won't be surprised that as a result the man you and I simultaneously nicknamed "the passer-by" one evening had a very heavy heart. Now so did I, witnessing that and other heartbreaking things. His voice as he sang for his child took on a strange timbre in which there was a hint of a woman rocking a cradle or a distressed wet nurse.'[34]

Vincent was always a caring man, but this hypersensitivity, especially to others, was similar to what he had experienced before his first breakdown. As long as they remained in Arles, he continued to see Augustine and the children regularly. At the end of the month he went to the local music hall to see a traditional Provençal *pastorale*, an allegorical retelling of the Christmas tale.[35] As it was a family event, it is most likely he went with the Roulins. His painting *The Dance Hall in Arles* of December 1888 depicts a music hall with bright-yellow gas lights, hordes of spectators and cramped conditions, with Augustine placed clearly in the foreground. This music hall, Les Folies Arlésiennes, was the subject of a health report by Dr Rey some years later, in which he complained about the lack of privacy in the public facilities – anyone standing on the gallery could see directly into the toilets – and the plethora of signs asking clients to refrain from using corners of the music hall as urinals.[36] I doubt that in Vincent's time it was much different. Vincent described the *pastorale* to Theo:

Naturally it depicted the birth of Christ, intermingled with the burlesque story of a family of astounded Provençal peasants. Good – what was amazing, like a Rembrandt etching – was the old peasant woman . . . with a head of flint or gun flint, false, treacherous, mad, all that could be seen previously in the play. Now that woman, in the play, brought before the mystic crib – in her quavering voice began to sing and then her voice changed,

changed from witch to angel and from the voice of an angel into the voice of a child and then the answer by another voice, this one firm and warmly vibrant, a woman's voice, behind the scenes.

He finished his letter on a note of awe: 'That was amazing, amazing. I tell you.'[37] Vincent was showing some of the same symptoms that Gauguin had recorded a month earlier: a heightened sensitivity to sound, an obsession with the image of a mother rocking a child's cradle and all forms of religious symbolism. Much as he tried to persuade others that he was back to normal, Vincent knew that his mental state was still poor. As January drew to a close, his letters to Theo were thick with remarks about madness. To Vincent, though, madness was always linked to creativity and, as such, explicable:

Just a few words to tell you that I'm getting along so-so as regards my health and work. Which I already find astonishing when I compare my state today with that of a month ago.

He continued, 'And once again, either lock me up in a madhouse straight away, I won't resist if I'm wrong, or let me work with all my strength,' though more worryingly:

As it's still winter, listen. Let me quietly continue my work, if it's that of a madman, well, too bad. Then I can't do anything about it . . . If I'm not mad the time will come when I'll send you what I've promised you from the beginning . . . From what people tell me I'm very obviously looking better; on the inside my heart is a little too full of so many diverse emotions and hopes.[38]

Clearly conscious that he wasn't yet quite right, Van Gogh suddenly remarked to Theo on 22 January that 'everyone is afraid of me'.[39] Five days later, Vincent received a most unexpected visitor: 'The chief inspector of police came yesterday to see me, in a very friendly way. He told me as he shook my hand that if ever I had need of him I could consult him as *a friend*.' Vincent still had concerns about losing

his house; a policeman friend could be an enormous help. 'I'm waiting for the moment to come to pay my month's rent to interrogate the manager or the owner face to face.'[40]

Despite the station being across the road from the Yellow House, the chief of police was a busy man, and so popping in to see someone who had recently been hospitalised was highly unusual; it's unlikely his visit was a simple courtesy, and implied that he had heard that the inhabitants of place Lamartine were corralling into action. Even the terminology Vincent employed, that the police official – a busy man – came 'as *a friend*', should have set alarm bells ringing, but Van Gogh seemed unaware of any secondary purpose to Inspector d'Ornano's visit: 'everyone here is good towards me, the neighbours &c., good and attentive as in one's native country'.[41] How strongly the sense of being a stranger in Provence still resonated. As did his fears that he wasn't entirely well: 'there are indeed still signs of the previous over-excitement in my words, but there's nothing surprising about that, since in this good Tarascon country everyone is a touch cracked'.[42]

After paying his rent at the beginning of the month, he wrote to Theo, 'I'm keeping the house for the time being, since I need to feel at home here for the sake of my mental recovery.'[43] By early February, Vincent was once again in turmoil: his neighbours were both 'afraid of him' and yet also 'kind'. His emotions were extreme and jumbled and he constantly projected his own feelings onto others.

In this utterly confused state of mind, Vincent decided it was time to pay someone a visit. 'Yesterday I went back to see the girl I went to when I went out of my mind. I was told there that things like that aren't at all surprising around here.' Was he really told this? Or is he rationalising a moment of extreme intensity into an everyday event, for his own peace of mind? He goes on, 'She had suffered from it and had fainted but had regained her composure.' Yet again he links his own troubled mind with local custom, as if to alleviate the agony of thinking he alone is unwell: 'But as to considering myself completely healthy, we shouldn't do it . . . The local people who are ill like me indeed tell me the truth. You can live to be old or young, but you'll always have moments when you lose your head.'[44]

Desperately trying to get back to work and lead a normal life,

Vincent focused entirely on his painting. Little did he know that there was a slow-building storm heading his way. Perceived as a madman by the people around place Lamartine, he was the subject of unfriendly gossip. By early February 1889, Joseph Roulin, the only person in Arles who would have been able to defend him against his critics, had left for Marseille. Salles, living across town, was unlikely even to have been aware of the talk around place Lamartine and wouldn't have had much sway over public opinion. Vincent was about to face a witch-hunt that would force him out of the city he loved so much. Vincent felt his solitude keenly, telling Theo that it seemed as if he were 'alone on the sad sea'.[45]

CHAPTER 18

Betrayal

For the first two weeks of 1889 Van Gogh made regular visits to the hospital to get his wound dressed and although he had started painting again, it was difficult to get his life back on track. He was still recuperating from the two crises of late December: the breakdown of the 23rd, followed by another on the 27th when he was recorded trying to eat coal and which led to his first traumatic experience of the isolation cell at the hospital. Occurring so soon after his first, this second and clearly distinct breakdown appears to have been overlooked by scholars.[1] Suffering from insomnia and nightmares when he did manage to sleep, Vincent was drained both physically and mentally. For the rest of January and early February and with no contact with a doctor, Van Gogh was left to cope as best he might at the Yellow House. His illness had taken its toll and Van Gogh was struggling: 'I well knew that one could break one's arms and legs before, and that then afterwards that could get better but I didn't know that one could break one's brain and that afterwards that got better too', he told Theo.[2] Only he wasn't 'better'.

Over the following six weeks from 3 February to 19 March 1889, he only managed to write three letters. For this reason, it has been a complicated task to unravel the chronology of this period – a time when Van Gogh's life in Arles changed completely. By the first days of February, Vincent began showing signs of renewed disturbance once again.[3] This was not an isolated incident. His odd behaviour was witnessed by his neighbour Madame Ginoux, as she later related to the German biographer Julius Meier-Graefe. 'She only became afraid once,' he wrote, 'in the basement, as she was hanging up laundry.':

'Suddenly Monsieur Vincent came down the steps and said nothing. And you know, when someone says nothing, that tells you something. I quietly continued to hang up the washing. He did not say much at all. When I was finished, he still stood there and looked at me with such eyes. I said: "Say something, Monsieur Vincent!" Then he suddenly pulled down the whole rope and the entire wash lay on the floor and he said nothing. I stepped back a bit and he moved toward me. I tell you, I became really afraid then. It only lasted a minute though. I made a joke and he laughed, although he still had such [strange] eyes. That was the only time. His ear was very painful. He said: "It is a good thing that I didn't cut off anyone else's ear." And he would not have done that, of course!'[4]

The strange look Madame Ginoux describes concurs with Gauguin's description of Vincent in the days leading up to his first breakdown and seems to be consistent with his behaviour throughout this period. Still unsettled, on 3 February Vincent mentioned to Theo that he had gone to see 'Rachel'. Feeling the need to visit the girl was an ominous sign; Vincent was in crisis mode again. A few days later, on 7 February, Reverend Salles wrote to Theo with bad tidings:[5]

For three days he believed that he is being poisoned and sees poisoners or people poisoned everywhere. The house cleaner, who looks after him with a certain devotion, given his more than abnormal state, thought it her duty to mention it and it was brought to the attention of the police station by neighbours . . . Today, according to what the cleaner told me, he refuses all food; throughout yesterday and this morning he hardly spoke and his attitude sometimes frightened the poor woman who informed me that, given the situation, she could no longer continue to look after him.[6]

It wouldn't be long before news started to spread about Monsieur Vincent's strange behaviour among the locals of place Lamartine. Thérèse Balmossière, his cleaning lady, would have likely discussed

the matter with her cousin, Marguerite Crévoulin, whose husband
was the owner of the grocery next door to the Yellow House. I imagine
the clientele of the Crévoulins' grocery store discussed little else. This
local gossip-mill would soon have disastrous consequences for Van
Gogh.

Clearly in the throes of another breakdown Van Gogh was
readmitted to hospital and placed in the isolation cell on arrival. After
waiting a few days to see if there was any change in his condition,
Dr Rey wrote to Theo on 12 February. He was a little improved, but
in general the news was not good:

> The first day he was greatly overexcited, and his delirium was
> general. He no longer recognised me or M. Salles. Since yesterday,
> however, I have noted a perceptible improvement. He is less
> delirious, and he recognises me. He talks to me about painting,
> but sometimes he loses his train of thought and speaks nothing
> but disjointed words and jumbled phrases.

It was a far cry from Vincent's assertions to his family in January
that he was well, and happy to be home and working. Once again Dr
Rey raised the question of a transfer to the asylum: 'We will keep
Vincent in the hospital for some time longer. If we see him returning
to health we will continue to treat him here. If not, we will send him
to the regional asylum.'[7] For the time being, he kept him in the isola-
tion cell, as much for his own safety as the safety of others. It was
lonely and very grim.

Van Gogh's illness was not straightforward: the extreme crises he
had experienced were interspersed with periods of calm, lucidity and
apparent recovery. It made it especially difficult for Dr Rey to settle
on a course of action. On this occasion, Vincent stayed in the hospital
for a fortnight, writing to his brother on 18 February 1889: 'Today I've
just returned home for the time being, I hope for good. There are so
many moments when I feel completely normal, and actually it would
seem to me that, if what I have is only a sickness peculiar to this area,
I should wait quietly here until it's over.' Vincent's light comment that
he had a 'sickness peculiar to the area' would become significant as

his mental health deteriorated during the course of the following year. Despite trying to understand why his reason failed him, he remained oddly optimistic: 'Even if it were to happen again (which, let's say, won't be the case).'[8]

However, resting quietly at home was no longer an option. While he had been away, the local residents had been discussing the bizarre behaviour of the painter living in the Yellow House and they had been working themselves up to take action.

> We the undersigned, residents of place Lamartine in the city of Arles, have the honour to inform you that for some time and on several occasions the man named Vood, Vincent, a landscape painter and a Dutch subject . . . over-indulges in drink, after which he is in a state of over-excitement such that he no longer knows what he is doing or what he is saying, and very unpredictable towards the public, a cause for fear to all the residents of the neighbourhood, and especially to women and children . . . [he should] return forthwith to his family, or the formalities required in order to have him admitted to an asylum should be completed.[9]

On 25 February 1889 this petition was received by the Mayor of Arles.[10] It was signed by thirty individuals – locals from the neighbourhood, people Vincent saw daily, people he ate with and talked to. Following official procedure, the mayor passed it on to the police, whose role was to interview witnesses in order to establish whether the accusations were founded. Vincent was returned by the police to the hospital yet again. He had only been home a matter of days. Van Gogh must have been showing signs of mental delirium even at this point as later he wrote to his sister, 'In all I've had four big crises in which I hadn't the slightest idea of what I said, wanted, did.'[11] Confused and in a state of distress, this fourth breakdown in little more than two months was a severe blow to Vincent's morale as he began to realise that there might be no cure.

★ ★ ★

The Arles petition, late February 1889

From the perspective of modern medicine, it's clear Van Gogh had severe mental-health problems. So it is hard for me not to interpret the Arles petition drawn up by the residents of the place Lamartine as a petty, mean act by a group of unsympathetic locals. But we are looking at the situation with modern eyes. The inhabitants of the place Lamartine do not in fact seem especially worried in the petition text: Vincent 'over-indulges in drink', is 'unpredictable' and 'a cause for fear'. They just wanted him out of the way. The inquiry, however, was a very different matter. Drawing up a petition and sending it to your mayor was a totally normal reaction to a civil problem in late nineteenth-century France. Any issue was open to debate, if enough people supported it. There are many such petitions in the archives in Arles, dealing with everything from requests for decent paving to complaints about the red-light district. However, it was highly unusual to write to a mayor about a particular individual and ask him to take action to remove him and in this sense, the Arles petition is unique.

The day after the petition was sent Reverend Salles wrote to Theo:

> A petition, signed by thirty neighbours, informed the mayor of the inconvenience of allowing this man to remain entirely free, with evidence to support this. The document was promptly passed to the chief of police who had your brother taken to hospital and recommended he be kept there. He has just left after making me aware of the situation and he asked me to write.[12]

Theo wrote to his sister, telling her that Vincent was to be transferred to the asylum in Aix and that the prognosis was not good: 'I expected this, but now it is certain that it will be a long time before he is again completely healthy.'[13]

Around 16 March 1889, Vincent received a visit from the chief of police Joseph d'Ornano. Sequestered at the hospital in Arles since 26 February, it is clear from his reaction that he had still not been made aware of his neighbours' official complaint. During the meeting, Van Gogh was officially informed of the existence of the petition and the conclusions of the subsequent police inquiry. He was told he would have to stay at the hospital for the immediate future. Believing –

wrongly, as it turned out – that eighty of his neighbours had demanded he should leave Arles, he was devastated:

> You can imagine how much of a hammer-blow full in the chest it was when I found out that there were so many people here who were cowardly enough to band themselves together against one man, and a sick one at that . . . I'm badly shaken, but all the same I'm recovering a certain calm so as not to get angry . . . I'm convinced that the mayor, as well as the chief of police, are more like friends and that they'll do everything they can to settle all this.[14]

Reassuring Theo that 'all of this accusation will be reduced to nothing' and that there was no point in arguing as this would make him look like a 'dangerous madman', he rationalised that 'strong emotions could only aggravate my state'.[15] Angry, yet capable of reasoning, by the time Van Gogh wrote this letter on 19 March he was no longer in crisis mode. Before the events of 23 December 1888, Vincent hadn't had cause to worry about his neighbours; he was unusual, to be sure – a gentleman painter would have very different habits from the working-class locals – but he had never posed a risk or danger to anyone. Policeman Alphonse Robert recalled, 'As to whether I noticed any eccentricities – no, never. He was fine all the time I knew him, the children did not pay him any attention.'[16] This in fact wasn't entirely true. Local teenagers had been teasing Vincent for some time about his eccentricities; yet it wasn't until after he had mutilated his ear, and all the stories and elaborations that flourished in the wake of his hospitalisation, that the atmosphere around place Lamartine changed dramatically. Interviewed before her death in 1911, Marie Ginoux recalled that Vincent 'only became really ill afterwards and because of the behaviour of the stupid people here'.[17]

The Arles librarian, M. Jullian, recalled in the 1950s, 'We only became scared after his self-harm, because we all understood that he was really crazy.'[18] Throughout January and February 1889, groups of people gathered outside the Yellow House, attempting to get a glimpse of the painter who had cut off his ear. They turned his home into a sideshow.

In a letter to Theo written on 18 March the Reverend Salles recounted Vincent's reaction to the petition: 'This document has distressed him greatly. If the police – he told me – would protect my freedom by preventing children and even grown-ups from gathering around my house and climbing onto the windows as they have done (as if I were some strange beast) then I would have been calmer; I haven't hurt anyone and I'm not dangerous.' There's a poignancy to Van Gogh's desperate desire for peace. What horrible irony that the community where he had made his first-ever home, and felt at his most free creatively, was now rejecting him. Salles went on:

> I understand, that goes without saying, that he is treated as being crazy and the thought of this upsets and revolts him at the same time. I told him that once he is fully restored, he should in his own interest and for his peace of mind, settle in another neighbourhood. He appeared to accept this idea whilst pointing out that it might be difficult to find an apartment elsewhere after what had happened.[19]

Still in the isolation cell at the hospital Vincent felt yet again that his freedom had been violated: 'Here I am, shut up for long days under lock and key and with warders in the isolation cell, without my culpability being proven or even provable.'[20]

The petition against Van Gogh was another part of the puzzle I was keen to understand. Given the harsh criticism directed at Arles over the last century for casting out a sick man, it has always been a sensitive subject for the locals here, something I was aware of before I started my research. The number of people who signed the petition had been exaggerated for decades, but the petition had apparently been lost, so what evidence was there to support any one view? Writers and historians researching Van Gogh's life had little to go on other than the indignation in his letters. Over time, the petition gradually became a symbol of man's inhumanity to man, and an essential part of the Van Gogh legend, reinforcing the view of Vincent as a wronged, misunderstood loner. By the early 1920s it was said that close to a

hundred people had signed it. These numbers fuelled the image of Vincent as a tragic hero and a misunderstood genius, and implied that local people were philistines. 'He hadn't counted on the renewed cruelty of a few Arlésiens,' Gustave Coquiot wrote in 1923, 'a petition to get "the dangerous painter" locked up again met with universal enthusiasm. A hundred people, including the mayor, signed it . . . Everybody breathed a sigh of relief.'[21] But there was no 'universal enthusiasm' for the petition, as Coquiot purported, and of course the Mayor of Arles was never involved in signing it.

Ever since Vincent's letters were first published in 1914, generations of researchers regularly contacted the archives in Arles to ask about the petition's whereabouts. The reply was always the same: it was lost. Then in 1957, during the quiet time between Christmas and New Year, Violette Méjan, a librarian at the archives, stumbled upon some interesting paperwork and she contacted her immediate superior:

Found this day Sunday, 29 December 1957, when I was working in the library, the following documents mixed in with various papers left by my predecessor, M. Luchat, who was librarian from 1944 to 1947.

1. Petition by the residents of Arles against 'Vood, Vincent', undated.
2. Inquiry and witness statements (27 February 1889).
3. Letter to Mayor of Arles (M. Jacques Tardieu) 6 March 1889.
4. Certificate from Dr Delon declaring that V. van Gogh is suffering from mental alienation.
5. Two undated and unsigned examples of the mayor's committal order.
6. A paper that is undated and unsigned of his transfer to Aix.

She added a note in red ink: 'After having examined them, I gave these documents to M. Rouquette [her boss] this day.'[22] This was a treasure trove of riches to a historian, or anyone else interested in the story of Van Gogh. It should have been made public immediately. But this was no simple matter.

Many direct descendants of the petitioners were still alive, and by

the late 1950s the image of Vincent van Gogh had changed: he was now a world-famous artist and star of the silver screen. In 1956 Vincente Minnelli's *Lust for Life* had been released, with handsome star Kirk Douglas as Van Gogh. The film had portrayed Vincent as a tortured genius and a figure certain to arouse great sympathy; it had transformed the tourist trade in Arles. Visitors had begun to flock to the city to bathe in the Provençal sunshine that glowed from Van Gogh's canvases and look out at the cornfields he had painted. Fearful that these documents would damage the reputation of the citizens and paint the town in a bad light, the mayor chose not to mention their rediscovery and they were swiftly secured in a museum safe.[23] Very occasionally the documents would be shown to visiting dignitaries or scholars, but any detailed research on the petition and subsequent inquiry was hampered by the city's reserve. The documents entered the public domain only in 2003, when for the first time this 'missing Van Gogh file' was revealed in its entirety.[24]

The police inquiry in response to the petition began on 27 February, 1889, the day after Vincent had been returned in a manic state to the isolation cell at the hospital. Each person interviewed declared their statement to be accurate, before signing their name alongside that of Chief Inspector Joseph d'Ornano. The chief inspector, like many others in Provence, had trouble with Vincent's surname, using the spelling 'Van Goghe' throughout:

> I, Joseph d'Ornano, Chief Inspector of police in the city of Arles
> . . . [given] the instructions of the Mayor of Arles, ordering that Van Goghe's degree of madness be established, have opened an inquiry and interviewed those named below:
> 1. M. Bernard Soulé [*sic*], aged 63, landowner, of 53 Avenue Montmajour, who made the following declaration to me: As the managing agent of the house occupied by M. Vincent van Goghe, I had occasion to speak with him yesterday and to observe that he is suffering from mental disturbance, because his conversation is incoherent and his mind wandering. Furthermore, I have heard it said that this man is prone to

interfering with women living in the neighbourhood; I have even been assured that they actually no longer feel at ease in their homes, because he enters their residences.

In short, it is a matter of urgency that this insane man be confined in a special asylum, especially in view of the fact that Van Goghe's presence in our neighbourhood compromises public safety.

This choice of Soulè as the first witness is highly significant. Vincent's house agent was the only one of those interviewed who had actually signed the petition. Soulè began his statement to the police by saying, 'I have heard it said', before recounting Vincent's erratic behaviour. This testimony should have been discounted immediately, because it was hearsay rather than his own eyewitness account. The police document continues:

2. Mme Marguerite Crevelin [sic], née Favier, aged 32, general grocer, of Place de Lamartine [sic], who told us the following: I occupy the same house as Mr Vincent van Goghe, who is truly insane. This individual comes into my shop and makes a nuisance of himself. He insults my customers and is prone to interfering with women from the neighbourhood, whom he follows into their residences. In fact, everyone in the neighbourhood is frightened on account of the presence of the said Van Goghe, who will certainly become a threat to public safety.

3. Mme Maria Viany, née Ourtoul, aged 40, retail tobacconist, of Place de Lamartine [sic], confirmed the declaration of the previous witness.

4. Mme Jeanne Coulomb, née Coriéas [sic], aged 42, dressmaker, of 24 Place de Lamartine [sic]: Mr Van Goghe, who lives in the same neighbourhood as myself, has become increasingly mad in the past few days, and everyone in the vicinity is frightened. The women, especially, no longer feel comfortable, because he is prone to interfering with them, and makes obscene remarks in their presence. In my own case, I was seized round the waist outside M. Crevelin's shop by this individual the day before yesterday, Monday, and lifted off my

feet. In short, this madman is becoming a threat to public safety, and everyone is demanding that he be confined in a special establishment.

5. M. Joseph Ginoux, aged 45, café owner, of Place de Lamartine [*sic*], who agreed that the facts recounted by the previous witness are true and genuine, and has stated that 'he had nothing to add to her statement'.

It was the chief inspector's duty to make an assessment of his findings, based on the evidence from the various witnesses. 'M. Vincent van Goghe is truly suffering from mental disturbance,' he concluded, 'however, I have noted on several occasions that this madman has moments of lucidity. Van Goghe is not yet a threat to public safety, but there are fears that he may become so. All his neighbours are frightened, and with good cause, because a few weeks ago, in a fit of insanity, the madman concerned cut off an ear, a crisis that could be repeated and be harmful to somebody in his vicinity. Chief Inspector d'Ornano.'[25]

On 6 March 1889 the chief inspector's paperwork, complete with his conclusions and suggestions, was sent to the Mayor's office, stamped in red ink with 'Arles, Commissariat Central'. For all that he was a kindly man, sympathetic to Van Gogh's situation and well aware that the accused wasn't consistently mad, d'Ornano's final conclusions were damning: 'I am of the opinion that there are grounds for detaining this patient in a specialised asylum.'[26]

Accompanying the paperwork in the public archives was a certificate from Dr Delon, who had been commissioned by the police to assess Vincent's mental state after he was sent to hospital in February 1889:

I found this man in a state of extreme excitement, suffering from true delirium, pronouncing incoherent words, only momentarily recognising the people around him. In particular, he is subject to auditory hallucinations (he hears voices reproaching him) and to a fixed idea, according to which he is supposed to have been the victim of an attempted poisoning. This patient's condition appears to be very serious, requiring close surveillance and treatment in a special asylum, as his mental faculties are profoundly impaired.[27]

From Dr Delon's perspective, it seemed an open-and-shut case. But Delon was a paediatrician, with no experience of treating patients with mental illness. He had moved from Paris to Arles, and in July 1888, only a few months after Vincent arrived in the city, took up a post at the hospital looking after the newborns.[28] It was Dr Félix Rey who had been Van Gogh's doctor consistently since December 1888; Dr Delon was neither responsible for general medical cases, nor was he Dr Rey's direct superior. Why he was the person who signed the certificate concerning Van Gogh isn't entirely clear. Dr Rey was only an intern and likely could not sign a committal procedure; in theory the paperwork should have been signed by Dr Urpar or, if he was absent, his deputy, Dr Béraud.[29] However, for some reason Van Gogh's committal certificate was never dispatched to the mayor. The explanation for this came in a letter from the Reverend Salles to Theo van Gogh:

> However, it seems to me, and this view is shared by M. Rey, that it would constitute an act of cruelty to lock up a man permanently who has done no one any harm and who, with care and kindness, could return to his normal state. I repeat, the best will prevails among all those around him at the hospital and everyone is willing to do their utmost to prevent his transfer to a lunatic asylum.[30]

Thanks to the reticence of Dr Rey and the desire of the chief of police not to force the issue, the paperwork that was prepared for the mayor to commit Van Gogh to the regional asylum was rather conveniently *delayed*. Once Vincent learned from the chief inspector about the inquiry's findings, he wrote plaintively to Theo, 'All that I would ask is that people I don't even know by name (for they took great care to act so that I don't know who sent that document in question) don't meddle with me.'[31]

The people who signed the petition have always been judged severely by historians and writers. In 1969, Van Gogh biographer Marc Edo Tralbaut called the petition 'A Conspiracy of Hyenas'. He continued in the same vein: 'the behaviour of the people of Arles reached a new level in sending a petition to the mayor . . . the accusations which motivated Vincent's imprisonment were solely founded

on vague declarations and dubious gossip'.[32] But dubious gossip has always made good copy.

By the 1980s the true figure of thirty petitioners had been widely reported in books and articles. Yet despite having access to the original documents Martin Gayford, author of *The Yellow House*, a book published in 2006 about Vincent and Gauguin's time in Arles, perpetuated the myth that 'a large proportion of the community around place Lamartine signed the petition'. The district around place Lamartine had a population of 747 in 1888, and thirty people cannot be considered to constitute a 'large proportion' by any measure.[33]

Researching whether the whole town was up in arms against Vincent led to a complete reappraisal of the petition and associated documents. As I investigated, I came across an article entitled 'Van Gogh Betrayed' also by Martin Gayford in which he declared that the owner of the Café de la Gare played an integral part in 'Vincent's downfall'. Referring to the petition, he stated that 'prominently legible in the middle column was the name of Joseph Ginoux'.[34] I was intrigued. The Ginouxs were close friends of Van Gogh; it would be a callous move indeed if Joseph was one of those who had forced Vincent to leave Arles. I consulted the original petition. Over the course of researching this book I have spent many long hours studying the handwriting of the late nineteenth century. Although some of the script on the document is difficult to decipher, the signature Gayford referred to as Joseph Ginoux appeared to me as 'Joseph Gion'. It was a simple task to check if I was right. After the petition had been sent Joseph Ginoux was indeed interviewed for the police inquiry, and had signed his statement, so I had a verifiable signature. I also had a signature from his marriage certificate.[35] It was so clear: they were not the same person at all.

Signature from Police Enquiry 27 February 1889 | Signature from Marriage Certificate | Signature from the Petition

Comparison of Joseph Ginoux's signature (the first two examples) with Joseph Gion's signature (the third example)

I began to question everything: now I wanted to identify everyone who had been listed on the petition. Who were these people, and why had they become involved in forcing Vincent to leave Arles? What did they have to gain from signing the petition?

On one of my trips to Amsterdam I mentioned the discrepancy in the signatures of Ginoux and Gion to Louis van Tilborgh at the Van Gogh Museum. I discussed how there had been no forensic analysis of the petition and, until every signature on the petition had been cross-checked, how could we know for certain who was really on that list? The discrepancy between Gion and Ginoux, which had been so easy to uncover using my knowledge of local surnames, was merely the start of a much bigger, more important inquiry. Louis was intrigued. Ginoux is an important character in the story of Van Gogh and his legacy. He was not only the husband of the woman Vincent had painted as the Arlésienne, but Vincent had lived with the couple for four and a half months. After Van Gogh's death many of the paintings that were still in Arles passed through Ginoux's hands. The fact that no one had noticed the discrepancy in the signatures before was a small feather in my cap, and from that moment on, I felt a growing trust from the Museum. If the names on the petition could be verified, it might throw some light on why they wanted Vincent out of town. There might only be thirty names, but if I were to be thorough, I had to find the same signature for each person on a comparable legal document in the archives. Checking the names scrawled on the petition would be a huge job that would take hundreds of hours. Of course, it could be done, but with tens of thousands of signatures to check, I wasn't sure I really had the heart to do it. For the time being I put the idea aside.

A few months later my brother, who lived near me in Provence, fell ill and was hospitalised. After exhausting visits to the hospital, dealing with the dire practicalities of a serious illness, I couldn't find the focus to work on anything too taxing, once I got home. I was in absolutely the right frame of mind for a mind-numbing and dull task: I went back to the petition.

I wasn't the first person to work on it; the Van Gogh Museum put

me in touch with a historian from Nîmes, Pierre Richard, who was the first to publish a photocopy of the petition in 1981. After managing to decipher two-thirds of the signatures, he had tried to identify the people listed, by looking for people of the same name who lived in and around place Lamartine.[36] In this way, he had worked out who a few of the petitioners were. This method wasn't foolproof, though. As I compiled my database I had noticed that often there were people of the same name who lived in the same part of town – fathers, sons, cousins, and so on. Identifying the names alone would never be enough to work out who had really signed the petition. My database would help with the occupations, family connections and social position of each petitioner, but what I really wanted to know was what each of these people had to gain by removing Van Gogh from Arles. What could possibly be so important that it was worth making a sick man homeless?

As the petition is very fragile and written on cheap paper more than a century old, it is rarely possible to consult the actual document. I made a special request to the archives in Arles and was allowed to take a digital photograph of the petition. In this way I could enlarge it on my computer screen to look at each signature individually. Only about half of the names were legible. The police inquiry had provided personal details of five interviewees who gave testimonies, but the petition itself was just a list of names on a page.

Fortunately, legal documents in France are renowned for their rigour. Most official documents require a plethora of signatures, with at least six on every marriage certificate. I spent every evening for several months trawling through the Arles marriage registers online, hunting down the particular curl or flourish of each signature. I identified twenty-four of the thirty names in this way. Further examination of the original document brought other curious details to light: four of the individuals who had apparently put their signature to the petition had, in fact, not. From my research I learned that these four were illiterate and their names seemed to have been added in another person's hand.[37] I wondered if they had given their permission for another person to sign on their behalf, or whether the instigators of the petition needed to increase the numbers. Now however, I could formally identify twenty-eight of the petitioners.

Identifying the two remaining people from their signatures was pure luck. But once the drudgery had been done, I actually had a far harder task ahead of me. Although petitions in late nineteenth-century France were a relatively commonplace occurrence, they still presumed a certain vested interest and there was still a nagging question outstanding: why did these thirty individuals go to the trouble of signing the petition? The most obvious explanation was because Van Gogh was crazy and the residents were afraid of him. Yet, when I asked the locals around me, they insisted that being 'fada' – the Provençal word for crazy – was not enough of a reason to chase a man out of town, which concurred with Vincent's remark that everyone was a bit 'cracked' in Provence. Van Gogh had certainly behaved in a way that would justify fear amongst his neighbours – such an act of savage violence, even upon oneself, would have been frightening. But the thought still nagged at me that the residents could also have been influenced to sign the petition by someone else. I didn't take the view about having a vested interest too seriously at this point, but I would soon be proved wrong.

The roots of the petition can be traced to late December 1888, almost immediately after Vincent cut off his ear. With Van Gogh in hospital, it seemed very likely he would be committed and sent to the asylum as soon as the paperwork had been settled. Mental illness was not rare in Arles. The archives detail numerous occasions of the transfer of psychiatric patients to the asylum in Aix-en-Provence. Then suddenly at New Year, Van Gogh made a miraculous recovery. On 2 January 1889 the Reverend Salles went to see Roulin, Ginoux and other friends at the Café de la Gare, and the artist's state of mind and his radical improvement were openly discussed.[38] However, not everyone in the café was overjoyed at this development.

The signatures seem to be largely from people who lived in and around place Lamartine, who would have witnessed Van Gogh's behaviour at first hand before and after 23 December 1888. Although Van Gogh was never a threat to public safety, by February 1889 his neighbours were wary. By the time of his third breakdown in early February, it would have been easy for certain people with influence to persuade the locals that a dangerous madman was in their midst.

I had assumed that what lay behind the petition was fear: of an outsider in a small, insular community; of unrestrained creativity and the madness and erratic behaviour that seemed to accompany it. But by identifying the signatures a different story began to emerge.

The first signatory on the petition was Vincent's immediate neighbour, the grocer Damase Crévoulin, whose wife was interviewed by the police during the inquiry. Given the proximity of their living conditions, and how much the Crévoulins must have seen and been affected by Vincent, it has always been assumed that they were solely responsible for the petition.[38] However, there is another person, a crony of Crévoulin, who had much more to gain by Vincent's removal from 2, place Lamartine, and the significance of his role has long been overlooked: his house agent, Bernard Soulè.

The Yellow House was prime real estate, perfectly placed for commercial activity – it was on a corner, facing a public garden and in a lively part of town. Recently, at Vincent's insistence, money had been spent on renovating the building and adding gas lighting. The land agent couldn't afford to leave 2, place Lamartine empty for long. While Van Gogh was stuck in hospital and expected to be committed, Soulè had started to look for a new tenant. In late December 1888 he had made a contract to convert the house into a tobacconist's. He told Van Gogh about this arrangement when he went to pick up the rent in early January, but on learning this news Vincent wrote to Theo vociferously defending his right to keep his home.[40] For Soulè, it was a disastrous scenario. Van Gogh had a lease and Soulè couldn't force him out without very good reasons. This was a problem that needed subtle – even underhand – tactics.

The petition was drawn up on thin, inexpensive paper and three different pens were used. The handwriting of the petition text certainly appears to be in the florid style of Crévoulin, and it is likely that the document was left on the counter of his grocery store for customers to sign. He was the first person to put his name down, followed by a man he employed as a shop assistant, Esprit Lantheaume. Discovering that the shop assistant was illiterate, though, led me to study other signatures. The other three who 'signed' the petition also appear to have been added in Crévoulin's script, most notably the woman who

ran the restaurant next to the Café de la Gare where Vincent regularly took his meals, the Widow Venissac. Two bar owners from place Lamartine, Guillaume Fayard from the Bar du Prado and the Café de l'Alcazar's proprietor, François Siletto, are also listed – Siletto's establishment was where Vincent threw a glass at Gauguin the evening before the drama. Charles Zéphirin Viany, the fourth name on the petition, was the tobacconist who had made the contract with Soulè to take over the Yellow House while Vincent was in hospital, whose wife, Maria, was interviewed during the police inquiry.[41] Another of the petitioners, only sixteen and still a schoolboy in 1889, Adrien Berthet, added gravitas to his signature by usurping his uncle's profession of *brigadier poseur*, or chief platelayer for the railway company. As I learned more about each signature on the petition, another surprising detail emerged: twenty-three of the thirty people who signed it were not even born in Arles. For the people of the area who did not endorse the petition, Vincent was an *estranger*, so why should they bother to defend him? They owed him no particular loyalty and, like Ginoux, sat on the sidelines and did what most people do when faced with a *fait accompli*: absolutely nothing.

My research showed that the people behind the signatures were all connected, as if in some giant local web. Even for a small, close-knit town like Arles, the ties between these people are remarkable. They were long-standing neighbours, witnesses at one another's weddings, work colleagues or relatives. Four of the people can also be found on an earlier petition to the mayor.[42] The common link between all of these characters, is that for the large part they were friends or work colleagues of Bernard Soulè.

Unfortunately the petition and police inquiry have often been looked at together.[43] But they must be examined as separate entities: the petition was written by the locals and sent to the mayor, and the inquiry was the official procedure undertaken by the police following the complaint. In the petition the accusations claim that Vincent had 'lost his mind', 'drank excessively', 'is unstable' and that local women and children were 'fearful'. It also requests that Vincent should be returned to 'the care of his family' or, failing that, should be interned.[44] By the time the police were taking witness statements in early March,

the complaints had become more serious and more specific: claims
of 'interfering with women' and 'entering their homes' were allega-
tions only raised during the inquiry.

Of the five people interviewed by the police, damning declarations
came from Bernard Soulè, Vincent's next-door neighbour Marguerite
Crévoulin, and Jeanne Coulomb, who was married to a work colleague
of Soulè's.[45] These three went into detail about the serious threat Van
Gogh posed. Their virulent remarks, depicting Vincent as a highly
dangerous madman, have been quoted in almost every book written
about him since then. Not only were these remarks taken out of
context, but just three people – all with a vested interest – said anything
negative about Vincent's behaviour: three individuals out of a total
population of more than 13,000 in Arles – this hardly represented a
whole town up in arms against Vincent van Gogh, as many biographers
would have us believe.

It seems incredible that the testimony of three individuals, given
to Joseph d'Ornano more than 125 years ago, is mentioned in almost
every description of Van Gogh's insanity. In conclusion, the petition
was instigated to serve the needs of Soulè and Crévoulin: Soulè needed
Vincent to leave the Yellow House because he had a legal obligation
to the tobacconist; Crévoulin regarded Vincent as a liability since the
Yellow House was right next door to his shop, and the passers-by and
teenagers who pestered Van Gogh were bad for business. Yet there
was no way they could turn Van Gogh out of the house for mere
personal gain. Vincent's unstable mental health gave them the perfect
excuse. In whipping up local fervour by spreading tales of his crazy
behaviour, it was easy for the two men to find a few good friends
who would sign the petition.

On my frequent trips to Arles I have often overheard tourist guides
affirm that Vincent van Gogh was mentally deranged, illustrating their
argument with descriptions of his madness taken from the statements
of 1889. It's true that Vincent did have severe psychiatric problems
and during a breakdown his behaviour was erratic and paranoid, but
the story has been exaggerated to seed the myth. For the town fathers
of Arles, the petition and related documents have always been an
issue. They imply an apparent lack of compassion for a man suffering

from acute mental distress. Perhaps because of this, there is no centre for Van Gogh studies in Arles and many of its inhabitants are not even aware of the petition's existence. The accusations made against him by a few people living on place Lamartine more than a hundred years ago still influence how he is perceived in the region today and has ramifications for all Van Gogh scholars. It almost appears as if this episode has been carefully edited out of the story of Van Gogh in Provence.

CHAPTER 19

Sanctuary

Let's try to seize our fate in whatever form it comes.
Vincent van Gogh to Theo van Gogh, 18 February 1889

Vincent's stay at the hospital in Arles lasted on and off for five months, from 24 December 1888 until 8 May 1889, one-third of the total time he spent in Arles. During this period, decisions were being made that would shape his future irrevocably. Theo only received sporadic news about what was happening to Vincent from the Reverend Salles and Dr Rey. The lack of correspondence from Vincent, compounded by the fact that all patient records from the nineteenth century have been lost or destroyed, means that Van Gogh's time at the hospital is more or less a blank.

From the outside, the hospital looks very forbidding – it has a high wall that circles its perimeter, with only a few windows punctuating the austere façade. There was a method to this aesthetic: when the hospital was built in 1573 the exterior was made as uninviting as possible, to dissuade patients from using the building as free lodgings. The large wooden entrance door leads to a corridor, which opens out to a colourful courtyard, that is almost always in full bloom. Every detail of the building has become so familiar to me: the elegant white stone, the walk along the terraces, the stylised carving of the Agnus Dei over the stairwell leading to the old chapel, the traces of long-demolished buildings cut into the walls, and the fragrant flowered garden at its heart.

In April 1889, just before he left Arles for good, Van Gogh painted this courtyard. It was a place reserved exclusively for the use of the

patients and their visitors, and his canvas sings with colour. He described the inner courtyard in a letter to Wil:

> It's an arcaded gallery like in Arab buildings, whitewashed. In front of these galleries an old garden with a pond in the middle and eight beds of flowers, forget-me-nots, Christmas roses, anemones, buttercups, wallflowers, daisies &c . . . And beneath the gallery, orange trees and oleanders. So it's a painting full of flowers and springtime greenery. However, three black, sad tree trunks cross it like snakes, and in the foreground four large sad, dark box bushes. The people here probably don't see much in it, but however it has always been so much my desire to paint for those who don't know the artistic side of a painting.[1]

He painted the scene from the first-floor terrace, showing not simply the garden, but giving a clear view across the courtyard to the men's ward beyond. In this painting *The Courtyard of the Hospital in Arles*, the Augustine nun Sister Marie Heart of Jesus, the pharmacist's assistant, is shown walking away from the hospital dispensary and the burly man under the arcades carrying a shovel is the gardener Louis Auran.[2] On the opposite terrace just beyond the far trees, ladies in Arlésienne dress are standing in front of the adjacent women's ward. Once this painting was completed, it ended up in the hands of the head pharmacist at the hospital, François Flaujat. He must have hung it in his pharmacy, because in 1893 it was seen by a postal official, who wrote that he saw a number of paintings at Arles hospital, including a view of the garden that Vincent 'did while convalescing'.[3]

In the archives I found order books giving details of the quantities of food ordered and prices paid, medical supplies and how the wards were furnished and heated. Thanks to the minutes of the Hospital Board, I learned about the employment history of the institution: who had been hired and fired, their salaries and various complaints. I made lists of the nuns who nursed, the daily workers who met Van Gogh and the doctors he came into contact with, all of which I culled from the census returns – copious, rich detail, masses of background information, which built up a portrait of the hospital and its daily routines.

There was still so much that remained out of my grasp, though. With no medical records, Vincent's own experience as a patient there felt hazy and incomplete, and though the geography of the hospital was deeply familiar to me from my hours at the archives, I still had no idea for a long time where Dr Rey's office and Vincent's ward had been.

One day in the archives, I was looking at a catalogue of documents about the hospital and found mention of a floorplan drawn up by the city architect, outlining improvements that needed to be made. It took a few months before I was able to consult the actual document. These two large sheets of yellowing architectural paper illustrate exactly where everything, from the pharmacy to the kitchens, was situated. As I read the date – 8 January 1889 – I shivered. This was one day after Van Gogh left the hospital for the first time. Not only did I find the plan of the hospital I was seeking, but it was drawn by the city architect at the very moment Vincent van Gogh was an in-patient. For the first time, I could precisely locate the room that featured in his painting *Ward in the Hospital in Arles*, and also Dr Rey's office and treatment room.[4] But I still felt my understanding of Vincent's time at the hospital was dry and impersonal and I felt sad and frustrated. Then I had another piece of good luck. In the city archives I stumbled upon a health questionnaire from the hospital, commissioned by the French Ministry of Health. I took photos of the document, but it was absurdly long, written in barely intelligible script. Once I got home I simply filed it, awaiting a day when I felt especially patient. Then once again fate intervened.

Trying to get my *Van Gogh's Ear* project off the ground, I had cold-called a TV production company and arranged a meeting to explain my project. Friends in London put me up and, excited by the prospect of the meeting, I didn't sleep too well the night before. As I went off to buy breakfast the next morning, I twisted my ankle and fell awkwardly onto the street. As I lay on the ground, feeling self-conscious and very sore, commuters rushed by me without stopping. Eventually a lovely woman helped me up.

I felt exhausted by the pain and tense with anxiety, yet I decided

to go to my appointment against the advice of my friends. Unsurprisingly the meeting didn't go too well. Not normally nervous, I was shaking as I told the story of Van Gogh. I stumbled through, although at moments I even had trouble understanding which language we were speaking in. After the two-hour meeting was over, I was sure I'd blown it. As the day wore on and the pain got steadily worse, I decided to go to the hospital. The X-ray revealed that I had broken not only my left ankle, but also my right elbow.

Once back at home in France, unable to leave the house or do much for myself, I finally had some quiet time in which to turn to the long hospital questionnaire I had found in Arles. What had appeared as drudgery turned into a real discovery. The questionnaire described the conditions at the hospital in great detail. What was more extraordinary still was that this paperwork was compiled between July 1888 and February 1889, overlapping precisely with Van Gogh's confinement, and gave me a precise snapshot of the institution at the very moment that Vincent van Gogh – traumatised and fragile – was lying in a hospital bed or locked up in an isolation cell.[5]

In late December 1888 Vincent found himself in a building that had seen better days. For the previous twenty years the town council had sent numerous letters and reports to the Ministry of Health highlighting the urgent need to improve conditions. Yet nothing had been done. There were complaints about a pungent smell that hung in the air, a so-called 'miasma', which in the nineteenth century was commonly thought to transport infection. Situated in a low-lying part of the city, the hospital had drainage facilities that dated from Roman times.[6] The hospital administrators hoped to build a new establishment rather than improve the existing 300-year-old structure, yet investment was sorely lacking and the building fell into disrepair.

It wasn't only the building that was crumbling: the hospital's care also left a lot to be desired. The nursing staff was doddering and elderly and hygiene rudimentary. In contemporary newspapers there are frequent remarks about the hospital being a dangerous, insalubrious place. Following a spate of deaths in the months preceding Vincent's stay, one of the senior doctors had been cautioned by the

police for 'reckless' surgical practice, and since then there had been a moratorium on anything but emergency surgery. The staff were keenly aware of the hospital's shortcomings – an administrator noted in the questionnaire that 'disinfection is not undertaken in a particularly thorough manner'. Van Gogh was lucky to find in his doctor, Félix Rey, such a competent physician.

When Vincent arrived at the Hôtel-Dieu, it was run by a committee that reported directly to the Mayor of Arles, yet in keeping with most nineteenth-century hospitals in France, the principal nursing staff came from religious orders. The Catholic Church had been administering care in hospitals throughout Europe since the Middle Ages, and little had changed. These were nuns from the order of Saint Augustine and the convent where they lived formed part of the same building. The nuns oversaw cooking, cleaning, preparing treatments and monitoring the wards. In Vincent's paintings of the hospital, these nursing sisters can be seen pottering about the courtyard and on the wards tending to their duties. A few local people were also employed: a barber, a concierge, workmen and duty officers. French institutions had been non-denominational since the Revolution and the notion of secularity was strictly enforced at the hospital. A month before Vincent's first admission, there had been a small scandal: three nursing sisters, including the Mother Superior, were removed from their duties for trying to convert the patients to the Catholic faith.[7]

By late February 1889 when Vincent was taken back to the hospital, he had already been placed in isolation twice. This would be his third time in as many months.[8] Until final decisions were made in relation to the petition, the Yellow House and his removal to an asylum, he would have to stay there.

The potential loss of the Yellow House was devastating for Van Gogh. It was the embodiment of so many dreams, including a long-hoped-for future with a wife and child. And if the petitioners got their wish, he would have to leave the city altogether. These developments weighed heavily: 'as you well know, *I love Arles so much*', he wrote to Theo, 'I no longer dare to urge painters to come here after what has happened to me, they run the risk of losing their heads like me.'[9]

Reverend Salles wrote to Theo on 1 March saying that Vincent

would be allowed to pick up paints and brushes from his house, so that he could have some distraction while at the hospital; the following day, though, the police were at place Lamartine interviewing the residents about Vincent's behaviour.[10] At such a delicate juncture it would be inadvisable to let him out. 'Obviously, at the point where things stand, the neighbours are afraid of your brother and they have egged each other on,' Salles wrote to Theo:

> The things they accuse your brother of (assuming they are true) do not justify declaring a man insane and demanding he be locked up. It is said that children crowd around and run after him, that in turn, he runs after them and could do them harm.[11]

While the authorities were deliberating his fate, Van Gogh remained in isolation. Theo wrote to his sister Wil, 'I've had another letter from the Rev. Salles. Just as I had thought, his condition is the same, and not at all better . . . I expected this, but now it is certain that it will be a long time before he is again completely healthy.'[12] The future did not look promising. The Yellow House was sealed off by the police until a final decision about Van Gogh's future was made. This meant that for the time being, Soulè was unable to rent out 2, place Lamartine to anyone else including the tobaconnist.[13]

In Paris, Theo had practical issues of his own to contend with. His wedding to Jo was scheduled to take place in Amsterdam on 18 April. He was also hoping to move. Since his engagement he had been hunting for something more suitable for a married couple, finally settling on an apartment at 8 Cité, Pigalle. There was little he could do to alleviate Vincent's suffering. He ended his letter of 16 March with 'I wish you better health and I remain your brother who loves you. Theo.'

Theo was in a difficult position. His new situation – a wife, and hopefully a child before long – would put a strain on his finances and he knew he would struggle to cover Vincent's costs on his own if Vincent were to need paid care. He wrote to his sisters for assistance and guidance: 'At the moment there's no reason to change his present treatment, which is free . . . Should the contrary be deemed necessary,

that he be admitted to a special nursing home, we must decide to what extent paid care needs to be provided.'[14]

Despite always finding succour in painting, Van Gogh produced little artwork during March 1889. For the first two weeks he had been in the isolation cell, before being transferred to the men's ward, but he still wasn't allowed to roam freely around the hospital. As he wrote to his brother in late March, 'As far as I can judge I'm not mad, strictly speaking. You'll see that the canvases I've done in the intervals are calm and not inferior to others.'[15] In fact the delay in taking him out of isolation and the restrictions imposed upon him were less to do with his mental state, which was steadily improving, but due to a major health scare at the hospital.

Since October 1888 the city had been battling a smallpox outbreak and the health services were severely overstretched. Dr Rey's main preoccupation was combating the spread of this highly contagious disease. Each patient was vaccinated on entering the hospital and disinfected on leaving.[16] Movement outside the wards was limited and patients were forbidden from walking along the galleries.[17] There was a fairly long incubation period for smallpox, and by the time victims entered the hospital they were already gravely ill. The treatment was basic: balm was applied to the boils, and the patients were calmed with doses of opium and ether.[18] Dr Rey's approach to the spread of the disease was very effective. In the six months of the outbreak there were forty-one cases, with only six deaths. He wrote a series of recommendations to the hospital board in a report dated 15 April 1889, after the epidemic was declared to be over. He was highly commended by the hospital administrators for his effective treatment of the outbreak, which some years later led him to being offered the post of Head of Hygiene in Arles.[19]

Van Gogh spent the latter part of his stay at the hospital as a patient in the male ward. Dr Rey would occasionally welcome Vincent into his room. The doctor's daughter recalled many years later that 'Vincent found the noise of the ward very distracting. Father allowed him to use his office so that he could write to his brother Theo in peace.'[20] As the building still exists, it is easy to imagine the large and draughty wards. When built, it was deemed important to let the air circulate,

so the patients were housed in vast, open spaces; Vincent's ward was 131 feet long and 26 feet wide. There were 16½-feet-high ceilings, with twelve large windows punctuating the white lime-washed walls. Each window was shaded by a pink-and-white checked curtain – a little note of gaiety in this otherwise austere interior.[21] The beds were made of metal, with straw mattresses, a bolster and pillows. In Vincent's ward there were twenty-eight beds on floors of simple unglazed tiles. There was little privacy, with just 3 feet between each bed, to house a chair and a cupboard for personal effects. If special treatment was needed, a thin voile curtain was drawn. Treatment notes were attached to the curtain rail. It was also difficult to sleep; pungent oil or paraffin lamps suspended from the ceiling needed constant attention and were left on at night, though dimmed slightly.

In summer the ward was too hot and in winter too cold. There was a sole lavatory, a 'Turkish toilet' (an open hole) in the stairwell for all twenty-eight patients, with no flushing system, only a bucket of water placed next to it.[22] The patients wore their own clothes on the wards and their undergarments were changed 'as necessary'. The bathhouse was on the ground floor and opened just twice a month for ablutions. The metal baths were heated by gas pipes. It was impossible to keep the water clean and hot enough for every patient, so for a total of 15,510 patient nights in a year at the hospital, only 400 baths were taken. In answering the question 'How often do the patients bathe?', the administrator joked: 'As often as the need is felt (or smelt).'[23]

Water was boiled for tea or broth. Coming directly from the Rhône, it was considered so unhealthy that the patients were never given fresh water to drink. Liquid intake was through soup, herbal tea, coffee or wine. No matter how unwell the patient, even on the most restrictive diets they were entitled to their daily wine allowance. Women, including those who were breastfeeding, were given ¼ litre of wine per day. The men's ration was much more generous – 1 litre per day. It would seem to modern readers that the patients were kept in an inebriated fog, but wine was drunk with most meals in late nineteenth-century France. Patients were fed twice a day, at 10 a.m. and 5 p.m. The food was fairly basic, but sufficiently nutritious to build

up strength: meat (beef, mutton and lamb), lots of rice, beans and lentils, vegetables, salad and olive oil.[24] The cost for all of this – the treatment, lodging, nursing, and so on – was 1.50 francs per day per patient, but for those who were natives of the city of Arles, it was free.

The patients were allowed to smoke on the terraces or walkways, and this provided a welcome opportunity to interact with others. Vincent was only allowed this privilege towards the end of his stay, due to the restrictions imposed because of the risk of smallpox. 'If sooner or later I became really mad I think I wouldn't want to stay here at the hospital,' Vincent wrote to Theo at the end of March, 'but just for the moment I still want to *leave* here freely. For if I still understand myself a little there will be an interval between here and there.' Again he displays an extraordinary sensitivity to others: 'The best for me would certainly be not to remain alone, but I would prefer to remain eternally in a madhouse than to sacrifice another existence to my own.' Despite his emotional intelligence, though, cracks were again showing in his sanity and, as the letter goes on, he begins to show signs of paranoia: 'The administration of the hospital is – how shall I put it – Jesuit, they're very, very shrewd, very learnèd, very powerful, even Impressionistic . . . they know how to obtain information with an unheard-of subtlety – but – but – it astonishes and confuses me – yet.'[25] His syntax is confused, his thoughts jumbled.

By mid-March, Theo, concerned because he had had so little news from Vincent, learned that the artist Paul Signac was about to set off from Paris on a painting trip to the south. He asked if Signac would mind stopping off in Arles to see his brother.

Paul Signac arrived in Arles on 23 March 1889 and spent the day with Vincent, leaving for the coast the following morning. This unexpected visit by an artist friend from the capital boosted Vincent's morale. Dr Rey let him out of hospital for the day and they made their way to the Yellow House to see Vincent's paintings.

I'm writing to tell you that I've seen Signac, which did me a lot of good. He was very nice and very straight and very simple when the difficulty arose of whether or not to force open the

door closed by the police, who had demolished the lock. They began by not wanting to let us do it, and yet in the end we got in. As a keepsake I gave him a still life which had exasperated the good gendarmes of the town of Arles because it depicted two smoked herrings, which are called gendarmes, as you know.[26]

Not having seen his artwork since the ill-fated exhibition Vincent had organised fifteen months before in Paris, Signac was taken aback. Van Gogh's work was radically different, no longer influenced by the Impressionist style, but a new mature form of painting, with strong, pure colour and bold brushwork. 'He took me to see his paintings,' Signac told Theo, 'of which many are very good and all of them very intriguing.' He reassured Theo of how well he had found Vincent, and how again it was his work that dominated Vincent's preoccupations: 'I found him, I assure you, in the most perfect state of health and reason. He wishes for one thing only, to be able to work undisturbed.'[27]

Galvanised by seeing his work again and the visit from a fellow painter, Vincent requested painting supplies from Theo. He resumed work in mid-April, finally being allowed to leave the confines of the hospital to capture once again the orchards in blossom. He didn't feel comfortable venturing too far and simply walked across the road from the hospital grounds and worked in the fields of the hospice, beside the military barracks on the boulevard des Lices. These paintings are quite different from his canvases from the summer of 1888, with flatter surfaces and *cloisonné* lines, showing the influence not only of Japanese prints, but also of Paul Gauguin.

Sadly, Vincent could not paint in complete calm. His circumstances seemed to change on a daily basis; unable to stay indefinitely at the hospital, but not permitted to return to the Yellow House, he was effectively homeless. The Reverend Salles had suggested he should move.[28] Still smarting from the betrayal of those he thought of as his friends in and around the place Lamartine, Vincent debated the matter with Theo: 'What's new is that I think M. Salles is trying to find me an apartment in another part of town. I approve of that, for in that

way I wouldn't be forced to move house immediately.'[29] He was annoyed that he had to abandon the home where he had invested so much time and money – having the house repainted and the gas installed. He was irked by the idea that someone else would benefit from these improvements. But he couldn't return to place Lamartine – the petition had put paid to that. And patients could not remain at the hospital for longer than three months, unless their medical condition dictated otherwise.[30] Another solution needed to be found.

In mid-April he wrote to Theo, 'I've taken an apartment of two small rooms at six (or eight francs a month, water included) which belongs to M. Rey. It's certainly not expensive, but not nearly as nice as the other studio.'[31] The location of this apartment has never been established. Luckily, Robert Fiengo of the land registry in Arles kindly replied to my request with a reference about Dr Rey, proprietor of 6, rue Rampe du Pont.[32]

Checking the map of Arles with the technical details that the land registry supplied, I realised this flat was on the top floor of Dr Rey's surgery and, coincidentally, was where Irving Stone had gone to see the doctor in 1930. Despite Vincent's great confidence and claims for independence, at the moment he was about to sign for the apartment, he got cold feet. Salles later explained to Theo, 'he was coming to an arrangement with a landlord when all of a sudden he confessed to me that for the time being he did not feel he had the courage to take possession of himself again and that it would be infinitely better for him, that it would be more sensible for him to go and spend two or three months in an asylum'.[33] Vincent was still reeling from the trauma of his breakdowns, which had shocked him and left him weakened. The antagonism of his neighbours further compounded his fragile state. Unable to stay at the hospital, the state asylum was the only option, unless Theo and the Van Gogh family could afford the extra expense of a private institution.

The Reverend Salles began to look for a suitable rest home, eventually finding a sanatorium in Saint-Rémy, not far from Arles, at a cost of 100 francs a month. There was a world of difference in nineteenth-century France between the regional asylum and a private sanatorium. Once you entered the state system it was almost impossible to leave,

and few made it out alive. A private institution would be infinitely better for Vincent, offering him a certain freedom of movement and the ability to paint.

Vincent was now resigned to leaving Arles, writing to Theo:

> At the end of the month I'd still wish to go to the mental hospital at St-Rémy or another institution of that kind, which M. Salles has told me about. Forgive me for not going into details to weigh up the pros and the cons of such a course of action. It would strain my mind a great deal to talk about it. It will, I hope, suffice to say that I feel decidedly incapable of starting to take a new studio again and living there alone, here in Arles or elsewhere – it comes down to the same thing – for the moment – I've nevertheless tried to make up my mind to begin again – for the moment not possible. I'd be afraid of losing the faculty of working, which is coming back to me now, by forcing myself to have a studio, and also having all the other responsibilities on my back.[34]

Now that it was settled that he would leave the city, Van Gogh set about making a record of the place that had been his home over the previous months, painting his view of the courtyard and the *Ward in the Hospital in Arles* towards the end of April 1889. This is a bleak scene: the male patients fully clothed and huddled around the stove for warmth in a vast, echoing room. The staff are stooping and clearly elderly. Next to the stove in the foreground is a coal scuttle, where Van Gogh tried to wash himself during his second breakdown in late December. There's an unabashed quality to his determination to record events – no matter how troubling, traumatic or personal – and the painting can be seen as a memento of his struggles.

'Various letters from Vincent report that he feels very well physically,' Theo told their mother on 5 May. 'He is gradually beginning to realise, however, that he has received a blow and therefore feels the need for treatment.'[35] By the first days of May 1889, with his belongings from the Yellow House now stored with the Ginoux, everything

was organised for his departure from the hospital.[36] Vincent received a note from the Reverend Salles:

> I will be available to take you to Saint-Rémy on Wednesday. If it suits, we'll take the 8.51 train. Having already met Mr Peyron, it'll be best if I accompany you.[37]

On 8 May 1889, Vincent van Gogh arrived at the private sanatorium of Saint-Paul de Mausole in Saint-Rémy – within fifteen short months he would be dead.

CHAPTER 20

Wounded Angel

Late one afternoon my phone rang. 'Madame Murphy?' The voice on the other end was slightly shaky and sounded elderly. The man introduced himself. It turned out that he was the grandson of 'Rachel', to whom I had sent a letter many weeks before. I couldn't quite believe he had called; I had given few details in my letter about the reasons for my interest other than that I had come across her name in relation to Van Gogh, but he said he would be happy to meet me.

So one very hot summer afternoon I set off to meet the elderly man who I hoped would help me solve the enigma of 'Rachel'/'Gaby', the girl Vincent went to see on 23 December. I was welcomed with great kindness. Despite his advanced years, he was full of stories and answered all my questions about Arles before the war. I was desperate to get to the purpose of my visit, but wanted to tread carefully. He spoke fondly about his grandmother, Gabrielle, and with great respect. As we talked he pointed to one of the photographs on the wall – a young couple on a sunny day in Provence. The woman was about thirty, smiling broadly with a warm, friendly face, standing beside an olive tree in a Provençal garden next to a seated man sporting a jaunty hat. I was finally face-to-face with the woman I had been seeking for so long. It was hard to rein in my excitement.

He showed me a second photograph; in this one she was older and looked quite different; with age, her face had become slimmer and more angular, quite different from the plump cheeks of her youth. I was surprised to see her dressed in full Arlésienne costume in both photos, which until our discussion I had believed was worn only on special occasions. He told me that Gabrielle came from a long line of

Arlésiennes, and his grandmother (like her mother before her) wore her traditional costume and dressed her hair in its particular topknot style every day. He told me she had never left Arles, apart from a single trip to Paris for some medical treatment, where she had also gone to see a show with live horses on stage.[1] He couldn't remember the year of the Paris trip, but she had been a young girl, he said.

Finally I took a deep breath and began to explain the reason for my visit. I showed him the family tree I had drawn up and related what little I knew about Gabrielle's life. At last I asked him whether he had ever heard of any connection between his grandmother and Van Gogh. I was in full flow, at the most crucial part of my story, when there was a knock on the door. It was the elderly gentleman's daughter. Until that point he had been expansive and generous with his memories, but with a third person in the room he became quieter, like a child afraid of being chastised for talking too much. I tried to steer the conversation back to Gabrielle. A second knock at the door ended our discussion completely; it was a priest to see him.

I left the sunny room, saying my goodbyes. We kissed each other on the cheek and I promised I would return. The trip hadn't been a waste of time. I had already learned so much. I always knew that confirming Rachel's identity would take a huge amount of patience. I would have to be patient for a while longer.

Women were invariably linked to Van Gogh's breakdowns. Before and after his breakdown in December 1888, Vincent was working on a series of paintings known as *La Berceuse*. These five portraits show Augustine Roulin seated, looking away from the painter, holding onto a length of rope used to rock a cradle and absorbed in something the spectator cannot see – her five-month-old daughter Marcelle. Van Gogh was planning to show the portrait as part of a triptych, between two sunflower paintings, and that motif is continued here. Madame Roulin is positioned in front of a highly decorative wallpaper-like background depicting squashed sunflower blooms. The colours are deliberately strong, reminiscent of *The Night Café* of early September 1888. Van Gogh wrote to Theo in January 1889, decidedly lucid about his intentions with this portrait:

Now it looks, you could say, like a chromolithograph from a penny bazaar. A woman dressed in green with orange hair stands out against a green background with pink flowers. Now these discordant sharps of garish pink, garish orange, garish green, are toned down by flats of reds and greens.[2]

Unlike the portraits of Joseph Roulin, Vincent observes but never engages with his *Berceuse* – she doesn't look out at the viewer – but appears absorbed by the mysterious mother–child bond. These are powerful images, showing Augustine indifferent to anything but her child. When suffering, it is a natural desire to have your mother near you. While painting these works with his mental health in severe decline, Vincent was metaphorically returning to the safety of unconditional maternal love. Augustine Roulin becomes a universal mother – a figure of consolation. Since the cradle is never seen, the viewer takes the place of her beloved child. This was clearly his intention, as he explains to Theo: 'I believe that if one placed this canvas just as it is in a boat, even one of Icelandic fishermen, there would be some who would feel the lullaby in it.'[3]

Mention of lullabies and being rocked by the sea were becoming a recurring theme in Van Gogh's letters and featured in the hallucinations he recounted to Gauguin in early 1889. Hypersensitivity and excessive religious zeal figured throughout Van Gogh's life and were remarked upon by others. In his letter to Albert Aurier following Vincent's first breakdown, Émile Bernard wrote that he showed 'extreme humanity towards women, I have borne witness to sublime scenes of devotion from him'.[4] While a preacher in the Borinage in Belgium, he had given away his clothes to the poor and shocked the church authorities by sleeping on the floor in an effort to emulate Christ. His relationships with women were not straightforward – so often they illustrate his overwhelming desire to be their saviour from distress. A series of women run through Vincent's life story: his landlady's daughter in London who was engaged to another man; his widowed cousin, Kee; Sien, the prostitute, pregnant with another man's child; Margot Begemann, who took poison in Neunen; all of whom Vincent proposed to or considered marrying. Others he

immortalised in paint, such as ex-lover Agostina Segatori, a café owner in Paris, Madame Ginoux and Augustine Roulin. But the most enigmatic of all of them is 'Rachel'. These women tend to fall into two categories: either older mother-figures or wounded angels, that only he could save.

As I studied his breakdowns in Arles, I realised each one seemed to be linked to the women in his life. His first breakdown arrived at its climax when he went to see 'Rachel'. During a visit from Augustine Roulin at the hospital, Vincent had his second breakdown on 27 December and, despite a respite of a few weeks, he suffered his third crisis after going to see 'Rachel' again on 3 February 1889.[5] His final admission to the isolation cell was shortly after Augustine Roulin left Arles in late February 1889.[6] The coincidences are too striking to ignore. It is clear that these women were hugely significant to Vincent van Gogh, but what about the woman linked to his first breakdown: the elusive 'Rachel'?

Something had bothered me since my meeting with Gabrielle's grandson. I was certain that she was my girl. Yet her profile didn't seem to fit with what I knew about the life of a prostitute in the 1880s. From the archives I had learned that it was very hard, if not impossible, ever to leave prostitution. There is a letter in the files in Arles from a baker officially requesting that his sister be released from prostitution, as he could finally take care of her financially. The reply from the official was a succinct 'No, she must remain a prostitute.'[7] As they got older, most of these women ended up as brothel madams. But Gabrielle married and had a child. Something was not right.

To help us respect and understand people of all faiths and nationalities, my father used to say, 'If you are born in a stable you are not necessarily a horse.'[8] As I reviewed once again all the information I had gathered on 'Rachel', it slowly began to dawn on me that I might have made a monumental mistake. Like every other researcher who read the contemporary newspaper story, I had *assumed* that just because Vincent asked for the girl at the door of the brothel, she must have been a prostitute. But what if she wasn't?

I had found Gabrielle by accumulating tiny little details and eliminating other candidates. Although I still believed I had found the real

identity of 'Rachel', there were a number of points that did not fit. My main issue was that Gabrielle would have been too young to be working as a prostitute. The Van Gogh biography by Pierre Leprohon, which also called her Gaby, claimed that 'Rachel' had been just sixteen years old when Vincent delivered his gift. In fact Leprohon had made a slight mistake: Gabrielle had died aged eighty-two, and 23 December 1888 was a few weeks after her nineteenth birthday. Nonetheless, she was still too young to be a prostitute. Moreover it seemed highly improbable that Virginie Chabaud, the proprietress of several brothels in Arles, would run the risk of losing her livelihood by employing underage women illegally.

I returned to the scene itself. Vincent knocked on the door of the House of Tolerance no. 1 in the rue Bout d'Arles on 23 December 1888. It is a tiny street and the brothels were small places with only a few girls each, where men could go for a drink and some company. I realised that in all the reports of that night there was no mention of him actually going *inside* the brothel. The madam's job was to get the men to use her girls. If Van Gogh had requested one of the prostitutes, surely the brothel owner – as a sensible businesswoman – would have persuaded him to come inside? Van Gogh would have been invited in to have a drink and wait or, if the girl was busy with another client, encouraged to spend his time with one of the other girls. This never happened. From all the independent press accounts, Vincent seems to have given his 'present' to the girl in the street outside the brothel. This small point turned the whole story of 23 December completely on its head.

Could Van Gogh have asked for someone other than one of the prostitutes on that fateful winter night? Laure Adler's book on *Maisons de Tolérance – La Vie Quotidienne Dans Les Maisons Closes 1830–1930* – details the other jobs in the brothels: depending on the size of the business, there would be bar staff, doormen, cooks, laundresses and cleaners.[9] The brothels in Arles were so small that these workers probably serviced the whole street, and were employed by the different proprietors. This would explain why 'Rachel' was later recorded as working for M. Louis, whose brothel was next door to Madame Chabaud's.[10]

I went back over every contemporary article about the drama, to remind myself what was said about the person Vincent asked for that night. The evidence was scant, but useful. The same newspaper stringer had written two of the articles I had uncovered and in both newspapers he called the girl 'Rachel'. Vincent was called 'Vaugogh' in the article in *Le Forum Républicain*, and in two accounts he was described as being Polish rather than Dutch – easily explained by the similarity in pronunciation. These press reports were transmitted by telegraph and mistakes were easily made. The name Gabrielle sounds almost the same in French as Rachel. Could an error in pronunciation have occurred in her case, too? The other newspapers didn't mention her name at all, although they provided other details I had previously overlooked. In one of the articles, published on Christmas Day, Vincent went to 'a bawdy house . . . and asked to speak to one of its residents . . . a person came to the door and opened it' – no mention of a prostitute.[11] Gauguin had said that a 'sentry' came to the door, while Émile Bernard called the woman Vincent asked for a 'girl from a café', the term also employed by *Le Petit Provençal*. 'Rachel' was looking less and less like a prostitute. However, Alphonse Robert, the policeman called to the rue Bout d'Arles that night, unequivocally stated 'the name of the prostitute escapes me, her working name was Gaby'.[12] Even though his account was written more than forty years later, by which time Vincent and his ear had become a much-embroidered legend in Arles, it seemed unlikely that the key witness to the events of that night was wrong.

In December 1888, Alphonse Robert had been working as a policeman in Arles for just fifteen months. He was a town official whose role was to patrol and keep the peace. Local statutes outlined the duties of a town policeman: he could stop a criminal *in flagrante*, but he could not undertake an investigation. This meant he practically never entered private premises in Arles. The serious business of policing was left to the gendarmes. Most importantly, he would not have been privy to the official register of prostitutes. Although he would have known all the girls who worked in the area by sight, Robert would have had only superficial dealings with the inhabitants of the red-light district. Unless he used the services of the girls himself,

which is fairly unlikely for a young married man with a small child, he wouldn't have known who did what, inside the brothels of the rue Bout d'Arles.

Something had always bothered me about a phrase of Van Gogh's in his letter of 3 February 1889. Telling Theo that he had gone to see the girl to whom he gave his ear on 23 December, he added, 'people say good things of her'. I had always thought this was a little odd. Would people say 'good things' about a woman who sold her body for a living? It only made sense if she was a local girl who was liked and respected. I began seriously to consider that perhaps she was simply someone Vincent had met locally and become obsessed with, as he had done with so many women. So I spent some days with the prostitutes of 1880s Arles: I checked the women who'd been treated for venereal disease, but Gabrielle wasn't on the list. I checked arrest records, and some of the names correlated with those treated for sexually transmitted diseases, but again she wasn't among them. I checked newspaper reports, illegitimate births and census records again. Still no sign of Gabrielle.

I needed to talk to her family again. I had followed up some of the leads her grandson had given me during our conversation, and had done research into her time in Paris. I thought the family would find this new information interesting. Again I wrote, asking if her grandson would meet me once more. In the intervening period he had fallen ill and had difficulty speaking, and this time his son was there to help.

I reopened our discussion where we had been interrupted. I started by showing them the information I had found out about Gabrielle, including her medical records from Paris. It was exciting to share with them part of their own family history. The elderly man became tired and left me with his son; I was now finally getting to the reason for my interest. He listened to me with great patience, asking questions as I went along. Relying on quotes in Van Gogh's letters and other information I had found, I didn't need to explain much before he suddenly he said to me, 'So "Rachel" is my great-grandmother.'

Sunday 8 January 1888 was a crisp sunny day in the Provençal countryside and Gabrielle's family had gathered for lunch together at the

mas (farmhouse) they owned outside Arles. They were celebrating Gabrielle's younger brother, whose birthday had been a few days before. The party fell on the Epiphany Sunday, traditionally celebrated in Provence with the special *gateau des rois*. During the course of the afternoon a neighbour's dog was seen circling near the group but no one paid it any attention. Then suddenly it jumped up and attacked Gabrielle, biting through the shawl and the sleeve that covered her left arm.[13] She began to bleed profusely. Dog bites were a serious threat – not only could the wound become infected (and without penicillin this was a life-threatening injury), there was also a risk the dog might have rabies. If left untreated an infected patient normally died within three days. A vaccine had been used by Dr Louis Pasteur for the first time less than three years previously and its discovery had been widely reported in the local press in Arles.[14] Gabrielle's family acted quickly. Dr Michel Arnaud, the town's veterinary surgeon, was summoned while a local shepherd shot the dog.[15] The autopsy confirmed that the dog was indeed infected by rabies. Gabrielle's wound was cauterised with a red-hot iron to kill any infection.[16] Cauterisation gave her a better chance of survival but it was still not protection enough. There was no time to waste. A telegram was dispatched to Paris by the doctor, bags were packed and arrangements made so that Gabrielle and her mother could leave Arles for the capital that very night to receive treatment at the Institut Pasteur.

Gabrielle and her mother, dressed in traditional Arlésienne costume, arrived in Paris at 5.40 p.m. the next day. [17] The following morning around 11 a.m. on Tuesday 10 January 1888 they went to Dr Louis Pasteur's surgery located in the Ecole Normale Supérieure building, rue d'Ulm, where Pasteur was director of scientific research.[18] Her medical file provides the details of her treatment – in all she would have 20 doses of the vaccine (made from the live rabies virus) between 10 and 27 January 1888.[19] However, the file shows she was absent from the Institut on 23 January 1888. One night during her stay her mother took her to see Jules Verne's *Michel Strogoff* at the Châtelet Theatre, which ended late at 11.45 p.m.; it was her first experience of the theatre. It's possible this show fell on 22 January and might explain why she missed her injection on the 23rd.

The book and later the film *Lust For Life* has, more than anything else, shaped the public perception of Vincent van Gogh. This 1956 poster from the film's release in France provides the elements of the story that created the myth: the sun-drenched landscape, the woman, the sunflowers and the mad countenance of Kirk Douglas.

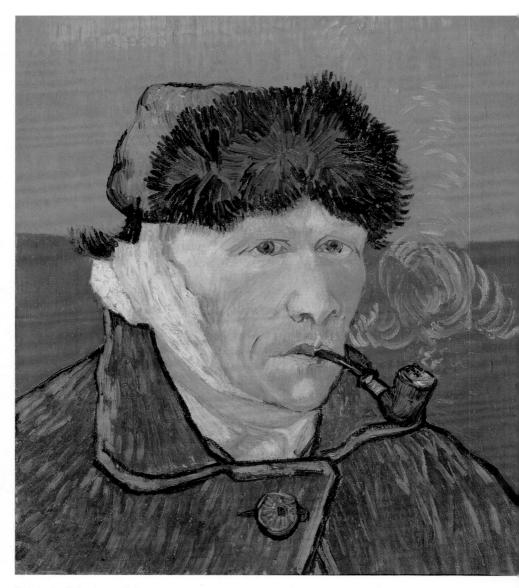

Painted within days of Vincent's return from hospital in the studio of the Yellow House, this *Self-portrait with Bandaged Ear and Pipe* was painted on or around 8 or 9 January 1889. The thick wadding on the ear and the bandaging held in place the oil-silk dressing that treated the self-inflicted wound.

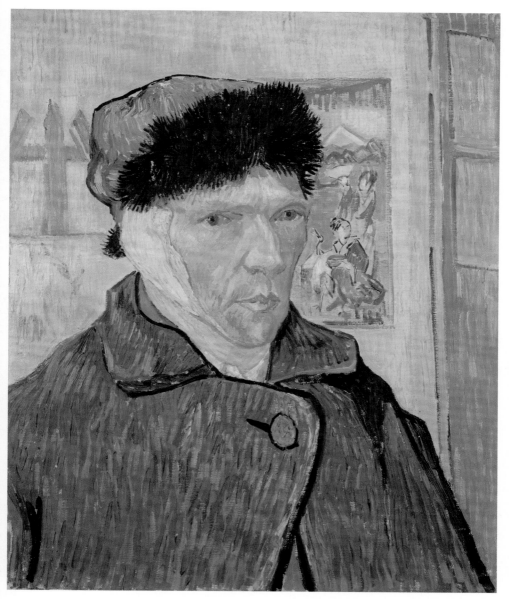

Painted about a week later, around 17 January 1889, *Self-portrait with Bandaged Ear* shows a different, flatter bandage, indicating that Vincent's wound was on the mend. Painted downstairs in the Yellow House studio, the Japanese print shown in the background, *Geishas in a Landscape* by Sato Torakiyo, was known to have been part of Vincent's personal collection.

The Ward in the Hospital records where Vincent had been living for some months, the large draughty male ward at Arles hospital. He appears to have included himself in the picture, reading a newspaper and wearing a straw hat, with a band around his head, exactly as Paul Signac had described seeing him a month previously.

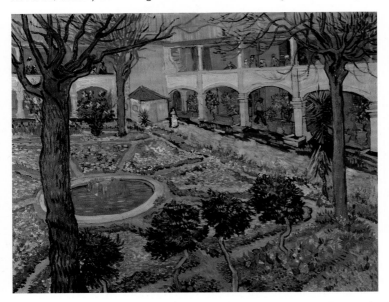

The Courtyard of the Hospital in Arles gives a clear view across the garden to the terrace of the male ward where Vincent stayed in 1889. Painted shortly before he left the hospital in Saint-Rémy, these two large paintings of the hospital form a diptych, and a souvenir of his last home in Arles.

Painted in late January 1889, this still life references some of Vincent's preoccupations once he returned to the Yellow House after his first breakdown: a medical dictionary and an envelope addressed to him – probably the announcement of Theo's engagement, which arrived on 23 December 1888.

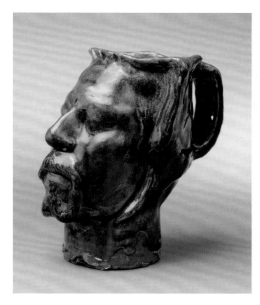

Modelled in early 1889, this enigmatic jug is a self-portrait by Paul Gauguin. The deep red colour in the firing appears to show blood running down the face and intriguingly, Gauguin's portrays himself with no ears.

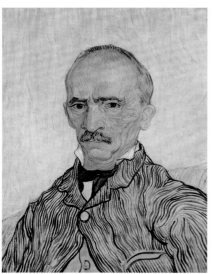

Painted in June 1889, *Starry Night* was a composition from memory, like many of his paintings from Saint-Rém and seems to capture the trajectory of stars in the sky. Although it is one of Vincent's most iconic works, he was dissatisfied with it and repainted it many times before sending it to Theo.

Vincent painted the fifty-nine-year-old hospital orderly *Charles-Elzéard Trabuc* whilst still a patient at the asylur in Saint-Rémy. Trabuc was probably the person who accompanied Vincent on his return visits to Arles.

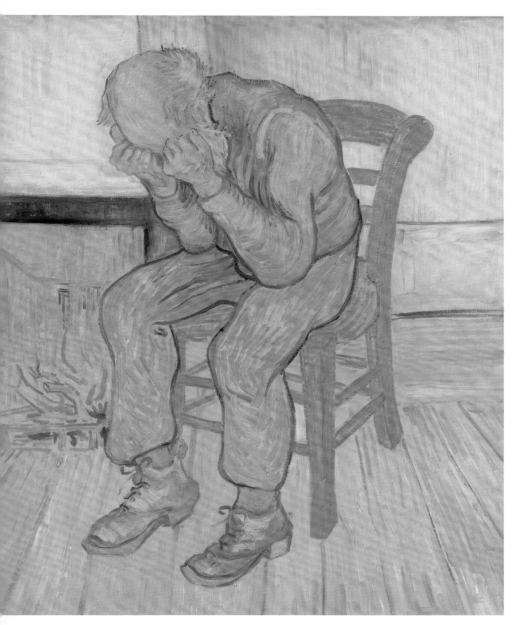

Painted shortly before Vincent left the asylum in May 1890, this simple scene of the old man with his head in his hands has an air of quiet desperation. Vincent had made similar studies in the past, but the date of this work, shortly before his suicide, makes this portrait particularly poignant.

Perhaps one of Vincent's most elegiac paintings, this large canvas was made as a spontaneou[s] gift to celebrate the birth of his nephew, Theo's son Vincent Willem, in early 1890. At the time V[an] Gogh was in the midst of a series of successive breakdowns, and had only a fragile grasp on hi[s] own stability and mental health, yet created this masterpiece.

Gabrielle was extremely impressed by what she had seen, so far from the simpler life in Arles to which she was accustomed, and she later described to her grandson the series of tableaux on stage, with 'real horses and mirrors' that created the effect of a whole army.[20] She had her last inoculation on 27 January 1888 before returning to Arles. She never went to Paris again. The family had spent a lot of money on saving her life and on her return home she began working as a cleaner to help pay for her expensive treatment and save up for little treats.[21] It's possible that she found her job in the rue Bout d'Arles through her cousins who lived nearby.

'Rachel' was slowly coming into focus. Before her marriage my 'Rachel' – Gabrielle – worked as a maid in the brothels during the night, and in the early morning she cleaned business premises on the place Lamartine. The neighbourhood was close-knit and familiar, and Vincent must have seen her almost every day. Yet this still sheds no light on why he would choose to give her his ear. The clue came in the words Vincent said to 'Rachel' on 23 December, which were repeated in various forms in almost all accounts of the drama: in Gauguin's account, Vincent apparently said, 'Here you are . . . a memory of me.' At first this made no sense to me. Some journalists repeated what Vincent had said, and although the wording varied from writer to writer, the meaning was the same: take great care of this for me. The local newspaper in Arles, Le Forum Républicain, quotes Vincent as saying, 'Take this and keep it preciously,' while the Le Petit Provençal newspaper states, 'Take this, it will be of use to you.'[22] Vincent was giving the young woman something he considered extremely important. But why part of his body? And why her?

Following her accident Gabrielle was left with a significant scar that was clearly visible, even under her Arlésienne costume. As she had never been to Paris before January 1888, nor did she ever go there again, I wondered if Van Gogh met her there shortly before he left the capital. Less than three weeks after she returned south, he turned up in Arles. Two women dressed in full Arlésienne costume would have been an unusual sight in Paris at the time. However, the Institut Pasteur was south of the River Seine close to the Luxembourg Gardens.

Vincent lived north of the river, so although this theory would be delightfully neat, it seemed rather unlikely. Still, he does mention the Institut Pasteur twice in his letters, most significantly in July 1888: 'Certainly these ladies are much more harmful . . . than the citizens bitten by rabid dogs who live at the Institut Pasteur.'[23]

A more likely explanation lay in Vincent's recorded obsession with religion in the days leading up to 23 December. In Gauguin's account, as told to Émile Bernard, Vincent was 'reading the Bible and giving sermons in all the wrong places and to the most vile people, my dear friend had come to believe himself a Christ, a God'. It may seem a stretch, but I would suggest that in Van Gogh's heightened state he gave the girl part of his own healthy body to replace her damaged flesh, and that the words he spoke that night recalled those of Christ at the Last Supper: 'This is my body . . . do this in memory of me.'

Gabrielle was indeed at the House of Tolerance no. 1 on the night of 23 December 1888, but she was not working as a prostitute. She was changing the sheets and washing the glasses. When Vincent appeared at the brothel that rainy night, I can only imagine the shock for the poor young woman – a frenzied man comes to her place of work and hands her a sinister gift. It is no surprise she fainted. Van Gogh had a great capacity for kindness, especially for anyone he considered less fortunate than himself; he would have been touched by the meek girl he saw working so hard, with such meagre reward. He would have been moved by her damaged arm. She was exactly the sort of woman he was attracted to – a wounded angel he thought he could save.

At my request, her family kindly met me again. In the intervening months one of them had gone on a guided visit of a Van Gogh exhibition and had been outraged by what was being said by the guides about the 'prostitute to whom Vincent gave his ear'. The family could not equate what had been said about the mysterious 'Rachel' with the woman they knew and loved. The perfume of scandal associated with the story scared the whole family. Devastated that her memory would be soiled, they begged me not to reveal her identity. I tried to persuade them otherwise, reasoning that my work would actually change the public's perception of the girl to whom Vincent gave his

ear. But her family were truly upset and I made a promise: until I am given permission by the family to reveal her surname, I will respect their wishes and keep it private.

Van Gogh's act of self-harm has always been the ultimate justification of his madness. Taking his ear to a prostitute has fuelled the legend of a wayward, bohemian painter who hung around with shady individuals and was irredeemably crazy. I can't pass judgement on him mutilating his ear. Of course it cannot be interpreted as the behaviour of a sane individual, indeed, his 'gift' was certainly perceived by the girl and the police as the act of a madman and reported as such by the press at the time. But giving his ear to 'Rachel' was part of a continuum of behaviour that had been gathering momentum throughout his adult life. Van Gogh rarely did things by half-measures. Set in the context of his past – thrusting his hand over the flame in Holland, giving away all his clothes to the poor in Belgium – his extreme behaviour in Arles looks less like a single crazy episode than an act of desperation by someone profoundly unwell. He was impetuous, intense, yet at the same time oversensitive and deeply empathic. Living mostly on his own, these traits remained unchecked. Clearly driven by his mental illness, nonetheless the motivation behind his actions was kindly intended and, within the parameters of his unbalanced mind, quite lucid.

Lust is often evoked as one of the reasons behind Vincent's self-harm. Although it cannot be excluded entirely, there seems to be little evidence for this. Émile Bernard's remark about witnessing Vincent's 'sublime scenes of devotion' towards women, and his close bonds with Madame Ginoux and Augustine Roulin amongst others, may have had a sexual basis, though they appear to be based on admiration or devotion rather than desire. Indeed, I think it doubtful that the mousmé's family would have let their daughter sit for hours on end with Vincent at the Yellow House if there was anything inappropriate or sexual in his behaviour towards the young girl. The discovery of the true identity of 'Rachel' surely alters how Van Gogh is perceived. Vincent didn't go to the Maison de Tolérance on a whim that night and he does not appear to have been motivated simply by lust. This girl was someone he knew, someone he appeared to sympathise with. I

believe that giving her the gift – part of his own flesh – was done out of genuine concern and tenderness for the young woman. The act was guided and influenced by his diminished mental state, of course, but no less noble for that.

Around 11.20 p.m. on 23 December 1888, Van Gogh set off from the Yellow House on an altruistic mission – to bring succour to a young woman in need; to help in his own particular deluded way, a wounded angel.

CHAPTER 21

Troubled Genes

I the undersigned, Doctor of Medicine, Director of the Saint-Rémy mental home, certify that the man named Vincent van Gogh, aged 36, a native of Holland and at present domiciled in Arles (Bouches-du-Rhône), under treatment at this city's infirmary, suffered an attack of acute mania with visual and auditory hallucinations that led him to mutilate himself by cutting off his ear. Today he appears to have regained his reason, but he does not feel that he has the strength or the courage to live independently and has himself asked to be admitted to the home. Based on all the above, I consider that M. Van Gogh is subject to attacks of epilepsy, separated by long intervals, and that it is advisable to place him under long-term observation in the institution.[1]

Dr Théophile Peyron, patient notes, 9 May 1889

Since no hospital records exist from his time in Arles, this is the only medical diagnosis we have of Van Gogh's illness. Dr Peyron gave further information, in particular mentioning that although Vincent had indeed cut off his left ear, 'he is not aware of it', noting that 'he has no more than a vague memory' of the incident. He reiterated that Vincent was 'terrified' by his visual and auditory hallucinations. In his first letters after his breakdown, Van Gogh had written several times about things he saw – in particular visions of the Horla, Maupassant's haunting spectre, and the sea – imagery also mentioned by Gauguin in his notes and description of Vincent in the midst of his crisis.

There was little that could be done to help people suffering from

mental distress in the late 1880s. Van Gogh's situation was not new; his family had been well aware of his problems since he was a teenager, trying to get him sectioned as early as 1870, when he was only seventeen years old. Throughout the correspondence from the wider family there are remarks that indicate everyone knew Vincent was unwell. Speaking after his death, one of his cousins wrote to Theo's wife, Jo: 'I and many in the family regarded it as a relief rather than a misfortune.'[2]

In France in the late nineteenth century all psychiatric disorders were gathered under the general term of 'epilepsy'. During his lifetime this was the only diagnosis ever given to Vincent. For many years, suspicious of the seeming inaccuracy of nineteenth-century doctors in their diagnosis of mental-health problems, biographers and historians rejected epilepsy as a cause for Van Gogh's ills. But Vincent wasn't the only member of his family to have some form of psychiatric illness, as his conversations with the doctors at Saint-Rémy indicate:

> He tells us that his mother's sister was Epileptic, and that there are several cases in his family. What has happened to this patient may be no more than a continuation of what has happened to several members of his family. He tried to resume his normal life when he left the infirmary in Arles, but he was forced to return there after two days because he was again experiencing bizarre sensations and bad dreams during the night.[3]

There are numerous examples of Vincent seeing psychiatric problems in the people around him – Gauguin and Mourier-Petersen, for example – but this quote from his medical file was the first acknowledgement from Van Gogh himself that mental illness occurred in his family.

The problem appears to have come through the maternal line. Van Gogh's mother, Anna, had all her children quite late in life – she was thirty-three years old when she gave birth to Vincent and almost forty-eight when her youngest child, Cornelius ('Cor'), was born. Anna's sister, Clara Adriana Carbentus, who died when Vincent was thirteen, was the epileptic aunt whom Vincent mentioned to Dr Peyron.[4] There

is strong evidence of hereditary psychiatric problems in the Van Gogh family: of the six children to reach adulthood, four suffered from problems with their mental health. The two other sisters showed no signs of troubled mental health. This high proportion of psychiatric issues in a relatively small family seems to have been largely overlooked in academic papers on Vincent's illness. In addition to Vincent's breakdowns and subsequent suicide, Willemien entered an asylum in December 1902 and died there in 1941. And Cornelius is believed to have committed suicide in South Africa in 1900. Theo's illness is, however, a case apart. Although he had a complete mental breakdown within a month of Vincent's death and died in an asylum in Holland six months later, he was diagnosed as suffering from cerebral syphilis, for which there was no treatment in the nineteenth century.

Whatever Vincent was suffering from, he was profoundly lucid about his own problems: 'As it's still winter, listen. Let me quietly continue my work, if it's that of a madman, well, too bad. Then I can't do anything about it.' And he continued, referring directly to the symptoms that plagued him so terribly: 'the unbearable hallucinations have stopped for now, reducing themselves to a simple nightmare on account of taking potassium bromide, I think'.[5] This letter, from January 1889, is the first time that medical treatment for Vincent's illness was mentioned. Potassium bromide was prescribed as a sedative for patients who suffered from seizures. However, if repeatedly ingested, it could provoke 'depression with loss of muscle control, hallucinations, eye disturbances, irritability, psychoses and memory loss'.[6]

For researchers into his mental-health problems, details of Vincent's illness must be gleaned from his letters or the few medical notes that remain, all of which date from his time in Saint-Rémy. Putting together a list of symptoms is a frustrating task. From Vincent's letters and patient notes, we know he was suffering from hallucinations that were both visual and auditory. The Reverend Salles provided a description of these, telling Theo in his letter of 7 February 1889 that Vincent suffered from paranoid delusions that he was being poisoned.[7] Vincent is also recorded as being incoherent, with jumbled speech and confused thoughts. There were also incidents of mania and confusion:

in Saint-Rémy he was seen trying to eat tubes of paint and Signac recalled that Van Gogh had tried to drink turpentine while showing him his paintings in the Yellow House.[8] Some of his symptoms – hearing voices and seeing visions – are confirmed by the jottings in Gauguin's sketchbook in the lead-up to his first breakdown. In particular, Gauguin's use of the word 'Ictus' twice in the sketchbook, and again as a doodle on a letter from Vincent that he received soon after the drama. This would seem to confirm that Gauguin had witnessed Van Gogh having some kind of fit and explains the treatment to control seizures adminstered to Vincent.[9]

Despite the paucity of knowledge, his madness never ceases to fascinate. Since the 1920s several hundred academic papers have been published on the subject. Reading them is an exasperating exercise, as his recorded symptoms could fit a wide variety of psychiatric conditions. In 1991 an American doctor, Russell R. Monroe, analysed 152 academic papers written between 1922 and 1981 about Van Gogh's illness.[10] The most frequent conclusions were that Vincent was suffering from epilepsy (fifty-five times), psychosis (forty-one), schizophrenia (thirteen), character/personality disorder (ten) and bipolar disorder (nine). Amongst the many other pathologies that fit Vincent's symptoms is acute intermittent porphyria, the hereditary disease that made King George III go mad. The only real point that can be established with any accuracy is the genetic factor behind his mental health, as Vincent told his doctor in Saint-Rémy. In addition to the examples from Vincent's nuclear family, there seem to be cases much further down the family line.

Modern interpretations of Vincent van Gogh's problems are subject to changing fashions in diagnoses as well as the geographical location of the writer. When psychiatric analysis took off, there were various different schools of thought about Vincent's health issues. Many academic articles refer to a key paper on Van Gogh and his illness written by French neurologist Henri Gastaut in 1956. One of the leading specialists in epilepsy at the time, Gastaut described Van Gogh having a seizure, apparently witnessed by a hospital orderly in Saint-Rémy.[11] Unfortunately, Gastaut lost the text of this interview, so there is no corroboration of the incident.[12] The neurologist diagnosed Van

Gogh with temporal lobe epilepsy, exacerbated by the use of absinthe. This form of epilepsy embodies his principal recorded symptoms – auditory and visual hallucinations – and can be genetically transmitted.

Many articles about Van Gogh's 'madness' refer to his suggested alcoholism. In the first academic article ever written on his illness, penned by French doctors Doiteau and Leroy in 1936, the idea that Vincent drank 'too much absinthe' was reiterated, as well as the excessive use of stimulants: coffee and tobacco.[13] More recently it was suggested to me that Vincent could have been suffering from schizo-affective disorder, which also embodies many of these symptoms.[14] In addition, much has been made of the fact that he was born a year to the day after a stillborn child also called Vincent Willem van Gogh, and the heavy psychological implications of being a replacement for another child.[15]

Non-medical reasons have also been suggested for Van Gogh committing such a unique act of self-harm. These, too, have found a public. Vincent 'hated' his mother, father, all women, and so on; or he was suffering from 'penis envy' of Gauguin, who was more successful with women. There is also a theory that he was inspired to cut off his ear by Jack the Ripper, whose murders of prostitutes took place in the autumn of 1888, just a few months before Van Gogh's breakdown – not quite as outlandish as it sounds, since Jack the Ripper cut off the ears of two of his victims, which was widely reported by the press in France.[16] It has also been suggested that Van Gogh was influenced by St Peter, who sliced the ear off a Roman soldier at the moment that Jesus was arrested in the Garden of Gethsemane. A fervent admirer of Giotto, Vincent would probably have been familiar with his famous image of the scene from the Scrovegni Chapel in Padua. Van Gogh's letters immediately after the drama certainly indicate that, like Jesus, he felt betrayed – especially by Gauguin.

Since none of these suggestions can be proved irrefutably, understanding what disorder Van Gogh suffered from quickly becomes a labyrinth of dead ends. As I studied each of these complicated illnesses in depth, I realised I was getting distracted. I'm no doctor; I needed to rely on expert opinion, not conjecture. An expert was recommended to me by the Van Gogh Museum, Dr Piet Voskuil, a Dutch neurologist

and expert in epilepsy who has studied Van Gogh's pathology in depth. He warned me to be circumspect when analysing medical hypotheses and theories about Van Gogh. To a specialist in ear, nose and throat disorders, he pointed out, it will seem that he was suffering from Ménière's disease (tinnitus), for example.[17] A psychiatrist will make a psychiatric diagnosis; a neurologist will find a neurological disorder; and so on. Each expert can find something in Vincent's symptoms to support their theory.

Epilepsy is one of the earliest-recorded pathologies, with the first-ever recorded seizure around 2000 BC.[18] It was believed by the ancient Romans to be a curse from the gods, and the first treatment for epilepsy came in the mid-nineteenth century with the use of bromide to control seizures. Being the most up-to-date treatment available, this compound was naturally administered to Van Gogh. Because epilepsy was considered a general term for all psychiatric illness, for many years it was overlooked as a possible reason for his behaviour. Yet there is good evidence to support the theory that epilepsy was indeed at the root of Vincent's mental distress. Heredity is now believed to be involved in the majority of cases of epilepsy, either directly due to genetic disposition or indirectly – for example, through childhood trauma. Given that other Van Gogh siblings seem to have suffered from mental illness, there has been speculation that Vincent experienced head-trauma during birth, which can provoke the illness. Similarly, the suicide rate of epileptics is significantly higher than it is among the general population.[19] Seizures – so often associated with the illness – can be full-blown, partial or even absent in patients, who are nonetheless still diagnosed as being epileptic.

Each form of epilepsy has its own pathology. 'Grand mal' seizures are the ones we recognise – patients have convulsions, shake violently and lose consciousness or fall into a semi-conscious state. Most patients describe partial seizure attacks that are preceded by an *aura*, a sensation of dizziness and the feeling of déjà vu.[20] Partial seizures have a wide variety of symptoms, including sudden and inexplicable feelings of fear or anger, sensory illusions, hallucinations, delusions and laboured speech. The hallucinations are slightly different from those experienced by psychotic patients, in that epileptics are aware that the

hallucinations are not real. The so-called 'absent seizures' are more subtle, sometimes almost imperceptible – hence the name – and are occasionally characterised by jerking movements or blinking of the eyes. Gauguin, amongst others, spoke about Vincent's particularly strange, uneven way of walking, and both Adeline Ravoux in Auvers (daughter of the owners of the inn where Van Gogh lodged) and Dr Rey in Arles commented that Vincent blinked rapidly as he worked. In the wider Van Gogh family there is evidence of a disposition for cerebral-vascular strokes, which were similarly interpreted as seizures by those who saw them.[21] Without a brain scan or detailed medical notes and history, it is impossible to be totally certain of what was truly the cause of his troubles. But, after looking at all the evidence, I can only concur with the Van Gogh Museum's theory that it seems most likely that he was suffering from some form of epilepsy, perhaps combined with schizophrenia or bipolar disorder.

CHAPTER 22

'The Certainty of Unhappiness'

That Sunday he went out immediately after lunch, which was unusual. At dusk he had not returned, which surprised us very much . . . When we saw Vincent arrive night had fallen, it must have been about nine o'clock. Vincent walked bent, holding his stomach, again exaggerating his habit of holding one shoulder higher than the other. Mother asked him: 'Monsieur Vincent, we were anxious, we are happy to see you return; have you had a problem?' . . . 'No, but I have . . .' he did not finish, crossed the hall, took the staircase and climbed to his bedroom . . . Vincent made such a strange impression on us that Father got up and went to the staircase to see if he could hear anything. Thinking that he could hear groans, [he] went up quickly and found Vincent on his bed, laid down in a foetal position, knees up to the chin, moaning loudly. 'What's the matter?' said Father. 'Are you ill?' Vincent then lifted his shirt and showed him a small wound in the region of the heart. Father cried: 'Oh no! what have you done?' 'I have tried to kill myself,' replied Van Gogh.[1]

The circumstances surrounding Vincent's death have been the source of much debate in recent years. In 2011 Steven Naifeh and Gregory White Smith suggested in their biography of Van Gogh that he was killed by a group of teenagers in Auvers-sur-Oise.[2] This sensational story of the 'murder of Van Gogh' was nothing new; it has long been a rumour in Auvers. Naifeh and Smith claimed to have identified the perpetrators, thanks to an interview given in 1957 and published by

Victor Doiteau.[3] The article never actually mentions murder; it simply states that the boys had known Van Gogh; indeed the interviewee, René Sécretan, never questions his suicide. The Van Gogh Museum refuted Naifeh and Smith's theory in an article published in 2013.[4]

Although I have not personally investigated this aspect of the story, Vincent van Gogh was a man with suicidal tendencies. Adeline Ravoux's testimony of the events of 27 July quoted above was not the only account which claimed that Vincent had died by his own hand. Before his death, the police went to the Auberge Ravoux to interview Van Gogh and when asked if anyone else had been involved Vincent clearly stated that he intended to take his own life.[5] Furthermore, the priest of Notre Dame d'Auvers-sur-Oise, discovering the cause of death at the last minute – suicide being against the tenets of the Church – refused to hold a religious ceremony for Vincent's funeral.[6] There is no reason to doubt that Van Gogh committed suicide on 27 July 1890. The question then becomes: what led Vincent to take such a desperate step?

Van Gogh's life had been on an ever-descending downward spiral since he left Arles on 8 May 1889 for the Hôpital de Saint-Paul de Mausole, a thirteenth-century monastery situated to the south of Saint-Rémy. Knowledge of mental health was so rudimentary that no specialised study was required for the post of director of the asylum. In 1889 the institution was being run by Dr Théophile Peyron, who had trained as an ophthalmologist.[7] This wasn't a particular hindrance, in fact, as in 1889 the only treatment available for mental illness was bromide, which sedated the patients. Vincent had hoped that by moving into the asylum his illness would be better controlled. Soon he was forced to acknowledge that there would be no quick fix to his woes. The asylum was a rude awakening from the relative calm of the hospital in Arles – he was now living in a madhouse. He wrote to Theo and his new wife, describing the 'shouts and terrible howls as though animals in a menagerie'.[8]

Aware that he was a huge financial burden for his brother, Vincent fretted, 'it makes me very worried when I tell myself that I've done so many paintings and drawings without ever selling any'.[9] This worry would be constantly in the background in the following months, growing like a cancer. Yet one of his paintings completed during the first week at the sanatorium would later be one of the most expensive

paintings ever sold, when it was auctioned off in 1989: *The Irises*.
Amongst the deep purple and green of these wild flowers, seen all
over Provence, is a lone white iris.[10] This notion of being apart or
somehow different became more pronounced in the paintings of Van
Gogh's last year. His style changed and he began using a more muted
palette, particularly less of the bright yellow that had characterised
the works before his first breakdown. Not always able to venture far
from the confines of the hospital, he painted the surrounding natural
world: 'funereal' cypress trees, olive groves and the mysterious under-
growth in the asylum's grounds. In these works the paint was often
applied thickly and seemingly in a very agitated manner. The trees
– accentuated by expressionist swirls in the sky – appear to be moving
in the wind. It was all a far cry from the joyous, calm brushstrokes
seen in his works of springtime the previous year.

In Arles he had lived in the middle of a town, surrounded by build-
ings and the light reverberation from street lamps. The hospital of
Saint-Paul de Mausole is on a hill, just over a mile from town. It is
now close to the site of an archaeological dig, but in Vincent's day
there were just farms and fields around. After his breakdown Vincent
often mentioned that he did not sleep well, taking camphor to help
him rest when in Arles. On clear nights, with nothing to disturb the
view in Saint-Rémy, Van Gogh could lie in his bed and observe the
trajectory of millions of stars.

Provence has the most extraordinary clarity at night. There is nothing
that can compare to it. With no cloud cover and all the dust blown away
by the wind, I have witnessed the most beautiful night-skies here. On
certain nights it seems as if it is still daylight, with strong shadows created
by the moon. The sky is peppered with stars in the far-off galaxies
twinkling brightly; it is an awe-inspiring and truly spectacular sight.

In June 1889 the full moon occurred on the 13th, with the mistral blowing
from 15 to 17 June.[11] Around these dates, sometime before dawn and unable
to sleep, Van Gogh planned a scene showing the stars seemingly travelling
through the night sky. In the nineteenth century galaxies were referred to
as *spiral nebulae*, and there were numerous illustrations in scientific journals
of whirlpool-like constellations. Van Gogh was an avid reader and the
images may have been familiar as the spiral nebulae drawings look very

Illustration of spiral nebulae, William Parsons, 3rd Earl Rose, 1861

similar to the forms shown in some of his most famous paintings.[12]

In his ground-floor studio he transformed this plan into the iconic work *Starry Night*.[13] Vincent remained dissatisfied, feeling that he had failed in what he wanted to achieve; he repainted *Starry Night* several times, only sending it to Theo much later in the year.

In early July, Vincent's new sister-in-law Jo wrote warmly to announce that she was pregnant.[14] He wrote back immediately to congratulate the couple. This happy news coincided with a trip to Arles. He had things to collect there and he desperately wanted to see his friends, the Reverend Salles and Félix Rey. But in his congratulatory letter his agitation was manifest: he rambled on, changing subject matter in the same sentence and musing on writers and painters. Theo, who had been preoccupied with health issues of his own, sent a telegram to the hospital in early August, having had no news from Vincent for more than two weeks. Shortly after returning from Arles, around 16 or 17 July, Vincent experienced a major breakdown with horrible hallucinations – his worst yet. With great tenderness Theo wrote to Vincent on 4 August 1889, 'Don't lose heart, and remember that I need you so much,' which indicates that Van Gogh had suicidal thoughts at least a year before his death.[15] This was confirmed by Dr Peyron when Vincent's crisis abated. 'His ideas of suicide have disappeared; there remain only his bad dreams.'[16] By this time he had been confined to his room, unable to work, for six long weeks.[17]

Returning to Arles was more than a simple visit. During the ensuing year it was to become a trigger for Vincent's breakdowns. Throughout the autumn and early winter of 1889, still wrestling with his troubled mind and unable to leave his room, Vincent began to revisit Arles

metaphorically in his paintings. He repainted a version of his bedroom at the Yellow House, and five portraits of Madame Ginoux as *L'Arlésienne*. His letters remained very depressed in tone, dwelling on the notion of fatality. Theo had sent Vincent some money so that he could return to Arles in early September, but he was still very apprehensive about going. 'First we'll see a little if this journey might provoke another crisis.'[18] It was only towards the end of November that he felt able to go back, spending two days in the city. It is obvious from his letters that he hoped to return to live in Arles one day. The city became an objective, or the embodiment of a happy past and a possible future: it was where he had started to realise his dream of creating a fraternity of like-minded painters while living with Gauguin, as well as representing a kind of normality and independent life.

Just before Christmas 1889, Vincent wrote to his mother, berating himself for causing his own illness and admitting that he should have allowed himself to be treated earlier. On 23 December – significantly, the anniversary of his first attack – he tried to poison himself by eating paint.[19] Once recovered, he told Theo that he had been 'quite disturbed' for a week:

> Ah, while I was ill, damp, melting snow was falling, I got up in the night to look at the landscape – never, never has nature appeared so touching and so sensitive to me.
>
> The relatively superstitious ideas people have here about painting make me more melancholy than I could tell you sometimes, because there's always basically some truth in it that as a man a painter is too absorbed by what his eyes see and doesn't have enough mastery of the rest of his life.[20]

Poor Theo, eagerly awaiting the birth of his first child, was distraught on hearing this and wrote to Reverend Salles, who travelled over to Saint-Rémy to see Van Gogh. He found Vincent painting frenetically; according to Vincent it was inactivity that was responsible for the other patients' poor mental health.[21] He was again showing signs of the hypersensitivity and paranoia that seemed to pre-empt all his breakdowns.

In mid-January 1890 he returned to Arles to sort out his furniture, which was still with the Ginoux at the Café de la Gare. This trip was delayed for a few days because Madame Ginoux was ill with 'a rather worrying nervous complication, and a distressing change of life', according to Vincent.[22] It seems unlikely that Madame Ginoux, at just forty-one years of age, was undergoing the menopause or that Vincent would even have been told about it. It is much more probable that yet again this was his own interpretation of the situation. By imagining that other people close to him were also ill, he could better accept and control his own problems. Projecting his illness onto others in this way – everyone else around him was 'a little cracked' – made Vincent feel that he was normal. Two days after returning to the asylum he wrote to the couple in Arles:

> I don't know if you'll remember, I find it quite strange, that about a year ago Mme Ginoux was ill at the same time as I was; and now it has been so again since – just around Christmas – for a few days I was again taken quite badly this year, however it was over very quickly; I had it less than a week. Since, therefore, my dear friends, we sometimes suffer together, it makes me think of what Mme Ginoux said – 'when people are friends they're that way for a long time'.[23]

Despite the letter's light tone regarding his crisis – 'I had it less than a week' – Vincent continued obsessively discussing illness in this letter, and the same day he had another attack.

Van Gogh was obsessive, a trait that became more acute as his mental health declined. Knowing that his visits to Arles affected his health, his return trips were almost masochistic. He wrote to his sister about a proposed visit to Arles, 'to see if I can bear the journey and ordinary life without the attacks recurring'.[24] He obsessed even to Gauguin, who cautioned, 'You say yourself that memories disturb you when you go to Arles.'[25] Vincent was testing himself, to see whether he could vanquish his demons. But the city was like a drug and he couldn't stay away.

Professionally speaking, 1890 began auspiciously. The first article

on Van Gogh, written by Émile Bernard's friend Albert Aurier, appeared in January's edition of *La Mercure de France*, a well-respected art magazine. A month later *The Red Vineyard*, one of his paintings from Arles, was purchased by Anna Boch, the sister of his friend Eugène, for 400 francs.[26] There was more good news: Jo gave birth to a son on 31 January 1890, whom they called Vincent Willem in honour of Vincent, who was made the baby's godfather. Although still painting furiously and constantly struggling with his mental health, he managed to create one of his most beautiful works, *Almond Blossom,* for the birth of his godson. 'I started right away to make a painting for him, to hang in their bedroom. Large branches of white almond blossom against a blue sky.'[27]

As she continued to be unwell, Madame Ginoux was much in Vincent's thoughts. He was in the middle of painting a portrait of her and was planning a visit to see her. Unfortunately, on this visit to Arles in February he suffered another breakdown and had to be returned to the hospital in Saint-Rémy. As he tried to understand why his reason failed him, Van Gogh wrote:

> Work was going well, the last canvas of the branches in blossom, you'll see that it was perhaps the most patiently worked, best thing I had done, painted with calm and a greater sureness of touch. And the next day done like a brute.[28]

The birth of Theo's baby underlined for Vincent his anxieties about being a burden. Not only did his brother have to face the obvious extra expense of a new baby, but he too was suffering from ill health. Vincent was aware that Theo worried about him constantly, but there was little he could do about it. Throughout the late spring of 1890, Van Gogh was plagued by negative thoughts – his paintings were worth little, he claimed, and 'a cry of anguish'.[29] Despite Aurier's favourable article praising his 'strange, intense and feverish work', within a few months Vincent was writing to Theo:

> Please ask M. Aurier not to write any more articles about my painting, tell him earnestly that first he is wrong about me, then

that really I feel too damaged by grief to be able to face up to publicity. Making paintings distracts me – but if I hear talk of them that pains me more than he knows.[30]

On 30 March 1890, Vincent had his thirty-seventh birthday. Jo and Theo wrote with love, but he did not reply. Dr Peyron informed Theo the following day that:

This attack is taking longer to subside than the previous ones; at times it's as if he's going to be himself again; he's aware of the sensations he's experiencing, then a few hours later the scene changes, the patient becomes sad and anxious again and no longer answers the questions put to him. I'm confident that he'll regain his reason as on other occasions, but it's taking much longer to come about.[31]

Theo patiently continued to write, trying to cheer up his brother by passing on compliments from Monet on Vincent's paintings from Provence. On 1 May, Van Gogh finally resurfaced, to send Theo his best wishes for his birthday. During this most recent crisis he hadn't been able to work for almost two months and in his letter, Vincent was very subdued, thanking his brother for all his kindnesses to him, 'for without you I would be most unhappy'.[32] Two days later he announced his decision to leave Saint-Rémy:

The unfortunate thing is that the people here are too curious, idle and ignorant about *painting* for it to be possible for me to practise my profession . . . you propose coming back to the north, and I accept.[33]

From the brothers' correspondence it is clear he had begun to moot the idea of leaving Provence for some time, and wrote as early as November 1889, 'in springtime it would however be good to come in any event to see the people and things of the north again'.[34] By the late spring of 1890, Vincent began to put his affairs in order, contacting friends and giving works away. He received a touching

letter from Roulin, who was sad to see him leave the south.[35] Writing
to his sister, asking her to ensure that certain people he cared for got
one of his paintings, Vincent told her that he wasn't 'a lunatic but
that the crises I have are of an epileptic nature. So it isn't alcohol
either that was the cause . . . But how difficult it is, how difficult it
is to resume one's ordinary life without being absolutely too demor-
alised by the certainty of unhappiness. And one clings on to the
affections of the past.'[36] These 'affections of the past' were his friends
and his life in Arles.

During the fifteen months he spent in Saint-Rémy he experienced
four serious breakdowns and was incapacitated through illness for
around eighty-seven days. Each one of these breakdowns was somehow
related to Arles: three of them occurred after a visit to the city, the
fourth on the anniversary of his self-harm. By now mentally and
physically drained, and unable to paint for weeks and sometimes
months at a time, it is all the more remarkable that he managed to
keep working.

When Van Gogh left the asylum on 16 May 1890, Dr Peyron wrote
the following entry in his patient notes:

> During his stay in the home, this patient, who was calm for most
> of the time, had several attacks lasting for between two weeks
> and a month; during these attacks, the patient is subject to terri-
> fying terrors, and on several occasions he has attempted to poison
> himself, either by swallowing colours that he used for painting,
> or by ingesting paraffin, which he had taken from the boy while
> he was filling his lamps.
>
> The last attack he had occurred following a journey that he
> made to Arles, and it lasted approximately two months. In the
> interval between attacks the patient is perfectly calm and lucid,
> and passionately devotes himself to painting. He is asking to be
> discharged today, in order to go to live in the north of France,
> hoping that that climate will suit him better.[37]

Vincent travelled to Paris and spent a couple of days in the capital
to meet his nephew and namesake. Feeling that the countryside might

be better for him, on 20 May he left for the village of Auvers-sur-Oise, about 10 miles from Paris, and took cheap lodgings at the Auberge Ravoux. Theo had made arrangements through the artist Camille Pissarro for Vincent to stay near Dr Paul-Ferdinand Gachet, an amateur artist and medical doctor who knew and collected some of the Impressionists. Once again Vincent's own nervous disorder was transferred, on meeting the doctor:

> I've seen Dr Gachet, who gave me the impression of being rather eccentric, but his doctor's experience must keep him balanced himself while combating the nervous ailment from which it seems to me he's certainly suffering at least as seriously as I am.[38]

Often portrayed as a hero in the story of Van Gogh, Dr Gachet was a complex character. Although Vincent regularly perceived other artists as suffering from nervous disorders linked to their creativity, he completely mistrusted Gachet, telling Theo four days after his arrival:

> I think that we must IN NO WAY count on Dr Gachet. In the first place he's iller than I am, it seemed to me, or let's say just as much, there you have it. Now when one blind man leads another blind man, do they not both fall into the ditch?[39]

However, Vincent, enthused by the change of scenery, started painting again in earnest. He was delighted when Theo, Jo and baby Vincent came out to see him in early June, and maintained contact with his friends from the south, receiving letters from Madame Ginoux and Paul Gauguin mid-month. In early July, little Vincent Willem fell ill, which made Vincent extremely anxious. He left Auvers on a brief day-trip on 6 July to see his nephew, demonstrating once again his extreme hypersensitivity. Vincent wrote to Theo upon his return from Paris:

> Once back here, I too still felt very saddened, and had continued to feel the storm that threatens you also weighing upon me.

What can be done – you see I usually try to be quite good-
humoured, but my life, too, is attacked at the very root, my step
also is faltering. I feared – not completely – but a little nonethe-
less – that I was a danger to you, living at your expense.[40]

The use of the past tense was a red flag – 'I was a danger to you.'
Theo told Jo on 25 July that he found this letter 'incomprehensible',
continuing, 'We've not fallen out, either with him or with each other
. . . But one cannot drop him when he's working so hard and so well.
When will a happy time come for him?[41] Something had happened
between the brothers. Jo answered her husband the following day
with a plaintive 'What might be the matter with Vincent? Did we go
too far the day he came? My dearest, I have firmly resolved never to
squabble with you again – and always do what you wish.'[42]

There had been a row during Vincent's trip to Paris: he had insisted
on speaking only French and the family had argued. Theo's phrase
'one cannot drop him' and Jo's question 'Did we go too far?' suggest
that the argument extended to the subject of money. With a wife and
growing family to support, Theo simply could not continue financing
Vincent's life to the same extent. This news would have been a heavy
blow for his agitated and fragile brother.

On Sunday 27 July 1890, Vincent shot himself in the chest. The bullet
travelled through his body and lodged in his left flank. The local GP,
Dr Mazery, was sent for, but there was nothing that could be done.
Theo wrote to Jo:

This morning a Dutch painter who is also in Auvers brought a
letter from Dr Gachet conveying bad news about Vincent and
asking me to go there. I dropped everything and went immediately
and found him better than I had expected, although he is indeed
very ill. I shan't go into detail, it's all too distressing, but I should
warn you, dearest, that his life could be in danger . . . He was
lonely, and sometimes it was more than he could bear. Don't be
too sad, my love, you know I tend to paint things blacker than
they are. Perhaps he'll recover yet and see better times . . . Is it

not strange that I was so nervous and uneasy all of last week, as if I had a premonition that something would happen.[43]

Theo sat with his brother through the following hours. The Dutch artist staying at the Auberge Ravoux, Anton Hirschig, witnessed the scene:

I can still see him lying in his little bed under the attic roof in the most horrible suffering . . . 'Is there no one who can open me up?' It was so stiflingly hot under that roof.[44]

Vincent van Gogh died of his wounds at 1.30 a.m. on 29 July 1890, 'still smoking his pipe which he refused to let go of, explaining that his suicide had been absolutely deliberate and that he had done it in complete lucidity'.[45] Theo was sitting with him in his last moments, as he told Jo:

One of his last words was: this is how I wanted to go and it took a few moments and then it was over and he found the peace he hadn't been able to find on earth . . . The following morning eight friends arrived from Paris and elsewhere, and in the room where the coffin had been placed they hung his paintings, which looked so very beautiful.[46]

The police were not the only people in Auvers who showed insensitivity at Vincent's death. At the last minute the parish priest cancelled the religious ceremony because Vincent had died by his own hand. He insisted that the mention of the religious service be struck from the *faire-part* – the formal notification of the funeral. Thus Vincent, the son of a pastor, had no religious blessing in death. Émile Bernard was one of those eight friends who came out from Paris and described the scene:

The coffin was covered with a simple white cloth and surrounded with masses of flowers, the sunflowers that he loved so much, yellow dahlias, yellow flowers everywhere. It was, you will

remember, his favourite colour, the symbol of the light that he dreamed of as being in people's hearts as well as in works of art. Near him also on the floor in front of his coffin were his easel, his folding stool and his brushes.[47]

Vincent was buried 'in a sunny spot among the wheatfields' in Auvers-sur-Oise on 30 July 1890.[48] He was thirty-seven years old. Within weeks of his death, Theo suffered a mental and physical breakdown and was placed in an asylum in Utrecht, Holland, where he died on 25 January 1891 at the age of thirty-two. Van Gogh no longer lies in the original site of his burial, as his remains were moved to another part of the cemetery in 1905. On 14 April 1914, Theo's widow Jo had her late husband reburied in Auvers alongside his beloved brother.[49] Today this grave is the site of pilgrimage. How appropriate that the brothers lie together – their relationship was such, that like lovers, one could not really live without the other. 'How empty it is everywhere,' Theo wrote the day after Vincent's funeral, 'I miss him so, everything seems to remind me of him.'[50]

Chair and sketch of a hand, Saint-Rémy, 1890

Epilogue

In late November or early December, as the days get shorter and the first frosts appear on the fields, Provence suddenly becomes a hive of activity. The olive harvest begins. In late 1889, Van Gogh began painting strange twisted trunks emblematic of the region's olive groves. Pruned so that 'a swallow can pass through the branches', olive trees are an integral part of the Provençal landscape. The harvest is labour-intensive and very physical – 11 to 13 lbs of olives are required to make a litre of oil – but it is a highly satisfying winter ritual that has remained unchanged for thousands of years since ancient times. Although many use rakes and nets, I prefer to pick olives by hand, carefully and methodically moving through the branches to gather the fruit. It may appear as if there is nothing left on the branches when a gust of wind will blow, suddenly revealing another cache of luscious green pearls, like tiny bird's eggs hiding among the silver leaves. A single olive is almost worthless, but when put together with hundreds of others it makes the liquid gold that is olive oil.

There are a lot of similarities between the harvest and the way I undertook my research for this book. *Van Gogh's Ear* contains some important discoveries – about the ear, 'Rachel' and the petition – but also lots of tiny, seemingly inconsequential details that together reveal a more nuanced story of Van Gogh in Arles. It has been a slow, methodical process, working through the archives, looking at the story from every angle, relentlessly gathering little pieces of information from every source I had at my disposal, including Vincent's paintings.

When I started this project my objective was to understand a small episode in Vincent's life – one that defines him for the general public

and is an essential part of the Van Gogh myth. There is a certain irony that Irving Stone, the very person whose papers helped answer my initial question, was also responsible for shaping that legend. The previous Head of Collections at the Van Gogh Museum in Amsterdam wrote, 'More than any other book *Lust for Life* has been instrumental in generating the prevailing myth of Vincent van Gogh.'[1] *Lust for Life* is a romanticised and fictionalised version of his life which has entered people's consciousness and over time become assumed fact. I realise now that for many years my perception of Vincent barely deviated from the character Irving Stone had created and Hollywood had amplified: an ill-kempt, lusty drunkard, a man whose creativity was fuelled by women, alcohol and madness. I had been happy to take received views of that fateful night of 23 December 1888 at face value, rather than trying to understand his mental state or what drove him to his truly spectacular act of self-harm. I interpreted his work through a very narrow telescope, blinded by the bright, flashy colours of his paintings and immunised by the constant use of these pictures. I fell for the image that great fame and unsurpassed popularity had bestowed upon Van Gogh – the legend of Vincent – the painter who was 'mad'.

When I started this investigation I had not looked properly at Vincent van Gogh's paintings for several decades, somewhat snobbishly because he was so popular. This popularity continues to travel far beyond the confines of the art world. The Van Gogh Museum in Amsterdam receives more than 1.6 million visitors annually, making it one of the top ten most visited museums in the world and the only establishment on this list devoted to the life of a single artist. This Van Gogh is a guaranteed money-spinner (a friend recently gave me a pair of socks showing Vincent's *Self-Portrait with Bandaged Ear and Pipe*). Yet all the fridge magnets, tea towels, umbrellas and notepads have done him great disservice: over-familiarity has in some ways weakened the impact of his imagery and obscured who he was and what motivated him to create.

Now I look at him very differently. Deeper knowledge has led to true appreciation and respect. I also look at Arles with fresh eyes now, seeing the people and landscape through Vincent's sharp focus. I had no idea how I would become captivated by his world and the people

who inhabited it. At first, simply names on a page in nineteenth-century script that I could barely decipher, they have gradually become real people and characters in the story. The faces caught on canvas more than a century ago are now so familiar to me it is as if I know them personally. These people weren't random individuals who lived in a small French town; these were people he chose to paint because they meant something to him.

Van Gogh and his work are almost always judged through the prism of his madness. Yet to categorise his work in this way is very reductive, the truth is infinitely more nuanced. Van Gogh had serious psychiatric problems, there is no doubt, but he wasn't manic all the time. His form of mental illness, with crises followed by periods of lucidity, had ramifications for his painting. Many of his works are masterpieces, but not all. As he acknowledged to Theo, Vincent was acutely aware of this. After finishing what he considered to be one of his best works, *Almond Blossom*, the next day he painted 'like a brute', distressed by being unable to control the impact his mental health had on his creative ability. With little to no treatment for mental illness in the nineteenth century, it is all the more remarkable that Van Gogh was able to produce so much work.

It is much easier to fit the story around the legend than to unravel the truth. If madness has long influenced our perception of his art, it is also through the paroxysm of madness that we have looked at his life. But, I have come to realise since I started this investigation, my simplistic images of Van Gogh and his madness are no longer valid. Vincent's creativity reached its apogee in spite of his poor mental health not simply because of it.

The petition was never the work of a whole town up in arms and eager to chase a mentally ill man out of house and home. Rather it was the doing of two cronies who conspired together and exploited their contacts, preying on the justified fears of a small neighbourhood. Vincent van Gogh was never involuntarily committed; if he truly had posed a threat to the population the police would have forced the issue. He went calmly to an asylum and of his own free will. Gauguin was not a coward who had lied about what had happened in Arles and run back to Paris as fast as he could. Rather Gauguin found himself sharing

the Yellow House with a man he barely knew, in the midst of a very dramatic breakdown so unfathomable that Gauguin recorded the blow-by-blow details in his notebook. There was little he could do to resolve the situation. Traumatised by probably being threatened with a razor in the park, Gauguin abandoned Vincent and his dream of a studio in the south – a lesser man would have left much earlier.

All of these points have been misinterpreted. The greatest distortion has been to do with the injury itself. Thanks to the discovery of Dr Rey's drawing, long forgotten in an American archive, it is now possible to finally understand what Vincent did. Taking a cut-throat razor and slicing off part of your anatomy, whilst watching yourself in the mirror, is hard to envisage without shuddering. The ensuing gory scene, with Vincent in crisis, desperately ripping up sheets and trying to staunch the bleeding with towels, suddenly becomes all too real.

Van Gogh was overly sensitive – and at times irrational. But behind his seemingly impulsive behaviour, there was always an ill-conceived logic, never more so than on the night he cut off his ear. Rather than a completely random act of self-harm, his behaviour on 23 December 1888 – cutting his ear, washing it, wrapping it in a newspaper and taking it across town – was both deliberate and conscious. 'Rachel' wasn't a prostitute as I had first thought. 'Rachel', or rather Gabrielle, was a young, vulnerable woman who worked hard to earn her wage. Van Gogh had carefully observed her as she went about her business: working through the night cleaning in the lowliest of places – a brothel. With her large visible scar, Gabrielle touched Vincent profoundly. Just as he had given his clothes away and slept on the floor as a young trainee pastor, just as he would commit suicide in part because he couldn't bear to be a burden on his brother, Vincent took his ear that night not to scare or frighten Gabrielle but to bring succour. It may well have been seen as irrational and even frightening behaviour by the girl at the door of the House of Tolerance no. 1 on the rue Bout d'Arles, but for Vincent it was a personal, intimate gift, meant to alleviate what he perceived as her suffering. This singular act tells us so much that has been overlooked about Van Gogh: it was altruistic – the behaviour of a thoughtful, sensitive, and extremely empathetic man. Van Gogh becomes 'Monsieur Vincent,' a more sympathetic

individual and the man whom the Ginoux, the Roulins and some of the other people of place Lamartine knew and appreciated.

Now, so many years later, I realise that practically everything I thought I knew about Vincent van Gogh in Arles when I set off on this adventure has turned out not to be true. Vincent had moments of deep crisis, but as his paintings, friendships and letters illustrate, despite his personal woes, he was far more than the sum of his torments and he never stopped creating. The world is far richer for it.

The Sower, Arles, 1888

Acknowledgements

I'd like to thank the people who helped make this book a reality: my very patient literary agent, Zoë Waldie, and her team at Rogers, Coleridge and White, my remarkably talented editor Juliet Brooke and her team at Chatto & Windus as well as the other contributors to the editorial process: my American agent Melanie Jackson, my Canadian editor Anne Collins of Random House Canada, my US editor Alex Star at Farrar, Strauss and Giroux and Robbert Ammerlaan at Hollands Diep.

The staff of the Van Gogh Museum have been unfailingly supportive throughout the process, offering helpful insights as well as lively debate into Vincent van Gogh's life. My particular thanks go to Fieke Pabst, Dr Louis van Tilborgh, Teio Meedentorp and Monique Hageman. In London, Bill Locke of Lion TV first suggested that Van Gogh's Ear should be a book and has given me guidance from the start.

I would like to thank most warmly all the people in Arles who went out of their way to help me: the staff at the municipal archives – Michel Baudat, Marc Rohmer and Philippe Geisler and particularly Sylvie Rebuttini, whose encyclopaedic knowledge led to numerous finds. Thanks also to Fabienne Martin of the Mediathèque, Claudine Cabot of the Service Electoral, the 'ladies' of Service d'Etat Civil – Stéphanie Danet and Marie-Jeanne Ruiz as well as the Service des Cadastres, Robert Fiengo and Véronique Chergui, who with great patience showed me how to unravel the complex land registry system.

I tried to trace the descendants of many different families related to Vincent's story and I am most grateful to the Mourier-Petersen family in Denmark, Jacques Deschard of the Verdier family for answering my questions and Jean François Lazerges of the Salles family who generously shared personal family archive material.

Some museum curators allowed me private access to the Van Gogh

works in their collections. Looking at these artworks in great detail provided new clues that helped with my investigation: Frances Fowle of the National Gallery of Scotland; Dr Liz Kreijn of the Kröller-Müller Museum, Otterlo; Ruth Nagel of the Foundation Collection E. G. Bührle, Zurich; Mariantonia Reinhard-Felice of Oskar Reinhart 'Am Röemerholz' Winterthur; Dr Dieter Schwartz of Kunstmuseum, Winterthur; Dr Karen Serres and Dr Ernst Vegelin of the Courtauld Institute, London and the Kunstmuseum, Zurich.

Many people have kindly helped me personally: Alexandre Alajbegovic, Fatiha Allagui, Michèle Audema, Martin Bailey, the Baraton family, Alain Barnicaud, Annie Barriol, Jean-Luc Bidaux, Sharon Birthwright-Greco, Dr Jean-Marc Boulon, Dr William Buchanan, Michel Chazottes, Martine Clément, Pierre Croux, Marie Claude Delahaye, Brigitte Delmas-Moulard, Victor Doiteau, Christophe Duvivier, Jean-François Delmas, Archie DiFante, René Garagnon, René Gazanhes, Steven Gerrard, Michèle Gil, Dominique Janssens, Dr Philippe Jeay, Dr Jean-Pierre Joubert, David Keating, David Kessler who went out of his way to locate Dr Rey's drawing, Professor James Lance, Pierrette Lasalle, Philippe Latourelle, Catherine Lavielle, Dr Christian Legay, the late Robert Leroy, Janice Lert, Janet Lorentz, Marika Maymard, Victor Merlès, Daniel Müller, Jacqueline Oliot, Anne Marie Para, Claudine Pezéron, Annie Puech, Dr Theodore Reff; my discussions with Pierre Richard have been most stimulating; Marianne Smith, Roland Stachino, Thérèse Thomas, Rémi Venture; Dr Piet Voskuil who kindly shared his academic work on Van Gogh with me; Dr. Bogomila Welsh-Ovcharov for her encouragement and Anne Zazzo.

All of the following have contributed to this project, often without realising how helpful they have been: Stephanie Austin, Vincent Barjolin, Magali Beguier, Mary Bennett, David Brooks, whose website vggallery.com was an invaluable source for referencing the paintings, Catherine Brunet, Alice Byrne, Jack Donnelly, David Duarte, Bibi Gex, Guy Hervais, Lucas Jeay-Bizot, Marie-Françoise Joseph for her incredible talent for deciphering difficult-to-read handwriting, Anne de Lanversin, Delphine Letondor-Maïno, Patricia Levitt, Sarah Martin, Gilles Massé, Jennie and Peter Mayle who have been unfailingly supportive at every turn, Edith Mézard, Ludovic Molinier, Emmanuelle

Noguès, Alexandre Perucca, Barbi and Jack Room, Kerry Spring-Rice, Rachel Thomas, Vanessa Tiersky, Hélène Vigouroux and Jean Paul Watremez.

There are three close friends whose presence throughout this project has been vital: Emmanuelle Clergerie-Garella, who always underestimates how valuable her insights have been and whose joy and laughter have kept me going; Aisling Ryan who opened her address book and gave me wise advice; and Evelyne Senac-Laferrière whose clear explanations of complex psychological conditions and overall support have been especially appreciated.

Finally, this book is in honour of my lovely family: Clare, whose death was its starting point, as well as my surviving brothers and sisters who have had unswerving belief in *Van Gogh's Ear*: Peter, Mary, Joseph, Theresa and Angela.

Although he will never read this, I would like to give special thanks to my dear brother, John Patrick Murphy, who kept my life on track while I was out rummaging. I bothered him on more occasions than I can remember, sounding him out and arguing over every detail of this investigation. John, whistle and remember, 'NWP'.

Notes

Abbreviations

ACA: Archives Communales de la ville d'Arles
AD: Archives Départmentales des Bouches-du-Rhône
CA: Service des Cadastres de la ville d'Arles
MA: Médiathéque Municipale de la ville d'Arles
VGM: Van Gogh Museum, Van Gogh Foundation, Amsterdam

Prologue

The prologue is an imagined recreation of the scene at the Yellow House when the police arrived. Details have been taken from a variety of sources including Vincent's artwork; the floorplan of the house drawn up by Léon Ramser in 1922; aerial photos of Arles taken in 1919; Paul Gauguin's sketchbook; and the two accounts Paul Gauguin left of the event – one recounted to Émile Bernard in person, who then recorded the details in a letter to Albert Aurier on 1 January 1889, and the other in his autobiography, *Avant et Après*, published in 1903.

1 *Le Petit Marseillais*, 26 December 1888.
2 Details concerning the Gendarmerie are taken from Cote: 4N, 226: Plans Gendarmerie, place Lamartine, Arles (AD) and Cote: 5R12: Cahier de Charge Gendarmerie, Arles (AD).
3 On 24 December 1888 the temperature during the day was 11.5°C. Annales Arles, 1888.
4 For a list of brothels in Arles in 1888 see Cote: J43 and F15, Census 1886 (ACA) and Cote: 6M290, Census 1891 (AD).
5 All times are my own estimations. Dawn broke at 8.13 a.m. in Arles on 24 December 1888.
6 Physical description of Joseph Antoine d'Ornano (1842–1906) taken from

the illustrations from *Etat Civil*, Joseph d'Ornano, Santa Maria Siché, Corsica, and Paul Gauguin, Arles/Brittany sketchbook, in René Huyghe (ed.), *Le Carnet de Paul Gauguin*, pp. 22–23.

7 The spent oil lamp and tobacco are mentioned in *Avant et Après*, p. 19–21.

8 For a description of the hallway and stairs see Gustave Coquiot's Arles notebook, p.37 (VGM).

9 Letter 677, Vincent van Gogh to Theo van Gogh, 9 September 1888 and Letter 678, Vincent van Gogh to Willemien van Gogh, 14 September 1888, *Vincent van Gogh: The Letters* (Van Gogh Museum and Huygens ING., vangoghletters.org).

10 Gauguin, *Avant et Après*, pp. 20–1.

11 Letter 677 explains of the guest bedroom: 'If Gauguin comes he will have a decoration of large yellow sunflowers on its white walls'.

12 For details of the decoration of the guest bedroom see Letter 678, Vincent van Gogh to Willemien van Gogh, 14 September 1888 (VGM).

13 Paul Gauguin remarks to Émile Bernard that he was initially arrested by the police and later released to Émile Bernard. Letter from Émile Bernard to Albert Aurier, 1 January 1889 (Rewald Archive Folder 80–1, National Gallery of Art, Washington, D.C.) and *Avant et Après*, p. 20–21.

Chapter 1: Reopening the Cold Case

1 Letter 728, Vincent van Gogh and Félix Rey to Theo van Gogh, 2 January 1889 (VGM).

2 *Vincent van Gogh: The Letters,* vangoghletters.org (Van Gogh Museum and Huygens ING, Amsterdam: 2009).

3 *Le Forum Républicain*, newspaper, Arles 30 December 1888 (MA).

4 Joseph d'Ornano had taken up his post on 23 January 1888. Named by the Arrêté Municipal of 23 March 1888 as the post of 'Commissionaire Central du Canton Est' (ACA).

5 Letter 764, Vincent to Willemien van Gogh, between about 28 April and 2 May 1889 (VGM). Vincent wrote 'tout plein de fleurs' in French, which I have translated as 'all full of flowers'. *The Letters* translates it as 'chock-full of flowers'.

6 *Van Gogh and Gauguin: The Studio of the South*, exhibition catalogue (Van Gogh Museum and Chicago Art Institute, Amsterdam and Chicago: 2001).

7 United States Air Force Archives, AFHRA, AFB, Alabama, USA.

8 The French accounts of the raid come from Cote: H244, Office munic-
 ipal d'hygiène, 'Rapport sur l'attaque aérienne du 25 juin 1944', dated
 29 June 1944 (ACA).
9 In the USAF report the height was described as between 14,500 and
 16,000 feet.
10 Cote: H244 Office municipal d'hygiène: 'Rapport sur l'attaque aérienne
 du 25 juin 1944', dated 29 June 1944 (ACA).
11 FR B3317, floorplan of the Yellow House, drawn up by Léon Ramser in
 1922 (VGM).
12 Léon Ramser's floorplan did not include the Crévoulin's part of the
 building. Coquiot's notebook also provided supplementary details after
 he visited the house in 1922. The Coquiot notebook is at the VGM.

Chapter 2: Distressing Darkness

1 Letter B1841/V/1970, Andries Bonger to Hendrick and Hermine Bonger,
 about 12 April 1888 (VGM).
2 Letter 567, Vincent van Gogh to Theo van Gogh, 28 February 1886 (VGM).
3 Vincent decided to become a painter in August 1880. See note 1, letter
 214, Vincent van Gogh to Theo van Gogh, on or about 2 April 1882 (VGM).
4 Much has been made of the fact that Vincent was a 'replacement' for
 this 'dead twin'. Although from a modern point of view this might seem
 strange, it was fairly common practice in the nineteenth century to give
 a child the same name as a defunct sibling. My own grand-parents called
 two of their children by the same name, both of whom died as babies.
 I have also found many similar examples in the birth registers of Arles.
5 Reverend Vincent van Gogh (1789–1874).
6 Vincent recalled his hospitalisation in letter 741, Vincent van Gogh to
 Theo van Gogh, 22 January 1889 (VGM).
7 Émile Bernard and Christian Mourier-Petersen both remark on the strange
 first impression. Quote from P. C. Gorlitz, who shared a room with
 Vincent in Dordrecht in 1877. For his personal recollections of Van Gogh,
 see Verzamelde brieven, Vol. 1 (VGM, Amsterdam: 1973), pp. 112–13 (VGM).
8 Letter 65, Vincent van Gogh to Theo van Gogh, Paris, 10 January 1876
 (VGM).
9 Letter FR B2496, Reverend Van Gogh to Theo van Gogh, 11 March 1880
 (VGM).

10 It was only in 1896 that Sigmund Freud published a medical text outlining the treatment of psychiatric patients, coining the term 'psychoanalysis'.

11 Reverend Van Gogh planned on placing Vincent in the asylum at Geel, Belgium.

12 Letter 185, Vincent van Gogh to Theo van Gogh, 18 November 1881 (VGM).

13 Letter B2425, Anna van Gogh to Theo van Gogh, 29 December [1888] (VGM). Anna quotes a neuropath, Dr Raamar, whom Vincent was to see in The Hague. He backed out at the last minute.

14 Dr Théophile Peyron, monthly patient notes, Saint-Rémy, 8 May 1889 –16 May 1890 (Documentation VGM).

15 Vincent committed suicide in 1890, and his brother Cornelius ('Cor', 1867– 1900) is also believed to have killed himself. Theo (1857–91) had a complete breakdown shortly after Vincent's death and died of syphilis of the brain at an asylum in Holland. Willemien ('Wil', 1862–1941) was committed to a Dutch asylum in 1902 and died there almost forty years later.

16 Clasina 'Sien' Maria Hoornik (1850–1904).

17 Letter 382, Vincent van Gogh to Theo van Gogh, 6 September 1883 (VGM).

18 Letter 456, Vincent van Gogh to Theo van Gogh, 16 September 1884 (VGM).

19 Émile Bernard, article on Vincent van Gogh, *La Mercure de France*, April 1893, p. 328.

20 Letter 623, Vincent van Gogh to Theo van Gogh, 12 June 1888 (VGM).

21 Émile Bernard (1868–1941), John Peter Russell (1858–1931) and Henri de Toulouse-Lautrec (1864–1901).

22 Letter 569, Vincent van Gogh to Horace Mann Livens, September or October 1886 (VGM).

23 The Reverend gave a prayer to each child as they left home: 'O Lord, join us intimately to one another and let our love for Thee make that bond ever stronger.' Letter 98, Vincent van Gogh to Theodorus and Anna van Gogh, 17 and 18 November 1876 (VGM).

24 It should be noted that Theo's account books do not cover the time Vincent was living with him in Paris, so any figures from February 1886 until his departure for Arles on 19 February 1888 are estimations. Biographical and Historical Context: 3.2, 'Theo's Income', *Vincent van Gogh: The Letters* (VGM), also see *The Account Books of Theo van Gogh and Jo Bonger van Gogh*.

25 Letter B907/V/1962, Theo van Gogh to Cornelius van Gogh, 11 March 1887 (VGM).

26 Letter B908/V/1962, Theo van Gogh to Willemien van Gogh, 14 March 1887 (VGM).

27 The Café-Restaurant 'Au Tambourin' was situated at 62, boulevard de Clichy. The detail concerning the sunflower paintings comes from Ambroise Vollard, *Souvenirs d'un marchand de tableaux*.

28 Its full name was Le Grand Bouillon Restaurant du Chalet, 43, avenue de Clichy, Paris.

29 Letter 578, Vincent van Gogh to Theo van Gogh, 24 February 1888 (VGM).

30 Adolphe Monticelli (1824–86), French painter who lived and worked in Marseille. Boats for Japan, via Egypt, left twice a month from Marseille; see *Le Petit Provençal*, Edition Marseille 25 December 1888 (Marseille, Bibliothèque de l'Alcazar).

31 Alphonse Daudet had written a novel and a play called *L'Arlésienne* in 1872 and Georges Bizet had then written an opera based on these works. The Arlésienne at the heart of the story famed for her looks is actually never seen, yet it led to the widespread belief in late-nineteenth-century France that the women of Arles were both mysterious and intensely beautiful.

32 Ronald Pickvance stated that 'Edgar Degas visited Arles in 1855 as a young man and Henri de Toulouse-Lautrec may have spoken of it in Paris.' R. Pickvance, *Van Gogh in Arles*, exhibition catalogue.

33 Theo told his sister Wil that the journey took a 'day and a night'. Letter FR B914, Theo van Gogh to Willemien van Gogh, 24 and 26 February 1888 (VGM). There were three trains to Arles that left Paris on 19 February 1888. I rejected the other two trains, which stopped at every station en route. Another train stopped at Tarascon, but there was no connecting service to Arles. 1887–8 winter train timetable, Paris–Marseille, (SNCF archives, Le Mans).

34 See Bernard's account, quoted in *Van Gogh and Gauguin: The Studio of the South*.

Chapter 3: Disappointment and Discovery

1 Victor Doiteau and Edgar Leroy, 'Vincent van Gogh et le drame de l'oreille coupée', *Aesculape*, No. 7, July 1936.

2 Martin Bailey, 'Drama at Arles: New light on Van Gogh's Self-Mutilation', *Apollo*, London, 2005.

3 Letter RM20, Vincent van Gogh to Theo van Gogh and Jo Bonger-van Gogh, Auvers-sur-Oise, 24 May 1890 (VGM).

4 Eugène Boch (1855–1941), Belgian artist.

5 Bailey, 'Drama at Arles'.

6 Eventually, after many months trawling through newspaper archives in Provence, I was able to tell Martin Bailey that the extract he had found came from a newspaper called *Le Petit Méridional*, dated Saturday 29 December 1888. However, I haven't yet been able to find the original article mentioned as having been published the 'previous Wednesday' (Bibliothèque Inguimbertine, Carpentras, France).

7 Letter 6, Theo van Gogh to Jo Bonger, 28 December 1888, in *Brief Happiness: The Correspondence of Theo van Gogh and Jo Bonger* (Van Gogh Museum, Amsterdam: 1999).

8 Ronald Pickvance was the first person to point out this detail about the façade.

9 Paul Signac (1863–1935), letter to Gustave Coquiot, 6 December 1921, transcribed in the Coquiot notebook (VGM).

10 See the Buckman archive (VGM).

11 *Lust for Life*, directed by Vincente Minnelli and George Cukor, Metro Goldwyn Mayer, 1956. Starring Kirk Douglas as Vincent van Gogh and Anthony Quinn as Paul Gauguin.

12 The Margaret Herrick Library, Los Angeles, California.

13 Letter from the editors of *Life* magazine to Edward Buckman, 30 June 1955 (VGM).

Chapter 4: Almighty Beautiful

1 PLM winter timetable, 1887–1888 (SNCF archives, Le Mans).

2 Letter 577, Vincent van Gogh to Theo van Gogh, 21 February 1888 (VGM).

3 All revised train times come from the PLM winter timetable. It should be noted that Vincent did not say that he got off the train in Tarascon, as has been suggested; see *Van Gogh and Gauguin: The Studio of the South*. Van Gogh was simply remarking on something he had noticed *while he was passing through*. I contacted the French national weather service

to see what I could find out. According to their archives, it began to
snow at 8 p.m. in Arles on 20 February 1888. There was no snow
recorded on the days prior to Vincent's arrival. If Vincent saw snow in
the surrounding countryside during the journey, it could only have been
in the late afternoon at the earliest (Annales Arles février 1888, Météo-
France, Région Sud-Est, and SNCF archives, Le Mans).

4 Annales Arles février 1888, Météo-France, Région Sud-Est.
5 In Vincent's letters he gives his address as 30, rue de la Cavalerie, but
 presumably this was taken from an old business card. The name of the
 street had been changed in 1887, with the inauguration of the Amédée
 Pichot fountain. See also note 4 of Letter 577, *The Letters* (VGM).
6 The hotel could not have been one Vincent stumbled on by chance.
 There were many places near the station, and immediately within the
 city walls, that offered rooms. On the place Lamartine there were
 lodging houses such as the Café de l'Alcazar, the Café de la Gare, the
 Auberge Venissac and the Auberge Veau d'Or, and on rue de la Cavalerie
 there were two hotels (*Indicateur Arlésien*, 1887 (MA) and Service
 Cadastres, Arles (CA)).
7 See Letter 577, Vincent van Gogh to Theo van Gogh, 21 February 1888
 (VGM).
8 In Letter 577 Vincent told Theo it was on the same street. (Louis)
 Auguste Berthet (1842–1903), of 5, rue de la Sous-Prefecture, worked for
 the PLM railway; his shop was just off rue Amédée Pichot at the point
 it became rue du Quatre Septembre (Plan cadastral Cote: F382, Ile 70).
 Indicateur Marseillais, 1889 (AD), Cote: 017 bis-1880, Renumérotation Rue
 d'Arles (ACA) and Plan Auguste Véran 1867 (MA).
9 Gustave Coquiot, Van Gogh notes, p. 35 (VGM).
10 Average based on census returns for the city of Arles (Cote: F14 1881
 Census = 13,571; Cote: F15 1886 Census = 13,354; and Cote: 6M 290 &
 6M 291, 1891 Census = 13,377). Most historians have erroneously esti-
 mated its population to be between 25,500 (Van Gogh Museum) and
 30,000 people (*Van Gogh and Gauguin: The Studio of the South*). This figure
 was first advanced by Ronald Pickvance. The error stemmed from
 confusion concerning the particular status that Arles holds in French
 administrative life. Arles is the largest *commune* in France. The word
 commune is usually translated as 'town', but in the case of Arles, this is
 a basic mistake. The *commune* of Arles in 1888 covered a huge area,
 stretching over some 103,005 hectares (almost 400 square miles). More

than three-fifths of the population lived in the surrounding villages. The actual *town* of Arles is administratively called the *agglomeration* (ACA, AD).

11 Van Gogh's letter indicates that the snowfall was heavy, but records show that it was considerably less than the artist estimated. In total just over 8 inches fell on 20 February and a further 2 inches fell the next day. The snow began at 8 p.m. Annales Arles février 1888, Météo-France, Région Sud-Est.

12 *L'Homme de Bronze* newspaper stated, '40–45 centimetres [fell] which is enormous for *le pays du soleil*', 26 February 1888 (MA).

13 Letter 577, Vincent van Gogh to Theo van Gogh, 21 February 1888 (VGM).

14 Paul Reboul was a good friend of the Hotel Carrel's owner and a witness at his wedding in 1868. Marriage of Albert Jean Carrel and Catherine Nathalie Garcin, Arles, 2 September 1868 (ACA).

15 The store is listed separately in the trade directory as being both a butcher's and cured-meat shop. *Indicateur Arlésien*, 1887, pp. 45 and 47 (MA).

16 Antoine (1817–97) and Paul Reboul (1845–?) were a 'father-and-son' butcher's at 61, rue Amédée Pichot. After examining the people Vincent seems to have met in Arles during his first few weeks, I have concluded that Elisabeth Paux (1819–?), the mother of Catherine Garcin-Carrel (1851–?), seems to be the most likely candidate for the portrait of the old woman. The painting was executed in a bedroom with a *lit de rouleaux* – a typically modest nineteenth-century bed – in the background. Due to social mores of the time, it would be unlikely that Vincent was able to paint a woman in a bedroom unless he knew her. Furthermore, there was no other person of a similar age working, or likely to be staying, in the hotel. According to an interview given to Gustave Coquiot in 1921, a previous owner described the hotel as being a masculine stronghold – for shepherds in town on market day. Coquiot notebook, p. 35 (VGM). (All page references are those annotated in pencil by the Van Gogh Museum.)

17 The visit was Saturday 3 March 1888. Letter 583, Vincent van Gogh to Theo van Gogh, 9 March 1888 (VGM). These visitors were the justice of the peace (Antoine Marie) Eugène Giraud (1833–?) and Jean Auguste 'Jules' Armand (1846–?), who had a store at 30, rue du Quatre Septembre just up the road from the Hotel Carrel. (Land Registry – F276 (CA)). One of the witnesses to Armand's wedding in 1872 was his drawing professor from Toulon. On the electoral register Armand is described as a *droguiste* – a hardware-shop owner. Madame Joséphine

Ronin-Armand, his wife, was interviewed by the writer Gustave Coquiot on 8 May 1922. She confirmed that Vincent bought paints from the store in 'small quantities', and that her husband was a painter. Interview with Madame Armand in Coquiot notebook, p. 40 (VGM).

18 Letter 583, Vincent van Gogh to Theo van Gogh, 9 March 1888 (VGM). The abbey was the ruined medieval abbey of Montmajour, a few miles north of the city.

19 Since he had begun painting and drawing in 1880, Van Gogh had signed his works 'Vincent'. Letter 589, Vincent van Gogh to Theo van Gogh, 25 March 1888 (VGM).

20 Christian Mourier-Petersen (1858–1945), Danish artist.

21 In his letter to Johan Rohde dated 10 January 1888, Mourier-Petersen gives his address as Café du Forum, place du Forum (Ms. Tilg. 392, The Royal Library, Copenhagen). This is the café that Vincent later painted; A52 and A53 on the land registry (CA).

22 Letter 613, Vincent van Gogh to Theo van Gogh, 26 May 1888 (VGM).

23 Note 11, Letter 736, Vincent van Gogh to Theo van Gogh, 17 January 1889 (VGM).

24 Christian Mourier-Petersen to Johan Rohde, 16 March 1888 (Ms. Tilg. 392, The Royal Library, Copenhagen; translation: Sharon Birthwright-Greco). This letter was first published in Håkan Larsson, *Flames from the South: On the Introduction of Vincent van Gogh to Sweden* (Gondolin, Stockholm: 1996).

25 Letter 585, Vincent van Gogh to Theo van Gogh, 16 March 1888 (VGM).

26 Jean-Paul Clébert and Pierre Richard, *La Provence de Van Gogh*, p. 89.

27 Letter 669, Vincent van Gogh to Theo van Gogh, 26 August 1888 and note; Letter 670, Vincent van Gogh to Willemien van Gogh, 26 August 1888 (VGM).

28 Letter 557, Vincent van Gogh to Theo van Gogh, 2 February 1886 (VGM). The false teeth are mentioned in Letter 574, Vincent van Gogh to Willemien van Gogh, late October 1887 (VGM).

29 These comments are from the British painter A. S. Hartrick (1864–1950), who met Vincent in Paris. *A Painter's Pilgrimage Through Fifty Years* (Cambridge, CUP, 1939).

30 Larsson, *Flames from the South*, p. 17.

31 The spring of 1888 was late, due to the cold snap, with the flowers appearing around 10–11 March, once the weather became milder. Annales Arles Mars 1888, Météo-France, Région Sud-Est.

32 Letter 595, Vincent van Gogh to Theo van Gogh, 11 April 1888 (VGM).

33 Larsson, *Flames from the South*, p. 17, taken from Benni Golf, 'Van Gogh og Denmark', *Politiken*, 6 January 1938. Golf got this detail from Mourier-Petersen himself. Larsson erroneously dismisses the Café de la Gare and suggests that the candidate for their favourite café was the Café du Forum, painted by Van Gogh in September 1888. This is unlikely. Mourier-Petersen was staying at the Café du Forum, so surely he would say 'we would meet up at my hotel' or 'the place I was staying'. Furthermore, the Café de la Gare was on the artists' route to paint the orchards, which lay just beyond the train station in 1888. Gauguin clearly states that the Café de la Gare was Vincent's favourite café, even though he didn't much care for it himself.

34 Larsson, *Flames from the South*, pp. 17–18. Vincent's painting is *Pink Peach Trees (Souvenir de Mauve)*, 1888 (F394/JH 1374). Anton Mauve was Vincent's first painting teacher and had recently died (on 5 February 1888) when some weeks later Vincent painted this homage. Mourier-Petersen's painting is *Apricot Trees in Blossom, Arles*, now in Den Hirschsprungske Samling, Copenhagen.

35 There is a photo in a private collection in Belgium that appears to be taken in Provence, showing Eugène Boch and William Dodge Macknight together. As Mourier-Petersen spent time with both men and Vincent during the spring of 1888, he was probably the photographer.

36 *Bulletin Météorologique, L'Homme de Bronze*, No. 443, 8 April 1888, p. 2 (MA).

37 Letter 591, Vincent van Gogh to Theo van Gogh, 1 April 1888 (VGM).

38 Letter 585, Vincent van Gogh to Theo van Gogh, 16 March 1888 and Letter 590, Vincent van Gogh to Willemien van Gogh, 30 March 1888 (VGM).

39 Letter 594, Vincent van Gogh to Theo van Gogh, 9 April 1888 (VGM).

40 See note 6, Letter 594, Vincent van Gogh to Theo van Gogh, 9 April 1888 (VGM).

41 Jean de Beucken, *Un portrait de Van Gogh* (Gallimard, Paris: 1938), p. 89.

42 Letter 596, Vincent van Gogh to Émile Bernard, 12 April 1888 (VGM).

43 The first bull to be killed (*mise à mort* or *estoqué*) in the arena of Arles was on 14 May 1894. *L'Homme de Bronze*, Arles, No. 761, 20 May 1894 (MA).

44 William Dodge Macknight (1860–1950), American artist.

45 Larsson, *Flames from the South*, p. 14.

46 Letter 598, Vincent van Gogh to John Russell, 19 April 1888 (VGM).

47 Vincent painted Eugène Boch (1855–1941) in Arles. The Café de France, where Macknight was staying in Fontvieille, was next to the town hall.

48 Letter 594, Vincent van Gogh to Theo van Gogh, 9 April 1888 (VGM).

Chapter 5: Living in Vincent's World

1 The diligence service left for the closest villages of Raphèle five times a day and Fontvieille twice a day, going further afield to Nîmes and Maussanne once a day. Twice a week it left for Saint-Rémy (Wednesdays and Saturdays) and on Thursdays it went to Tarascon. Van Gogh painted the Tarascon diligence, which left from 12, place du Forum (plan castadral A302). Timetable for the carriage services, *Le Forum Républicain*, 18 March 1888 (MA) and Service Cadastres, Arles.

2 I compiled a list of Protestant families. These were taken from P13, 'List of Protestant families and their children in Arles 1847', and from the tombs to be found in the 'Carrée Protestante' in Arles Cemetery. For the towns they came from, I referred to Arles' electoral and marriage registers, where a person's place of birth is indicated. Most of the villages are Protestant enclaves in the Cévennes region to the north-west of Arles. Electoral registers Arles, 1876, 1886, 1888 (ACA). See also Cote: P13, 'Request for the nomination of a Protestant pastor' (ACA).

3 (Joseph Etienne) Frédéric Mistral (1830–1914), Provençal poet. The Félibrige movement that he and five other poets founded was to foster the use of Provençal. Until then the language had been transmitted orally and had never been formally written down.

4 Between 1 April and October there were more than twenty spectacles involving bulls in the arena of Arles. *L'Homme de Bronze*, January–December 1888 (MA).

5 Les Folies Arlésiennes was at 4, avenue Victor Hugo, an extension of the boulevard des Lices. In 1888–9 it was run by Jules Nicolas Dallard (also spelt Dalard) (1843–?) (ACA & MA).

6 Letter 594, Vincent van Gogh to Theo van Gogh, 9 April 1888 (VGM).

7 Letter 602, Vincent van Gogh to Theo van Gogh, 1 May 1888 (VGM).

8 Cote: Q90 'Fournitures de l'Hôpital' d'Arles', 1888.

9 Cote: J157 'Collection de seau hygiènique', Arrêté Municipal, 14 June 1905 (ACA).

10 Policeman Alphonse Robert's letter of 11 September 1929, in Doiteau and Leroy, 'Vincent van Gogh et le drame de l'oreille coupée'.

11 Letter 602, Vincent van Gogh to Theo van Gogh, 1 May 1888 (VGM).

12 The population had to water the street in front of their houses for two hours from 6 a.m. to 8 a.m. and again from 5 p.m. to 7 p.m. If the inhabitant had no running water, small fountains were made available

from 1 June until 30 September. 'Déliberations du Conseil Municipal', 29 May 1888, and Arrêté Municipal, 30 May 1888, announced in *L'Homme de Bronze*, No. 451, 5 June 1888 (MA).

13 A press article mentions the recent discovery that the virus was spread by fetid water. *L'Homme de Bronze*, No. 456, 5 July 1888 (MA). In Arles this disease was particularly feared, as the cholera epidemic of 1884 had killed 118 people. J91 'Rapport sur l'épidémie de choléra 1884' (ACA).

14 The first five years of life were the most critical, and death rates amongst newborns remained high – eighty-five out of 545 deaths in 1888 were of children under one year old. However, if stillborn or early child deaths are not included, more than two-thirds of the population died aged over sixty years old, with thirty-eight people dying over eighty years old. Statistics from the death registers in Arles, 1888 (ACA).

15 Letter 628, Vincent van Gogh to Émile Bernard, 19 June 1888 (VGM).

16 Météo-France, Région Sud-Est.

17 Letter 626, Vincent van Gogh to Willemien van Gogh, between 16 and 20 June 1888 (VGM).

18 Although in the spring of 1888 he painted the Langlois bridge, which was to the south of Arles.

19 Benni Golf, 'Van Gogh og Danmark', *Politken*, 6 January 1938, quoted in Larsson, *Flames from the South*, p. 17.

Chapter 6: Night Owls

1 Letter J43, from the chief of police to the Mayor of Arles, 19 May 1875 (ACA).

2 Code Civil des Français: Loi de Marthe Richard, 13 April 1946.

3 *Maisons de Tolérance*, rue Bout d'Arles, 1891 Census of Arles (AD).

4 *Life*, 15 February 1937.

5 Cote: 4M 890, 'La Scandale d'Arles', 1884, letter sent to the Préfet, Bouches du Rhône (AD).

6 Unfortunately, in Arles, none of these registers have survived.

7 Cote: J43, 'Réglementation: Maisons de Tolérance', Arrêté Municipal of 29 May 1867– see also the complementary ruling, 24 July 1873 (ACA).

8 Vincent must have left by a side door as there was no brothel in this street, but the House of Tolerance no. 14 had a side door onto rue des Récollets. Cote: Ile 44, E96, or the land registry (ACA, CA). See also Letter 585, Vincent van Gogh to Theo van Gogh, 16 March 1888 (VGM).

9 Public petition, rue Bout d'Arles, undated, c.1878. Cote: J43 (ACA).
10 M. Autheman, member of the town council, mentioned in the petition
 of 1878. J43, ACA.
11 They sold property to each other. Isidore Benson lived at number 22,
 Virginie Chabaud (1843–1915) at number 24, and Albert Carrel at number
 30, rue Amédée Pichot. Services Cadastre, Arles, Archives Départementales
 du Bouches du Rhône, Marseille (AD).
12 Virginie Chabaud ran the House of Tolerance no. 1 at 1, rue Bout
 d'Arles. Cote: Ile 44, E103 (AD, ACA, CA).
13 Letter 585, Vincent van Gogh to Theo van Gogh, on or about 16 March
 1888 (VGM).
14 *L'Homme de Bronze*, 18 March 1888 (MA).
15 This was the same establishment that Vincent went to on 23 December
 1888, 1, rue Bout d'Arles. Cote: Ile 44, E39 (CA).
16 *L'Homme de Bronze*, 18 March 1888 (MA).
17 Ibid.
18 Monsieur Riverau, quoted in ibid.
19 Virginie Chabaud was running this brothel – *Maison de Tolérance* no. 14,
 on the corner of rue Bout d'Arles with rue des Récollets – with her
 older sister Marie Chabaud (1834–?). Land registry: Ile 44, E96 (CA) J43,
 Prostitution (ACA).
20 1886 and 1891 Arles Census returns (ACA, AD).
21 Louis Farce (1834–94) ran the brothel with his common-law wife, Jenny
 Berthollet (1852–?). On the electoral registers he gave his address as 5,
 rue Bout d'Arles, a known brothel (ACA).
22 Although she sold the rights to Adelina Pahin, Virginie Chabaud was
 still running the *Maison de Tolérance* no. 1 in 1890; she accused two of
 her girls of stealing a watch from her. Police file J159, 'Crimes et Délits,
 12 juillet 1886–10 novembre 1890', 10 May 1890 and Cote: J43 (ACA).
23 She left all her properties to her nephew, her sister Marie's son, Antoine
 Justin (1871–1916). Land registry files, Arles, 1832–1900. Cote: Section E,
 Ile 44, 39 and 96 (CA).
24 Service Cadastres, Arles (CA).
25 Letter 699, Vincent van Gogh to Theo van Gogh, 5 October 1888 (VGM).
26 Cote: P13, 'Etat de la population Israelite habitants dans la commune
 d'Arles', (ACA).
27 Cote: F15 1886 Arles census returns (ACA).
28 Cote: 4 M 890, Prostitution: Statistiques des maisons de tolérance, Arles (AD).

29 Police file J159, 'Crimes et Délits, 12 juillet 1886–10 novembre 1890' (ACA).
30 Information culled from Cote: J43, Prostitution (ACA).
31 Van Gogh's first stay at the hospital in Arles was from 24 December 1888 to 7 January 1889.
32 Rémi Venture, vice president of the Amis du Vieil Arles and head of the archives in Saint-Rémy.
33 Robert was officially given the post on 31 August 1887. Cote: 36 W 183 Personal File of Alphonse Robert, (ACA).
34 Dr Edgar Leroy (1883–1965), director from May 1919 of the Hôpital Saint-Paul de Mausole, Saint-Rémy, was the first person to write about Vincent's medical condition who had access to the artist's file.
35 Victor Doiteau and Edgar Leroy, 'Vincent van Gogh et le drame de l'oreille coupée', Aesculape, No. 7, July 1936.
36 Quoted in Doiteau and Leroy, 'Vincent van Gogh et le drame de l'oreille coupée', and in Bailey, 'Drama at Arles'.
37 Pierre Leprohon, Vincent van Gogh (Editions Corymbe, Le Cannet de Cannes: 1972), p. 355.
38 Ibid.

Chapter 7: Monsieur Vincent

1 Carrel allowed Vincent to use the top-floor terrace to let his paintings dry. Vincent described his problems with Carrel in Letter 601, Vincent van Gogh to Theo van Gogh, 25 April 1888 (VGM).
2 Vincent received on average 200 francs per month, which increased once he took the Yellow House. His friend Roulin who worked at the post office had to feed his family of five on 135 francs per month. Letter 738, Vincent van Gogh to Theo van Gogh, 19 January 1889, (VGM).
3 Ibid, Letter 601.
4 Ibid.
5 Letter 602, Vincent van Gogh to Theo van Gogh, 1 May 1888, and Letter 603, Vincent van Gogh to Theo van Gogh, 4 May 1888 (VGM).
6 Interview with Madame Carrel by Gustave Coquiot, in the Coquiot notebook, p. 39 (VGM).
7 Letter 602, Vincent van Gogh to Theo van Gogh, 1 May 1888 (VGM).
8 Letter 656, Vincent van Gogh to Theo van Gogh, 6 August 1888 (VGM).
9 The area began to grow steadily after 1846, with the development of

the railway line, which was opened on 18 October 1847. Alphonse de Lamartine (1790–1869) campaigned for the PLM to be based in Arles and therefore his name was given to the square. Louis Venissac had purchased land from the town hall outside the Cavalerie gates and began acquiring land in 1852. He was responsible for a lot of the construction around the place Lamartine, including the Café de la Gare, the Auberge Venissac and the gendarmerie. Cote: O51, Projet Place Lamartine (ACA and AD).

10 Avis d'acquisition, l'Homme de Bronze, 7 January 1888, p. 3 (MA).

11 Cote: 404 E1356, Maître Rigaud, Acte 141, 24 December 1887 (AD).

12 The Café de la Gare building had been acquired by the Ginoux on 24 January 1879. The couple are found living there from that date on Cote: 403 E 675, Maître Gautier-Descottes (AD). The café had been developed by Jean-Baptiste Venissac (1808–62). His wife Marguerite Canin-Venissac (1818–97) ran the restaurant next door (Land Registry Q400). Due to debts, the Venissac children had to sell part of the building where the Café de la Gare was situated (Land Registry Q401) by public auction in 1873. The business of running a café was finally acquired by the Ginoux on 24 December 1887. Cote: 404, E1356, Acte 141, Maitre Rigaud (AD). They had to take out a personal loan to be able to purchase the café. Cote: 404, E1357, Prêt époux Ginoux, le 24 janvier 1888, Maître Albert Rigaud (AD).

13 On the 1861 and 1866 census returns, the Julien family are described as living at 'chez Julien, Maison Verdier' and 'place Lamartine' respectively. Cote: 6M130 and 6M151 (AD). The 'Maison Verdier' was all of 2, place Lamartine (Land Registry Q398 and Q399) as well as the large building behind; Cote: O5 (ACA). On the Arles land registry papers there are two people cited as proprietors of the parcelle Q398: Verdier and, in 1910, Cambon. When Vincent lived at the Yellow House, it was no longer owned by Aimé Verdier, who had died in 1872. The house had passed to his daughter, Marie Louise. In 1879 she married Raymond Triare-Brun, a lawyer from Montpellier. Later the house was passed on to her daughter Marie Louise Henriette (probably as part of her dowry in 1908), who married Marcel Léon Clément Cambon. She died in childbirth and the house was passed through inheritance to her sole surviving daughter, Marie-Charlotte Louise Cambon. The property was sold in 1943. Marie-Charlotte Louise Cambon died without ever marrying in 2010. Source: Service Cadastres, Arles, and Jacques Desnard, great-nephew of Mlle Cambon.

14 The address given at death for Marie Ginoux's parents (Pierre Julien, 23 December 1885 and Marie Allet, 28 May 1886) is 2, place Lamartine,

Arles. Pierre Julien (1801–1885) and Marie Allet-Julien (1804–1886) (ACA).

15 Bernard Soulè dit 'Noulibos' (1826–1903). His name was written as Soulé on the police inquiry of 1889, but the accent on the 'e' was transcribed incorrectly. The difference in pronunciation in French is very slight, and both spellings appear in the archival sources. Soulè signed his name clearly on an official document while he was a local councillor in 1898; Cote: J157, 'La salubrité municipale' (ACA).

16 He was a *conseilleur municipal* in 1898. Cote: J157 (ACA). In his will Bernard Soulè left the sizeable sum of almost 8,500 francs, including shares and his house. This was far above the income of a comparable ex-train-driver. 'Succession Bernard Soulè', Maître Rigaud, Actes 16 and 17, 1904, Cote: 404, E1375 (AD).

17 Soulè lived at 53, avenue Montmajour (Land Registry Q373), Electoral registers 1886–98 and death certificate, 23 February 1903 (ACA).

18 Letter 614, Vincent van Gogh to Theo van Gogh, 27 May 1888 (VGM).

19 The Ginoux charged thirty francs a month, the rental of the Yellow House was fifteen francs a month and Vincent's lunch and evening meal cost one franc fifty per day.

20 Marguerite Favier (1856–1927) married (François) Damase Crévoulin (1844–1903) in 1881. Marguerite was the daughter of Pétronille Julien-Favier (1826–1900), Marie Julien-Ginoux's sister (ACA).

21 Land registry: Q397. It was purchased on 9 July 1887. Maître Rigaud, Cote: 404, E1356 (AD).

22 The Café de l'Alcazar was subject to a compulsory purchase order in 1963 and was demolished a few years later (ACA).

23 The Alcazar was most notably declared to be Vincent's café interior by art historian Marc Edo Tralbaut in *Van Gogh: Le Mal Aimé*. This was picked up by many other art historians, including Martin Bailey in his article 'Van Gogh's Arles', *Observer* magazine, 8 January 1989 and Ronald Pickvance. See *Van Gogh in Arles* and *The Letters*, note 2, Letter 676, Vincent Van Gogh to Theo van Gogh, 8 September 1888 (VGM).

24 Interview, Siletto family descendants, June 2014.

25 Letter 691, Vincent van Gogh to Theo van Gogh, 29 September 1888 (VGM).

26 Reverend (Louis) Frédéric Salles (1841–97).

27 Interview with the Reverend Salles' daughter, Madame Jean Paul Lazerges, née Lucie Antoinette Salles (1874–1941), by Gustave Coquiot, in the Coquiot notebook, p. 38 (VGM). Though she is not named directly

by Coquiot, Madame Lazerges was the wife of Frédéric Salles' successor as Protestant pastor of Arles. When Coquiot visited the region, her sister Eugénie (Mme Jaulmes) was living in Nîmes, where her husband – also a pastor – was working in the 1920s. Eugénie stated that her father received a letter from Theo mentioning that his brother was in Arles. Unpublished 'Souvenirs de Vincent Van Gogh' from Madame Edmond Jaulmes, née Eugénie Gabrielle Salles (1878–1966). Courtesy of the Salles' family descendants.

28 Letter of 26 January 1882, Frédéric Salles to Mr Brunning in London (the father of his children's nurse), written in English. Summary of letters of Reverend Salles, 17 December 1874 to 7 February 1886, compiled by Madame Marie Prouty, 1988 (VGM).

29 Unpublished 'Souvenirs de Vincent Van Gogh' by Madame Edmond Jaulmes, October 1964 (Salles family archives).

30 Letter 836, Vincent van Gogh to Theo van Gogh, 4 January 1890 (VGM).

31 This painting was 'sold to a bric-a-brac salesman in Nîmes', according to Reverend Salles' daughter, Madame Edmond Jaulmes, in her unpublished account (Salles family archive). This is also quoted by Benno Stokvis, 'Vincent van Gogh in Arles', in *Kunst und Künstler* (Berlin, 1929), where he recounts that the painting was 'sold for 200 francs' (VGM).

32 Joseph Etienne Roulin (1841–1903).

33 Marcelle Roulin mentioned the fact that they lived in the same street, in the only recorded interview she gave, for the French Postal Service magazine in 1955: J.-N. Priou, 'Van Gogh et la famille Roulin', *Revue des PTT de France*, Vol. 2, No. 3, mid-June 1955, p. 27 (Musée de la Poste, Paris). As Marcelle was a baby when her parents knew Vincent, she must have heard this. This detail is confirmed by the Arles electoral register. Roulin lived on rue Amédée Pichot during 1888 and moved to 10 rue Montagne des Cordes at Michaelmas. Vincent remarks in his letters that the family had moved many times. Augustine Roulin would have stayed in Lambesc after the birth of Marcelle and probably met Vincent in late August on her return to the city with her children, who were of school age. Vincent mentions Augustine Roulin for the first time in Letter 667 to Theo of 9 September 1888. Arles Electoral Registers 1888 Cote: K38 and 1889 Cote: K39 (ACA).

34 The couple had five children altogether. Roulin's first daughter, Josephine Antoinette, was born in 1869. I can find no record of her death, which must have been prior to 1872 – she does not appear on the 1872 census returns or anywhere after that date. The other children were Armand

Joseph (1871–1945); Camille Gabriel (1877–1922), who died from the wounds he received in the First World War; Marie Germaine Marcelle (1888–1980). The couple's fifth child was a daughter, Cornelie (1897–1906). Archives Communales de Lambesc, Archives Communales de Nice, Archives Communales de Le Beausset.

35 Roulin called the baby that would be born on 31 July 1888 (Marie Germaine) Marcelle – the same name as the daughter of General Georges Boulanger, the leader of the ultra-nationalist 'Boulangist' party and a well-known political figure in France at the time.

36 Julien François Tanguy (1825–1894), seller of artists' materials in Paris Letter 652, Vincent van Gogh to Theo van Gogh, 31 July 1888 (VGM).

37 Letter 656, Vincent van Gogh to Theo van Gogh, 6 August 1888 (VGM).

38 Letter 723, Vincent van Gogh to Theo van Gogh, 1 December 1888 (VGM).

Chapter 8: A Friend in Need

1 Émile Bernard, French artist (1868–1941).

2 Émile Bernard, *La Mercure de France*, Paris, April 1893, pp. 328–9.

3 (Claude) Émile Schuffenecker (1851–1934) met Paul Gauguin in 1872 when they both worked on the stock exchange. Gauguin encouraged him to become a painter. He became Gauguin's great friend. The artist stayed with Schuffenecker in Paris after returning from his trip to the Caribbean in 1887, and fled to his home after returning to the capital from Arles in late December 1888.

4 Mette-Sophie Gad (1850–1920).

5 Alphonse Portier (1841–1902), Parisian art dealer.

6 From April to October 1887 Gauguin travelled to the Caribbean with the painter Charles Laval (1861–94).

7 Vincent organised an exhibition in Le Grand Bouillon Restaurant du Chalet in November–December 1887.

8 Letter 576, Paul Gauguin to Vincent van Gogh, December 1887 (VGM). Cluzel's store was at 33, rue Fontaine Saint-Georges, Montmartre, Paris.

9 Paul Gauguin's painting is called *Among the Mangoes*, Amsterdam, Van Gogh Museum.

10 Letter 581, Paul Gauguin to Vincent van Gogh, 29 February 1888 (VGM).

11 The accepted dates for the trip to Les Saintes-Maries-de-la-Mer are 30 or 31 May to 4 or 5 June. I suggest that these dates may be incorrect. While

on this trip Van Gogh painted a seascape showing a fairly strong wind whipping across the waves. The mistral blew at Les Saintes-Maries on 27 May and again on 7 June. Marie Julien-Ginoux had her fortieth birthday on Friday 8 June – Vincent may have had to give up his room at the Café de la Gare where he was staying in May 1888, if she was putting up friends and family for a few days. This would explain why he planned his return from Saturday, the day after her birthday. As this is only a hypothesis, I have chosen to maintain the dates for this trip and the letters put forth by the Van Gogh Museum. Carriages left for Les Saintes-Maries-de-la-Mer every day at 6 a.m. from rue Saint-Roch. *L'Homme de Bronze*, 30 May 1888 (MA); Annales Arles mai et juin 1888, Météo-France, Région Sud-Est.

12 Letter 619, Vincent van Gogh to Theo van Gogh, Arles, 3 or 4 June 1888 (VGM).

13 The gypsies camping in allée de Fourques on the opposite side of the river were moved by the police on 21 and 22 August. *L'Homme de Bronze*, 26 August 1888, p. 3 (MA).

14 Letter 619, Vincent van Gogh to Theo van Gogh, 3 or 4 June 1888 (VGM).

15 Émile Bernard, Paul Gauguin, Louis Anquetin, Armand Guillaumin were amongst the painters that Van Gogh admired in Brittany.

16 Letter 616, Vincent van Gogh to Theo van Gogh, 28 or 29 May 1888 (VGM).

17 The fellow artist was Auguste Joseph Bracquemond, called Félix Bracquemond (1833–1914), painter and ceramist. Letter from Camille Pissarro (1830–1903) to his son Lucien Pissarro, 23 January 1887. Janine Bailly-Herzberg (ed.), *Correspondance de Camille Pissarro, 1886–90*, Vol. 2 (Editions du Valhermeil, Paris: 1986), pp. 120–2.

18 Letter 646, Paul Gauguin to Vincent van Gogh, 22 July 1888 (VGM).

19 Letter 653, Vincent van Gogh to Willemien van Gogh, 31 July 1888 (VGM).

20 Letter 672, Vincent van Gogh to Theo van Gogh, 1 September 1888 (VGM).

21 Letter 674, Vincent van Gogh to Theo van Gogh, 4 September 1888 (VGM).

22 Letter 682, Vincent van Gogh to Theo van Gogh, 18 September 1888 (VGM).

23 For confirmation that Gauguin was the artist Van Gogh intended to paint, see note 8 of Letter 663, Vincent van Gogh to Theo van Gogh, 18 August 1888 (VGM).

24 Letter 693, Vincent van Gogh to Eugène Boch, 2 October 1888 (VGM).

25 *L'Homme de Bronze*, 30 September 1888 (MA). On 6 January 1884 the town newspaper had reported that the level of illumination in front of the café was the equivalent of thirteen Carcel lamps or fifteen ordinary gas jets. *L'Homme de Bronze*, 6 January 1884 (MA).

26 Letter 688, Paul Gauguin to Vincent van Gogh, on or about 26
 September 1888 (VGM).
27 The *surimonos* tradition was explained in *L'Art japonais* by Louis Gonse,
 Paris, 1883. See note 16, Letter 695, Vincent van Gogh to Paul Gauguin,
 3 October 1888 (VGM).
28 Letter 692, Paul Gauguin to Vincent van Gogh, 1 October 1888 (VGM).
29 Letter 697, Vincent van Gogh to Theo van Gogh, 4 or 5 October 1888 (VGM).
30 Letter 701, Vincent van Gogh to Theo van Gogh, 10 or 11 October 1888 (VGM).
31 Letter 706, Vincent van Gogh to Paul Gauguin, 17 October 1888 (VGM).

Chapter 9: A Home at Last

1 Among the first historians to go to Arles in the early decades of the
 twentieth century were Julius Meier–Graefe, Benno Stokvis and Gustave
 Coquiot.
2 A full list of the plants and shrubs can be found in the archives in Arles.
 Cote: O31, 'Aménagement du jardin de la Place Lamartine 1875–1876' (ACA).
3 Letter 626, Vincent van Gogh to Willemien van Gogh, between 16 and
 20 June 1888 (VGM).
4 Vincent calls these *briques rouges*, a local term for unglazed floor tiles.
 They can be seen in several of his paintings (e.g. *Vincent's Chair, The
 Bedroom in Arles, The Zouave*).
5 A 'petticoat episode' meant having a relationship with a woman. See note
 18, Letter 602, Vincent van Gogh to Theo van Gogh, 1 May 1888 (VGM).
6 In 1881 Vincent had proposed marriage to his cousin Kee Vos, and he
 considered marrying Margot Begemann in 1884. For Vincent's views on
 marriage, see note 2 in Letter 181, Vincent van Gogh to Theo van Gogh,
 18 November 1881; and Letter 227, Vincent van Gogh to Theo van Gogh,
 14 or 15 May 1882 (VGM).
7 Letter 574, Vincent van Gogh to Willemien van Gogh, late October 1887
 (VGM).
8 Two public bathhouses were situated on quai de la Gare, one run by
 Pierre Trouche and the other by Antoine Chaix; *Indicateur Arlésien*, 1887
 (MA). The quai de la Gare ran alongside the Rhône from the train
 station to the bridge. The respective addresses of these bathhouses were
 38, rue des Vers (Land Registry: F66) and 18, rue du Grand Prieuré
 (Land Registry: H96); *Indicateur Marseillais*, 1888 and 1889 (ACA). Vincent

would probably have gone to Pierre Trouche's establishment, which was much closer to place Lamartine. See also note 4, Letter 657, Vincent van Gogh to Theo van Gogh, 8 August 1888 (VGM).

9 *'Moi je le rencontrais souvent avec sa serviette sous le bras. Il me semble que je le vois devant moi.'* Alphonse Robert in his letter of 11 September 1929, in Doiteau and Leroy, 'Vincent van Gogh et le drame de l'oreille coupée'.

10 Letter 677, Vincent van Gogh to Theo van Gogh, 9 September 1888 (VGM).

11 The suitable age that I chose was anyone thirty-five or above.

12 Thérèse Balmossière (née Brémond) (1839–1924). The surname is occasionally spelt Balmoussière.

13 She was Madame Crévoulin's second cousin. Her paternal grandmother, Jeannette Favier (née Brémond), was Thérèse's aunt. Bernard Soulè and Joseph Balmossière held the same job, *chef des trains*, on the census returns, prior to their retirement.

14 Letter 649, Vincent van Gogh to Émile Bernard, 29 July 1888 (VGM).

15 Anne Zazzo, Palais Galliera Musée de la Mode de la Ville de Paris, 4 April 2014.

16 The Balmossières came from Tarascon (who do not of course wear Arlésienne dress) and appeared to be a Catholic family. P14 List of Protestants in Arles, *Etat Civil* (ACA).

17 Thérèse Antoinette Balmossiere (1874–1961) was the cleaning lady's daughter. Her niece was Thérèse Catherine Mistral (1875–?), who lived at 37, avenue Montmajour (ACA).

18 Letter 650, Vincent van Gogh to Theo van Gogh, 29 July 1888 (VGM).

19 Dr Rey mentioned that Vincent blinked constantly, and Adéline Ravoux that he smoked his pipe non-stop.

20 The illustrations of the Yellow House are a painting, *The Yellow House (The Street)*, F464, JH1 569, where the shutters are wide open. In the watercolour, *The Yellow House (The Street)*, F1413, JH1591 and drawing F1453, JH1590, only Vincent's bedroom shutters are open.

21 Letter 653, Vincent van Gogh to Willemien van Gogh, 31 July 1888 (VGM).

22 Paul Eugène Milliet (1863–1943).

23 Letter 660, Vincent van Gogh to Theo van Gogh, 13 August 1888 (VGM).

24 François Casimir Escalier (1816–89). Vincent wrote that Patience Escalier worked on a small farm on the Crau Plain (Letter 663, Vincent van Gogh to Theo, 18 August 1888 (VGM)). There was one other Escalier family living in Arles at this time, also from Eyragues, who lived on the Crau Plain at the Mas Niquet. They do not seem to be related to François

Casimir Escalier, and the father could not be the famous shepherd, as he was only forty-six in 1888.

25 Letter 663, Vincent van Gogh to Theo van Gogh, 18 August 1888 (VGM).

26 Ibid.

27 The Bompard & Fils shop was at 14, place de la République, the main square in Arles. *Indicateur Arlésien*, 1887, p. 23 (MA).

28 Letter 660, Vincent van Gogh to Theo van Gogh, on or about 13 August 1888 (VGM).

29 Vincent paid 15 francs a month to rent the Yellow House as a studio from 1 May 1888 to 29 September 1888. When he took over the whole house his rent increased. From December 1888 to May 1889 he paid 21 francs 50 per month, because of the extra two rooms. See 3.3 Vincent's income and expenditure, *The Letters* (VGM).

30 Letter 676, Vincent van Gogh to Theo van Gogh, 8 September 1888 (VGM).

31 Letter 677, Vincent van Gogh to Theo van Gogh, 9 September 1888 (VGM).

32 Letter 685, Vincent van Gogh to Theo van Gogh, 21 September 1888 (VGM).

33 Letter 677, Vincent van Gogh to Theo van Gogh, 9 September 1888 (VGM).

34 Gauguin's small room was 8.71 metres square and Vincent's was 9.54 metres square. Plan Ramser 1922 (VGM).

35 Letter 678, Vincent van Gogh to Willemien van Gogh, between 9 and 14 September 1888 (VGM).

36 This new purchase included the pair of simple straw-seated Provençal chairs seen in the painting of the bedroom. In Vincent's house there was also a more formal chair with a straw seat and armrests, as seen in Vincent's portrait *L'Arlésienne* and in *Gauguin's Chair*. Similarly in the drawing of a seated Zouave another chair, which has a strange cross-bar for the feet, can just be made out (F1443/JH1485).

37 The importance of Christian symbolism in Van Gogh's art has been explored by Tsukasa Kōdera in *Vincent van Gogh: Christianity Versus Nature*. An article on the significance of twelve figures in *Café Terrace at Night* is explored by Lorena Muñoz-Alonso in 'Scholar Claims Van Gogh Hid Secret Homage to Leonardo da Vinci's *The Last Supper* In His *Café Terrace at Night*', *Artnet*, 10 March 2015.

38 Letter 685, Vincent van Gogh to Theo van Gogh, 21 September 1888 (VGM).

39 Letter 682, Vincent van Gogh to Theo van Gogh, 18 September 1888 (VGM).

40 Letter 709, Vincent van Gogh to Theo van Gogh, 21 October 1888 (VGM).

41 Letter 701, Vincent van Gogh to Theo van Gogh, 10–11 October 1888 (VGM).

42 *Décret officiel* of President Carnot, 2 October 1888; *L'Homme de Bronze*, 14 October 1888 (MA).

43 Cote: F41, Statistiques: Mouvement de la population 1889 & 1890 (ACA).

44 The passport and birth certificate were requested in September 1887. See note 3, Letter 572, Vincent van Gogh to Johannes van Homberg, Mayor of Neunen, 1 September 1887 (VGM).

45 Letter 701, Vincent van Gogh to Theo van Gogh, 10 or 11 October 1888 (VGM).

46 Letter 653, Vincent van Gogh to Willemien van Gogh, 31 July 1888 (VGM).

47 Paul Signac to Gustave Coquiot, 6 December 1921, in the Coquiot notebook (VGM).

Chapter 10: The Artists' House

1 The arrival time of 5 a.m. suggested by the 2001 Chicago Art Institute exhibition catalogue *Van Gogh and Gauguin: The Studio of the South* cannot be correct. The train number they suggest in fact arrived at 4.49 in the afternoon (rather than 4.49 a.m.). I believe they simply misread the timetable. During the nineteenth century, train timetables did not follow the twenty-four-hour clock, instead they indicated whether the train was in the morning or afternoon. The twenty-four-hour clock system was introduced during the Occupation of France by Germany in the Second World War. Gauguin clearly stated that he arrived early in the morning. The train between Pont-Aven and Arles involved numerous changes. The last change Gauguin needed to take would have been from Lyons. He arrived on train number 3, the express train that left Lyons at 10.43 p.m. and arrived in Arles at 4.04 a.m. (SNCF archives, Le Mans).

2 Paul Gauguin, *Oviri: Ecrits d'un sauvage* (Gallimard, Paris: 1903), p. 291.

3 Letter 712, Vincent van Gogh to Theo van Gogh, on or about 25 October 1888 (VGM).

4 Letter 713, Theo van Gogh to Vincent van Gogh, 27 October 1888 (VGM).

5 Letter B0850, Paul Gauguin to Theo van Gogh, on or about 27 October 1888 (VGM).

6 Letter 714, Vincent van Gogh to Theo van Gogh, 27 or 28 October 1888 (VGM).

7 Letter 715, Vincent van Gogh to Theo van Gogh, on or about 29 October 1888 (VGM).

8　　Ibid.

9　　Letter 716, Vincent van Gogh to Émile Bernard, 2 November 1888 (VGM).

10　　The bearded man is sometimes suggested to be the postman Roulin. The recently discovered military documents, showing that Roulin was shorter than had previously been assumed, would seem to confirm this. See Pierre E. Richard, *Vincent. Documents et inédits*, Nombre 7, Nîmes, 2015, p. 56.

11　　There were no manufacturers of absinthe in Arles in 1888, nor did I find absinthe in the inventory of bars that went bankrupt. Absinthe was manufactured outside the region at the time. It is possible that there was some unofficial production of the drink, although what was sold in bars was carefully controlled by the police. Cote: 6 U 2 214, Faillites Arles (AD).

12　　Letter 718, Vincent van Gogh to Theo van Gogh, 10 November 1888 (VGM).

13　　Letter 717, Vincent van Gogh to Theo van Gogh, on or about 3 November 1888 (VGM).

14　　The 'nocturnal excursions' were visits to a brothel. Paul Gauguin, *Avant et Après* (G. Crès, Paris: 1923), pp. 16–17.

15　　Letter 715, Vincent van Gogh to Theo van Gogh, on or about 29 October 1888 (VGM).

16　　The three paintings were *Les Alyscamps (Leaf Fall)* (F486/JH 1620), *Les Alyscamps (Leaf Fall)* (F487/JH 1621) and *Les Alyscamps* (F 568/JH 1622). Letter 716, Vincent van Gogh to Émile Bernard, 2 November 1888 (VGM).

17　　Letter 714, Vincent van Gogh to Theo van Gogh, 27 or 28 October 1888 (VGM).

18　　Letter 716, Vincent van Gogh to Émile Bernard, 2 November 1888 (VGM).

19　　Letter 721, Vincent van Gogh to Theo van Gogh, 1 December 1888 (VGM).

20　　The draft of the letter attached to Letter 616 of May 1888, which Vincent sent to Theo for his approval, was the only time he used '*tu*'.

21　　Letter B7606, Jo van Gogh to Julius Meier-Graefe, 21 February 1921 (VGM).

22　　Letter 719, Vincent van Gogh to Theo van Gogh, 11 or 12 November 1888 (VGM).

23　　Gauguin, *Avant et Après*, p. 19.

Chapter 11: Prelude to the Storm

1　　Letter LXXVIII, Paul Gauguin to Émile Bernard, (undated) December 1888. Paul Gauguin, *Lettres à sa femme et à ses amis*, p. 174.

2 Letter 724, Vincent van Gogh to Theo van Gogh, 11 December 1888 (VGM).
3 Paul Gauguin to Theo van Gogh, 11 December 1888, in *Correspondence de Paul Gauguin*, p. 301.
4 Douglas Cooper, *Paul Gauguin: 45 lettres à Vincent, Theo et Jo van Gogh*, p. 87.
5 Gauguin, *Avant et Après*, pp. 21–2.
6 Letter LXXVIII Paul Gauguin to Émile Bernard, in Gauguin, *Lettres à sa femme et à ses amis*, p. 175.
7 Letter 726, Vincent van Gogh to Theo van Gogh, 17 or 18 December 1888 (VGM).
8 Gauguin, *Avant et Après*, p. 16.
9 Paul Gauguin, Arles/Brittany sketchbook, in *Le Carnet de Paul Gauguin*, p. 220. This is the same page as the '*Je suis sain d'esprit . . . Saint Esprit*' quote.
10 Letter from Émile Bernard to Albert Aurier, 1 January 1889, written '4 days after Gauguin's return'. Rewald Archive Folder 80–1, National Gallery of Art, Washington, D.C.
11 Letter 726, Vincent van Gogh to Theo van Gogh, 17 or 18 December 1888 (VGM).
12 Annales Arles décembre 1888, Météo-France, Région Sud-Est.
13 Gauguin, *Avant et Après*, p. 19.
14 Ibid.
15 Ibid.
16 Letter from Paul Gauguin to Émile Schuffenecker, 22 December 1888, *Paul Gauguin et Vincent van Gogh, 1887–1888: Lettres Retrouvées, Sources Ignorées*, note p. 238. 'Van Gog' in Gauguin's correspondence is Theo – Gauguin never spelt the surname correctly. In the French pronunciation of the surname the final 'h' is silent.
17 *L'Homme de Bronze*, 23 December 1888 (MA).

Chapter 12: A Very Dark Day

1 Letter 736, Vincent van Gogh to Theo van Gogh, 17 January 1889 (VGM).
2 Letter 739, Vincent van Gogh to Paul Gauguin, 21 January 1889 (VGM).
3 Gauguin, Arles/Brittany sketchbook, in *Le Carnet de Paul Gauguin*, p. 71.
4 These chairs were both the subject of paintings in mid-November 1888: *Van Gogh's Chair* and *Gauguin's Chair*.
5 Letter from Émile Bernard to Albert Aurier, 1 January 1889, Rewald

Archive Folder The tense used in this letter, *'a pris la fuite'*, can be translated into either the present perfect or the past.

6 *L'Intransigeant*, 23 December 1888 (BNF). This newspaper article was first identified in the 2001 Chicago catalogue *Van Gogh and Gauguin: The Studio of the South*, p 260. Martin Bailey also reprinted this newspaper extract in 'Drama at Arles'.

7 *'Paris coupe-gorge'*; in this context, as the article speaks about a person, 'Parisian Cut-throat' seems to be the most appropriate translation of the headline.

8 Gauguin, Arles/Brittany sketchbook, in *Le Carnet de Paul Gauguin*, p. 220.

9 For further information on the 'Ictus' reference, see also note 10, Letter 739, Vincent van Gogh to Paul Gauguin, 21 January 1889 (VGM).

10 *Le Horla*, a science-fiction novel by (Henri René Albert) Guy de Maupassant (1850–93). Published in 1886, this book is part of a trilogy. Reputedly the story was written 'under the influence of ether'. In the book the narrator believes he is accompanied everywhere by an invisible presence called the Horla. He gradually descends into madness and believes only suicide will rid him of it.

11 The word 'Ictus' was used by Gauguin on several occasions: in the notebook, on a letter from Vincent and as a title of an artwork. *Ichthus* (the Greek word for fish) is a well-known symbol for Christ. In Letter 739 the word 'Ictus' is written inside a fish and was probably added to the letter by Gauguin. 'Ictus' / 'Ichthus' could be a play on words or simply a result of Gauguin's poor spelling. For further information, see note 10, Letter 739, Vincent van Gogh to Paul Gauguin, 21 January 1889.

12 Gauguin, *Avant et Après*, p. 19. I have used my own translation. Gauguin can be forgiven for making an error about where he lived in Arles, as he was writing so long afterwards. However, 'scented with flowering laurels' seemed an odd detail, especially in the middle of winter. Checking the garden records of the place Lamartine park in the city archives, I found a shrub with white flowers that gives off scent in winter and was planted in the park in 1888. I think this must be what Gauguin remembered, as its name in French includes the word for 'laurel' (*'laurier tin'*). The plant is called viburnum. Gauguin might not have known what the plant was, as viburnum does not thrive in the north. Plantings of place Lamartine garden listed in Cote: O31, 'Aménagement du jardin public de la Place Lamartine 1874–1875' (ACA).

13 Gauguin, *Avant et Après*, p.153.

NOTES 285

Chapter 13: The Murky Myth

1 René Descartes, *Les Principes de la Philosophie, Première partie, Des princ-
 ipes de la connaissance humaine* (AT IX, ii, 25).
2 Brian Fallon, *Irish Times*, 29 December 1971.
3 Letter 594, Vincent van Gogh to Theo van Gogh, 9 April 1888 (VGM).
4 Letter from Police Brigadier Mazon to the Mayor of Arles, 'Complaint
 against Policeman Langlet', 27 August 1878. Cote: J118 Plaints Police (ACA).
5 All these letters are to Theo van Gogh. Colour: Letters 634 and 660;
 drinkers: Letters 588 and 770; Adolphe Monticelli: Letters 600, 702 and 756.
6 Louis Marcé was the first scientist to study the toxic effect of absinthe
 on animals. He included in his paper detailed drawings of rats convulsing
 after being injected with thujone in the form of essence of absinthe, 'Sur
 l'action toxique sur l'essence de l'absinthe', Comptes rendus des séances
 de l'Academie de sciences, Paris, 1864, Tome LVIII. Marcé's experiment
 was seriously flawed; he injected up to 8 grams of essence of absinthe,
 estimated as being the equivalent of 500–1500 glasses of absinthe sold on
 the open market (the disparity in the number comes from the opposing
 views of Drs Cadéac and Meunier): Dr Valérian Trossat, psychiatrist, 'La
 folie de l'Absinthe: Retour sur les troubles mentaux attribués à l'Absinthe
 à travers son histoire', unpublished medical thesis, (Centre Hospitalier
 Universitaire, Besançon, France: 2010) p. 69–70. Marcé's pupil (Jacques
 Joseph) Valentin Magnan (1835–1916) was a celebrated Parisian psychiatrist
 whose work based on Marcé's findings led to the ban of absinthe. He
 was a member of the Temperance movement, who believed that the
 active ingredient present in wormwood was responsible for epileptic fits.
7 Henri Gastaut, 'La Maladie de Vincent van Gogh envisagée à la lumière
 des conceptions nouvelles sur l'épilepsie psychomatrice', *Annalles
 Medico-psychologiques*, tome 1, February 1956, p. 197–238.
8 Extract taken from a letter to an unknown recipient, sold at J. A.
 Stargardt, Berlin, auction 30 and 31 March 1999, catalogue 671, lot 699.
9 Émile Bernard to Albert Aurier, 1 January 1889 (Rewald Archive Folder).
10 Gauguin, *Avant et Après*, pp. 20–1.
11 Letter 736, Vincent van Gogh to Theo van Gogh, 17 January 1889 (VGM).
12 Ibid.
13 The French Larousse dictionary definition of the word 'mystère' is:
 'something that is inaccessible to human reason, which is about the
 supernatural, that is obscure, hidden, unknown, incomprehensible'.

14 In the notes accompanying the facsimile of Gauguin's sketchbook René Huyges wrote 'Who is this painter, seen in profile, smoking a pipe on pages 170–171?' Though he doesn't name him directly he suggests that he is a painter. With the beret and shaved head, plus the word 'mystère' clearly highlighted, I would suggest that this is indeed a portrait of Van Gogh. See *Le Carnet de Paul Gauguin*, p. 117.

15 Gloria Groom and Douglas Druick, *The Age of French Impressionism: Masterpieces from the Art Institute of Chicago*, p. 143.

16 There was another fountain in the public park close to the boulevard des Lices in 1888, but this does not resemble Gauguin's painting in any way. It can still be seen in this park in Arles. See garden plans, Cote: O31 (ACA).

17 The present-day fountain was rebuilt in the 1980s and is significantly higher than the previous one. It can be seen in a photograph from the 1950s, which shows a much lower fountain, with a similar rock-like structure that would barely appear above the surface of the pond. This low fountain would have been hidden by the reeds shown in Vincent's painting of the hospital courtyard.

18 This was first published in the 1957 edition of *Le Carnet de Paul Gauguin*, pp. 22–3 and note on p. 95.

19 Joseph d'Ornano's passport provided the details concerning his height and physical description. Cote: 4M 752/578 Registre, Police Générale – *Passe-port à l'étranger* (Archives de la Gironde).

20 Robert Rey, *Onze menus de Paul Gauguin*.

Chapter 14: Unlocking the Events

1 Letter 736, Vincent van Gogh to Theo van Gogh, 17 January 1889 (VGM).

2 Jo Baart de la Faille's *Catalogue raisonnée de l'oeuvre de Van Gogh*, 1928, stated that Vincent van Gogh cut his right ear. This was quoted and rectified in Doiteau and Leroy's article in 1936, 'Vincent van Gogh et le drame de l'oreille coupée', p.8.

3 Hans Kauffmann and Dr Rita Wildegans, *Van Goghs Ohr: Paul Gauguin und der Pakt des Schweigens*.

4 Letter 734, Paul Gauguin to Vincent van Gogh, between 8 and 16 January 1889 (VGM).

5 Teio Meedendorp, senior researcher at the Van Gogh Museum, Amsterdam, email to the author, 28 May 2013.

6 Tralbaut, *Van Gogh: Le Mal Aimé*, pp. 260–1.

7 M. Jullian, the librarian of Arles, gave an interview describing how Van Gogh was perceived in Arles, in 'Dans Arles, à la recherche de Van Gogh', *La Dauphine Libérée*, 19 January 1958. The account of children teasing Van Gogh is similar to Louis Rey's account, published in *Rheinischer Merkur*, 23 November 1962. The term *'fou Roux'* appears in Julius Meier-Graefe, *Vincent van Gogh*. Theo's widow mentions an article entitled 'Le Fou-Roux' in Letter b7606 V/1996, Jo van Gogh to Julius Meier-Graefe, 25 February 1921; and it also appears in Irving Stone, *Lust for Life*.

8 Referring to Vincent as the *'fou-roux'*, Jean-Paul Clébert and Pierre Richard state, 'I believe one should place this expressive and damning nickname in the pathetic pile of stupid legends concerning Vincent that circulated in Arles in the 1910–1920s when the painter began to be universally known.' Clébert and Richard, *La Provence de Van Gogh*, p. 89.

9 Letter of 11 September 1929, in Doiteau and Leroy, 'Vincent van Gogh et le drame de l'oreille coupée'.

10 This same drawing has been used as an illustration by many authors, including Tralbaut, *Van Gogh: Le Mal Aimé*, and Pascal Bonafoux, *Van Gogh: Le soleil en face*, part of that publisher's popular 'Discovery' series.

11 The late Robert Leroy to the author, 19 December 2008.

12 Edgar Leroy to Irving Stone, 25 November 1930 Stone Papers: Banc MSS 95/2 folder 10, Bancroft Library, University of California, Berkeley.

13 Ibid.

14 This visit was on 8 June 1890.

15 Jo van Gogh-Bonger (ed.), *Vincent van Gogh. Brieven aan zijn broeder*, Amsterdam, 1914, Vol. 1, p. 30.

16 Dr Paul-Ferdinand Gachet (1828–1909) signed his artworks 'Paul van Ryssel'. *Vincent van Gogh sur son lit de mort, le 29 juillet 1890*, charcoal sketch (VGM). He also did a painting of the same scene, which is in the Van Gogh Museum's collection.

17 Paul Louis Lucien Gachet (1873–1962), also an amateur artist, signed his work 'Louis van Ryssel'.

18 Letter B3305 V/1966, Paul Gachet *fils* to Gustave Coquiot, c.1922, in the Coquiot notebook (VGM). *'Ce n'est pas toute l'oreille et autant que je me rappelle c'est une <u>bonne partie</u> de l'oreille externe (plus que le lobe). (Réponse ambigüe, direz-Vous.)'*.

19 Paul Gachet *fils*, quoted in Doiteau and Leroy, 'Vincent van Gogh et le drame de l'oreille coupée'.

20 Paul Signac to Gustave Coquiot, 6 December 1921, in the Coquiot notebook (VGM).

21 Letter to Edward Buckman from Barbara Storfer, for the editors, *Time Life*, New York, 30 June 1955 (VGM).

22 'You won't believe it, but I've found the drawing you were looking for!!!'

23 His office was at 6, rue Rampe du Pont, a street that led up to the bridge across the Rhône to Trinquetaille. K72 Régistre Electoral Arles, 1931 (ACA).

24 Coquiot clearly states in his notebook – it is underlined – that Vincent cut off the whole ear, but published in his book that it was just the lobe. Coquiot notebook, p. 31 (VGM).

25 Dr Félix Rey, 18 August 1930, Stone Papers: Banc MSS 95/205 CZ/, Bancroft Library, University of California, Berkeley.

Chapter 15: Aftermath

1 Cote: 1S46, 'Procès Verbal de l'Hôpital Dieu Saint-Esprit', 30 January 1888 (ACA).

2 These numbers can still be seen on the wall of the library administrative offices.

3 Dr Louis Jean Baptiste Noël Rey (1878–1973).

4 Interview of Dr Louis Rey, *Rheinischer Merkur*, 23 November 1962, translation by Dr William Buchanan.

5 Ibid.

6 According to Dr Rey, the severed ear – by that stage a specimen – was placed in a jar in his office and was later thrown out by a member of staff. Quoted in Doiteau and Leroy, and in Bailey, 'Drama at Arles'.

7 Interview of Dr Louis Rey, *Rheinischer Merkur*.

8 Named after Lord Joseph Lister (1827–1912), the English surgeon who developed the use of antiseptics.

9 Annales Arles December 1888 and January 1889 Météo-France, Région Sud-Est.

10 Bailey, 'Drama at Arles'.

11 My researched overlapped with that of Martin Bailey, who published another of these new articles in his 2013 book *The Sunflowers Are Mine*. However, as far as I am aware, two of the articles I have uncovered have not been seen since their original publication in 1888.

12 *Indicateur Arlésien*, 1887 (MA).

13 *Le Petit Marseillais*, 25 December 1888, Edition Aix, (Bibliothèque Méjanes, Aix-en-Provence).

14 The newspapers are: *Le Petit Provençal*, 25 December 1888, (Edition Gard, Bibliothèque Patrimoine Ville de Nîmes); *Le Petit Marseillais*, 25 December 1888 (Edition Aix, Bibliothèque Méjanes, Aix-en-Provence); *Le Petit Journal*, 26 December 1888, (Edition Paris, BNF); *Le Petit Méridional*, 29 December 1888, (Bibliothèque Inguimbertine, Carpentras); *Le Forum Républicain*, 30 December 1888 (MA).

15 *Le Petit Provençal*, 25 December 1888.

16 Letter 743, Vincent van Gogh to Theo van Gogh, 28 January 1889 (VGM).

17 For the purchase of a hat, see the list of expenses outlined in Letter 736, Vincent van Gogh to Theo van Gogh, 17 January 1889 (VGM).

18 Adéline Ravoux, 'Souvenirs sur le séjour de Vincent van Gogh à Auvers-sur-Oise', *Les Cahiers de Vincent* 1 (1957), pp. 7–17 (VGM).

19 Paul Signac to Gustave Coquiot, 6 December 1921, in the Coquiot notebook (VGM).

Chapter 16: 'Come Quickly'

1 Introduction to *Brief Happiness: The Correspondence of Theo van Gogh and Jo Bonger*.

2 Ibid.

3 Letter 8, Jo Bonger to Theo van Gogh, 29 December 1888, in *Brief Happiness*.

4 Letter B2389V/1982, Anna van Gogh to Theo van Gogh, 22 December 1888; and Letter B2387V/1982, Willemien van Gogh to Theo van Gogh, 23 December 1888 (VGM).

5 Letter 3, Theo van Gogh to Jo Bonger, 24 December 1888, in *Brief Happiness*.

6 The post office in 1888 was at 10, place de la République (A38 Ile 1). A new post office in Arles was built on the opposite side of the square and opened in 1898. Cote: O17 bis Numérotation des rues (ACA) and *Indicateur Arlésien*, 1887 (MA).

7 Letter 4, Theo van Gogh to Jo Bonger, 24 December 1888, in *Brief Happiness*.

8 Two trains left Paris in the afternoon or evening. I have chosen as the

most probable the express train, number 11, which left Paris at 9.20 p.m. This train enabled Theo to arrive in Arles at the earliest possible time on 25 December. Winter timetable 1888–9 (SNCF archives, Le Mans).

9 Christmas Eve and Christmas day were both rain-free days. The weather records show that it rained for 3 days in Arles from 21 to 23 December with 30 inches of rain recorded. From 24 to 29 December there was a let-up in the weather, followed by another period of torrential rain with 85 inches falling in the four days days until 1 January 1889. Annales Arles 1888–1889 (Météo France-Agence Sud-Est).

10 Gauguin, *Avant et Après*, p. 22.

11 The only other train that left for Paris on 25 December departed at 3.47 p.m. and wouldn't have given Theo enough time in Arles. There was no other train to Paris that day until after midnight; this was a much slower train, which would have got to Paris at 11.16 p.m. on the 26th. Thus I have chosen the 'express train', number 12, which was only for first-class passengers, as being the most likely (SNCF archives, Le Mans).

12 Letter 6, Theo van Gogh to Jo Bonger, 28 December 1888, in *Brief Happiness*.

13 Theo received letters from Dr Félix Rey, Joseph Roulin and Reverend Salles in the days after his visit to Arles. It is evident from the wording in these letters that they had promised to keep Theo abreast of Vincent's progress. See Letter B1055, Félix Rey to Theo van Gogh, 29 December 1888 and Letter B1056, Félix Rey to Theo van Gogh, 30 December 1888 (both VGM). For the letters from Roulin and Reverend Salles, see Jan Hulsker, 'Critical Days in the Hospital at Arles: unpublished letters from the postman Roulin and the Reverend Mr Salles to Theo van Gogh' in *Vincent*, Bulletin of the Rijksmuseum Vincent van Gogh, 1–1, 1970, pp. 20–31.

14 The train arrived at Paris at 5.40 p.m. (SNCF archives, Le Mans).

15 Letter B1065, Joseph Roulin to Theo van Gogh, 26 December 1888 (VGM). In 1888, the concierge at the Hôtel-Dieu Saint-Esprit in Arles was (Alexis François) Joseph Bonnet (1826–1901).

16 Letter 732, Vincent van Gogh to Theo van Gogh, 7 January 1889 (VGM).

17 In this painting Augustine appears to be sitting in the same chair as that seen in the painting of Gauguin's chair from the same month, so the *Berceuse* series is assumed to have been painted at 2, place Lamartine. However, these chairs were very common in the nineteenth century and can still be found all over Provence. It is known from Letter 669 (Vincent to Theo van Gogh, 26 August 1888, VGM) that Vincent spoke

to the Roulins about purchasing furniture and may have had the same, or a similar, chair. I believe this painting was done at the Roulins' home (10, rue Montagne des Cordes) rather than at the Yellow House. This perhaps explains the decorative wallpaper. To get to the Yellow House, Augustine would have had to walk 350 metres, crossing a main thoroughfare, and pass under two railway bridges, all the while carrying her baby and the cradle. It would be difficult and cumbersome, not to say fairly impractical. It seems more logical that Vincent would go to her house to paint her, under the circumstances. I would suggest that, apart from the *Berceuse* series, another portrait of Augustine was also made at her home (F503, JH 1646). This shows pots with bulbs outside a window, and a pathway in the far distance. With the meandering pathway, it has been suggested that this painting was also done in the Yellow House, but in Van Gogh's illustrations of 2, place Lamartine there is no indication of any ledge, nor could pots of this size sit on a windowsill. The Roulins had a garden at the back of the house, as can be seen on the land registers (Q372) and thanks to aerial photographs taken in 1919. Service Cadastres, Arles and Cote: 1919 CAF_C14_26, Photothèque, l'Institut national de l'information géographique et forestière (IGN).

18 Letter 739, Vincent van Gogh to Paul Gauguin, 21 January 1889 (VGM).
19 Letter B1066V/1962, Joseph Roulin to Theo van Gogh, 28 December 1888 (VGM).
20 Letter 747, Vincent van Gogh to Theo van Gogh, 18 February 1889 (VGM).
21 Dr Marie Jules Joseph Urpar (1857–1915), chief physician at Arles hospital in December 1888. Extract taken from the hospital register of letters, Cote: Q92, 'Hospices Civils de la Ville d'Arles, Registre de correspondance' (ACA).
22 Letter FR B1055/V/1962, Félix Rey to Theo van Gogh, 29 December 1888 (VGM).
23 Letter 9, Theo van Gogh to Jo Bonger, 29 December 1888, in *Brief Happiness*.
24 Letter FR B1056, Félix Rey to Theo van Gogh, 30 December 1888 (VGM).
25 Ibid.
26 Ibid.
27 Formal committal procedure called *Loi des aliénés*. Loi du 30 juin 1838. This process remained unchanged until 3 January 1968.
28 Letter FR B1056, Félix Rey to Theo van Gogh, 30 December 1888 (VGM).

29 Cote: 1S 46, 'Procès Verbal de l'Hôpital Dieu Saint-Esprit', 31 December
 1889 (ACA).
30 Letter B1045/V/1962, Reverend Salles to Theo van Gogh, 31 December
 1888 (VGM).
31 Émile Schuffenecker lived at 29, rue Boulard in Montparnasse, across
 the city from Montmartre, where Theo van Gogh lived.
32 Letter FR B2425, Anna van Gogh to Theo van Gogh, 29 December 1888
 (VGM).

Chapter 17: 'Alone on the Sad Sea'

1 These few documents were among the papers, including the petition
 to get Vincent out of Arles, which finally entered the city archives in
 2003. There is an absence of any documents relating to Van Gogh's
 breakdown in *Correspondance du Maire* and Police file Cote: J159, *Crimes
 et Délits, 12 juillet 1886–10 novembre 1890* (ACA).
2 Letter FR B1067, Joseph Roulin to Theo van Gogh, 3 January 1889 (VGM).
3 Letter 728, Vincent van Gogh to Theo van Gogh, 2 January 1889 (VGM).
4 Letter FR B1068, Joseph Roulin to Theo van Gogh, 4 January 1889 (VGM).
5 Vincent enumerated the cost: 'Paid for having all the bedding, blood-
 stained linen &c. laundered: 12fr 50'. Letter 736, Vincent van Gogh to
 Theo van Gogh, 17 January 1889 (VGM).
6 Letter 728, Vincent van Gogh to Theo van Gogh, 2 January 1889, note
 added by Dr Félix Rey (VGM).
7 Letter 729, Vincent van Gogh to Theo van Gogh, 4 January 1889 (VGM).
8 Letter 728, Vincent van Gogh to Theo van Gogh, 2 January 1889, note
 added by Dr Félix Rey (VGM).
9 Letter 730, Vincent van Gogh to Paul Gauguin, 4 January 1889 (VGM).
10 The character Pangloss says these words throughout Voltaire's *Candide*,
 1759. See note 1, Letter 730, Vincent van Gogh to Paul Gauguin, 4 January
 1889 (VGM).
11 Letter 733, Vincent van Gogh to Anna van Gogh and Willemien van
 Gogh, 7 January 1889 (VGM).
12 Letter FR B1069, Joseph Roulin to Theo van Gogh, 7 January 1889; and
 Letter FR B710, Joseph Roulin to Willemien van Gogh, 8 January 1889 (VGM).
13 Letter 732, Vincent van Gogh to Theo van Gogh, 7 January 1889 (VGM).
14 After reading the letter in French, I have modified the official translation,

which reads: 'My suffering in that way in the hospital was appalling, and yet in the midst of it all, though I was more than insensible, I can tell you as a curiosity that I kept thinking about Degas', Letter 735, Vincent van Gogh to Theo van Gogh, 9 January 1889 (VGM).

15 Note 12, Letter 735, Vincent van Gogh to Theo van Gogh, 9 January 1889 (VGM).

16 Letter 735, ibid.

17 Letter 730, Vincent van Gogh to Paul Gauguin, 4 January 1889 (VGM).

18 This print was *Geishas in a Landscape* by Sato Torakiyo. See note 2, Letter 685, Vincent van Gogh to Theo van Gogh, 21 September 1888 (VGM).

19 Geraldine Norman, 'Fakes', *New York Review of Books*, 5 February 1998.

20 Aviva Burnstock, unpublished technical report on Van Gogh's *Self-Portrait with Bandaged Ear*, 2009, curatorial file, Courtauld Institute, London.

21 Letter 735, Vincent van Gogh to Theo van Gogh, 9 January 1889 (VGM).

22 Burnstock, unpublished technical report on Van Gogh's *Self-Portrait with Bandaged Ear*.

23 Vincent stated on 17 January that he had already paid ten francs to the hospital for dressings. Following Lister's recommendations, if these were changed every five days, Vincent would have had his wound dressed on 24 and 28 December 1888, 1, 5, 9 and 13 January 1889, and the last bandage would have been removed on 17 January 1889. If they were changed every six days, it would be 24 and 29 December 1888, 3, 8 and 13 January 1889, and the last bandage would have been removed on 18 January 1889. Letter 736, Vincent van Gogh to Theo van Gogh, 17 January 1889 (VGM).

24 Vincent first refers to having finished these paintings in his Letter 736, ibid.

25 For details concerning the extra expenses Vincent's breakdown had incurred see Letter 736, Vincent van Gogh to Theo van Gogh, 17 January 1889 (VGM).

26 Note 5, Letter 736, ibid.

27 Martin Bailey, 'Why Van Gogh Cut his Ear: New Clue', *Art Newspaper*, January 2010.

28 These deliveries were at 7.45 a.m., 11 a.m. (Paris), 2.30 p.m. and 7 p.m. The last delivery was not within the town but to outlying rural locations, such as the farms in the Camargue.

29 Letter 736, Vincent van Gogh to Theo van Gogh, 17 January 1889 (VGM).

30 The pictures that use this device are: various portraits of *Joseph Roulin*,

F435, JH1674, F436, JH1675 and F439, JH1673. Pictures of *Augustine Roulin*
(*La Berceuse*): F505, JH1669, F508, JH1671, F507, JH1672, F506, JH1670 and
F504, JH1665. *Félix Rey*, F500, JH1659 and *Eugène Boch*, F462, JH1574.

31 Annales Arles janvier 1889, Météo-France, Région Sud-Est.

32 Letter 738, Vincent van Gogh to Theo van Gogh, 19 January 1889 (VGM).

33 Letter 736, Vincent van Gogh to Theo van Gogh, 17 January 1889 (VGM).

34 Letter 739, Vincent van Gogh to Paul Gauguin, 21 January 1889 (VGM).

35 Les Folies Arlésiennes, 4, rue Victor Hugo. On 27 January 1889 there were
 two shows of *La Grande Pastorale*, with artists from Marseille at 2 p.m.
 and 8 p.m. If children were in tow, it is likely Vincent attended the 2 p.m.
 show. Advert, *Le Forum Républicain* newspaper 20 January 1889 (MA).

36 Cote: J275, *Rapport, Les Folies Arlésiennes*, Dr Félix Rey, 24 November
 1916 (ACA).

37 Letter 743, Vincent van Gogh to Theo van Gogh, 28 January 1889 (VGM).

38 Ibid.

39 Letter 741, Vincent to Theo van Gogh, 22 January 1889 (VGM).

40 Letter 743, Vincent to Theo van Gogh, 28 January 1889 (VGM).

41 Letter 744, Vincent van Gogh to Theo van Gogh, 30 January 1889 (VGM).

42 Ibid.

43 Letter 745, Vincent van Gogh to Theo van Gogh, 3 February 1889 (VGM).

44 Ibid.

45 Letter 743, Vincent van Gogh to Theo van Gogh, 28 January 1889 (VGM).

Chapter 18: Betrayal

1 In note 1, Letter 747, (Vincent van Gogh to Theo van Gogh, 18 February
 1889), a second breakdown is mentioned as occuring in February 1889
 when in fact it was Vincent's third. Vincent clearly states in Letter 704
 (Vincent van Gogh to Willemein van Gogh, between 28 April and 2
 May 1889) that he had had 'four big crises' (VGM).

2 Letter 743, Vincent van Gogh to Theo van Gogh, 28 January 1889 (VGM).

3 Vincent's crises were on 23 and 27 December 1888 and 4 February 1889. He
 had a fourth breakdown around 26 February 1889, confirming the number
 of crises Vincent mentioned in his letter to his sister. Letter 764, Vincent van
 Gogh to Willemien van Gogh, between 28 April and 2 May 1889 (VGM).

4 Julius Meier-Graefe interview with Marie Ginoux, 'Erinnerung an van
 Gogh' (Memories of van Gogh) in *Berliner Tageblatt und Handels-Zeitung*,

Berlin, No. 313, 23 June 1914, p. 2 (http://zefys.staatsbibliothek-berlin. de); translation by Dr William Buchanan.

5 Letter 745, Vincent van Gogh to Theo van Gogh, 3 February 1889 (VGM).

6 Letter FR B1046, Reverend Frédéric Salles to Theo van Gogh, 7 February 1889 (VGM).

7 Letter B1057/V/1962, Félix Rey to Theo van Gogh, 12 February 1889, (VGM).

8 Letter 747, Vincent van Gogh to Theo van Gogh, 18 February 1889 (VGM).

9 *Pétition documentation* (ACA).

10 Jacques Tardieu (1834–97), Mayor of Arles 13 May 1888–21 April 1894. Election results, *l'Homme de Bronze*, 20 May 1888, p. 1(MA). 'Liste des maires' (ACA).

11 Letter 764, Vincent van Gogh to Willemien van Gogh, between 28 April and 2 May 1889 (VGM).

12 Letter FR B1047, Reverend Frédéric Salles to Theo van Gogh, 26 February 1889 (VGM).

13 Letter FR B921, Theo van Gogh to Willemien van Gogh, 15 March 1889 (VGM). The letter from the Reverend Salles has been lost.

14 Letter 750, Vincent van Gogh to Theo van Gogh, 19 March 1889 (VGM).

15 Ibid.

16 Alphonse Robert in his letter of 11 September 1929, in Doiteau and Leroy, 'Vincent van Gogh et le drame de l'oreille coupée'.

17 Julius Meier-Graefe, article 'Erinnerung an van Gogh'.

18 Interview with M. Jullian, 'Dans Arles, à la recherche de Van Gogh', (VGM).

19 Letter FR B1049, Reverend Frédéric Salles to Theo van Gogh, 18 March 1889 (VGM).

20 Letter 750, Vincent van Gogh to Theo van Gogh, 19 March 1889 (VGM).

21 Gustave Coquiot, *Vincent van Gogh*, p. 193. Other writers give different figures: Julius Meier-Graefe states that there were eighty-one signatures, and Irving Stone says ninety. In Letter FR B1047 (Reverend Frédéric Salles to Theo van Gogh, 26 February 1889), Salles mentions that there were around thirty petitioners. It was only with the work of Marc Edo Tralbaut, *Van Gogh: Le Mal Aimé*, and the reproduction of the petition in Clébert and Richard, *La Provence de Van Gogh*, p. 90, that the exact number of thirty was confirmed.

22 D693, *Correspondance de Violette Méjan* (ACA).

23 Charles Raymond Privat, Mayor of Arles 1947–1971, ordered the documents to be placed in a safe at the Musée Réattu, Arles.

24 The text of the inquiry was published by Marc Edo Tralbaut in *Van Goghiana X* (Editions P. Peré, Antwerp: 1975), although those interviewed by the police were indicated only by their initials.

25 Inquiry documentation, 27 February 1889 (ACA).

26 Ibid.

27 Dr Jean-Henri Albert Delon (1857–1943), letter to the Mayor of Arles, 7 February 1889, *Pétition documentation* (ACA).

28 *Le Forum Republicain,* 20 January 1889 (MA).

29 Dr Marie Jules Joseph Urpar (1856–1915) was Head of Medicine at Arles hospital. His deputy, Joseph Béraud (1851–?), was named as '*médecin suppléant*' on 7 March 1888. Cote: Q92 'Registre Correspondence de la commission administrative des Hospice d'Arles an préfet' (ACA).

30 Letter B1048/V/1962, Reverend Frédéric Salles to Theo van Gogh, 1 March 1889 (VGM).

31 Letter 751, Vincent van Gogh to Theo van Gogh, 22 March 1889 (VGM).

32 Tralbaut, *Van Gogh: Le Mal Aimé,* p. 270.

33 D63, *Mouvement de la Population* 1889, statistics concerning 'Place Lamartine et Portnagel' (ACA).

34 Martin Gayford, *The Yellow House* and 'Van Gogh Betrayed', *Daily Telegraph,* 25 June 2005.

35 www.archives13.fr., *Etat Civil,* mariage Ginoux–Julien, 1866 (ACA).

36 Clébert and Richard, *La Provence de Van Gogh,* p. 91.

37 These were: Esprit Lantheaume, Maurice Villaret, the Widow Nay and the Widow Venissac.

38 This visit is mentioned in Letter B1067/V/1962, Joseph Roulin to Theo van Gogh, 3 January 1889 (VGM).

39 Clébert and Richard, *La Provence de Van Gogh.* Pierre Richard first suggested that Damase Crévoulin wrote the petition.

40 See Letter 735, Vincent van Gogh to Theo van Gogh, 9 January 1889 (VGM).

41 Charles Zéphirin Viany (1846–1909), a retail tobacconist. His wife, Maria Ourtoule (1846–?), was one of those interviewed by the police during their inquiry. Viany (a Ginoux cousin) and his family had only recently arrived from the nearby town of Boulbon, where he appears on the 1886 census as a tailor. By the time of his death in Arles he was a retail tobacconist. Madame Ourtoule was also a relative of one of the other petitioners, Sébastien Calais (1862–1943). Viany had purchased the right to have a tobacconist's from François Pélissier, who held the concession on place Lamartine. Pélissier's daughters were both linked through marriage to the petitioners:

Charles Chareyre (1858–1938) and François Trouche (1846–1923) through his brother Louis: *Etat Civil* and *Liste Electorale* 1888 and 1889 (ACA), *Indicateur Arlésien*, 1887 (BMA), *Etat Civil*, Boulbon, and 1886 Boulbon census (AD).

42 Contemporary documents were examined to see if the petitioners for Van Gogh could be found on similar complaints in the area. In the Arles archives there are two other petitions from this period, from 1878 and c.1886. The latter concerns the area reserved for prostitutes, and none of the petitioners overlap. Of the forty signatures on the 1878 petition to improve place Lamartine, four were also on the petition relating to Van Gogh. Cote: O14 and Cote: O17 (ACA).

43 See Marc Edo Tralbnut in *Van Goghiana X* and Clébert and Richard, *La Provence de Van Gogh*. All three have worked extensively on the documents. In their work the petition and the inquiry were discussed together.

44 Inquiry Annex 2 (ACA). The family's responsibility for Vincent's welfare was customary at the time.

45 Bernard Soulè, see notes 15–17 in Chapter 7. Marguerite Favier, married to (François) Damase Crévoulin, lived next door to Vincent at 2, place Lamartine. Jeanne Corrias (1842–?) lived at 24, place Lamartine; she was the wife of Théophile Coulomb, a railway employee and one of the petitioners. *Pétition documentation* (ACA), *Etat Civil*, Beaucaire.

Chapter 19: Sanctuary

1 Letter 764, Vincent van Gogh to Willemien van Gogh, between 28 April and 2 May 1889 (VGM).

2 Sister Marie Heart of Jesus (née Marguerite Bonnet, 1821–91) worked in the pharmacy, and gardener Louis Auran (1818–93). *Etat Civil*, Arles. Cote: D451 and Cote: D92, *Correspondance de l'hôpital*, and Cote: 1S46, *Procès verbal de l'Hôpital Dieu* (ACA).

3 Letter from Alfred Massebieau to Alfred Vallette, 10 April 1893, *La Mercure de France*, No. 999, 1-VII-1940-I-XII-1946, Paris, 1946.

4 Architectural drawings of the hospital by Auguste Véran, *Plan Général de Hôtel Dieu, Arles, le 8 janvier 1889*, Cotes: 1 Fi 123 and 1 Fi 124 (ACA).

5 In Question 11 it states that the most recent annual report was 30 June 1888. In Section II – Personnel – Dr Gay is cited as being a member of staff. Gay resigned his post on 14 February 1889. So the questionnaire was compiled between these dates. 1S8, 'Questionnaire sur les hôpitaux

et les hospices émanant du ministère de l'intérieur', 1888, and Cote: Q92, *Registres de correspondance* (ACA).

6 According to the report, the hospital was built above Roman sewers, which were still being used in 1888.

7 Cote: Q92, *Registres de correspondance* (ACA).

8 The exact dates of his hospitalisation are 24 December 1888–7 January 1889 and 3–18 February 1889 (after which he was 'eating and sleeping at the hospital', but working at the Yellow House). He was returned to the hospital on or about 26 February and placed in the isolation cell again until 19 March 1889, after which he remained in the hospital ward until 8 May 1889.

9 Letter 747, Vincent van Gogh to Theo van Gogh, 18 February 1889 (VGM).

10 Letter FR B1048, Reverend Frédéric Salles to Theo van Gogh, 1 March 1889 (VGM).

11 Letter FR B1051, Reverend Frédéric Salles to Theo van Gogh, 2 March 1889 (VGM).

12 Letter FR B921, Theo van Gogh to Willemien van Gogh, 15 March 1889 (VGM).

13 The tobacconist, Charles Zéphirin Viany, eventually opened a business up the road from Vincent's Yellow House. On the 1891 Census of Arles he is described as being a 'débitant-tabac' (tobacconist) who lives at 56, avenue Montmajour (AD).

14 Letter FR B790, Theo van Gogh to Anna and Joan van Houten (his sister and brother-in-law), 10 March 1889 (VGM).

15 Letter 751, Vincent van Gogh to Theo van Gogh, Arles 22 March 1889 (VGM).

16 Smallpox vaccination had been available in France since the early nineteenth century. Disinfection was undertaken with sulphur and ferrous sulphate. Cote: 1S14, 'Rapport sur l'épidémie de la variole', Dr Félix Rey, 15 April 1889 (ACA).

17 This explains why Van Gogh's production was curtailed. He was only able to recommence work once the immediate danger of spreading the infection had passed. Because of the epidemic, all his paintings and drawings while he was a patient at the hospital can be dated precisely to the last month he spent in Arles: early April to 8 May 1889.

18 Cote: 1514, 'Rapport sur l'epidemic de la variole', Félix Rey, 15 April 1889 (ACA).

19 Ibid and Cote: J127, Curriculum Vitae, Dr Félix Rey, 10 January 1912.

20 Pauline Mourard-Rey, quoted in Martin Bailey, 'Van Gogh's Arles', *Observer* magazine, 8 January 1989.

21 Further details of the fabrics used can be found in Cote: Q90, *Registre de fournitures*, and Cote: 1S8, 'Questionnaire sur les hôpitaux et les hospices émanant du ministère de l'intérieur', 1888 (ACA).

22 Cote: Q62, 'Projet de reconstruction d'un hôpital fin 19ème siècle' (ACA).

23 Cote: 1S8, 'Questionnaire sur les hôpitaux et les hospices émanant du ministère de l'intérieur', 1888 (ACA).

24 Cote: Q90, 'Cahier des Charges 1888–1889', Hospices Civils de la ville d'Arles, Registre des Fournitures, 1872–1905 (ACA).

25 Letter 751, Vincent van Gogh to Theo van Gogh, 22 March 1889 (VGM).

26 Letter 752, Vincent van Gogh to Theo van Gogh, 24 March 1889 (VGM).

27 Letter FR B640, Paul Signac to Theo van Gogh, 24 March 1889 (VGM).

28 Letter FR B1049, Reverend Frédéric Salles to Theo van Gogh, 18 March 1889 (VGM).

29 Letter 751, Vincent van Gogh to Theo van Gogh, 22 March 1889 (VGM).

30 Cote: 1S7, article 15, 'Règlementation du service intérieur, Règlementation internes Hospices' 1888 (ACA).

31 Letter 758, Vincent van Gogh to Theo van Gogh, between 14 and 17 April 1889 (VGM).

32 The details of the property from the land registry are: 'île 98 – I n° 13–14 – Folio 6962'. Robert Fiengo to the author, 21 May 2012 (CA).

33 Letter FR B1050, Reverend Frédéric Salles to Theo van Gogh, 19 April 1889 (VGM).

34 Letter 760, Vincent van Gogh to Theo van Gogh, 21 April 1889 (VGM).

35 FR B940, Theo van Gogh and Johanna Bonger to Anna van Gogh, Paris, on or around 5 May 1889 (VGM).

36 'For the time being the furniture has been sent to the house of a neighbour, to whom your brother has paid three months' rent for this purpose, eighteen francs in all.' Letter FR B1050, Reverend Frédéric Salles to Theo van Gogh, 19 April 1889 (VGM).

37 Letter FR B1054, Reverend Frédéric Salles to Vincent van Gogh, Arles, 5 May 1889.

Chapter 20: Wounded Angel

1 The show was Jules Verne's *Michel Strogoff* at the Théâtre du Chatelet, January 1888. Interview with Gabrielle's grandson.

2 Letter 743, Vincent van Gogh to Theo van Gogh, 28 January 1889 (VGM).

3 Ibid.
4 Émile Bernard to Albert Aurier, 1 January 1889, Rewald Folder.
5 Letter FR B1066, Joseph Roulin to Theo van Gogh, 28 December 1888; and Letter FR B1046, Reverend Salles to Theo van Gogh, 7 February 1889 (VGM).
6 Letter FR B1057, Félix Rey to Theo van Gogh, 12 February 1889 (VGM). Augustine Roulin left Arles sometime before 25 February 1889. Vincent mentions her departure in Letter 748, Vincent van Gogh to Theo van Gogh, 25 February 1889 (VGM).
7 Cote: J43 Maisons de Tolérance (ACA).
8 Often erroneously attributed to Arthur Wellesley, 1st Duke of Wellington (1769–1852), this quote actually came from Irish political leader Dónall Ó Conaill (Daniel O'Connell, 1775–1847) in 1843. The comment 'Being born in a stable does not make a man a horse' was made *about* the famous general, who was born in Ireland. Dónall Ó Conaill, in a speech of 16 October 1843. Reported in *Shaw's Authenticated Report of the Irish State Trials*, 1844, p. 93.
9 Laure Adler, *La Vie Quotidienne Dans Les Maisons Closes 1830–1930* (Hachette, Paris: 1990).
10 Leprohon, *Vincent van Gogh*, p. 355.
11 *Le Petit Provençal*, 25 December 1888.
12 Doiteau and Leroy, 'Vincent van Gogh et le drame de l'oreille coupée'.
13 Institut Pasteur, 1888 (Archives Institut Pasteur).
14 Dr Louis Pasteur, French scientist (1888–1911). The first treatment using the rabies vaccine was for a young boy called Joseph Meister on 6 July 1885 (Archives Institut Pasteur).
15 Dr Michel Arnaud (1859–?) listed as living at 14, rue Rampe du Pont. Cote: K38, *Listes Electorales* 1888 (ACA). The shepherd who shot the dog was called Moreau (Archives Institut Pasteur).
16 Cauterisation could either be with a red-hot iron bar or, if available, carbolic acid (phenol). Gabrielle's medical records state that she was 'cautérisée au thermocautéré', using heat (Archives Institut Pasteur).
17 There were two trains that Gabrielle could have taken: the direct train no. 46, which left Arles at 00.19 a.m. on 9 January 1888 and arrived in Paris at 11.16 p. m. the same day and took 1st, 2nd and 3rd class passengers, or the express train no. 12, which left at 1.04 a.m. and arrived earlier at 5.40 p.m. This train only took first class passengers. Her grandson told me that she had arrived around 5 p.m. Bearing in mind the urgency of the situation it's most likely her family ensured that she

take the quickest, yet more expensive train. Interview with Gabrielle's grandson, 26 June 2010 and PLM winter train timetable 1887–88 (SNCF archives, Le Mans).

18 The Institut Pasteur building was opened in its present location at 25–28 rue du Docteur Roux (previously named rue Dutot) on 24 November 1888 (Archives Institut Pasteur).

19 This virus of the nervous system was extracted from infected rabbit brains – rather than infected dogs as it was too virulent – then a solution was made up from specially dried rabbit spinal cord sections which were injected into the patient. It was important to have fresh supplies of this spinal-cord solution as Gabrielle's medical records show (Archives Institut Pasteur).

20 Interview with Gabrielle's grandson, June 2010.

21 Interview with Gabrielle's family, March 2015.

22 *Le Forum Républicain*, 30 December 1888; and *Le Petit Provençal*, 25 December 1888.

23 See Letters 638, Vincent van Gogh to Theo van Gogh, 10 July 1888 and Letter 780, Vincent van Gogh to Willemein van Gogh, 10 June 1888 (VGM).

Chapter 21: Troubled Genes

1 Dr Théophile Peyron, twenty-four-hour patient notes, 9 May 1889, Hôpital Saint-Paul de Mausole. As these documents are now lost I worked from the photographs of the original registers shown in Tralbant, *Van Gogh: Le Mal Aimé*, pp. 276–7 (VGM documentation).

2 Letter FR B1140, Caroline van Stockum-Haanebeek to Jo van Gogh, The Hague, 23 October 1890 (VGM). Caroline was a distant relative on his mother's side of the family. See note 1, Letter 010, Vincent van Gogh to Willem van Stockum and Caroline van Stockum-Haanebeek, 2 July 1873 (VGM).

3 Dr Théophile Peyron, monthly patient notes (VGM documentation).

4 Clara Adriana Carbentus (1813–66), Van Gogh's aunt. There was another female Carbentus child who had died as a baby, Gerarda (1831–2). And there were other close blood ties: his father's brother, Uncle 'Cent', was married to Vincent's mother's sister, Cornelia Carbentus (1829–1913).

5 Letter 743, Vincent van Gogh to Theo van Gogh, 28 January 1889 (VGM).

6 E. de Bécoulet, 'L'emploi du bromure de potassium dans la folie épileptique', *Annales Médico-psychologiques*, 1869, Vol. 1, pp. 238–47; and R. E.

Gosselin, H. C. Hodge, R. P. Smith and M. N. Gleason, *Clinical Toxicology of Commercial Products,* Williams and Wilkins, Baltimore, fourth edition 1976, pp. 11–77.

7 Letter FR B1046, Reverend Frédéric Salles to Theo van Gogh, 7 February 1889 (VGM).

8 Paul Signac to Gustave Coquiot, 6 December 1921, in the Coquiot notebook (VGM).

9 See footnote 10, Letter 739, Vincent van Gogh to Paul Gauguin, 21 January 1889 (VGM).

10 Russell R. Monroe, 'Another diagnosis for Vincent van Gogh?', *Journal of Nervous & Mental Disease,* No. 179, 1991, p. 241.

11 Henri Gastaut, 'La maladie de Van Gogh envisagée à la lumière des conceptions nouvelles sur l'épilepsie psycho-motrice', *Annales Médico-psychologiques,* No. 114, 1956, pp. 196–238.

12 Dr Piet Voskuil requested further details from Henri Gastaut prior to the psychiatrist's death in 1995 and was told that his interview with the hospital orderly 'was a long time ago' and that he 'had destroyed his notes'. Author interview with Dr Piet Voskuil, July 2015. See also Piet Voskuil's article, 'Van Gogh's Disease in Light of his Correspondence', in J. Bogousslavsky and S. Dieguez (eds), *Literary Medicine: Brain Disease and Doctors in Novels, Theater, and Film* (Karger, Basel: 2013) pp. 116–25.

13 Doiteau and Leroy, 'Vincent van Gogh et le drame de l'oreille coupée'.

14 Dr Jane Siegal, clinical psychotherapist, San Francisco.

15 M. Benezech and M. Addad, 'Van Gogh, le stigmatisé de la société', *Annales Médico-psychologiques,* No. 142, 1984, pp. 1161–72.

16 This notorious murderer, who terrorised London in the autumn of 1888, was widely reported in the Arles press. All of his victims were prostitutes. On the night of 30 September 1888, Jack the Ripper cut an ear off one of his victims, Catherine Eddowes, as reported in *Le Petit Marseillais* of 2 October 1888 (AD). Mary Jane Kelly had both ears removed on 9 November 1888. See Albert J. Lubin, *A Stranger on Earth: A Psychological Biography of Vincent van Gogh,* pp. 159–60.

17 I. Arenberg, L. Countryman, L. Bernstein and E. Shambaugh, Jr, 'Van Gogh had Ménières disease and not epilepsy', *Journal of the American Medical Association,* No. 264, 1990, pp. 491–3.

18 E. Magiorkinis, S. Kalliopi and A Diamantis, 'Hallmarks in the history of epilepsy: Epilepsy in antiquity', *Epilepsy & Behavior,* No. 17, January 2010, pp. 103–8.

19 3.5–5.8 per cent higher risk of suicide; statistics from the Epilepsy Foundation.
20 Professor James Lance, consultant neurologist, Australian Institute of Neurological Sciences.
21 Dr P. H. A. Voskuil, 'Diagnosing Vincent van Gogh, an expedition from the sources to the present, "mer à boire"', *Epilepsy & Behavior*, No. 28, 2013, pp. 177–80.

Chapter 22: 'The Certainty of Unhappiness'

1 Adeline Ravoux-Carrié, 'Les Souvenirs d'Adeline Ravoux sur le séjour de Vincent van Gogh à Auvers-sur-Oise', *Les Cahiers de Vincent* 1, 1957 pp. 7–17 (VGM).
2 Steven Naifeh and Gregory White Smith, *Van Gogh: The Life*.
3 Victor Doiteau, 'Deux "copains" de Van Gogh, inconnus, les frères Gaston et René Sécretan, Vincent tel qu'ils l'ont vu', *Aesculape*, March 1957, pp. 38–58.
4 Louis van Tilborgh and Teio Meedendorp, 'The Life and Death of Van Gogh', *The Burlington Magazine*, London, CLV, July 2013, pp. 456–62.
5 Adeline Ravoux, 'Les Souvenirs'.
6 The funeral was due to be held at the Church of Notre Dame in Auvers-sur-Oise at 2.30 p.m. on 30 July 1890. Details taken from the *'faire-part'* – the formal notification of the funeral reproduced by the Auberge Ravoux for the 120th anniversary of Van Gogh's death: Auberge Ravoux, Auvers-sur-Oise, 29 July 1890–29 July 2010, '120ème anniversaire de la mort de Vincent van Gogh à l'Auberge Ravoux'.
7 Dr Théophile Zacharie Auguste Peyron (1827–95).
8 Letter 772, Vincent van Gogh to Theo and Jo van Gogh, 9 May 1889 (VGM).
9 Ibid.
10 The original purple colour of these irises has changed over time. The paint has discoloured and now appears blue.
11 Annales Arles juin 1889, Météo France, Agence Sud-Est.
12 William Parsons, the Third Earl Rosse, first presented his drawings to the Royal Society, London in 1851.
13 Vincent sent a sketch of this painting to Theo (F1540, JH1732). See note 16, Letter 784, Vincent van Gogh to Theo van Gogh, 2 July 1889 (VGM).
14 Letter 786, Johanna van Gogh to Vincent van Gogh, Paris, 5 July 1889 (VGM).

15 Letter 794, Theo van Gogh to Vincent van Gogh, Paris, 4 August 1889 (VGM).
16 Letter 798, Vincent van Gogh to Theo van Gogh, on or about 2 September 1889. See also FR B650, a note added by Dr Théophile Peyron (VGM).
17 Letter 800, Vincent van Gogh to Theo van Gogh, 5 and 6 September 1889 (VGM).
18 Letter 820, Vincent van Gogh to Theo van Gogh, on or about 19 November 1889 (VGM).
19 See note 2, Letter 883, Vincent van Gogh to Theo van Gogh, 31 December 1889 or 1 January 1889 (VGM).
20 Letter 836, Vincent van Gogh to Theo van Gogh, 4 January 1890 (VGM).
21 Letter 833, Vincent van Gogh to Theo van Gogh, 31 December 1889 or 1 January 1890 (VGM).
22 Letter 841, Vincent van Gogh to Willemien van Gogh, 20 January 1890 (VGM).
23 Letter 842, Vincent van Gogh to M. and Mme Joseph Ginoux, 20 January 1890 (VGM).
24 Letter 856, Vincent van Gogh to Willemien van Gogh, 19 February 1890 (VGM).
25 Letter 844, Paul Gauguin to Vincent van Gogh, 22 or 23 January 1890 (VGM).
26 B 2205V/1962: Chris Stolwijk and Han Veenenbos, *Account book of Theo van Gogh and Jo Bonger van Gogh*, (ed.) Sjraar van Heugten, 2002 (VGM).
27 Letter 855, Vincent van Gogh to Anna van Gogh, 19 February 1890 (VGM).
28 Letter 857, Vincent van Gogh to Theo van Gogh, on or about 17 March 1890 (VGM).
29 Letter 856, Vincent van Gogh to Willemien van Gogh, Saint-Rémy, 19 February 1890 (VGM).
30 Letter 863, Vincent van Gogh to Theo van Gogh 29 April 1890 (VGM). For the article on Vincent, see Albert Aurier, 'Les Isolés: Vincent van Gogh', *La Mercure de France*, January 1890, pp. 24–9.
31 Letter FR B1063, Dr Théophile Peyron to Theo van Gogh, 1 April 1890 (VGM).
32 Letter 863, Vincent van Gogh to Theo van Gogh, 29 April 1890 (VGM).
33 Letter 865, Vincent van Gogh to Theo van Gogh, on or about 1 May 1890 (VGM).
34 Letter 814, Joseph Roulin to Vincent van Gogh, 24 October 1889 (VGM).

35 Letter 820, Vincent van Gogh to Theo van Gogh, on or about 19
 November 1889 (VGM).

36 Letter 813, Vincent van Gogh to Willemien van Gogh, on or about 21
 October 1889 (VGM).

37 Dr Théophile Peyron, patient notes, Saint-Rémy, 16 May 1890
 (Documentation VGM).

38 Letter 873, Vincent van Gogh to Theo van Gogh, Auvers-sur-Oise, 20
 May 1890 (VGM).

39 Letter RM20, Vincent van Gogh to Theo and Jo van Gogh, Auvers-sur-
 Oise, 24 May 1890 (VGM).

40 Letter 898, Vincent van Gogh to Theo and Johanna van Gogh, 10 July
 1890 (VGM).

41 Letter FR B2063, Theo van Gogh to Johanna van Gogh, 25 July 1890 (VGM).

42 Letter FR B4241, Johanna van Gogh to Theo van Gogh, 26 July 1890 (VGM).

43 Letter FR B2066, Theo van Gogh to Johanna van Gogh, 28 July 1890,
 in *Brief Happiness*, pp. 269–70 (VGM).

44 Anton Hirschig, quoted by Abraham Bredius in *Herinneringen aan Vincent
 van Gogh*, Oud Holland, Brill, 30 January 1934, Vol. 57, p. 44 (VGM).

45 For date and time of death, see *Acte du décès*, No. 60, 29 July 1890, Mairie
 Auvers-sur-Oise. The declaration of death was made by Theo van Gogh
 and Arthur Gustave Ravoux. Letter from Émile Bernard to Albert Aurier,
 31 July 1890, Rewald Folder.

46 Letter FR B2067, Theo van Gogh to Johanna van Gogh, 1 August 1890 (VGM).

47 Émile Bernard to Albert Aurier, 31 July 1890, Rewald Folder.

48 Letter FR B2067, Theo van Gogh to Johanna van Gogh, 1 August 1890
 (VGM).

49 In 1905 the cemetery concession ran out. Andreas Obst, 'Records and
 Deliberations about Vincent van Gogh's First Grave in Auvers-sur-Oise',
 unpublished monograph on Vincent and Theo's tomb, Germany, 2010.

50 Letter FR B2067, Theo van Gogh to Johanna van Gogh, 1 August 1890
 (VGM).

Epilogue

1 Sjaar van Heugten, 'Vincent van Gogh as a Hero of Fiction', in Tsukasa
 Kōdera (ed.), *The Mythology of Vincent van Gogh* (John Benjamins
 Publishing Company, Amsterdam: 1993), p. 162.

Bibliography

Adler, Laure, *La Vie Quotidienne Dans Les Maisons Closes 1830–1930* (Hachette, Paris: 1990)

Allard. G. and Bertrand (ed.), *L'indicateur marseillais. Guide de l'administration et du commerce. Annuaire du département des Bouches-du-Rhône* (Marseille: 1886–1905)

Arenberg I., L. Countryman., L. Bernstein and E. Shambaugh, Jr, 'Van Gogh had Ménières disease and not epilepsy' in *Journal of the American Medical Association*, No. 264, 1990, pp. 491–3

Aurier, Albert, 'Les Isolés: Vincent van Gogh' in *Mercure de France*, January 1890, pp. 24–9

Bailey, Martin, 'A Friend of Van Gogh: Dodge MacKnight and the Post-Impressionists' in *Apollo*, No. 165, July–August 2007, pp. 28–34

Bailey, Martin, 'Van Gogh's Arles', in *Observer*, 8 January 1989

Bailey, Martin, 'Drama at Arles: New Light on Van Gogh's Self-Mutilation' in *Apollo*, London, 2005, pp. 31–41

Bailey, Martin, *The Sunflowers Are Mine: The Story of Van Gogh's Masterpiece* (Francis Lincoln, London: 2013)

Bailey, Martin, 'Why Van Gogh cut his ear: New Clue' in *The Art Newspaper*, January 2010

Bailly-Herzberg, Janine (ed.), *Correspondance de Camille Pissarro, 1886–90*, Vol. 2 (Editions du Valhermeil, Paris: 1986)

Benezech, M. and M. Addad, 'Van Gogh, le stigmatisé de la société' in *Annales médico-psychologiques*, No. 142, 1984, pp. 1161–72

Bernard, Émile, 'Vincent van Gogh' in *Mercure de France*, April 1893, pp. 324–331

Bernard, Émile, 'Souvenirs de Van Gogh' in *L'Amour d'Art*, V, Paris, 1924, pp. 393–400

Bernard, Émile, 'Vincent van Gogh' in *Les Hommes d'Aujourd'hui*, 8, No. 390, 1891

Bonafoux, Pascal, *Van Gogh: Le soleil en face* (Gallimard, Paris: 1987)

Boulon, Jean-Marc, *Vincent van Gogh à Saint-Paul-de-Mausole* (Association Valetudo, Saint-Rémy de Provence: undated)

Brand, E. J. P., *Dossier Van Gogh: Gek Of Geniaal?* (Uitgeverit Candide, Amsterdam: 2010)

Braumann, Max, 'Bei Freunden Van Goghs in Arles' in *Kunst und Künstler*, Vol. 26 September 1928, Berlin, pp. 451–454

Burnstock, Aviva, 'Van Gogh's Self-Portrait with Bandaged Ear' unpublished technical report, curatorial file, Courtauld Institute, London, 2009

Cheyne, Sir William Watson, *Antiseptic Surgery: Its Principles, Practice, History and Results* (Smith Elder, London: 1882)

Clébert, Jean-Paul and Pierre Richard, *La Provence de Van Gogh* (Edisud, Aix-en-Provence: 1981)

Colin, Paul, *Van Gogh* (Les Editions Rieder, Paris: 1925)

Commune, Laurent, 'Le fauteuil de van Gogh' in *l'Accent Printemps*, 1956

Cooper, Douglas, *Paul Gauguin: 45 lettres à Vincent, Theo et Jo van Gogh* ('S-Gravenhage, The Hague: 1983)

Coquiot, Gustave, *Vincent van Gogh* (Ollendorf, Paris: 1923)

Daudet, Alphonse, *Tartarin de Tarascon* (Alphonse Lemerre, Paris: 1872)

Daudet, Alphonse, *Tartarin des Alpes* (Alphonse Lemerre, Paris: 1885)

Dauphin, Honoré, 'Les amis de van Gogh' in *Le Petit Marseillais*, 28 November 1930

De Bécoulet, E., 'L'emploi du bromure de potassium dans la folie épileptique' in *Annales médico-psychologiques*, 1869, Vol. 1, pp. 238–47

De Beucken, Jean, *Un portrait de Van Gogh* (Gallimard, Paris: 1938)

Descartes, René, *Les Principes de la Philosophie, Première partie, Des principes de la connaissance humaine*, IX Edition (Adam et Tannery, Paris: 1965–1974)

Doiteau, Victor and Edgar Leroy, 'Vincent van Gogh et le drame de l'oreille coupée' in *Aesculape*, No. 7, July 1936, pp. 169–192

Doiteau, Victor and Edgar Leroy, *La folie de Vincent van Gogh*, Collection Sous la signe du Saturne (Editions Aesculape, Paris: 1928)

Doiteau, Victor, 'Deux "copains" de Van Gogh, inconnus, les frères Gaston et René Sécretan, Vincent tel qu'ils l'ont vu' in *Aesculape*, March 1957, pp. 38–58

Druick, Douglas W. and Peter Kort Zegers in collaboration with Britt Salvesen, *Van Gogh and Gauguin: The Studio of the South*, Exhibition Catalogue (Van Gogh Museum with The Art Institute of Chicago, Amsterdam and Chicago: 2001)

Du Quesne, Elisabeth H., *Personal recollections of Vincent van Gogh* (Constable and Co., London: 1913)

Duplessy, M., *L'indicateur Arlésien: Annuaire de la ville d'Arles* (Première année, Marseille: 1887)

Duvivier, Christophe, *Hommage à Anna et Eugène Boch* (Exhibition Catalogue Musée de Pontoise, Pontoise: 1994)

Fallon, Brian, 'Van Gogh' in *Irish Times*, 29 December 1971

Gastaut, Henri, 'La maladie de Van Gogh envisagée à la lumière des conceptions nouvelles sur l'épilepsie psycho-motrice' in *Annales médico-psychologiques*, No. 114, 1956, pp. 196–238

Gauguin Paul, *Avant et après* (Editions G. Crès et Cie., Paris: 1923)

Gauguin, Paul, *Lettres à sa femme et à ses amis* (Editions Bernard Grasset, Paris: 1946)

Gauguin, Paul, *Oviri: Ecrits d'un sauvage* (Gallimard, Paris: 1903)

Gayford, Martin, *The Yellow House: Van Gogh, Gauguin and Nine Turbulent Weeks in Arles* (Fig Tree, London: 2006)

Gayford, Martin, 'Van Gogh Betrayed' in *Daily Telegraph*, 25 June 2005

Gennauer, Emily, 'The Town That Forgot Van Gogh' in *Herald Tribune*, 7 February 1954

Golf, Benni, 'Van Gogh og Danmark' in *Politken*, 6 January 1938

Gosselin, R. E., H. C. Hodge, R. P. Smith and M. N. Gleason, 'Clinical Toxicology of Commercial Products' in *Williams and Wilkins*, Baltimore, fourth edition, 1976, pp. 11–77

Groom, Gloria and Douglas Druick, *The Age of French Impressionism: Masterpieces from the Art Institute of Chicago* (Art Institute of Chicago, Yale University Press, New Haven and London: 2010)

Hanson, Lawrence and Elizabeth Hanson, *The Noble Savage: A Life of Paul Gauguin* (Chatto & Windus, London: 1954)

Hartrick, Archibald Standish, *A Painter's Pilgrimage Through Fifty Years* (Cambridge University Press, Cambridge: 1939)

Hirschig, Anton, quoted by Abraham Bredius in 'Herinneringen aan Vincent van Gogh' in *Oud Holland*, Brill, 30 January 1934, Vol. 57, p. 44

Hulsker, Jan, 'The elusive van Gogh, and what his parents really thought of him' in *Simiolus*, Netherlands Quarterly for the History of Art 19–4, 1989, pp. 243–270

Hulsker, Jan, 'Critical days in the hospital at Arles: Unpublished letters from the postman Roulin and the Reverend Mr. Salles to Theo van Gogh' in *Vincent*, Bulletin of the Rijksmuseum Vincent van Gogh 1–1, 1970, pp. 20–31

Hulsker, Jan, *Vincent and Theo van Gogh: A Dual Biography* (Fuller Technical Publications, Ann Arbor: 1990)

Hulsker, Jan, 'Vincent's stay in the hospitals at Arles and Saint-Rémy: Unpublished letters from the Reverend Mr. Salles and Doctor Peyron to Theo van Gogh' in *Vincent*, Bulletin of the Rijksmuseum Vincent van Gogh 1–2, 1971, pp. 24–44

Hulsker, Jan, '*Van Gogh, Roulin and the two Arlesiennes a re-examination: Part I & II*' in *The Burlington*, Part I: Vol. 134, September 1992, pp. 570–576, Part II: Vol. 134 November 1992, pp. 707–715

Huyghe René (ed.), *Le Carnet de Paul Gauguin* (Editions Quatre Chemins-Editart, Paris: 1952)

Jansen, Leo, Han Luijten, Nienke Bakker, *Vincent van Gogh: The Letters* (Thames and Hudson, London: 2009)

Janssens, Dominique, *120ème anniversaire de la mort de Vincent van Gogh à l'Auberge Ravoux*, Exhibition Catalogue Auberge Ravoux, Auvers-sur-Oise, 29 July 1890–29 July 2010

Januszczak, Waldemar, 'Starry, Starry Night' in *Guardian*, 23 December 1983, p. 19

Jaulmes, Madame Edmond, 'Souvenirs de Vincent Van Gogh' unpublished souvenirs of Van Gogh recorded in October 1964 (Salles family archives)

Jullian, M., 'Dans Arles, à la recherche de Van Gogh', in *La Dauphine Libéré*, 19 January 1958

Karagheusian, Artemis, *Vincent van Gogh's letters written in French. Differences between the printed versions and the manuscripts. Les lettres de Vincent van Gogh écrites en français. Les différences entre les versions imprimées et les manuscrits*, preface by Jan Hulsker (Stylo-O-Graph Letter Shop, Inc., Huntington: 1984)

Kauffmann, Hans and Wildegans, Dr. Rita, *Van Goghs Ohr: Paul Gauguin und der Pakt des Schweigens* (Osberg Verlag, Berlin: 2008)

Kōdera, Tsukasa, *Vincent van Gogh: Christianity versus nature* (OCULI, Amsterdam: 1990)

Koldehoff, Stefan, *Van Gogh: Mythos und Wirklichkeit* (Dumont, Cologne: 2003)

Larsson, Håkan, 'Flames from the South: The Introduction of Vincent van Gogh in Sweden before 1900', Thesis (Lund: 1993)

Larsson, Håkan, *Flames from the South: On the Introduction of Vincent van Gogh to Sweden* (Gondolin, Stockholm: 1996)

Leprohon, Pierre, *Vincent van Gogh* (Editions Corymbe, Le Cannet de Cannes: 1972)

Leroy, Edgar, letter to Irving Stone, 25 November 1930, Stone Papers: Banc MSS 95/2 folder 10, Bancroft Library, University of California, Berkeley

Longuet, Jean-Denis, 'Jean François Poulet, qui fut le gardien de Van Gogh à l'asile de Saint-Rémy-de-Provence' in *Le Dauphine Libéré*, 5 April 1953, p. 4

Lubin, Albert J., *Stranger on Earth: A Psychological Biography of Vincent van Gogh* (Da Capo Press, New York: 1996)

Magiorkinis, E., S. Kalliopi and A. Diamantis, 'Hallmarks in the history of epilepsy: Epilepsy in antiquity' in *Epilepsy & Behavior*, No. 17, January 2010, pp. 103–8

Malingue, M., *Paul Gauguin, lettres à sa femme et à ses amis* (Bernard Grasset, Paris: 1946)

Massebieau, Alfred, 'Lettres à l'editeur Alfred Vallette' in *Mercure de France*, No. 999, I-VII-1940-I-XII-1946, Paris, 1946

Meier-Graefe, Julius, *Vincent van Gogh: A Biography*, translated by John Holroyd (Michael Joseph Ltd, London: 1936)

Meier-Graefe, Julius, Interview with Marie Ginoux, 'Erinnerung an van Gogh' in *Berliner Tageblatt und Handels-Zeitung*, Berlin, No. 313, 23 June 1914, p. 2

Merlhès, Victor (ed.), *Paul Gauguin et Vincent van Gogh, 1887–1888: Lettres Retrouvées, Sources Ignorées* (Avant et Après, Taravao: 1989)

Merlhès, Victor (ed.), *Correspondance de Paul Gauguin: Documents, témoignages* (Fondation Singer-Polignac, Paris: 1984)

Michel, Ernest, *Catalogue des peintures et sculptures exposées dans les galeries du Musée Fabre de la ville de Montpellier* (Ville de Montpellier, Montpellier: 1890)

Mirbeau, Octave, 'Vincent van Gogh' in *Le Journal*, Paris, 17 March 1901

Monroe, Russell R., 'Another diagnosis for Vincent van Gogh?' in *Journal of Nervous & Mental Disease*, No. 179, 1991, p. 241

Mourier-Petersen, Christian, Letter to Johan Rohde, March 1888 Ms. Tilg. 392, Royal Library, Copenhagen

Mühsam, Joachim A., 'Besuch bei einem alten Arzt, Errinnerungen an van Gogh' in *Rheinischer Merkur*, 23 November 1962

Muñoz-Alonso, Lorena, 'Scholar Claims Van Gogh Hid Secret Homage to Leonardo da Vinci's *The Last Supper* in his *Café Terrace at Night*' in *Artnet*, 10 March 2015

Naifeh, Steven and Gregory White Smith, *Van Gogh: The Life* (Random House, New York: 2011)

Norman, Geraldine, 'Fakes' in *New York Review of Books*, 5 February 1998

Obst, Andreas, 'Records and Deliberations about Vincent van Gogh's First Grave in Auvers-sur-Oise', unpublished monograph on Vincent and Theo's tomb, Germany, 2010

Parsons, William, the Third Earl of Rosse, 'The Whirlpool or Spiral Nebula' in *Transactions of the Royal Society* (Royal Society publications, Royal Society, London: 1851)

Pickvance Ronald, '"A great artist is dead"': Letters of condolence on Vincent van Gogh's death', (ed.), Sjraar van Heugten and Fieke Pabst in *Cahier Vincent 4*, Zwolle, 1992

Pickvance, Ronald, *Van Gogh et Arles. Exposition du centenaire*, Exhibition Catalogue (Société Anonyme d'Economie Mixte, Arles Développement, Ronald Pickvance et Musées d'Arles, Arles: 1989)

Pickvance, Ronald, *Van Gogh in Arles*. Exhibition Catalogue (Metropolitan Museum of Art, New York: 1984)

Priou, J. N., 'Van Gogh et la famille Roulin' in *Revue des PTT de France 10–3*, May–June 1955, pp. 26–32

Prouty, Marie, 'Auprès de Monsieur le Pasteur Frédéric Salles en relisant ses lettres du 1er décembre 1874 au 17 février 1886', unpublished document, Eglise Reformée d'Arles, 1988

Rabinow, Rebecca A., Douglas W. Druick, Maryline, Assante di Panzillo, *Cézanne to Picasso: Ambroise Vollard, Patron of the Avant*

Garde, Exhibition catalogue (Metropolitan Museum of Art, New York: 2006)

Ravoux, Adeline, 'Souvenirs sur le séjour de Vincent van Gogh à Auvers-sur-Oise' in *Les Cahiers de Vincent 1,* 1957, pp. 7–17

Rewald, John, *Post-Impressionism: From Van Gogh to Gauguin,* 3rd revised edition (Museum of Modern Art, New York: 1978)

Rey, Robert, *Onze menus de Paul Gauguin* (Editions Gérard Cramer, Geneva: 1950)

Richard, Pierre E., *Vincent: Documents et inédits* (Nombre 7, Nîmes: 2015)

Runyan, William McKinley, 'Why Did Van Gogh Cut Off His Ear? The Problem of Alternative Explanations' in *Psychobiography, Journal of Personality and Social Psychology,* American Psychological Association, Vol. 40, No. 6, 1981, pp. 1070–77

'Saint-Paul-de-Mausole, Dernier Séjour de Van Gogh en Provence' in *Le Provençal,* 13 July 1954, p. 4

Stokvis, Benno, 'Vincent van Gogh in Arles' in *Kunst und Künstler,* Gand Artistique 8–1 Berlin, 1929, pp. 2–9

Stolwijk, Chris and Han Veenenbos, *The Account Book of Theo van Gogh and Jo Bonger van Gogh* (ed.), Sjraar van Heugten (Van Gogh Museum, Leiden: 2002)

Stone Papers: Banc MSS 95/205 CZ/, Bancroft Library, University of California, Berkeley California

Stone, Irving, *Lust for Life* (Longmans, New York: 1934)

Termeau, Jacques, *Maisons closes de province* (Editions Cénomane, Le Mans: 1986)

'The Van Gogh Exhibit' in *Life Magazine,* Vol. 2 No. 7, 15 February 1937

Tralbaut, Mark Edo, *Van Gogh: Le Mal Aimé* (Edita, Lausanne: 1969)

Tralbaut, Mark Edo, *Van Gogh: Une Biographie par Image* (Hachette, Paris: 1960)

Trossat, Dr Valérian, 'La folie de l'Absinthe: Retour sur les troubles mentaux attribués à l'Absinthe à travers son histoire', unpublished medical thesis, Centre Hospitalier Universitaire, Besançon, France, 2010

Tuloup-Smith, Annie, *Rue d'Arles qui êtes-vous?* (Editions Les Amis du Vieil Arles, Arles: 2001)

Unknown, 'Maison de santé de Saint-Rémy de Provence, Etablissement privé consacré au traitement des aliénés des deux sexes' (Masson, Paris: 1866)

Van Crimpen, Han (Introduction and commentary) and Leo Jansen and Jan Robert (eds.), *Brief happiness: The correspondence of Theo van Gogh and Jo Bonger* (Cahier Vincent 7, Amsterdam and Zwolle: 1999)

Van Crimpen, Han, *Friends Remember Vincent in 1912*, Vincent van Gogh, International Symposium, Tokyo, 17–19 October, 1985

Van Hatten, Jan and Jan Hulsker, 'What Theo really thought of Vincent' in *Vincent*, Bulletin of the Rijksmuseum, Vincent van Gogh 2, Vol. 3, Amsterdam 1974, pp. 2–27

Van Heugten, Sjaar, 'Vincent van Gogh as a Hero of Fiction' in Tsukasa Kōdera (ed.), *The Mythology of Vincent van Gogh* (John Benjamins Publishing Company: 1993)

Van Tilborgh, Louis and Teio Meedendorp, 'The Life and Death of Van Gogh' in *The Burlington*, London, CLV July 2013, pp. 456–462

Verzamelde brieven, Vol. 1, Van Gogh Museum Amsterdam, 1973

Vollard, Ambroise, *Souvenirs d'un marchand de tableaux* (Albin Michel, Paris: 1937)

Voskuil, P. H. A. and Wilfred Arnold, 'The Illness of Vincent van Gogh: Letters to the Editor and Author's Response' in *Journal of History of Neurosciences*, Vol. 14, pp. 169–176, 2005

Voskuil, P. H. A., 'Vincent van Gogh's malady: A test case for the relationship between temporal lobe dysfunction and epilepsy?' in *Journal of History of Neurosciences*, Vol. 1, 1992, pp. 155–56

Voskuil, P. H. A., 'Van Gogh's Disease in Light of his Correspondence' in J. Bogousslavsky and S. Dieguez (eds.) in *Literary Medicine: Brain Disease and Doctors in Novels, Theater, and Film* (Karger, Basel: 2013)

Voskuil, P. H. A, 'Diagnosing Vincent van Gogh, an expedition from the sources to the present, "mer à boire"' in *Epilepsy & Behavior*, No. 28, 2013

Wilkie, Ken, *The Van Gogh File: The Myth and the Man* (Souvenir Press, Fish Books, London: 1998)

Index

Bernadette Murphy was born and brought up in the UK. She has lived in the south of France for most of her adult life and worked in many different fields. A series of chance events led her to start investigating the life of Van Gogh in Arles, but little did she know at the time quite what an exciting adventure it would turn out to be. *Van Gogh's Ear* is her first book.

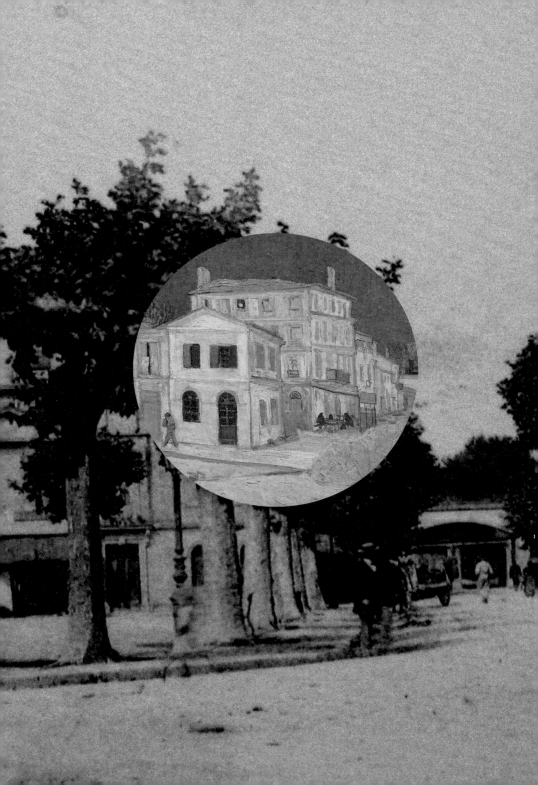